PRAISE FOR

Generation Friends

"Saul Austerlitz gets at the heart of [the show's] appeal." —*New York*

"[An] under-the-hood chronicle of the nineties sitcom."
—*The New Yorker*

"Austerlitz has written a love letter for fans of the show to remember key moments from the ten-season run of *Friends* while also revealing the good and bad of how difficult it is to create a show, put it on the air, and find lightning in a bottle." —Associated Press

"An engaging read with lots to appeal to *Friends* fans." —*Forbes*

"We might not ever get that reunion special at Central Perk, but Austerlitz has given us the next best thing with this behind-the-scenes look at the world that brought us Monica, Rachel, Ross, Chandler, Phoebe, and Joey." —*Newsweek*

"Saul Austerlitz gives a comprehensive behind-the-scenes look at everyone's favorite show." —*InStyle*

"All die-hard fans need to read this tome, which reveals never-before-known tidbits, including how the show writers' lives inspired the storylines for the beloved characters." —*Star*

"Chock-full of behind-the-scenes info, this fond accounting is a must-read for both new and old *Friends* fans." —*Booklist* (starred review)

"Addictively readable. Come because you're a fan, stay because you realize that *Friends* did (take that, Chandler Bing!) define a cultural moment: a world where coffee shops were just beginning to take off as 'third places,' television wasn't available to DVR or stream, and networks were starting to warm up to sitcoms about nothing. I'm halfway through Saul Austerlitz's ode to this NBC hit, and I can't wait to finish it and annoy my friends with fun *Friends* facts."

—Sarah Gelman,
director of books and editorial for the Amazon Book Review blog

"A treat for *Friends* fans, from OG must-see-TV viewers to the new generation of streamers, full of insights into what made a quintessential '90s phenomenon into a lasting, international classic for the ages. You'll get your share of juicy behind-the-scenes tidbits, from vicious writers'-room debates about Rachel and Joey's romance to the time the producers almost moved the setting to Minneapolis (seriously). But you'll also get a hit of nostalgia for a time when an entire nation hung on the fate of Ross and Rachel, and plenty of smart analysis of why *Friends* was the right show at the right time . . . and also continues to be the right show at an entirely different time."

—Jennifer Keishin Armstrong,
New York Times bestselling author of *Seinfeldia*

"*Friends* wasn't just a funny show—it was a generational work of art that evolved television's scope. It proved that shows could travel beyond the dynamics of nuclear families and the virtue of strong cast chemistry. In *Generation Friends*, Saul Austerlitz transports us back to Central Perk with our eternal friends trying to find their place in the world. Just as importantly, he lifts the curtain to provide a sprawling behind-the-scenes look at its creation, enactment, and still-growing legacy."

—Jonathan Abrams,
New York Times bestselling author of *All the Pieces Matter*

"With careful research and new and revealing interviews, Austerlitz's *Generation Friends* does what a great behind-the-scenes book should do: It'll make you want to rewatch the entire series again from start to finish, with a new appreciation of everything from the writing and acting to set design and costumes. Better yet, Austerlitz provides some much-needed validation for those of us who never warmed to the whole Ross-Rachel thing, assuring us that we *might* have been on to something, even as he argues we were wrong. FIGHT ME, SAUL."

—Brian Jay Jones,
New York Times bestselling author of *Jim Henson: The Biography* and *Becoming Dr. Seuss*

"The ultimate peek behind the scenes into the creation and execution of the series that broke new ground with its inclusion of a lesbian wedding and other LGBTQ-related storylines." —*Baltimore Outloud*

"On its twenty-fifth anniversary, the show's die-hard fans will love Austerlitz's detailed, discerning, and sumptuous history." —*Kirkus Reviews*

"Guiding readers through Hollywood politics, notes from the network, and a complicated casting process, the author documents the creation of the legendary television show. . . . Austerlitz also goes behind the scenes, detailing overnight writing sessions, contract negotiations, and disagreements with directors. . . . For followers of the program and lovers of pop culture." —*Library Journal*

ALSO BY SAUL AUSTERLITZ

Just a Shot Away:
Peace, Love, and Tragedy with the Rolling Stones at Altamont

Sitcom:
A History in 24 Episodes from I Love Lucy *to* Community

Another Fine Mess:
A History of American Film Comedy

Money for Nothing:
A History of the Music Video from the Beatles to the White Stripes

GENERATION FRIENDS

An Inside Look at the Show
That Defined a Television Era

SAUL AUSTERLITZ

DUTTON

DUTTON
An imprint of Penguin Random House LLC
penguinrandomhouse.com

Previously published in a Dutton hardcover edition in September 2019

First Dutton trade paperback edition: September 2020

Credit information for photo insert:
Photos 1–10: Getty Images
Photos 11–20: Copyright © Bruza Brother Productions, LLC

THE LIBRARY OF CONGRESS HAS CATALOGUED THE HARDCOVER EDITION AS FOLLOWS:

Names: Austerlitz, Saul, author.
Title: Generation Friends : an inside look at the show that defined a
television era / Saul Austerlitz.
Description: New York, NY : Dutton, an imprint of Penguin Random House [2019] |
Includes bibliographical references.
Identifiers: LCCN 2018058454 (print) | LCCN 2019013605 (ebook) |
ISBN 9781524743376 (ebook) | ISBN 9781524743352 (hc)
Subjects: LCSH: Friends (Television program)
Classification: LCC PN1992.77.F76 (ebook) | LCC PN1992.77.F76 A97 2019 (print) |
DDC 791.45/72—dc23
LC record available at https://lccn.loc.gov/2018058454

Dutton trade paperback ISBN: 9781524743369

Printed in the United States of America
10 9 8 7 6 5 4 3 2 1

BOOK DESIGN BY KRISTIN DEL ROSARIO

For Nate,
my favorite new reader

CONTENTS

GENERATION FRIENDS

INTRODUCTION

They would gather, every few minutes, in clumps and packs. They were wielding smartphones, of course, and digital cameras, and disposable models you might pick up at a souvenir shop or pharmacy checkout counter. There were mothers posing with their daughters, European couples who looked as if they had only just stepped off the runway in Milan, and amateur photographers setting up shoots in the middle of the street.

My friend Jennifer and I were having lunch, and we both found ourselves distracted by the onslaught of humanity in the street, although of course we were there for much the same reasons. We were at the Little Owl, a twenty-eight-seat restaurant in the West Village that describes itself as "a corner gem with a big porkchop and an even bigger heart." We were there for the superb food, but more so for the location. Based on the establishing shot that displayed the building's exterior, the Little Owl was in the spot where Central Perk would have been—you know, if it ever existed. We were on a brief tour to find the traces of *Friends* in the real New York of early 2018, and we were beginning our

search with the polenta (for Jennifer) and the eggplant parmigiana (for me).

There was something ludicrous and obsessive about our expedition. *Friends* had not only been filmed on a soundstage on the Warner Bros. lot in Los Angeles, it had contained only the faintest traces of New York, regardless of its claims to residency. We were equipped with a blog post listing some of the purported locations of the characters' apartments and a handful of other West Village destinations that the show explicitly mentioned or featured as an exterior. The list, which included Ross's apartment, Phoebe's apartment, and the Lucille Lortel Theatre, where Joey had performed in a show, was short.

Friends lacked even the New York credibility of *Sex and the City* or *Seinfeld,* two other comedy series of the era that had used the city as a backdrop. They had at least made New York a kind of permanent supporting character on their shows, whereas *Friends,* after a few brief forays onto the subway or into Bloomingdale's, had retreated into its preferred interior spaces, including the faux neighborhood spot whose spiritual footprint we were now occupying.

Throughout our lunch, we anticipated the arrival of fellow *Friends* fanatics, there to commune with the setting of their favorite show. But no one even approached the restaurant. They were mostly standing catty-corner to the restaurant, on the northwest side of the street. The collective agreement to stand only on that corner was baffling. Why not get a bit closer?

Once Jennifer and I concluded our meal and stepped outside ourselves, the riddle answered itself almost instantaneously. Standing on the northwest corner, of course, placed the façade of the familiar building at 90 Bedford Street directly in the backdrop of fans' selfies, looking just as it had on television. After all, 90 Bedford had only ever been glimpsed in brief establishing shots on *Friends,* and only ever from a single angle. To photograph it from any other perspective would be to render it entirely unrecognizable. This was the perspective they wanted to see, and share, and post.

To be a *Friends* fan touring the West Village in search of relics from the show was to grasp at any and all straws. Ross's apartment was supposed to be across the street, but while we had the address, the building did not look much like it had on the show—or perhaps we were remembering it wrong. And the same went for 90 Bedford. Seeing the building—even eating lunch inside it—the mind balked at the notion that Rachel and Monica and Chandler and Joey were supposed to have lived right here. Real and imaginary geography did not line up, and it was next to impossible to picture this twenty-first-century bistro superimposed atop that orange couch, and Gunther hunched behind the counter.

There was so little to see on our *Friends* walking tour that after checking in on Ross, we walked five minutes to 5 Morton Street, where Phoebe was supposed to live, and wound up our corkscrew-shaped tour at the Lucille Lortel Theatre, where Joey had once performed. While I suppose we could have stopped in at Bloomingdale's, where Rachel had worked, or the Plaza, where Monica and Chandler had celebrated their engagement, how much would it have added to our understanding of *Friends*' place in New York?

The tour felt like a letdown, even though I had known there was practically nothing to see, but I kept thinking about those tourists who had ventured to the corner of Grove and Bedford to pay homage to the show they loved. There was essentially nothing to do other than snap a selfie, but they kept coming, from New Jersey and from Europe and from everywhere else *Friends* pilgrims originated. The lack of anything worth seeing was not a marker of their being hoodwinked; it demonstrated the ferocity of their devotion that they were there nonetheless, present in the West Village to see nothing much at all simply because it had been granted the mark of *Friends*.

In coming to visit *Friends* places, it was hard not to ponder the remarkable life and afterlife of this show, which seemingly reached new heights of the impossibly mundane upon its premiere in 1994 and yet still captivates new audiences a quarter of a century later. There was so

little to look at, at first glance, and yet it was impossible to look away. *Friends* had emerged in an era when comedies were finding new ways to amuse their audiences by being about as little as possible. At the same time, *Friends'* comic minimalism was conjoined to a soap-operatic maximalism. It was a show that compelled us to stay glued to our screens by the promise of emotional revelation. Its characters, often so devoid of ambition or drive, were rendered whole by the force of their yearning: for romance, for sex, for understanding. There were teenagers around the United States—around the world, for that matter—who discovered *Friends* and believed it to be their own. As someone who had been a teenager himself when the show premiered, I was fascinated by that desire to claim the show as theirs. Television was almost inevitably a cultural product with an expiration date attached. How often did viewers go back and watch series that had premiered decades prior, unless out of nostalgic drift?

I wanted to tell the story of a show that had been created in an entirely different media universe—before streaming, before #MeToo, before the War on Terror, before Trump—and understand the roots of its success. By delving into the particulars of the making of the show, I hoped to understand how *Friends* had achieved its remarkable success, and how it had sustained that appeal across decades, and generations of viewers.

Friends' perceived weaknesses had become its strengths. Its lack of realism (Chandler and Joey living in the West Village?) had been transformed, through the passage of time, into an evergreen fantasy of youth. It was a show about young people that would be discovered, year after year, by new cohorts of young people aching to know what adulthood would be like. The show may not have had much of anything to do with New York, but people continued to come to New York to see what they could of the show they loved so fiercely. They were here to say thank you.

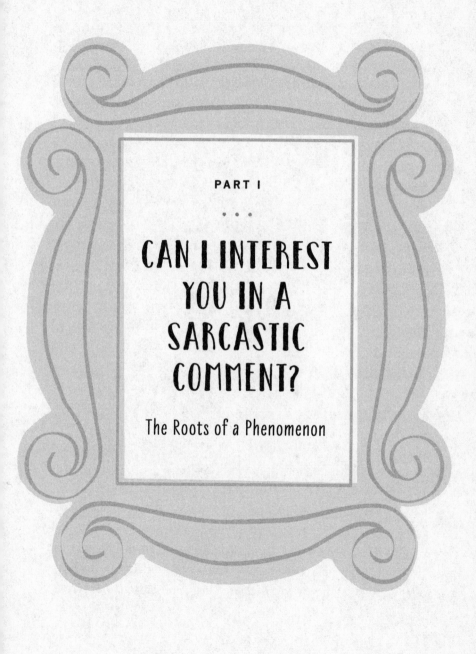

PART I

. . .

CAN I INTEREST YOU IN A SARCASTIC COMMENT?

The Roots of a Phenomenon

CHAPTER 1

INSOMNIA CAFÉ

A TV Show Is Born

One day in late 1993, a young television writer named Marta Kauffman was driving along Beverly Boulevard when she passed a funky coffee shop called Insomnia Café, located across the street from an Orthodox synagogue. Full of lumpy couches and garish chairs, strings of Christmas lights, and towering bookshelves piled high with mismatched books, the place was a beacon calling to the artists and slackers of the Fairfax–La Brea area. Kauffman, who lived nearby in Hancock Park, was trawling for ideas that could be transformed into stories for the upcoming pilot season.

Along with her writing partner David Crane, Kauffman had created the groundbreaking HBO series *Dream On* and, after leaving the show, had been fruitlessly seeking network success. Last pilot season had been disappointing, and it was important to the two writers that 1994 be a better year for them than 1993 had been. Something about Insomnia Café grabbed her attention, and she began to mull over an intriguing idea. Could a comedy series set in a coffee shop appeal to viewers? Kauffman and Crane had only recently moved to California from New York,

and found that they missed their old crew of friends from Manhattan terribly. They had spent all their spare time together, done everything together, served as a kind of surrogate family. What if they put together a show about that?

———

Sometime in the mid-1980s, Warren Littlefield discovered something new about television. The NBC executive, protégé to network president Brandon Tartikoff, was attending an advertising meeting, and the research department displayed a gridded chart showing the relative audience shares for two shows: CBS's *Murder, She Wrote* and NBC's own *St. Elsewhere*. At the bottom left, *Murder, She Wrote,* featuring Angela Lansbury as a crime-solving mystery novelist, a fixture in the Nielsen top ten, and at the top right, NBC's quirky hospital drama, beloved by critics but lagging noticeably in the ratings. The message was clear: NBC's niche effort was having its clock cleaned. What came next changed Littlefield's entire career.

If you think *Murder, She Wrote* is kicking *St. Elsewhere*'s ass, the researcher continued, you're right—when it comes to total audience. Now a new graph replaced the initial chart. This one showed the fees networks charged advertisers for their shows. Quirky, niche, never-gonna-be-a-hit *St. Elsewhere* made NBC more money than the far more successful *Murder, She Wrote* made for CBS. NBC was able to charge more for its thirty-second spots than CBS charged for theirs.

And why? The answer lay in a steady shift in advertisers' interests. Advertisers increasingly preferred younger eyeballs. Reaching a mass audience was too diffuse and too unpredictable. Advertisers preferred a targeted approach, pushing their sports cars and light beers to youthful viewers, whom they believed to be more likely to purchase them. The ratings were no less important today than they had been yesterday, but the youth market—broadly speaking, viewers between the ages of eighteen and forty-nine—was becoming the only market that really mattered. (Older people, the thinking went, could be safely ignored, being

unlikely to buy the razors and sports cars and beer advertisers hoped to sell.) Littlefield understood that the ground was shifting in network television.

Littlefield had been studying government at American University in Washington, DC, during the final years of Richard Nixon's presidency, imagining himself rescuing American democracy from unconstitutional knavery. When Nixon resigned, the urgency of Littlefield's cause dissipated, and he switched to studying psychology. Before beginning a graduate program, he wanted to accrue some work experience and was offered a job by a hometown friend as a gofer at a production company.

After stints as a location scout and an assistant editor, Littlefield was acquiring properties of his own for production. He was feeding original movies to the gaping maw of the networks, which had approximately three hundred such slots to fill on their yearly calendars. One such effort, an East Africa–set adventure called *The Last Giraffe,* was selected by *The Hollywood Reporter* as one of the ten best TV movies of 1979, and Littlefield decided it was time to relocate to Los Angeles. He soon took up a job at NBC in comedy development and began his meteoric rise at the network.

Just a few years after the *St. Elsewhere* epiphany, Littlefield was named the president of entertainment at NBC, replacing Tartikoff. Littlefield was inheriting a network that was simultaneously flourishing and endangered. Under the tutelage of the highly esteemed Tartikoff, NBC had dominated the 1980s with series like *Cheers, The Cosby Show,* and *L.A. Law.* Tartikoff had been skeptical about a new series from two comedians named Jerry Seinfeld and Larry David ("too New York and too Jewish," said the New York Jew) but developed the acerbic, high-concept, defiantly unlikable *Seinfeld* anyway.

Now Littlefield had succeeded Tartikoff and was watching as the network's most beloved series were leaving the air. *The Cosby Show* had ended, *Cheers* was ending, and NBC's historic run of dominance on Thursday nights was running the risk of coming to an end. NBC needed to develop some new shows, and Littlefield's newfound fixation on

younger audiences found him constructing a mental graph of his own. The x-axis was the mass market; the y-axis was the youth audience. Littlefield was aiming to simultaneously maximize both, creating shows that were appealing to younger viewers without turning away older audiences.

As Littlefield was pondering his future audience, Bill Clinton was close to wrapping up his first year as president and soon to face a wipeout in the 1994 midterms, in which Republicans would gain fifty-four seats and make Newt Gingrich Speaker of the House. The Soviet Union had collapsed two years prior, leaving the United States as the sole world superpower. Democracy had seemingly won its titanic struggle with world communism without firing a shot. The American way of life was ascendant.

The sports world was about to be rocked by the news that, for the first time in ninety years, there would be no World Series played that fall, due to a labor strike. Quentin Tarantino won the Palme d'Or at Cannes for his neo-Godardian crime film *Pulp Fiction*, which resuscitated the moribund career of John Travolta, and the dominant film of the summer would be the overpraised, conservative *Forrest Gump*, in which Tom Hanks's title character was present at much of postwar American history while serving as proof that all was as it should be. Independent film was ascendant, with Miramax, run by the later-to-be-disgraced Harvey Weinstein, leading a phalanx of new voices with films like *The Crying Game*. In the mid-1990s, film was still considered the primary visual medium of the American arts, attracting exciting new voices like Tarantino, Todd Haynes, John Singleton, and Allison Anders. Television, by comparison, while it had produced exciting new series like *Seinfeld* and *NYPD Blue*, was considered a backwater, a place you went when the movies didn't work out, whose audience was far less discerning than film's.

Meanwhile, a coffee company that had originally been started by two teachers and a writer in Seattle had begun to expand beyond the

Pacific Northwest. Starbucks had opened stores in Portland and Chicago, and then targeted California, tackling San Francisco and Los Angeles. The company had gone from eleven stores in 1987 to one hundred sixty-one stores only five years later. Coffee was suddenly big business, and Starbucks was rapidly becoming the name most prominently associated with coffeehouse culture. With its oversize plush chairs, its soothing soundtrack of folk, indie rock, and world music, and its distinct language (who decided that a "tall" would be one of the smaller sizes for its drinks?), what had once been associated with college campuses and Greenwich Village was soon to be a nationwide phenomenon. Coffee was no longer solely a matter of dumping hot water into powder over the kitchen sink; it was now an entire lifestyle, with a culture of (occasionally harried) leisure to accompany it. Young Americans would not just drink coffee for a burst of caffeine; they would lounge around in coffeehouses, bantering, laughing, and trading confidences, seizing on the relatively new spaces forming in cities across the nation and making them their own.

As president, Littlefield was carrying with him the message he had received from the legendary former NBC CEO and chairman Grant Tinker earlier in his career. Tinker had continually sought to remind Littlefield and his colleagues that the audience was not an alien race. What shows were his employees breathlessly anticipating each week? What series would convince them to cancel their plans and rush home, in this pre-streaming era, to catch the latest episode? Those were the shows they should be making. It was time for stories that spoke to the audiences they craved, that were about young people.

And if the story of the sitcom could be said to have followed an arc, one of the major changes that had unfolded across the four decades of television history had been the shift away from the family show. Television had begun as a domestic medium, a place for families to gather in their living rooms to watch other, fictional families in their living rooms. It had been a feminine counterpoint to the increasingly masculine

sphere of the movies. But over time, the domestic families of *Father Knows Best* and *Leave It to Beaver* had given way to the workplace families of *The Mary Tyler Moore Show* and *M*A*S*H*.

With the American family dissolving and re-forming in unimaginable new patterns, the sitcom increasingly preferred its groupings of colleagues and squads. The 1980s had seen a resurgence of the family sitcom, with the former B-movie-star-turned-national-father-figure Ronald Reagan inspiring a wave of sturdy sitcom dads like *The Cosby Show*'s Heathcliff Huxtable and *Family Ties*' Steven Keaton. Ratings indicated that younger audiences, less likely to be married or raising children, mostly preferred to see themselves reflected on their television screens, and even older, married viewers were often happier watching a crew of friends bantering.

Seinfeld was a show like that. The specials department at NBC, not the prime-time programming team, had picked up the pilot in 1989. Rick Ludwin and his group had fallen in love with a stand-up comedian named Jerry Seinfeld. Seinfeld and fellow comedian Larry David had spent an afternoon walking around a Manhattan deli and talking about the strange products on display there, belatedly realizing that their aimless banter could form the foundation of a new kind of television series. The pilot flopped with audiences, and NBC expressed little enthusiasm for the show, but Ludwin's fierce advocacy bankrolled a four-episode run, and eventually got it an invitation for a fuller second season.

Seinfeld rewrote the rules of the sitcom. Its characters were amoral, callous, and self-centered. There were no meaningful romantic relationships on the show; the one partnership heading toward marriage would later be brutally, hilariously interrupted by a batch of poisoned envelopes. And yet, NBC understood that part of the attraction of *Seinfeld* was its aura of charming Manhattan singles in pursuit of true love—or at least a fruitful one-night stand. Much of *Seinfeld* was turned over to the logistics and limitations of big-city dating, with many of its most memorable moments, from "They're real, and they're spectacular" to

"Not that there's anything wrong with that," stemming from relationship stories. People enjoyed watching George and Elaine and Kramer sitting on Jerry's couch and bantering, and NBC was betting that there was a huge untapped market for series similar to *Seinfeld*, the third-highest-rated series of the 1993–94 season after *60 Minutes* and *Home Improvement*. The search for the next *Seinfeld* was on.

Each morning at six o'clock, Littlefield received a fax from the research department, based in New York, with the overnight ratings. It was like a daily report card, delivering updated assessments of the audience's feelings regarding NBC programming. As Littlefield perused the overnights from San Francisco and Houston and Atlanta, he thought about what it must be like to be a young person starting a life in one of those places. Rent was expensive, jobs were scarce, and moving somewhere new, beyond the reach of parents and old friends, could be lonely. Littlefield considered his own formative postcollege years, living with roommates in the suburbs of New York and taking the commuter train to work daily. It had been harsh and unromantic, but it had also been a testing ground. To be young was to scuffle, but it was also to discover the world afresh. ABC was flying high with blue-collar comedies like *Roseanne* and *Home Improvement*, and CBS was devoted to its older audience, seemingly unaware of the advertising pot of gold that Littlefield was chasing. No one was serving the younger viewers Littlefield had in mind.

Littlefield put out a call to writers and producers he had worked with: Bring me ideas for shows about young people. He was in search of stories about breaking away, about stepping out, about finding yourself. Littlefield was convinced that older audiences could easily be compelled to watch a show in which they communed with their younger selves, but younger audiences could never be cajoled to watch characters living lives they had not yet experienced. Littlefield didn't want any more pitches about crusading lawyers or wholesome single dads; he wanted clever, warmhearted shows with instantly recognizable characters. He

wanted a kinder, gentler *Seinfeld*—less New York and less Jewish (while maybe still retaining some of the original's Semitic, five-boroughs appeal). He didn't get it.

The first batch of pitch meetings came and went, and a few scripts were given the green light for development, but nothing of substance propelled itself forward. None of them felt unique, and Littlefield went about his business, conscious that there was an opportunity that might vanish. Another network might grab the reins, and NBC's chance to win over a new generation of viewers, and the resulting advertising dollars, might dissipate.

For television writers, pilot season, the weeks when writers proposed new concepts for television series to the networks bidding for their services, was a hectic flurry of all-night writing sessions and snap decisions that even the people involved could hardly remember. To maximize one's options, it was customary for working writers to pitch two, or even three, pilots to networks, in the hopes that one might catch fire. Marta Kauffman and David Crane were hoping to expunge the bad taste that still lingered in their mouths from the preceding season.

Jeff Sagansky at CBS had been happy to listen to Crane and Kauffman's pitches during the 1993 pilot season, including an idea for a musical show with original songs each week, but had his own ideas. He was looking for a white-collar version of the bickering, loving family of *Roseanne*, he told them, and was not much interested in anything else. Kauffman and Crane came back with *Family Album*, which was meant to fulfill Sagansky's desire.

Crane believed that some shows fed you exciting angles, new story lines, and rich characters, and some simply didn't. *Family Album*, about a California doctor (played by Peter Scolari) who moves to Philadelphia along with his family to look after his parents, didn't. After six episodes, CBS canceled the show. Kauffman and Crane concentrated their efforts on the next pilot season.

Kauffman and Crane had cocreated the critically admired HBO comedy series *Dream On* (1990–96), in which Brian Benben's randy divorced book editor ran through a seemingly infinite array of beautiful young women interested in bedding him. Benben's Martin, raised by television, finds his endless romantic snafus punctuated in his mind by clips from old movies and TV shows, offering a stream of witty and arch commentary on the show's plotlines.

Dream On was a superb opportunity for Kauffman and Crane, but they were surprised to discover how exhausting it could be to produce a show with only one star. Benben was a fine actor, but given that he had to appear in almost every scene, production could become a slog. If Benben was tired or under the weather, the show would have to halt until he recovered. It was simply too much pressure to place on one performer. The next time they had an opportunity to put a show on the air, Kauffman and Crane promised themselves, they would work with an ensemble.

The failure of *Family Album* had dinged their reputation some, which meant that the next show had to be fresher—had to be something that emerged from their own hearts and memories. For the 1994 pilot season, Kauffman and Crane hammered out three new ideas. *Dream On* had made them a sought-after commodity at the networks, who were looking for something equally creative, if less sexually explicit. They talked it over with Warner Bros. Television president Leslie Moonves and the other Warner Bros. executives and settled on a plan, based on the four networks' open time slots for the fall and their rough preferences regarding what kinds of shows, and audiences, they were in search of. At the time, there were only four broadcast networks producing original programming, and independent production companies like Warner Bros. would create shows that they might sell to any of the networks.

They would begin with their idea for a show about high schoolers who express their feelings by bursting into song, a kind of *Glee* two decades before Ryan Murphy's show. ABC had told them that they wanted

their own *Dream On*, but when they came back with the idea for a single-camera comedy, the network was disappointed. They wanted to know where the laugh track was. *Dream On* had no laugh track, either, but it was rapidly evident that ABC was not ready yet for single-camera comedies like *The Larry Sanders Show*, which was generally considered to be for more sophisticated audiences than the traditional three-camera sitcom setup still prevalent on network TV. ABC passed on the high school show—"As soon as a couple of words left our mouths, their eyes glazed over," Kauffman would tell a reporter—but the other two moved forward. Networks paid lip service to the idea of breaking the rules, but more often than not, they preferred the rules to the chaos of the new.

Fox took the next step and ordered a script for their show *Reality Check*, a single-camera series about a teenage boy with a vivid imagination. The idea was that, as with *Dream On*, audiences would be afforded glimpses into the mind of its protagonist—first called Harry, then later renamed Jamie. And there was still one more idea to hash out, a comedy series about twentysomethings that they believed might be a good fit for youth-oriented Fox as well.

They had come up with the idea while sitting at their desks in their Warner Bros. office, surrounded by posters from their New York theatrical productions, taking up a pose similar to the ones they had struck in other rooms for the last decade and a half. Kauffman and Crane had met as sophomores at Brandeis University when they were both cast in a production of Tennessee Williams's *Camino Real*. Kauffman played a prostitute, and Crane was a street waif.

When he was growing up, Crane was sure he was going to be an actor. He would watch his favorite television shows, smart, character-based series like *The Mary Tyler Moore Show*, and daydream about what a career as a performer might be like. Crane imagined a life in the arts, and being an actor seemed like the most straightforward route to success. When he arrived at Brandeis University, Crane dove into the school's theater scene, and it took a number of years before he came to a realization: He was not, and would never be, much of an actor.

After *Camino Real*, Kauffman was asked to direct a production of Stephen Schwartz and John-Michael Tebelak's *Godspell* at school and approached Crane about casting him in the show. Crane turned down the part but offered to codirect, and a partnership was formed. They bonded over their mutual affection for *The Dick Van Dyke Show* and its miniaturist plots. The presence of Rose Marie as a member of the show-within-the-show's writing staff had demonstrated to Kauffman that women could be television writers, even if Kauffman felt like Rose Marie's character, Sally Rogers, was around mostly to order sandwiches for the other writers.

Kauffman had been an aspiring actor and writer as an adolescent when an AP English teacher told her that she was the least perceptive student he had ever had. She would, in case she bore any illusions to the contrary, never be a writer. The high school senior accepted her teacher's harsh verdict and began her time at Brandeis University primarily interested in acting. It took some time for the sting of her teacher's comments to wear off enough for her to realize that she enjoyed writing substantially more than acting. What's more, she was good at it.

Kauffman and Crane branched out from directing to writing their own original material. Their show *Personals*, a musical about characters who place personal ads, was well received at Brandeis. After graduation, Kauffman and Crane moved to New York and began writing shows of their own in earnest, along with Seth Friedman. Kauffman and Crane contributed songs and poetry for the musical *A . . . My Name Is Alice* (1984), a revue conceived and directed by Joan Micklin Silver and Juli-anne Boyd. *Alice* was a compendium of songs about women, with Kauff-man and Crane contributing a song called "Trash"—although, notably, not the number called "Friends." *Personals* received an off-Broadway run in 1985, with Kauffman's husband, Michael Skloff (who had once been Crane's roommate), serving as musical director and composing some additional material for the show.

Alice's success—*New York Times* theater critic Frank Rich called it "delightful"—attracted the attention of an agent, ICM's Nancy

Josephson, whom they signed on with. They worked on a series of shows for TheaterWorksUSA, which commissioned musical theater for inner-city children, and then were approached by the rights holders to the Dudley Moore film *Arthur*. Kauffman, Crane, and Skloff were hired to put together a musical version of *Arthur*, which occupied the next five years of their careers before stalling.

After Crane and Kauffman had been working in New York theater for about five years, a young television agent came to the theater one night to attend their latest show. She approached the partners after the show and asked them if they had ever thought about writing for television. Neither had, but the agent strongly encouraged them to give it a try.

Most writers looking to transition to television would move to Los Angeles and look for a staff-writer job on a show, but Crane and Kauffman wound up taking an unexpected route. Neither was ready to leave New York, or the theater, so the agent recommended that they come up with ten ideas for new shows. She would take them and shop them around, and see if she could drum up any interest in them.

Crane and Kauffman painstakingly came up with the requested ideas and began flying out occasionally to Los Angeles to pitch them in person. Theater was engrossing and emotionally rewarding, but when the two writers turned thirty with little financial success to show for their efforts, California beckoned. They took a job in development for Norman Lear's production company. They were in the television industry but still were not in a writers' room, where they would have been working on someone else's show, fleshing out someone else's ideas, and serving someone else's concepts. Consciously or not, Crane and Kauffman were intent on protecting their voices from the incursion of other influences.

On *Dream On*, which had developed out of a desire to utilize the rights to Universal's film library, Crane ran the writers' room with Kauffman, who also oversaw the onstage work, and Kevin Bright, who had become their partner, took charge of postproduction. Each of the

three partners had their own discrete but overlapping role, allowing them control of a single aspect of television production while also ensuring that the others were aware of, and included in, their work.

———————

For as long as he could remember, Kevin Bright had known he did not want to be in show business. His father, Jackie, had started off as a vaudeville comic and then transitioned into work as a personal manager for Catskills acts. He would book comedians and other performers for breakfast and brunch acts, or to appear on cruise ships. Jackie would bring Kevin to the Concord Resort Hotel, part of the legendary Borscht Belt. Bright's family had photographs of him as an exhausted little boy asleep in the lap of none other than Sammy Davis Jr.

Kevin knew he was not cut out for the life of the showbiz hustler. By the time he enrolled in college, he had decided to study philosophy, which was about as far away as you could get from the Catskills. After he enrolled in an elective film course, he realized philosophy was not in the cards for him. Entertainment had possibilities that were tremendously appealing to him. Bright transferred to Emerson College in Boston, which had a highly regarded film-and-television program, and decided to immerse himself in the very thing he had always thought was not for him.

Bright had been raised in the fading light of vaudeville and was passionate about its television inheritor, the variety show—the place where his childhood experience met his passion for the moving image. When he graduated, he went to work for producer Joseph Cates, whose brother Gilbert would eventually produce the annual Academy Awards telecast. Bright began by fetching coffee, and by the end of his six-year run with Cates, he was producing variety specials of his own. He produced five David Copperfield specials, the Miss Teenage America pageant, and a number of Johnny Cash specials in the late 1970s and 1980s. Bright had practically cornered the market on variety television produced in New

York, but in doing so, he realized that the business was dying. There were fewer and fewer specials being made, and those that remained were being made in California.

Bright decided to make the leap to Los Angeles, and to comedy. Bright's history in variety had granted him an accidental specialty in maximizing minimalist budgets. HBO was looking to get away with making half-hour comedy programming in the low six figures, and Bright knew how to do it. He went on to produce comic specials for Paul Shaffer, Harry Shearer, and Merrill Markoe. Bright would also produce the first original-to-syndication sitcom, sold directly to local stations instead of to a network, *Madame's Place* (1982), shooting seventy-five episodes of the adventures of a faded-movie-star puppet named Madame in just eighteen weeks.

Bright had been brought in for *Dream On* by noted director John Landis (*The Blues Brothers, Animal House*). Landis was looking to branch out into television but needed an experienced hand to walk him through the work of packaging and producing for TV. Landis had been offered the opportunity to make use of Universal's remarkable film archive and was in search of marketable ideas when he was introduced to Kauffman and Crane. Bright had not worked in six months when, all at once, he was hired for *Dream On* and for the pilot of *In Living Color,* a new comedy sketch series for Fox. It was Bright, a music buff, who convinced Damon Wayans and David Alan Grier to use the Weather Girls' "It's Raining Men" for the sketch featuring their flamboyantly gay film critics, "Men on Film." Bright assumed that he would stay on with *In Living Color,* a network show, but when that opportunity fell through for him, he happily became a producer on *Dream On.*

After a number of years of working together on *Dream On,* Kauffman, Bright, and Crane were sitting around their office one day when Kauffman wanted to share her enthusiasm over their professional arrangement, with she and Crane serving as writers and Bright producing. "This is so great," she told Bright and Crane. "Wouldn't it be great if we could just keep doing this?" "We could, if you want to," Bright told her,

and beginning in 1993, the three partners had an overall deal with Warner Bros. to produce new television series. That year had not been their year, but now it was 1994, and Kevin Bright was free to throw himself into finding a spot in the network lineup for the fall.

Fox immediately began bombarding Kauffman and Crane with suggested changes to *Reality Check,* the show that brought viewers inside the mind of a teenager. The network desperately wanted the show to be raunchier than it was, more like a Fox-friendly *Dream On.* Couldn't Harry (or Jamie) be older? Couldn't he already be driving? Couldn't he be having sex? Their protagonist did indeed become older, a high school junior, not a freshman, and the bulging script was trimmed down by losing some characters, including his father.

Reality Check was another headache, just like *Family Album* had been. The network wanted something new, but then wanted that new thing to be as familiar as possible. Kauffman and Crane knew they had made their name with a high-concept series, but Crane in particular was drawn to the idea of an ultra-low-concept show. Sitting in their office on the Warner Bros. lot, Kauffman and Crane began to banter about their own group of friends from New York, a sextet that also included a lesbian couple. They borrowed personality traits from acquaintances and from actors they had worked with, melding together a hodgepodge of characteristics into loose outlines for their protagonists. In the evenings, Kauffman pulled aside two of the babysitters who helped care for her children to quiz them about life as a single twentysomething.

The two writers drafted a seven-page pitch document to be shared with networks, detailing the characters, the setting, and some of the adventures they imagined unfolding. "It's about searching for love and commitment and security . . . and a fear of love and commitment and security," they wrote. "And it's about friendship, because when you're young and single in the city, your friends are your family."

"That's basically it," they closed the pitch document. "And even if

we are going to play with the form a little bit, ultimately, it's about six people who you can invest in. For us, it's kind of like writing six Martin Tuppers."

There were bits of the creators themselves in their characters. Kauffman put more than a touch of herself into the character of Monica, whom she thought of as being someone who always needed to close the marker until it clicked. Monica was worn out by an endless schedule of dating. "She feels like if she has to eat another Caesar salad, she's going to die," Kauffman told a *New York Times* reporter chronicling that year's pilot season.

Traces of Crane could be found in the dry, acerbic wit of Chandler. Crane, who is gay, initially thought of making Chandler's character gay as well, which would have notably changed the story arc of the series to come. Chandler wound up straight, but the kind of straight man Crane envisioned getting regularly mistaken for gay. (A college friend of Kauffman's named Chandler would later jokingly accuse her of having ruined his life by giving a *Friends* character his name.) Kauffman also saw some of herself in the antic spirituality of Phoebe.

The truth was, though, there simply was not enough time to put too much thought into these characters. "WRITE FASTER," they urged themselves via a message scribbled on their blackboard as the deadline for the script neared. Then the message subtly changed: "WRITE BETTER."

The two writers, then in their midthirties, kept it simple. They would pitch the series as being about six intertwined characters, in and out of one another's apartments and one another's lives as they went about the ordinary business of their daily existence. Crucially, they wanted a story with three female protagonists who were given equal time and equal heft. They were not just girlfriends, or sisters, or funny sidekicks. Kauffman would later insist that no script ever contain the word *bitch* (or, for that matter, the phrase *shut up*). Kauffman and Crane even came up with a tagline they would present to the networks they pitched to: "It's that time of life when your friends are your family."

Crane was more than satisfied with their minimal work. If they had

the six characters they were looking for and the setting was roughly acceptable, it was good enough to pitch. To be a television writer was to endlessly spin out new characters, new situations, new juicy story lines. These were just the latest iteration from two hamsters trapped on the Hollywood treadmill. In all likelihood, they thought, this show would disappear without a trace, just like so many of their past pilot scripts. Fox surprised them by expressing interest in green-lighting a script, but Warner Bros. was still interested in cutting a deal elsewhere (at the time, Fox was still an upstart with little of the cachet of the other three networks) and scheduled Kauffman and Crane for a meeting with NBC in December 1993.

Warren Littlefield always judged writers by their ability to hold a room. Could they seize control of the dead Burbank air and commandeer it with the power and vigor of their stories? Could they make script characters come to life? To do so was, of course, little guarantee of future success, but Littlefield intuitively felt that being able to convince jaded network executives was a promising down payment toward winning over a skeptical national audience.

Kauffman and Crane had worked with NBC once before, on the short-lived 1992 political farce *The Powers That Be*. The network had been won over by their witty scripts, but Kauffman and Crane had not been the showrunners (Norman Lear of *All in the Family* fame was also involved in the show, as an executive producer), and Littlefield had felt that the show had never lived up to its potential.

As Littlefield and his colleagues sipped water, Kauffman and Crane brought the room to life with their amusing, heartfelt pitch about six Manhattan twentysomethings in search of themselves. They acted out the characters and the scenarios for a show they were calling *Insomnia Café*, allowing the room of network executives to momentarily imagine a crew of friends, swigging coffee and bantering, that felt more like a substitute family.

It was a simple pitch—*Cheers* in a coffee shop—but it was more than that. It felt deeply personal, a transmutation of lived experience into a story that would register with the widest possible swath of viewers. A bell was going off in Littlefield's head, confirming that the nebulous thing he had been in search of since becoming president of NBC had been located. This, finally, was what he wanted.

Kauffman and Crane's series was being produced by Warner Bros., and WB Television's president, Les Moonves, was representing the show's interests in negotiations. Moonves neglected to tell NBC that Fox had already expressed interest in the show, or even that it had been pitched to other networks at all. Moonves, soon to become the president of CBS's entertainment division, told Littlefield that picking up the show would come with certain conditions. Acquiring Kauffman and Crane's series would require a pilot commitment. NBC would have to bypass the script stage, where the network could acquire a single script from the writers and decide whether to proceed to filming a pilot. Filming a poor pilot that did not make it to air would be the equivalent of a $250,000 penalty. NBC would hardly sink under the weight of such a cost, but too many failed pilots could blow a substantial hole in the network's development budget.

For Littlefield, it felt like a reasonable request coming from Moonves and the Warner Bros. team, and there wouldn't be any penalty unless the series wound up a disappointment. Littlefield was confident that the new show would fill one of the slots on their new, youth-oriented Thursday-night lineup, and so the up-front costs of developing the show were simply the price of doing business. Moonves was being aggressive, but NBC wanted to be in business with Warner Bros. on this show and did not want it to end up elsewhere.

NBC made the pilot commitment for *Insomnia Café* and took the show off the market. But Kauffman and Crane remained unsatisfied with the show's title. Their outline for the show was renamed *Bleecker Street*, after the Manhattan street Kauffman had lived on, and the first draft of the pilot script was labeled *NBC Pilot Which Still Needs a Title*.

Littlefield only had one notable tweak he wanted to suggest. He was concerned, he noted to Kauffman and Crane, about how much time their characters were spending in their neighborhood coffee shop. How much action could reasonably take place in a café? Littlefield wanted the characters' apartments to take on more prominence. And if the characters were meant to live in the same apartment building, as the pilot script indicated, Littlefield suggested that the apartment of roommates Joey and Chandler be placed directly across the hall from Rachel and Monica's apartment, allowing some of the action to take place in the hallway between their doors.

Crane thought the note was a solid one. "You could call it *Across the Hall*," Littlefield helpfully suggested. "Or just have it be across the hall," Crane responded, nonplussed by the mediocre title. They still couldn't settle on a decent title for the show. After a temporary interlude where they adopted Littlefield's suggestion, Warner Bros. sponsored an internal name-that-show contest. The big winner was Crane's partner Jeffrey Klarik, who suggested *Friends Like Us*.

NBC was mostly hands-off after ordering Kauffman and Crane's pilot, with their notes running to such minor matters as the beige-toned color of the couch in the coffeehouse. (They preferred a less repellent shade.) The one major suggestion the network had for Crane and Kauffman was the addition of an older secondary character. NBC was concerned that if all the main characters were in their twenties, it would distinctly limit the series' breakout appeal. An older character—even one that made only occasional appearances—could convince hesitant older viewers to check in with *Friends Like Us*. Perhaps, the network thought, there might be an older acquaintance they ran into at the coffeehouse who could give them advice about their lives?

It was a poor idea, and while it would not sink the show, it would undoubtedly weaken its spell. Kauffman and Crane reluctantly agreed, and began trying to wedge the character, whom they referred to as "Pat

the Cop," after an older police officer who used to hang out in the movie theater where *Dream On* writers Jeff Greenstein and Jeff Strauss used to work in Somerville, Massachusetts, during college, into their next script. The writers made a good-faith attempt, even casting the role, but hated the resulting script so much that they pleaded with NBC to drop the idea. If only NBC would kill Pat the Cop, they promised, they would give their six protagonists parents in notable supporting roles, and find older guest stars to attract a more mature audience. NBC gave its permission, and Pat the Cop was no longer.

The show would live or die on the strength of its six main characters. But who would play the roles?

CHAPTER 2

SIX OF ONE

Casting the Show

Barbara Miller, the head of casting for Warner Bros. Television, handed over a script. "Read this," she told Ellie Kanner, "work on some lists, and you'll meet with David Crane, Marta Kauffman, and Kevin Bright. Be ready!" Kanner, then only twenty-nine, had recently been promoted to casting director, having cast shows like *Step by Step* and *Lois & Clark: The New Adventures of Superman,* and this script would be one of the first she would help to cast at Warner Bros. After reading the script, Kanner was puzzled. Why wasn't everyone else at Warner Bros. as excited about this pilot as she was?

It was a casting director's job to be familiar with most of the young performers in the industry and able to mentally pore over the possibilities and identify strong candidates. Kanner took out her notepad and began making lists of all the funny young performers she knew, breaking them into subcategories for each of the roles in the script: sad-sack divorcé Ross; his luckless-in-love sister, Monica; quirky Phoebe; neurotic Chandler; Chandler's actor roommate, Joey; and Monica's high school friend Rachel. Kanner's assistant Lorna Johnson began calling

agencies and checking actors' availabilities. And as Kanner and Johnson were winnowing their list, they were also being sent further candidates by the agencies. Kanner wound up receiving upward of one thousand headshots for each role.

It was February 1994, and Kanner knew she only had about eight weeks to scrutinize her lists, audition the performers she'd selected, narrow it down to about one hundred actors that the producers would see, and help them make their final selections. Actors would be called in for a first audition, where they would read briefly from the script. Kanner would sort through the performances and select a smaller swath of actors who would audition for the showrunners as well. The next step would be to pick a handful of finalists for each role—professionally successful but personally devastated Ross, guitar-playing New Age princess Phoebe, tough-talking "downtown woman" Monica, self-impressed heartthrob Joey, runaway bride Rachel, and sarcastic, witty, perpetually single Chandler—who would be given the opportunity to audition for not only Kanner and the showrunners but Warner Bros. executives as well.

The early casting would be overseen by Kauffman and Bright. Crane had a self-diagnosed tendency to love every actor he saw and had voluntarily removed himself from the first part of the process. He wanted to hire every actor who came in and felt guilty when they couldn't. Crane would be invaluable in the later stages of casting, but it was primarily Kauffman and Bright's task to cull the initial list.

The producers expressed a desire to be open about race and ethnicity as well. They knew that the Ross and Monica characters were to be siblings, and had decided that they would be played by white performers, but were open to anyone for the other four roles. Kanner's initial lists included numerous African-American and Asian-American performers. The flexibility was a step forward, to be sure, but some of *Friends*' later struggles regarding diversity were etched in stone here. Without an explicit desire to cast actors who looked more like New York, the producers were likely going to end up, as if by default, with an

all-white cast. As later critics would note, comedy was a less integrated genre than drama. Dramatic series had room for a greater variety of characters, and their settings—hospitals, precinct houses, courtrooms—allowed for characters from different walks of life to interact. Comedy expected its audiences to embrace its characters and was far more tentative about asking them to identify with characters who were not white and middle-class. Television executives were more fearful of asking audiences to laugh along with characters of color, concerned that such shows would be ignored by the majority-white audience.

Kauffman and Crane had their own casting ideas, as well. They had auditioned David Schwimmer on a previous pilot of theirs, called *Couples*, and had loved his work. They had pushed strongly to cast him, but the network had insisted on selecting the other finalist, Jonathan Silverman, instead. Kevin Bright had watched the process, noting the careful language that the network had used, and believed it was a matter of finding Schwimmer too Jewish for network television. The situation was ludicrous, of course; here they were, three Jewish showrunners being forced to select one Jewish actor instead of another one. But Bright suspected that Silverman was seen as a handsome Jew, one who could pass as a leading man, and Schwimmer was not.

Schwimmer had recently attracted glowing reviews for his turn on *NYPD Blue* as creepy neighbor "4B." Schwimmer was a theater kid like Kauffman and Crane, a trained actor with an impressively wide range and a seriousness about the craft that they admired. While they were working on the pilot script for *Friends Like Us,* Kauffman and Crane conferred about the Ross character, remembered the actor they loved but hadn't been able to cast, and said, "David Schwimmer for this."

They envisioned Ross as a highly educated scientist in a crew consisting mostly of working-class strivers. "So his career is pretty together," Kauffman and Crane wrote in their pitch document. "However, when we meet him, he's just signed his divorce papers. . . . His wife left him for his best friend . . . Debbie. He had no idea." Ross would be the "loyal husband" who suddenly found himself excited by the world of available

women around him: "It's kind of like he's back in junior high. Only there are no books." Kauffman and Crane pictured an episode where Ross would take a date to the planetarium and woo her under the stars—a plotline that would notably be reused, with a different woman. The pilot would eventually drop the wife-runs-off-with-female-best-friend angle but still retain Ross's wife coming out as a lesbian.

They were ready to offer him the role without his even having to audition—a rare privilege for a young, untested actor. There was only one problem: Schwimmer did not want to do the show. More than that, he did not want to do any more television at all.

Schwimmer had just been on the short-lived Fox comedy series *Monty* (1994), in which he had played the left-wing son of a Rush Limbaugh–esque conservative firebrand, played by *Happy Days'* Henry Winkler, and had found it to be a miserable experience. As he saw it, television was a place where nobody listened to your ideas, where you reported for duty every day to do mediocre, unsatisfying work. When *Monty* was canceled, Schwimmer felt immense relief and immediately returned to Chicago, where he was working on a new theatrical production of *The Master and Margarita*. His theater company, the Lookingglass, had just moved into a new space, and Schwimmer felt like he was in the exact place he wanted to be. He had gotten a buzz cut for the role of Pontius Pilate for the show and was prepared to thrust himself into Mikhail Bulgakov's fantastical world of Soviet totalitarianism tempered with magical realism.

Schwimmer had appeared in a number of pilots that had never gone anywhere, and he found the whole process mystifying and frustrating. What was the point of acting if no one could see your work? He would not, his agent Leslie Siebert told Kanner, be reading any more television scripts. Kauffman and Crane were chagrined but not quite ready to give up on their dream casting.

In the meantime, though, the producers began looking at other actors. The casting process for *Friends Like Us* was moving slowly, and

other, faster series began to snatch away talented performers. Kanner brought Noah Wyle in for the role of Ross. The producers liked his audition and wanted him to test for the network, but the pilot was not going to shoot until May. In the meantime, Wyle auditioned for *ER,* also being produced by Warner Bros. that same pilot season, and *Friends Like Us* moved into second position, meaning that they were second in line for the actor's services. If the first show fell through, they would be able to cast him on their series. Wyle, of course, wound up being cast on *ER* instead. Among the other actors who auditioned for Ross was future *Will & Grace* star Eric McCormack, who came in two or three times.

They also considered Mitchell Whitfield, who would eventually be cast as Rachel's ex Barry. Whitfield advanced so far in the process that after one meeting, he received a surreptitious phone call from someone involved with the show who brought good, if inaccurate, news: "Hey, congratulations, they love you for Ross. Looks like you're going to be Ross."

Meanwhile, Siebert had begged Schwimmer to look at the script, telling him that Kauffman and Crane were admirers of his craft. Schwimmer remembered how much he had enjoyed the *Couples* script and was pleased to learn that their new show was to be an ensemble series, with no designated star. This could be a television series that worked a bit more like a theatrical troupe.

Schwimmer had also gotten unexpected phone calls from Robby Benson, the former child star who had become a well-regarded television director, and from James Burrows, the legendary director behind *Taxi* and *Cheers.* Both of them were also telling him that Kauffman and Crane had specifically written the role with him in mind, which Schwimmer had not fully understood beforehand. If these titans of television were suggesting he reconsider, Schwimmer later told Littlefield, he would be an idiot not to go. Schwimmer read the script and agreed to fly out to Los Angeles to meet with them.

Executives from Warner Bros. and NBC filled the edges of the room

as Schwimmer picked up the pages of the pilot script. Kanner, who was reading with him, was immediately overcome with the quiet joy of knowing that an actor was perfect for a role. The role of Ross was like an off-the-rack suit that did not require any tailoring for Schwimmer to wear. He could simply put it on. It already fit perfectly. "OK," she told herself, "this was meant to be." Fortunately, Schwimmer agreed and accepted the part.

After Schwimmer was cast, Bright and Kauffman spent weeks fruitlessly looking at actors for the other roles. They would listen to the script, day after day, being mauled by performers who could not locate the comedy trapped inside of it. They began to doubt the value of the script itself. Perhaps they had mistakenly believed it was funnier than it actually was?

One early session was held in Barbara Miller's office. The actors auditioning for *Friends Like Us* were surrounded by photographs of Greta Garbo and Bette Davis, as if to remind them of the legendary work that had been done on this very lot. Actors came fully dressed for the job they wanted, with a passel of Phoebes in nose rings and bell-bottoms, and an array of Joeys displaying ample chest hair. Auditions were a frustrating process, with actors displaying distinct limits to their range or unable to replicate what they had done in an earlier audition. Miller exchanged notes with Kanner, Kauffman, Crane, and the Warner Bros. executives after the session, and everyone agreed that there were only a few performers good enough for the next audition—which would be held at NBC. Some of the performers were too sitcom-y, while others were too theatrical. They would have to keep searching.

———

Television acting was about graciously accepting the near-inevitability of failure. You would audition for a role, but you would never get it. You would get a role, but the show would never make it to air. The show would make it to air, but it would never find an audience. And even when big breaks arrived, they could vanish without warning.

At Vassar, everyone had thought Lisa Kudrow was a dumb Southern California blonde because she was always smiling, but she had ambitious career plans for herself. She was a biology major, and after graduation, she would work for her father, a migraine specialist, before proceeding to a graduate program in neuroscience. In her spare time, she would turn on the television and catch an episode of a sitcom and be turned off by the ways their performers emoted. "I'd hear the delivery of a line or a joke and I'd think, '[They're] pushing it too hard,'" she would later tell an interviewer. "It just kept happening and so I finally just surrendered and said, 'All right, I'm going to give it a try.'" Kudrow worried about what it might mean to become an actor. They were, in her mind, doing things like appearing on late-night television to ask audiences to save the planet on their behalf and other acts of self-regarding hubris. What would happen to her were she to become a performer as well?

Once Kudrow set out to act, she realized she could use what others mistakenly perceived to be her ditziness to her advantage. Kudrow joined the Groundlings improv troupe, briefly dated future late-night host Conan O'Brien, and took acting lessons. She soon came to understand that feeling the need to apologize for being an actor was an impediment to success. It would be far better to acknowledge that there were countless other actors competing for the same jobs, and that solid work and dedication would eventually carry the day. Being funny was a serious business. It would be enough to maintain your dignity and do your work. Eventually, people would begin to notice.

Kudrow appeared in small roles on *Cheers* and *Mad About You*, and was going out regularly on auditions. *Cheers* had just ended, and Kelsey Grammer was to continue playing Dr. Frasier Crane in a new show called *Frasier*. After wowing the producers during auditions, Kudrow received the opportunity of a lifetime: She was cast as Frasier's radio producer Roz.

Once the show was in rehearsals, cocreator Peter Casey was taken aback by what he was seeing. Kudrow was excellent, but Roz was intended to be a forceful foil to Frasier, able to give as good as she got.

Instead, following each day's run-through, Casey and the writers were modifying the script because Kudrow was not able to be as steely as they had intended Roz to be. And Grammer was playing down his lines because he was concerned that he might overwhelm Kudrow if he performed them as intended.

Casey consulted with James Burrows, the director supervising the series, and they were in agreement: Lisa Kudrow had to be fired. *Frasier* retooled, casting Peri Gilpin, another finalist for the role, as Roz, and Kudrow was convinced that the best opportunity she would ever get as an actor had slipped through her fingers.

A few months later, running perilously low on money, Kudrow got a call from her agent, who was delivering an unusual message. There was an offer of a role that she should turn down. *Mad About You* had called about Kudrow's coming back to play a new part. She would be needed on set in one hour and would not be able to see the script until she arrived. It was, her agent argued, insulting and demeaning.

Kudrow took the job anyway, and did so well that series creator Danny Jacobson immediately offered her a recurring role, with at least five more appearances over the course of the season. One of the people she impressed on *Mad About You* was staff writer Jeffrey Klarik, who proceeded to tell his partner, David Crane, all about the gifted performer playing hapless waitress Ursula. One day, she got a call from Crane, who told her he was casting for his new show and would love to have her come in and read. Would she be interested?

Phoebe was, according to the pitch, "sweet, flaky, a waif, a hippie." Crane and Kauffman pictured her as a free spirit who played bad folk songs on her guitar and dated a lot: "She sees the good in everyone, which is a nice way of saying she's indiscriminate. One week she can be in love with a Japanese businessman, the next week a street mime, the next a fifty-three-year-old butcher." Phoebe would not have her own apartment: "She owns what she can fit in her backpack." The pilot would eventually tone down Phoebe's serial dating while retaining her musical stylings and her flakiness.

When Kudrow arrived, both Kanner and Crane felt an instant buzz telling them she was just right for the part. But they knew that the networks would not be satisfied with only one choice, and so dozens of other actresses tried out for Phoebe as well, including future stars Jane Lynch and Kathy Griffin.

Kudrow went back to work at *Mad About You*, where she was helping many of her friends and fellow guest performers run lines for their auditions. She was struck by the enthusiasm other actors seemed to have for this new show in particular. It seemed like every dramatic actor in Los Angeles was out for a role on *ER*, and every comedic actor was hoping to be cast in Kauffman and Crane's show.

It wound up being another month until Kudrow was called back to test for the role. While she waited, Kudrow had had ample time to think over the part of Phoebe. The day before the test, Kudrow's agent called Kanner, frantic. "Look. Lisa is thinking about a different way to do the audition with you tomorrow at the network," she told Kanner. "And she just wants to run it by you."

Kanner knew from experience that time was often not the actor's friend. Actors granted too much time to ponder their performance might tweak it excessively, coming in with a take on a role so radically changed from their first attempt that the producers could no longer see what had appealed to them at first.

Kudrow was wise enough to know that she might be about to stumble and asked if she could first appear in front of just Kanner and Kauffman. They agreed, and she came in to offer her new version of Phoebe. It was fine, but it lacked the brilliant flakiness they had loved about her first attempt. Kauffman and Kanner looked at each other, and Kanner said, "No no no no no, go back to the original way. That was what we want. That will get you this job." "OK, great," Kudrow responded, unruffled. "I just wanted to double-check." She went back to her original take and got offered the role.

Kudrow was excited about playing Phoebe but concerned that a failed series might do damage to her recurring role on *Mad About You*.

She was relieved that *Friends Like Us* was going to be on NBC, meaning that her two series shared a network. "Pilots work and don't work," she told the NBC executives, "but we have to protect *Mad About You*, please." Kudrow did not want a failed pilot to mean the end of her role on *Mad About You*.

The biggest star the producers were considering for the show was *Family Ties* veteran Courteney Cox. Kanner originally had Cox on her list for Rachel, which she believed would be the best fit for an essentially sweet performer like Cox. Monica, who was not yet cast, they envisioned as an edgier role. The producers were looking for someone slightly less glamorous who could potentially play a harried, occasionally bitter everywoman.

Monica was to be "tough, defended, cynical, sarcastic." In an ultra-nineties reference, they described her as having "the attitude of Sandra Bernhard or Rosie O'Donnell and the looks of Duff," referring to the MTV VJ and model Karen Duffy. Monica, in this original conception, was to be a blue-collar New Yorker with aspirations of starting her own restaurant. She would work at a Le Cirque–like establishment: "We just think it would be fun to see this tough, downtown woman in this uptown, French bullshit arena." Monica would also have a "real maternal side," looking after Rachel and adopting a pregnant woman who would end up giving birth in her apartment. Monica dreamed of becoming a mother but first found herself in search of a man to have children with.

When Kauffman and Crane had written the role, they had pictured the dialogue emerging from the mouth of Janeane Garofalo, who had the snarky attitude and comic bite that they envisioned for Monica. They offered her the role, but Garofalo turned them down, preferring to join the cast of *Saturday Night Live* instead. Kauffman and Crane were unsure where to turn next.

Cox came in and read for Rachel, and was excellent. Afterward, Cox requested to come back and read for Monica as well, and Kanner acquiesced. Cox was good as Monica—a definite maybe—but the producers knew they wanted her as Rachel.

They had already brought in hundreds of performers for Monica, including future stars like Leah Remini (*The King of Queens*). The producers were now strongly considering Nancy McKeon, another 1980s sitcom star, familiar to audiences as Jo from *The Facts of Life*.

Kauffman and Crane were confident enough that Cox was right for Rachel that they were willing to offer her a test option deal, which gave her a guarantee of the role without another audition. Courteney Cox would be Rachel, and casting for Monica would carry on. Cox told them she was glad for the offer but really preferred the role of Monica.

Kanner and the producers agreed to let her read again for Monica, figuring all along that they would offer her the part of Rachel immediately after the audition and that the excitement of being cast would win out over any lingering preference for the role of Monica. Instead, Cox came in and absolutely nailed it as Monica. "Holy crap!" Kanner thought to herself. "She's great as Monica! Why didn't we see that before?"

Where Kudrow had gone off and returned with a performance less charming than her original version of Phoebe, Cox had clearly returned with a vastly improved Monica. She had committed to her vision of the role and had won over Kanner and the skeptical producers, who had initially been unable to see her in any role but Rachel's. Cox's casting turned the show away from its initial concept of Monica as a working-class interloper in an upper-crust sphere, and she was retooled as more middle-class and suburban. Now Monica was set—but casting Rachel was the new puzzle.

Meanwhile, the role of Joey had been described, in the casting call for actors, as a "handsome, smug macho guy in his 20s" with a passion for "women, sports, women, New York, women." The pitch referred to Joey as having moved to New York from Chicago to "become an actor. Well, to become Al Pacino." Joey "really thinks he's god's gift to women," but Monica in particular resolutely refuses to be charmed by his charms. Kauffman and Crane pictured Monica and Joey as foils for each other, squabbling about whether men are intimidated by Monica because she is a strong woman or because she is a "bitch." (Kauffman would later

make reference to never using the word *bitch* on the show, but it does appear in the pitch document itself.) Joey acts in children's theater, which he finds unfulfilling, and works a variety of gigs to make the rent, including bouncer, bike messenger, and "the guy in the department store saying 'Aramis? Aramis? Aramis?'"

Kauffman and Crane sat through more than fifty prospective Joeys, including future guest star Hank Azaria, making their way through the lines they were handed—a monologue debunking the idea that there is only one woman for any given man. Women, Joey would observe, were like flavors of ice cream—each delicious in her own way. Writing those lines had brought up a certain sound. There was a pacing and delivery that Kauffman and Crane imagined for Joey, and no one yet had captured it.

Crane and Kauffman initially pictured Joey and Monica as the central romantic couple for the show. Joey, the perpetual horndog, would be lured, and possibly tamed, by the warm, affectionate Monica. In this initial version, Joey was less dim-witted than he would eventually become, with an emphasis on his ladies'-man style and his city-boy attitude. Initially, the casting search was for more of a leading-man type. Crane was taken aback to find that this approach led Joey to feel more boring than they had expected him to be. None of the actors they brought in to audition conveyed the charm they had in mind. As it stood, Joey felt as if he did not belong in this particular circle of friends.

Casting assistant Stacy Alexander had brought Kanner a tape of an actor who had begun to make a name for himself on low-rent Fox comedy series like *Married . . . with Children*, *Top of the Heap*, and *Vinnie & Bobby*. The material was notably different, but there was something about Matt LeBlanc that could possibly work for the role of Joey. "He could be perfect," thought Kanner.

Matt LeBlanc had been born to a working-class family in the ritzy Boston suburb of Newton. LeBlanc grew up in a household run by his mother and did not meet his father, a Vietnam veteran, until he was eight years old.

He was in love with the roar and flash of motorcycles and sports cars, something he shared with his mechanic father. LeBlanc dreamed of success as a motorcycle racer and spent his leisure hours participating in youth racing events. He studied to be a carpenter but found the profession too staid for his more adventurous tastes. At eighteen, LeBlanc left Newton for New York, intent on pursuing a career as a model but was repeatedly told he was too short.

One day, LeBlanc was walking down the street when he paused to check out a beautiful woman's butt. As it happened, she had paused to check out *his* butt, and the two laughed about their undisguised attraction. She told him she was an actress and was on the way to an audition. Why didn't he come and meet her manager? LeBlanc agreed, and an impromptu career in acting was launched. He soon won roles in television commercials. LeBlanc was the intrepid young man in the Heinz commercial who placed a ketchup bottle at the edge of a building so he could drizzle it onto his hot dog on the street below.

LeBlanc came in for an audition for the role of Joey, and the producers were charmed. He had been running lines the previous day with a fellow actor, and, inspired by the script's celebration of friendship, they had gone out for a drink together. LeBlanc, having perhaps gotten a bit too friendly, fell down and scraped his nose. When he came in to read, Kauffman asked what had happened to his face, and LeBlanc, replying, "Aw, it's a long story," launched into a description of his night on the town. Kauffman laughed at the story, and LeBlanc felt that the audition had suddenly tilted in his favor.

LeBlanc was not nearly as experienced as some of the other actors they were considering, but he had the remarkable capacity to continue improving each time they came back to him. He could naturally pull off the machismo and arrogance of Joey, but he also had an appealing sweetness to him. LeBlanc had the rare gift of likability. Even when Joey was saying something that might come off as hateful emerging from another character's mouth, LeBlanc was able to make it seem charming.

They decided to bring him back for a test and ultimately offered him the role of Joey.

After LeBlanc's audition, Crane and Kauffman began to rethink the role. Joey was still an actor, but he would now come with an outer-borough, working-class demeanor. The changes meant that it no longer made quite so much sense to have Joey and Monica as the central couple. That role was now open to be filled by other characters. LeBlanc himself had pushed for Joey to be more like a big brother to his female friends, never attempting to woo any of them. Kauffman thought the idea of Joey and Monica had made sense on the page, but once Cox and LeBlanc were cast, it no longer did.

Meanwhile, other roles were trickier to fill. The surprise switch to Monica for Cox had left the character of Rachel open once more. Crane thought the role of Rachel was an exceedingly tough one. He and Kauffman intended Rachel to be charming and warm and modestly clueless, but he worried that, in the wrong hands, she might become incredibly unlikable. Crane did not want Rachel to be perceived as a spoiled, petulant, husband-abandoning mess and needed the right actress who would telegraph Rachel's more attractive personality traits.

Rachel was described as someone who had belatedly come to a realization about her own life: "What happened was, she was in the room with all the presents, looking at the gravy boat, this gorgeous china gravy boat, and she realized she was more turned on by the gravy boat than by Barry, the man she's about to marry. So she got really freaked out and got high with Mindy, her maid of honor, and while she was getting high she realized that Barry looks an awful lot like Mr. Potato Head. She always knew he looked familiar. So she had to get out of there." Rachel was a young woman who unexpectedly had to start over again: "She decides to move to the city because she knows if she stays in Teaneck and she doesn't marry Barry, she'll marry Gary or Larry."

Numerous actors, including *Saved by the Bell*'s Elizabeth Berkley, had come in to read for the part. Kanner liked an experienced young

actress named Jennifer Aniston, who had starred in an ill-fated television adaptation of *Ferris Bueller's Day Off* on NBC in 1990–91. Kanner was charmed by Aniston, but she was already committed to another series. Aniston's series *Muddling Through*, picked up by CBS, had already shot eight episodes, and while they had yet to air it—generally the kiss of death for a new series—they still retained the right to do so. And if they did, Aniston would remain contractually obligated to the series.

Kanner decided to take the risk and have Aniston come in to read in second position. This meant that NBC did not have first dibs on Aniston, whose availability would be dependent on *Muddling Through's* getting canceled. When Crane and Kauffman first saw Aniston, they fell in love with her, rooting for Rachel to find her footing in spite of herself. Jennifer Aniston could be the heart of their series.

She had to lose thirty pounds if she wanted to stay in Hollywood. Los Angeles was a tough place to be an actress—it was a tough place to be a woman—and Jennifer Aniston's agent was reluctantly leveling with her. She had been called back for an audition, and this time, she was requested to arrive in a leotard and tights. "This'll blow it for me," she joked with her agent, and was surprised when he responded seriously. Aniston was hardly fat—everyone could see she was beautiful—but as the show she would one day become indelibly associated with later made a point of noting, the camera added ten pounds, and if Aniston wanted to be competitive for television roles, she would have to slim down.

Hollywood was a tough business, but Jennifer Aniston had known this her entire life. Her father, John Aniston, was an actor who had spent years as a featured performer on the soap opera *Search for Tomorrow*. Her godfather was none other than Kojak himself, Telly Savalas. Acting was a struggle. It took years for John Aniston to make a steady living from it. He had been selling vacuum cleaners door-to-door, subsisting on the occasional acting job Savalas could toss his way.

Her parents divorced when Aniston was nine years old, and her father was suddenly a ghost in their own home, an absence. She would sneak peeks of *Search for Tomorrow* to catch a glimpse of him. Aniston would record the dialogue of shows like *Joanie Loves Chachi* on cassettes and then play them in her room, seeing what it felt like to pretend to be Joanie.

When she was twenty, Aniston moved to Los Angeles. Aniston was pretty and sweet and unthreatening, and Hollywood liked her for roles as younger sisters and bratty upstarts on shows like *Ferris Bueller* and *Molloy,* which lasted for all of seven episodes. *Friends Like Us* was an opportunity to play a more significant leading-woman role, and she wanted it badly.

Crane knew that Aniston was committed to *Muddling Through* and decided to approach its showrunner to see if he would release her so she could join the *Friends Like Us* cast. In retrospect, Crane could not believe his own audacity. How would he have responded if the showrunner from some other show asked him to release one of the actors they had worked so hard to find so they could star in some entirely different show? Crane was politely but firmly turned down. Aniston made her own efforts to escape, approaching Leslie Moonves and crying to him about the situation in the hopes that he would help her escape her CBS straitjacket. This, too, did not work.

Ellie Kanner was about to leave for a much-needed vacation when she received a telephone call telling her that *Muddling Through* had been picked up by CBS. The Tiffany Network was getting to not only express its optimism in one of its own series but also potentially blow a giant hole in its rival's schedule.

Kanner was told it was time to recast the role of Rachel. She proceeded to spend the next month looking at head shots and overseeing auditions, but no one captivated her the way Aniston had. The role was offered to Téa Leoni, who was a superlative actor and comedian but might have come off as too sophisticated to play a role like Rachel.

Leoni turned the role down, and the network soon called Crane,

summarily informing him that Rachel had been offered to Jami Gertz, a sitcom veteran from *Square Pegs* and *The Facts of Life* who had also appeared on *Dream On*. Crane had always liked Gertz but believed she was wrong for Rachel. Moreover, Gertz was a Sabbath-observant Jew, and she asked the showrunners to commit to a Wednesday-to-Tuesday schedule, where shoots would take place on Tuesday nights, and not Friday nights, as with many other shows. The showrunners respected Gertz's commitment (Bright would later call her "the Sandy Koufax of show business") but could not lock themselves into such an arrangement.

They also shared with Gertz their conception of the show as an ensemble, lacking a single star, and were under the impression that she was looking for a series that could serve as more of a vehicle. Crane and Kauffman sweated out the lengthy wait until the next day, when Gertz passed on the show. They were relieved that they had not yet lost control of casting their series.

Eventually, CBS and NBC negotiated a temporary détente. CBS would allow Aniston to be cast in both series but would unambiguously retain first position for their show. Aniston would be able to shoot the first six episodes of *Friends Like Us*. But if the CBS series was picked up, *Friends Like Us* would lose Aniston midway through the season. It was an enormous risk.

———

Kauffman and Crane knew what they were in search of for the role of Chandler. The character had a certain timbre to the way his lines should be delivered, and they were hoping to find a performer who could capture the music in their heads. Crane thought it would be the easiest role to cast, consisting almost exclusively of a string of jokes to be rattled off. And yet no one could quite capture the sound they were looking for.

Chandler was to be "the droll observer of everybody else's life. And his own." He was an office drone who knows his job is "killing his brain cells and his sperm. But it's a place to make long distance calls from." Chandler was a romantic sad sack with "a knack for finding women who

turn out wierd [sic]." They would be the type who "wants to play the girl scout and the man who won't buy the cookies. Or another wants him to accept her Lord. A Lord that none of us is familiar with."

Chandler was a self-consciously comic role—a character who believed himself to be funny and used humor as a protective mechanism—and required an actor who could sell both the humor and the damaged self-confidence. In the first wave of actors coming in to read for Chandler, only one actor seemed to grasp what he should sound like: a twenty-four-year-old Canadian named Matthew Perry. Perry had appeared on *Dream On,* and he had an innate comic flair and a truly remarkable gift for delivering each line in an unexpected fashion.

Perry, though, was also already committed to another series: the futuristic ABC sitcom *LAX 2194.* Perry was to star alongside Ryan Stiles and Kelly Hu in a show about futuristic airport employees. Stiles was a robot customs agent and Hu his exasperated human partner, with Perry in a supporting role as a baggage handler tasked with sorting aliens' luggage. It simply could not be possible to come up with a more ludicrous sitcom premise, nor to find one less likely to ever make it to air, but Perry, whose business manager had just informed him that he was flat broke, had begged his agents to find him any work, and *LAX 2194* it was.

Kauffman, Crane, and Bright were at a loss as to how to proceed. Perry was clearly the best performer they had seen, but they could not have him. And Warner Bros. refused to allow them to place any more actors in second position at this point, meaning that Perry was entirely off the table.

Kauffman and Crane saw numerous actors, including Jon Favreau, and had also been impressed by a young actor named Craig Bierko. He was not quite Perry's equal, but the casting process was often a matter of compromise, and Bierko's mien reminded the producers of Perry. NBC had signed Bierko to a deal, and they were intent on finding a role for him in an NBC series. The network pressured Kauffman, Crane, and

Bright to cast Bierko as Chandler. They brought Bierko back for another audition and wound up offering him the role.

Bright was despondent at the thought of Bierko's being on their show. He was a terrific performer and a superlative actor, but he was not Chandler. Bright believed he lacked the instinctive comic pop that such a showy role demanded. He could not credibly convey the acerbic, sarcastic, self-deprecating, but surprisingly lovable persona that they were looking for in Chandler. Bierko was, by all accounts, a pleasure to work with. He just was not right for this particular role.

Bierko, too, had his doubts. He was looking for a starring role, not a part in an ensemble. Bierko wound up turning down *Friends Like Us*. Years later, Bright would receive a letter from Bierko, in which he expressed his realization that in turning down the part of Chandler, he had missed out on the role of a lifetime.

Later, the showrunners found out that Bierko had been practicing for the role by running his lines with another actor: Matthew Perry. Bierko was a talented actor and would go on to have an impressive career in series like *UnREAL*, but Kauffman and Crane realized that what they liked about him for the role of Chandler was merely a reflection of Matthew Perry, and that Bierko had been tutored by Perry to play the role as he would have. They learned that Perry liked the role of Chandler so much that he was coaching numerous other actors on how to play the part.

It was mid-April, and they were still looking to cast the role of Chandler. Crane began to wonder if the fault did not lie in their own writing. Was Chandler simply a poorly written role? Then there was some good news from Warner Bros. WB executive David Janollari had seen the pilot of *LAX 2194* and returned with a verdict: There was absolutely no chance of its making it to air on ABC. "Look," Janollari said, "I know he's not available, but I think he's great as Chandler, and he should go as second position." Kanner was not senior enough to make that call, but Janollari could, and so Kanner, with a sense of relief, agreed: "Great, I'll get him in."

Perry could be called back for a second audition. Crane felt the cartoon sweat flying off him, an expression of his overwhelming relief at having an actor he felt was up to the task of playing Chandler. Perry was brought in to read with Aniston, Cox, and LeBlanc, with another actor filling in for David Schwimmer as Ross. Perry impressed the producers once more with his ability to find a fresh method of delivering Chandler's lines, and they knew that no other performer would come as close to what they imagined their character would sound like.

Normally, a casting director was merely supposed to usher the actor out of the room, murmuring sweet nothings like "good job" but not offering any more information about casting. After Perry finished his audition, Kanner asked him to wait for a moment while she conferred with the producers. Everyone compared notes, and there was unanimous agreement that Perry was so superb there was no way anyone else could play the role. Kanner ran out of the room, pointed to Perry, and gave him a thumbs-up. Perry was shocked: "What?! Really? What?" Kanner had the rare pleasure of immediately sharing life-changing news with an actor she had championed: "Yeah, you got the job!"

———

After Perry joined the cast, the business-affairs department at NBC approached Littlefield and warned him that the role of Rachel needed to be recast. It was simply too great a risk to leave a promising show like *Friends Like Us* open to sabotage or self-destruction when it could so easily be avoided. Warner Bros. asked Littlefield if he was willing to cover the costs for reshoots if Aniston wound up being unavailable, and he said he would. Littlefield was cognizant of how important good casting could be for the future success of a show and was willing to take a major risk in order to keep the most preferred version of the cast together. But Littlefield also had a plan. He was going to call Preston Beckman.

Muddling Through had already shot a half-dozen episodes, none of which had aired, and CBS, after some dithering, ultimately chose to put

the show on its summer schedule, in the relative dead zone of Saturday nights. Hearing the news, Littlefield turned to Beckman, NBC's scheduling guru, with a two-word order: "Kill it."

Beckman returned with a crafty suggestion for eliminating *Muddling Through*'s prospects. Beckman was sitting on a trove of unreleased original TV films adapted from Danielle Steel novels. They were practically guaranteed to attract a substantial, and substantially female, audience. If they were to be scheduled opposite *Muddling Through*? Well, no show about an ex-con motel manager and her daffy family was likely to provide stiff competition for Steel's glamorous romances.

Beckman would schedule the Steel movies for the first few Saturday nights *Muddling Through* was on the air, with repeats scheduled for the weeks that followed. It was a necessary sacrifice, giving up some of the ratings the movies might have garnered on another, more attractive night in exchange for eliminating a rival to potential future Thursday-night success.

In private, Littlefield was scared to death. Losing Aniston would mean millions of dollars in reshoots and recasting. But a network president knew what a rare thing it was to feel the chemistry between performers. Something unique was brewing, and Littlefield felt he would have to be a fool to tamper with what was developing. He would just have to wait for CBS to fold.

———

The mood in the room on the Warner Bros. lot at the end of April was tense, and more than a little awestruck. To be cast on a network show was a thrill, even if the show, like most others, would almost inevitably fail. But to be working with James Burrows, the man who had shepherded the likes of *Taxi* and *Cheers* to unprecedented heights of artistic and ratings triumph, was to know that the possibility of success had drastically increased, and that there was an unquestioned master of the sitcom arts present at the first read-through of the *Friends Like Us* pilot script.

Burrows made a habit of going through the pilot scripts that his agent would send him each spring. Of all the shows he received for the 1994–95 season, the one that jumped out at him was *Friends Like Us*. Its professional polish appealed to him, as did the clever way in which it managed to introduce a passel of new characters with relatively little strain. Burrows agreed to direct the pilot. His presence alone was significant to the future prospects of the show; being able to say, "Jimmy thinks this is great," vastly improved the odds of its making it to the air in the fall.

The six actors selected by Bright, Kauffman, and Crane said their hellos and gathered around the conference-room table. They opened to the first pages of their scripts and began to read the lines, and Bright relaxed almost immediately. Often with a pilot, there was a sense of fumbling confusion on a first pass through a script. Everyone was exceedingly polite and cautious, and whatever comedy lurked in the script was stepped on by a lack of familiarity with the material. But something remarkable was happening as they read the story of the runaway bride and the lovesick divorcé and their crew of pals. People were laughing. More than that: People were cracking up.

Unlike on some of the other shows Burrows had worked on, the actors on *Friends Like Us* had never all read together before, and so there had been no way to confirm that this experiment would work. Two gifted actors might fail to find a way to coexist on camera, and a promising script might fall flat when performed. These actors appeared to have known each other their whole lives. Burrows nodded to himself, his belief that something unusual was taking place confirmed. Chills were running down Kauffman's spine as they read. This was something extraordinary.

Burrows saw his mission, at this early stage, as encouraging the actors to walk the comic plank for him. He would remind them that the creative process included them and ask them to make suggestions of their own. "Don't just say the words," he told them, "act the words." Burrows would not come into rehearsal with set ideas, would not have spent

his evenings moving dolls around a proscenium at home to plan the blocking for a scene. He wanted to be inspired by what his actors did, wanted to oversee a fluid creative process in which his actors peppered him with off-the-cuff ideas and he helped them edit those ideas into a coherent whole.

Burrows wanted the actors, above all, to understand they had the right to create. The actors were themselves taken aback by what their new castmates had come up with. Lisa Kudrow had been sure, after reading the script, that Chandler would be gay and was surprised by Matthew Perry's more hetero take on the character.

He also encouraged them to use physical action to shape the scene. If Ross was pleased with himself for speaking up to Rachel about his feelings, Burrows suggested that Schwimmer might pop the cookie he was holding into his mouth as a capper to the moment.

Kudrow was more than a little cowed by the presence of the man who had worked with Ted Danson, Marilu Henner, and Mary Tyler Moore. She wanted to impress Burrows, and so when he asked her to try a line while hiding under the conference-room table, she gamely crawled underneath and began croaking out her lines. Kauffman and Crane ambled by as Kudrow was perched on the floor, and they reluctantly approached the actress. Phoebe, they suggested, might not handle this scene in quite that fashion. Burrows jumped in to say that he was the one who had suggested it, and Kudrow, relieved, felt assured that she would not be fired—at least not yet.

Of all the performers, the only one anyone might have recognized on the street was Cox, who had made a splashy debut a decade prior as the fresh-faced fan Bruce Springsteen pulls onstage to dance with him in his iconic "Dancing in the Dark" music video. Cox had been raised in the tony Birmingham, Alabama, suburb of Mountain Brook and had plans for a career as an architect upon starting at Mount Vernon College. She wound up dropping out of school to become a model, and won campaigns for Noxzema and Tampax. Cox was the first person to ever use the word *period* in the context of women's health on American

television. Cox had built a successful career as a model, even though she had been considered too short for the profession, and she dreamed of establishing a beachhead in acting next.

After "Dancing," she spent two years on *Family Ties* as Michael J. Fox's girlfriend. When the show ended, Cox expected to be vaulted into the stratosphere and instead found herself in search of a big break that was tardy in arriving. She guest-starred on *Dream On* and *Seinfeld*, among other shows, but it was the 1994 film *Ace Ventura: Pet Detective* that finally gave her the opportunity to display her comic chops. She was the straight man to unhinged animal lover Jim Carrey, demonstrating she could hold her own in the wildest situations.

There was an unconscious deference around the table to Cox, as the closest thing the show had to a star. But Cox immediately set the tone for what was to come when she told her fellow cast members that if they had any notes for her, any suggestions about how she might improve her performance, she would be thrilled to hear them. This would be a show about six performers, not one star, and anything that might benefit the quality of the show would be welcomed.

Over the week of working through the script before filming the pilot, Bright watched as the cast grew more comfortable with the material and with each other and began to settle into the roles they had been selected for. Bright believed that they could have simply turned the cameras on for the first run-through and come away with an impressive show.

Nonetheless, the network was unsure about what it had. After a later, less impressive run-through, NBC West Coast president Don Ohlmeyer said he found the show confusing. There were too many characters to follow and too many story lines. This should be a show about Monica, since Courteney Cox was the only star they had. All the other characters should be relegated to secondary status. When Ohlmeyer finished speaking, James Burrows spoke up: "Well, that's not the show I signed on to do." The network's note was dropped. Burrows's word remained gospel.

Burrows was also studying the actors as they worked together,

waiting to see what might unfold between them. He was looking for what he thought of as "the unspoken word"—a kind of extrasensory perception that sometimes developed between two gifted performers, in which they could convey an entire array of emotions through the tilt of their shoulders, the angle of their eyebrows, the way their eyes would meet or shy away. It was not necessarily that David Schwimmer and Jennifer Aniston were the most gifted members of the cast—it was increasingly clear that *Friends Like Us* had not made a single misstep in the casting process—but that something profound and unexpected happened when the two actors occupied the screen together.

Traditionally, Burrows would bring in a studio audience about four days into the preparations for the pilot. They would watch what he and the actors had worked out, like a dress rehearsal for a Broadway show, and Burrows would be able to assess how much progress they had made. The audience response was through the roof, instantly reminding Burrows of *Cheers* and *Frasier*. This could be the start of something special.

CHAPTER 3

GRAB A SPOON

Making the Pilot

Having knocked out a first draft of the pilot, Kauffman and Crane called on some of their friends to assist in punching up their script. It was a standard practice in Hollywood for writers to offer a few days' unpaid labor on tightening and improving a pilot. Sometimes, there might be work to be had if the show made it to air; sometimes, those same friends could be asked for help when the time came to write your own show. Kauffman and Crane turned to a trusted inner circle for assistance: Crane's partner, Jeffrey Klarik; and the team of Jeff Greenstein and Jeff Strauss. Greenstein and Strauss had been neophyte writers, scrabbling a living out of writing freelance episodes of the likes of *Charles in Charge* and *Mr. Belvedere,* when they were hired as staff writers on *Dream On.* They had all been ushered into the inner sanctum of television success together and had simultaneously received their joint educations in the business.

When Kauffman and Crane left *Dream On* after its fourth season to sign a deal with Warner Bros., Strauss and Greenstein graduated from being baby writers to showrunners. They oversaw *Dream On*'s fifth

season, with guidance from Kauffman and Crane as consultants. Kauffman and Crane had served as their mentors in television writing, so it only made sense that when they were developing new shows, Greenstein and Strauss would gladly offer their time. In the spring of 1994, the pair assisted with punching up both *Reality Check* and *Friends Like Us*.

When the pilot was originally laid out, Kauffman and Crane pictured it as centering around a romantic couple whose ebb and flow would be the source of much of the show's comedy and serve as its emotional core, with Monica finding herself drawn to the slovenly, womanizing actor Joey.

After casting the show, Kauffman and Crane wisely stood back and watched their new troupe of actors interact, and were immediately struck by the intensity of the scenes that put together David Schwimmer and Jennifer Aniston. There was something about them—some fascinating, indescribable admixture of attraction and loathing and tenderness and brutishness—that was unlike anything they had ever seen before. The air was charged with anticipation, an empty space that could be creatively filled by the audience. Monica and Joey were no longer, but what about Ross and Rachel? Kauffman and Crane knew that there had to be a lot more of them together, and reimagined the central romantic plotline of the show as being one serving Ross and Rachel.

The pilot, now called *Six of One*, was filmed on the Warner Bros. lot in early May. It was just four months after the Northridge earthquake, and the ground was still occasionally rattling from unexpected tremors, remnants of the 6.7 quake. The night of the pilot's filming, Kevin Bright was relieved and glad to have someone like James Burrows present to oversee the shoot. Burrows was so professional and efficient that the potentially terrifying aspect of shooting a pilot—that so much was riding on this one twenty-two-minute demonstration—was muted.

Burrows was blazingly fast—something that Bright and his colleagues would eventually take exception to—and he made sure to get a loose, witty, exuberant version of the script on film. The tone was a reminder of an essential tenet of Burrows's: Anger was never funny. Anger

was a distraction for a comedy. Frustration had a comedic vigor that anger never did, and the trick was always to stay on the side of frustration and never of anger.

Burrows, the one true sitcom veteran among the creative team, was concerned about wearing out the jokes. The audience would be fired up between scenes by a stand-up comedian, but doing too many takes of the same scene would deliver diminishing returns. Burrows had been trained in the theater. He believed that if you wanted to see a second take, you should buy a second ticket, and he directed accordingly. Even still, the process, with camera and lighting resets, was slow enough that some of the audience trickled out before the shoot was complete.

The pilot crisply and subtly laid out much of what would come. It began in the hub of the show's social life, the Central Perk coffee shop. (Much later, Phoebe would gaze at the sign in the window, smile broadly, and say, "I just got that!") Each of the six protagonists was given a brief opportunity to introduce themselves. Chandler shared an anxiety dream from the previous night. He was back in school, flummoxed to find himself naked. Worse, his penis had been replaced by a telephone: "All of a sudden, the phone starts to ring and it turns out it's my mother, which is very, very weird, because she never calls me!" ("One word for you: therapy," another character had told Chandler in the initial outline of the pilot.)

Ross enters the coffee shop, a rain cloud metaphorically perched over his head. Joey spots him and offers a succinct summary of Ross's current mental health: "This guy says, hello, I want to kill myself." Ross has recently been left by his ex-wife, Carol, who has come out as a lesbian, and his friends are curious as to how he could have missed the warning signs. "She didn't know," he replies, "how should I know?"

Chandler, already marked by his Oedipal fixation and fears of castration, sees the story of Ross and Carol as yet another reminder of his own romantic failings: "Sometimes I wish I was a lesbian . . . did I say that out loud?" Both Ross and Chandler are presented as anxious neurotics, with Ross lamenting the loss of his romantic sureties and

Chandler acknowledging that he has never had anything of the kind. Ross's sister, Monica, anxiously preparing herself for a date, and eccentric Phoebe round out the ensemble. (In the initial outline, Monica had started off the episode by describing how she never wanted to go on another date again, and then caved when Phoebe offered to lend her a black dress.)

Ross completes his barrage of woes, which we suspect his friends have heard more than once before, with a lone wish: "I just want to be married again." And at that very moment, the final member of the sextet makes her entrance, her wedding veil streaming over her bare shoulders. Rachel Green (Jennifer Aniston) is now the wish fulfillment of Ross's nuptial fantasy, a bride summoned out of the depths of his psyche to restore him to marital fullness. (Chandler spots Rachel and, hoping for similar success, says, "And I just want a million dollars!") The original *Bleecker Street* script had included Ross's crush on Rachel but relegated it to a secondary plotline, behind Monica's bad date and Rachel's tempestuous arrival at singlehood. Now, with Aniston and Schwimmer cast, and their chemistry so palpable, it occupied center stage.

The ensuing scene is a master class in smooth and efficient storytelling, a compressed love story hidden in the ruffles of Rachel's wedding gown. The show would be sensational in its use of props as a physical expression of fleeting or emotional frames of mind, and it begins here with a sophisticated dirty joke. As Ross haltingly attempts to say hello to Rachel, his umbrella accidentally flies open. Ross's excitement is uncontrollable, visible for all to see, and a source of mild embarrassment. We grasp an elemental truth about him instantly and wordlessly, communicated solely through physical comedy.

Rachel, as it turns out, is an old high school friend of Monica's from Long Island. (Initially, her last name was to have been Robbins, not Green.) Rachel was set to marry Barry (Mitchell Whitfield), her dentist swain, but the sight of a Limoges gravy boat helped her decide at the last minute that a life of wedded bliss was not for her. She and Monica had drifted apart—Monica notes that she was not invited to Rachel's

wedding, which her friend acknowledges with a wince—but when Rachel found herself fleeing her life, she instantly thought of Monica.

Rachel and Ross are nudged forward as twin wounded spirits fleeing, or summarily excluded from, the paradise of marriage. Rachel soon finds herself back at Monica's apartment, calling her father to explain her rash decision: "It's like, all of my life, everyone has always told me, 'You're a shoe, you're a shoe, you're a shoe, you're a shoe.' And then today, I just stopped and I said, 'What if I don't want to be a shoe? What if I want to be a purse, you know? Or a hat?'"

Rachel is pegged as a spoiled Jewish American Princess type, on the cusp of leaping from her father's care to her husband's when she suddenly pauses, hesitating. She goes on to tell her father that she might not need his money anymore, only to step back, shocked, from her own self-created precipice: "Wait, wait! I said maybe!"

Joey, with a mop-top do and a black leather jacket to telegraph alpha-male vigor (he has already hit on Rachel, telling her he lives across the hall and that his roommate, Chandler, is often away), pulls Ross aside and, making use of the lines trotted out during auditions, compares women to flavors of ice cream. You could order rocky road or cookie dough, you could ask for sprinkles or whipped cream. "Welcome back to the world!" he tells Ross. "Grab a spoon!" "I honestly don't know if I'm hungry or horny," Ross responds.

Rachel, left to her own devices, finds herself sobbing over Joanie and Chachi's wedding from *Happy Days* (itself an echo of Aniston's childhood habit of recording *Joanie Loves Chachi*). Rachel will never be one of those radiant sitcom brides, she is realizing, and her rash decision has thrust her into an unfamiliar place whose rules are entirely foreign to her. "I'm gonna go get," she haltingly decides, stumbling over her words, "one of those job things." Rachel is not quite ready to cut the cord, though. In the next scene, she exultantly sways into Central Perk, showing off her latest purchase—a gleaming pair of boots, bought with her father's credit card.

Monica, still not entirely formed at this early stage (her plotline in

the pilot revolves around a date with a caddish guy), is primarily present as a foil and mentor for Rachel. Monica hugs Rachel after she cuts up her father's credit cards, telling her, "Welcome to the real world. It sucks. You're gonna love it."

Bright was intent on *Six of One*'s having a more cinematic feel than most television series. In the bittersweet moment when lovelorn Rachel was gazing out the window, Bright wanted a close-up of Aniston from outside the window—generally a sitcom no-no. He had prepared a temporary fourth wall, but Burrows bristled at the thought of such a composition.

Bright wanted to see Rachel's face in the window and was willing to put in the work to ensure that they could do it. "I need it," he told Burrows. "I've got to have that shot." Burrows reluctantly agreed, and set up and executed the shot so quickly that Bright almost missed it entirely. "All right!" bellowed Burrows. "That's it. We're moving on." It was not really the shot Bright had asked for. He would have to blow it up to get the full close-up he was hoping for, but it was at least the right actor from the right angle. It would do.

The pilot establishes another of the show's abiding interests: mining the past for comic and interpersonal insight. For it turns out that Ross—Monica's older brother—has also known Rachel for years. As Rachel pours her heart out at the coffee shop, Ross is silently pouring a packet of Sweet'N Low into her decaf coffee, attuned to Rachel's needs only moments after re-encountering her.

As they sit together in Monica's apartment, splitting the last Oreo, Ross tells her, "Back in high school, I had a *major* crush on you." (Schwimmer pauses meaningfully before *major,* sucking his tooth and extending his arm like a Supreme, or a running back barreling toward a first down.)

Aniston's response is beautifully understated. She meets Schwimmer's gaze, a smile tickling the edges of her mouth, before replying gently: "I knew."

"I always figured you just thought I was Monica's geeky older brother," Ross responds, surprised.

"I did," says Rachel. (This scene had initially taken place at Ross's apartment, as his friends helped him put together his new IKEA furniture. Rachel would tell him, "Thank you for a wonderful wedding night," as they laughingly snapped the legs onto his new coffee table.)

The scene is tender and awkward and funny, its emotional beats studded by a recurring desire to gently prick any lingering sentiment. "Listen," Ross asks, demonstrating his soon-to-be-familiar circuitous method of speech, "do you think, and try not to let my intense vulnerability become any kind of a factor here, but do you think it would be OK if I asked you out sometime, maybe?" Rachel looks back at him soulfully, replying, "Yeah," before softening into a smile and adding, "maybe."

Ross has been given a go-ahead of sorts but tellingly chooses to sit with it rather than pounce: "OK. OK, maybe I will." Ross looks at his Oreo half rather than at Rachel as he ponders her ambiguous invitation, and after she heads off to bed, he lustily eats his cookie and struts around his sister's apartment, headed toward the door. "Hey, what's with you?" Monica asks. Ross replies, "I just grabbed a spoon."

With this closing flourish, *Six of One* demonstrated its abiding interest not only in the saga of Ross and Rachel, but in the perpetual flurry of transformation that would come to define the show. Its characters were motile, alert to quicksilver changes around them, and searching for self-definition. No sooner would one enormous wave wash over them—divorce, or fleeing marriage—than the next set of questions would emerge. (Originally, the pilot was to end with Ross finding out his ex-wife was pregnant with his baby, but this development wound up being postponed for the second episode.) The pilot craftily pulls both Ross and Rachel out of stultifying existences that we can only too readily imagine, placing them in each other's orbit at precisely the moment they might be most receptive to the possibility of a new manner of existing in the world. The real world sucked, but we were going to love it.

CHAPTER 4

HOW YOU DOIN'?

Preparing for the Premiere

Testing, as Preston Beckman knew, was the crucible in which shows were formed. It was where new series made their way onto the fall schedule, and it was where they got pushed off. Beckman, possessed of a doctorate in sociology from NYU, had become head of scheduling for NBC in 1991, shortly after Littlefield had taken over from Brandon Tartikoff. Among Littlefield's many strengths was an acute awareness of his weaknesses, and he knew scheduling was not his forte. Beckman, who had previously been in the audience research department, and whose skills in after-the-fact analysis as an academic were ideal for the work, was put in place to oversee both day-to-day scheduling and overall planning. Beckman had to make sure that new episodes were ready on time, and that both original episodes and repeats were scheduled effectively. He was also the executive who had to anticipate the needs of the schedule and steer the other departments to develop and support new shows that would match those needs.

In early May, about one hundred people filed into a screening room on the NBC lot to take a first look at the *Six of One* pilot. The audience

included representatives from every notable department at NBC, including programming, public relations, marketing, and scheduling, and the mission was a brutal if necessary one. Everyone was here to say precisely what was wrong with the show. Backslapping and plaudits were all well and good for another time, but for today, the mission was to poke holes in *Six of One*, to speak bluntly about what faults could be found with it. And the network's assembled brain trust was not yet pleased with the show.

The overall feeling was that the pilot was a touch too cute, its world too elfin to feel genuine. The characters, too, were overly processed, lacking enough detail to distinguish them, both from each other and from other, past sitcom characters. People were also deeply skeptical about the idea of the show's characters' spending so much time in a coffee shop. A coffee shop was too New York and too downtown for the audience to relate to, they feared. "Don't worry," Bright would later tell NBC. "Everybody will be going to the coffee shop after they see this show." The coffee shop was an attempt to clearly delineate the Generation X trappings of this new show. This was a place where young people would be hanging out, all attempts at integrating Pat the Cop and others of his ilk to the contrary.

An internal memo described the show as "not very entertaining, clever, or original," with particular concerns about Ross, who "generated little sympathy." Audience testing found that viewers over the age of thirty-five especially disliked the show, finding it hard to connect with the characters. And some prominent voices at the network, including Eric Cardinal, the head of program research, simply hated the show.

The process was rough, but the overall message—that *Six of One* had not yet found its groove—was borne out by the later audience testing, which mostly agreed with NBC's critique. It received a "high weak" grade, which neither demolished its chances nor notably increased them. NBC West Coast president Don Ohlmeyer worried that some of the lack of enthusiasm was due to the erotic pursuits of Monica, who was seen sleeping with a stranger on a first date. What would audiences

think, Ohlmeyer wondered, about such a libertine young woman, and would they continue wanting to spend time with her after glimpsing her in so compromising a position?

Ohlmeyer had audience members at the research screening fill out a questionnaire about extramarital sex, in an effort to gauge viewers' comfort with such displays. Marta Kauffman was breathing fire out of her nose at Ohlmeyer's presumption and at the obnoxiousness of his questionnaire, which basically asked, she believed, if Monica was A) a whore, B) a slut, or C) easy. Ohlmeyer's sexist query was based on a mistaken assumption that the audience for the show was likely to judge Monica rather than identify with her.

Nonetheless, NBC picked up the show for its fall season on May 13, one week after the pilot was filmed. During the call with the showrunners to let them know the good news, the network requested that the show acquire a new title. The series, they decided, should be called *Friends*. Kevin Bright was unruffled by the request, and said as much: "If you're going to put it on Thursday night, you can call it *Kevorkian*, for all we care!"

The network was confident that a show about six humorous, attractive twentysomethings would play well with youthful audiences, but it had no guarantees that that audience could expand beyond its core. The hope, in the mind of NBC public-relations head Flody Suarez and others, was that people would tune in and note in astonishment, "That's who I was!" or "That's who I am!" or "That's who I will be!"

There was also talk on the NBC lot of more substantive changes to the pilot. The testing suggested that the male characters were viewed as being too similar, which may have reflected the fact that the show featured three brown-haired men. Perhaps the solution, some thought, was to recast one of the starring roles, or to add supporting characters to liven it up.

A concern elaborated by Littlefield and others suggested that there needed to be more of a professional life for the show's characters, establishing existences for the six protagonists outside of their apartments

and the coffee shop. But for all of his concerns, Littlefield was also intent on building a network at which passionate voices would be listened to. After strong pushback from NBC's Jamie Tarses and Warner Bros.' David Janollari, both intent on preserving Kauffman and Crane's initial vision, NBC decided, tremulously, to avoid making any major changes to *Friends*—although we did briefly see each of the characters at work in forthcoming episodes.

NBC already knew that it was retooling its Thursday-night lineup around *Seinfeld* and was shifting *Mad About You* over from Wednesdays to join it. The idea of adding a third sitcom about urbane New Yorkers was an appealing one, and Kauffman and Crane's show was tentatively penciled in for the eight thirty slot, between *Mad About You* and *Seinfeld*. Meanwhile, NBC's buzzy new hospital drama, *ER*, with a young, attractive cast of doctors and nurses (including George Clooney and Julianna Margulies) and a raw, handheld aesthetic, was slotted in at ten P.M.

The show the network was most excited about, though, was *Madman of the People*, featuring returning star Dabney Coleman as a cantankerous newspaper columnist displeased to find himself working for his daughter. *Madman of the People* was scheduled for the nine thirty slot on Thursdays, there to coast in the wake of *Seinfeld* and grease the path to the new *ER*. Networks were entrusted with entertaining America, but their sense of what audiences wanted to see was often wildly off base.

With *Mad About You*, on which she had an ongoing guest-starring role, and *Friends* scheduled for the same night, intrepid viewers could watch Lisa Kudrow going back-to-back on different New York–set sitcoms. Crane thought it was so strange that he decided to call *Mad About You* creator Danny Jacobson. What would he think about making Phoebe and Ursula twin sisters? Jacobson agreed, and a rope was extended to lash together one of NBC's current hits with a show they hoped would be the next tent pole of Must-See TV. In retrospect, Crane was unsure whether he would have been so kind in offering a helping hand to a totally untested new show.

Marta Kauffman passed along the pilot script to her husband,

musician Michael Skloff, and tasked him with writing a theme for the show. Skloff got in the car to pick up their five-year-old daughter and turned on the car radio. The Beatles' "Paperback Writer" came on the stereo, and John Lennon and Paul McCartney's euphoria captured the precise feeling that Skloff had while reading the script.

In writing the music, Skloff kept his ear trained on the exuberant sound of 1960s pop he had summoned on his FM dial: the Beatles, but also the Monkees and the sunny vocal tones of the early British Invasion. Skloff thought the song should sound like the feeling of waking up on a Saturday morning with a smile on your face.

Skloff was no lyricist, but he decided to pen a rudimentary set of lyrics to accompany his music. The show was about friendship, and being a friend meant being there for other people. He came up with one line he thought was pretty good and could serve as the chorus for his ditty: "I'll be there for you."

Skloff was put to work finding an artist to record the theme song. He was summoned to the producers' office, where his attention was directed to a towering stack of Warner Bros. CDs sitting on a table. After being turned down by R.E.M.'s Michael Stipe and 10,000 Maniacs' Natalie Merchant (who he suggested record as a duo) and They Might Be Giants, Skloff came on a duo that he thought might channel the Lennon/McCartney vibe. They might not have been the household names that Stipe and Merchant, or even They Might Be Giants, were, but what if the Rembrandts were to record the show's theme song?

In the demo, Skloff had used some processed drum sounds to provide a drum fill at one particular moment in the song. After recording with the Rembrandts, he sent the final version to Bright. Almost immediately, the phone rang. "Where's that drum fill?" Bright asked. "Well," responded Skloff, "we have real drums now, so the drummer just did what felt natural in that moment."

Unbeknownst to Skloff, Bright had gone ahead and begun editing together a credit sequence, and had used the four beats of the drum fill to make four fast visual cuts. Without that fill, Bright's video didn't quite

work. Skloff was sent back to the studio to record some new drum hits. He was brainstorming with the engineer for the session, Kerry Butler, and someone suggested filling the musical space with a series of hand claps. There were no better ideas, so Skloff, along with two of the show's assistants, got behind a microphone and clapped along with the song. The most memorable sequence of one of the most memorable television theme songs ever had just been recorded.

With the show given the green light to air, Kauffman and Crane's next task was to hire a writing staff. Kauffman and Crane wanted writers who were hungry, who had not yet been formed by their experience on other shows. The inspiration for *Friends* had come from Kauffman's and Crane's own time as struggling writers in their twenties living in Manhattan, but they were in their midthirties now. They were more than a decade older than their characters, and their twentysomething experiences, which were still so vibrant in their minds, were also a decade out of date.

Kauffman's and Crane's desks were piled high with books and magazines and article clippings about the lives of Generation X. They wanted to understand all the nuances of youth culture, from the music to the clothing to the pop culture references to the preferred hangouts. The questions underlying their search were fairly simple: What was it like to be twenty-five years old in 1994? How did young college graduates speak, banter, and think right now?

To help answer those questions, Kauffman and Crane decided that they needed a young writing staff. They wanted to be able to draw on the experiences of their writers to put the show together, both in mining their lives for story ideas and in serving as all-purpose bullshit detectors for its creators.

Adam Chase had grown accustomed to the sound of a grown woman screaming at him by the time he was twenty-two. He and his North-

western University classmate Ira Ungerleider had moved out to Los Angeles after graduation in the hopes of pursuing careers in television. Chase wound up with a job as an assistant to an agent who enjoyed shouting and throwing office equipment to express her frustration. This was just the nature of Hollywood, Chase thought, and he grimly stuck it out until he could find the next gig.

Like practically every other sentient college graduate with dreams of writing comedy, Chase aspired to one day make the staff of *The Simpsons*. The goal, for now, was to get a production-assistant job at Gracie Films, which produced the show, and Chase peppered Gracie's offices with letters and phone messages. One day, he called and happened to get a live person on the other end, who had thought Chase was a producer calling. Chase made them laugh, and they told him that they actually were looking for a PA and hired him.

It was a dream job, made even better by the opportunity to work in close proximity to James L. Brooks. Brooks, who had been responsible for *The Mary Tyler Moore Show* and *Taxi*, among others, was generous in offering his time to aspiring writers. Chase and Ungerleider sweated through writing a spec script (an unassigned script for an already-existing show, intended to serve as a calling card for an emerging writer) for *Seinfeld* that they planned to show Brooks. After tossing a first attempt, Chase and Ungerleider polished a second attempt a dozen times, and then when they had something they were pleased with, they brazenly stamped "first draft" on the cover and submitted it to Brooks's colleague Richard Sakai. Sakai liked their script and passed it along to Brooks, who offered them an opportunity to write one script for a show called *Phenom*.

Chase and Ungerleider eventually made the staff, and when the show was canceled at the end of the season, they were juggling offers from a number of shows. They had strong interest from the producers of the onetime ABC hit *Grace Under Fire*; they could sign on for the Dudley Moore–starring *Daddy's Girls*, or they could write for the variety series *The Martin Short Show*. Both writers admired Short, a big star and

a genuinely nice man who managed to remember the names of lowly writers like themselves when he stopped by the *Phenom* set. Chase and Ungerleider helped polish the *Martin Short* pilot and felt like their choice was made for them. The show would undoubtedly be a hit, and they would get to work with a comedic icon.

Then they got called for an interview for a new show by David Crane and Marta Kauffman and had the chance to look at the show's pilot. Chase and Ungerleider were thunderstruck by the echoes of their own lives. Here were characters who sounded just like them. Chase and Ungerleider had emerged from the same bookish East Coast Jewish milieu as Kauffman and Crane. Chase knew he could instantly summon that overly caffeinated, verbose, linguistically tricky voice.

Moreover, the life the show was describing was one Chase and Ungerleider had lived. When they first moved to Los Angeles, they had lived in a cramped three-bedroom in West Hollywood with three other people, including Andrew Reich, who would be brought onto *Friends'* writing staff for the fourth season. Chase felt like Kauffman and Crane's pilot inadvertently channeled his own life, with friends in the bedroom next door and others down the hall. Chase and Ungerleider took the *Friends* job.

Mike Sikowitz had been working in advertising in New York, where one of his clients was ABC. The network regularly sent over advance copies of scripts for Sikowitz and his fellow entry-level writers of ad copy to look over. After reading the scripts, they were tasked with writing short blurbs about new episodes for the likes of *TV Guide* or *People*, or brief advertisements that might run on radio stations. Sikowitz had been plugging away at these for some time when he had a realization: The people writing these scripts were likely having a whole lot more fun than he was, and making more money to boot.

He called his writing partner Jeff Astrof, then working in finance, and suggested they try their hand at some spec scripts. In the early 1990s, sitcoms were still booming, and the television industry had a seemingly endless need for young writers to staff the dozens of comedy

series then on the air. "Let's take a look at these," Sikowitz told Astrof. "Maybe we could write one."

The two young writers set to work laying out a spec script of *Seinfeld*. In it, George went to get his pants tailored, while Jerry was embroiled in a cheating scandal in an adult-education class. On the basis of their spec, and a connection with an agent, Sikowitz and Astrof decided to move out to Los Angeles, where they found work writing for *Hangin' with Mr. Cooper* and the animated series *Duckman*.

They were used to the process of auditioning for new series, which Sikowitz called dog-and-pony shows. They would be summoned, trot out all their best tricks, and then go home to pant by the phone for a treat that might not ever come. So when a call came in for a new show by Marta Kauffman and David Crane, they were unruffled. After watching the pilot, they were impressed with what they had seen. The creators were clearly talented writers, and meeting them in person, they felt genuine and like just the kind of people they would want to work for.

Alexa Junge had been so low on the writers' totem pole that she was not allowed to go upstairs at William Morris to visit her agent. Her agent had taken on Junge as a client before joining the firm, and William Morris had told her in no uncertain terms to drop Junge. Instead, they would meet in the building's lobby, where she would smuggle Junge a pile of photocopied pilot scripts to pore over.

In the spring of 1994, Junge headed out to a shabby inn in Palm Springs to read this year's haul, and stopped at the names of David Crane and Marta Kauffman. Junge had also been part of the New York theater scene and had seen their shows *Personal* and *A . . . My Name Is Alice*. Junge had been working for Nickelodeon and was struggling to connect with network series, but she had really enjoyed the script for Kauffman and Crane's *Family Album* the year prior. In the margins of the script for *Friends*, Junge scribbled her calorie count for the day alongside copious notes.

She asked her agent to submit a play she had written as her writing sample for the new show, and her agent refused. They had submitted the

same material last year for *Family Album*, when she had not been hired. Junge pleaded, arguing that Kauffman and Crane likely had not even had a chance to read her play. She won her argument, with her agent offering to say it was her mistake if anyone noticed. Kauffman and Crane called days later, wanting to meet. Hers was a voice they were looking for, especially given the overwhelmingly male staff they had assembled. She brought her food-stained script into her meeting to show Kauffman and Crane one note she had jotted down right near the calorie count: "This is so special."

The new writing staff, which also included Jeff Greenstein and Jeff Strauss, who were content to take the downward step from showrunners to writers to move to network television and collaborate with Kauffman and Crane again, was tasked with the job of planning for the season to come. Kauffman and Crane had a rough sense of where the story should go, and a few plot ideas, but little more. They knew that Ross's ex-wife, Carol, would be pregnant, and that the first season would track her pregnancy. Kauffman felt strongly that the season would culminate in Carol's giving birth. They also knew that Ross and Rachel's relationship would develop in some fashion, although precisely how far along they would get remained to be determined.

Beyond that, there were a handful of semideveloped stories. They knew that one episode would revolve around a sonogram for Carol, who would be pregnant with Ross's baby. There was the idea of having Joey serve as a butt double for Al Pacino. They even knew that Ross and Rachel would eventually have sex at his museum—a plot point that would not emerge until the second season. The rest was left to unfold in the writers' room.

Greenstein remembered that when he had worked on *Dream On*, he had devoted time—too much of it—to coming up with a pithy title for each episode. The title would appear on the screen at the beginning of an episode, and Greenstein, along with Kauffman and Crane, wanted the titles to properly set a mood before the episode started. In planning for *Friends*, it was understood that the episode titles were unlikely to

ever appear onscreen, but Crane and Kauffman were cognizant that fans might come across them in *TV Guide* or the listings of their daily newspaper. They talked it over and realized that even die-hard fans were unlikely to remember the name of a given episode when talking it over in homeroom or a nearby cubicle the next day. Instead, it would be, "Hey, did you see the one with the . . . ?" Since fans were already going to refer to episodes that way, why not simply make that the formula for the actual titles as well? *Friends'* episode titling was born, with nearly every episode's name beginning "The One with" or "The One Where." (Even the ones that diverged did so only partially, like "The One Hundredth.")

At Kauffman and Crane's urging, much of what the writers brought was material from their own lives. Jeff Greenstein remembered working a temp job at a Japanese insurance company as a claims processor soon after moving to Los Angeles. Everyone was obsessing over the crunching of numbers whose purpose Greenstein only dimly understood. The mixture of intense seriousness and ludicrousness of purpose activated Greenstein's comic taste buds; he recognized the Kafkaesque undertones of his workplace.

After six months, Greenstein's superiors wanted to give him a promotion to a full-time position. Instead of being pleased, Greenstein panicked. He was not a claims processor, nor did he ever want to be one, and the idea of progressing in a career that was anathema to his ambitions horrified him. Instead of accepting the promotion, he summarily quit. Greenstein's risky career decision wound up becoming Chandler's, who would also quit a mysterious data-processing job in search of more meaningful employment.

Originally, the pilot had gone into more depth on Chandler's professional life, with Rachel coming to his office to work on her résumé. Those scenes had been cut, but *Friends* retained an initial interest in Chandler's professional dilemmas, having him take a professional-aptitude test that suggested he was best qualified to—of course—process numbers. It was like a fever dream of Greenstein's transposed onto one

of *Friends*' characters, retaining that similar sensation of twentysome-thing aimlessness.

Writers also drew on the experiences of their friends and colleagues for inspiration. During the first season, planning commenced on a Thanksgiving episode, soon to become a tradition on the show. Green-stein and Strauss suggested that one of the characters should be an out-spoken Thanksgiving pessimist. The sardonic Chandler was the best fit for the role, but they lacked the backstory that would justify his grinchiness. Finally, Greenstein turned to Jeff Strauss and said, "Well, we could do your story."

Greenstein and Strauss had been classmates at Tufts, where they began their writing partnership, and Thanksgiving of sophomore year, Greenstein decided he did not feel up to going home for the holiday. His mother had died the previous summer, and home felt like an uncertain place. He asked Strauss if he could spend Thanksgiving with his family, which sounded like a respite from the crisis at home.

That weekend, Strauss's parents decided to announce that they were getting divorced. Greenstein was uncomfortably present as Strauss and his sister wrestled with the changes coming to their family. It was, of course, a perfect plotline for Chandler, and an explanation of sorts for his use of sarcasm as a shield deflecting the world's arrows.

The actors had varying amounts of sitcom experience, but it was James Burrows who understood the material, and the form, best and could offer necessary guidance. In an early run-through, Matthew Perry came up with a small bit of business that won a laugh, delivering a funny look after speaking his line. Perry returned to the gesture later on, garnering another laugh. Burrows interrupted the rehearsal and approached Perry. "I just want to tell you you shouldn't do that after the line," Burrows told him. "Because if this show is a success, which I think it will be, that will be all you're known for."

Burrows knew how television could chew up gifted actors and turn

them overnight into caricatures known for a single tic. The small gesture you created as a charming button to a scene could become, a few years down the road, the only thing anyone ever asked you to do. It was better not to take that laugh.

Kauffman observed her actors and noticed that the show's male actors were more willing to pitch ideas than the women. If they thought a particular joke wasn't clicking, they would mess around and make each other laugh until they had something they preferred. Kauffman believed that the female performers were still fearful of embracing their inner comedians—something that would change as the series went on.

Burrows's presence encouraged the young actors to think of their costars as their colleagues, not their competitors. He was intent on *Friends*' not becoming one of those shows where actors counted their lines and complained when they lagged behind. This was a show where an injury to one was an injury to all, and everyone's success rode on collective achievement.

The director offered the use of his lavish private dressing room for the cast to hang out in together between takes. They would gather in there and play poker, giving them a chance to banter and enjoy themselves away from the cameras.

While filming the second episode, before the show's premiere, Jane Sibbett, who had been cast as Carol after the original performer, Anita Barone, had demanded a larger role, walked around a corner and came on the three female stars of *Friends*. It was raining, and there they were, jumping in a puddle and splashing each other gleefully. Sibbett felt like she was privy to a privileged moment. If Aniston, Cox, and Kudrow could play like good friends when no one else was watching, it was just possible that they might be able to convey that sense of comradeship to the vast television audience.

After the cast had filmed a handful of episodes, but before the show premiered, Burrows called Les Moonves to ask for a favor. Might he borrow the Warner Bros. jet to take the *Friends* cast to Las Vegas? Burrows wanted to give the cast a well-deserved break, but he also was looking

out for the show. He believed that a crucial part of his work was to encourage the natural camaraderie that was blossoming between them. Burrows hoped that their respect for each other could turn into genuine love and affection, and that those feelings would be visible in their work together.

Moonves agreed, and the seven of them flew to Nevada. Burrows took them out to dinner at Wolfgang Puck's restaurant at Caesars Palace, and as they dug into their entrees, Burrows told them that this would be their last shot at anonymity. The actors looked at him, confused, and Burrows explained that after *Friends* premiered, they would not be able to enter a restaurant or casino without being mobbed. "You're kidding me," they told Burrows, not yet ready to accept what the future held in store for them.

The actors were interested in gambling after dinner but didn't have enough money to cut loose and enjoy themselves. Burrows took out his checkbook and wrote out a check to each of them. Burrows's only regret, later on, was that he didn't save the check stubs. What better memento could there have been of this pregnant moment in the history of American television?

Littlefield's intuition about an audience's hungering to see themselves onscreen was borne out by the earliest responses to the show. After being hired, Jeff Strauss flew with his wife to Northern California to visit her sister. *Friends* had not even premiered yet, but promos for the show were starting to run on NBC. On the airplane, Strauss's wife had begun chatting with her seatmate, and they exchanged notes about their professional lives. She mentioned her husband's writing for *Friends,* and the woman on the airplane told her, "I think that's going to be my new favorite show." Strauss and his wife never saw the woman from the airplane again, but she was a reminder that there was a whole audience of young television viewers who thought *Friends* might be their favorite new show, before even seeing it.

PART II

· · ·

MUST-SEE TV

(Seasons 1 through 3)

CHAPTER 5

GUM WOULD BE PERFECTION

The First Season Debuts

"Oh, no, you might well moan," reviewer John J. O'Connor wrote in *The New York Times* on September 29, 1994, "not another group of pals sitting around whining and nursing their anxieties, getting up once in a while to test the passing Zeitgeist." *Entertainment Weekly*'s Ken Tucker also began his review with a note of caution regarding *Friends*' familiarity: "If I tell you that it's a show about a bunch of attractive yuppies sitting around talking, what do you think of? *thirtysomething, Seinfeld, Mad About You*, yadda-yadda-yadda." But the show surprised Tucker with its comic vigor: "At its best, *Friends* operates like a first-rate Broadway farce, complete with slamming doors, twisty plots, and intricately strung together jokes. And even when it's not at its best, the crack acting and piquant punch lines give *Friends* a momentum and charm that win you over even if you're not laughing."

Tucker offered effusive praise to both the writers and the cast. "Kauffman and Crane can take an utterly standard sitcom scene—a discussion among the chums about whether foreplay is more important to women than to men—and turn it into a tensely funny playlet with a

beginning, middle, and end, all before the opening credits." Tucker singled out each member of the cast for praise, calling Kudrow "a cross between Goldie Hawn and Teri Garr [who, unbeknownst to Tucker, would later play Phoebe's mother on the show] with, I dunno, substance," and referring to LeBlanc as "a rarity—a hunk with a gift for deadpan comedy." Tucker went on to praise Cox for having "the most prominent, um, biceps—yeah, that's the ticket, *biceps*—in prime time," about which the less said, the better.

After his initial burst of dyspepsia, O'Connor was also enthusiastic about the debut of *Friends,* comparing it to *Dream On* and saying that it "promises to be equally offbeat and seductive." "The cast is appealing," O'Connor concludes, "the dialogue is pitch-perfect 1994, the time-slot is between the solidly established *Mad About You* at 8 P.M. and *Seinfeld* at 9 P.M. *Friends* comes as close as a new series can get to having everything."

There was generalized agreement that *Friends* was privileged enough to have been born standing on third base. "Wedged happily between *Mad About You* and *Seinfeld,*" wrote the *Chicago Tribune*'s Ken Parish Perkins, "this comedy series from the producers of HBO's *Dream On* would have to be an utter disaster—which it isn't—not to finish as the season's highest-rated new comedy."

Howard Rosenberg of the *Los Angeles Times* was the most enthusiastic of the early reviewers, calling *Friends* "flat-out the best comedy series of the new season." After describing the premise, he noted, "It sounds vacuous, and it is, sort of, but wittily vacuous, with crisply written dialogue adroitly executed by the show's strong ensemble cast." "It's all so light and frothy," Rosenberg concludes, "that after each episode you may be hard-pressed to recall precisely what went on, except that you laughed a lot."

Other reviewers were turned off by what they saw as *Friends'* childishness and lack of comic vigor. NBC's other shows were being wielded as cudgels against *Friends.* "Where *Seinfeld* is smart and appealingly free-form, *Friends* is inane and gimmicky," observed *Time* magazine, who called the show "sophomoric." "This half-hour is completely lacking in

charm or intelligence," groused the *Hartford Courant*'s James Endrst. He described it as "anemic and unworthy of its Thursday-night time slot."

Numerous critics agreed that *Friends* had a notable burden in introducing so many characters simultaneously. "Producers Marta Kauffman and David Crane are trying to give us enough information to make us care about all six people, in 22 minutes," said *The Baltimore Sun*'s David Zurawik. "There's something almost abstract about *Friends*," noted *Entertainment Weekly*'s Tucker. "Even after a few weeks, I'm still not clear about where each of the characters lives and what relationships they have with one another."

Tucker was concerned about how long it had taken him to grasp that Ross was Monica's brother and not her boyfriend, offering some advice to the actors to clear up any unwanted ambiguities: "I'd suggest to [David] Schwimmer that he resist the thoroughly understandable temptation to hug Cox in quite so passionate a manner."

Tom Shales of *The Washington Post* seemed to feel a particular revulsion toward the show, not only panning it as a "ghastly creation" but singling out Kauffman and Crane for abuse. They were "professional panderers" and "the witless duo who do *Dream On* for HBO." The show "comes across like a 30-minute commercial for Dockers or Ikea or light beer, except it's smuttier. . . . You keep waiting for Sally Jessy or some other cluck to interrupt the jabbering. The show is so bad that Sally Jessy would actually come as a relief."

When Don Ohlmeyer saw *Friends*' title sequence, after the first episode was broadcast, he was furious. He called Kevin Bright the next day with a pointed question: "What is that title sequence?"

"What do you mean?" Bright asked.

"It's awful. It's terrible," Ohlmeyer blustered. Bright still didn't know what Ohlmeyer was referring to, and asked him to explain his frustration. "It says to the audience, 'We're young, we're hip, we're dancing in a fountain and you can't dance with us.'"

"You really think it says all that?" replied Bright. Ohlmeyer was insistent that the sequence, in which the show's six stars fussed with umbrellas and splashed in a fountain, would cause the audience to feel left out, and demanded that Bright reinstate the original title sequence, set to R.E.M.'s "Shiny Happy People," which had run before the presentation of the pilot.

Bright's initial impulse was to fight, but on second consideration, he called back Ohlmeyer and offered a compromise. What if they worked up a new title sequence that was half Bright's and half Ohlmeyer's? "Let me see what it looks like," responded Ohlmeyer. In time for the second episode, Bright put together a new title sequence that mixed clips from the show, much like the "Shiny Happy People" sequence, with the fountain footage. The hybrid version could serve as an under-the-radar refresher in recent developments on the show, being updated every few episodes. In the end, Bright was happy that Ohlmeyer had made such a stink. It was, he believed, one of the only positive contributions Don Ohlmeyer had made to *Friends*.

The first season was a mostly steady, occasionally halting process of discovering what motivated the show's characters. While Ross and Rachel had been ably and efficiently thrust into their own orbits, other characters remained more mysterious to the *Friends* writers. Joey began life as a leather-jacketed lothario with an outer-boroughs affect and an overflowing little black book of conquests. Testing done after the pilot revealed that audiences found Joey off-putting and more than a little familiar, a Tony Danza–style stereotype.

The writers took another look at Joey in the hopes of making him more appealing. He was still a ladies' man, they thought, still someone who preferred a one-night stand to a committed relationship. But now he was more of a guy with a code. The show did not entirely approve of his cocksmanship, although it did regularly laugh off his excesses. But he was now a simpler soul, as writer Jeff Greenstein thought, a kid in a candy store who could not help glutting himself on every possible variety of sweet. Joey was an older brother to the three girls, his urges held

in place by the warmth of his affections. And the leather jacket was ditched.

Monica, too, was a mystery. She was supposed to be a den mother for her brother and their wacky friends, with a healing word for every wound and a bandage for every scrape. But that now felt like too limiting a role, with not enough to do when the other characters were caught up in their own romantic pursuits. The writers privately called Monica "the Riddler," because all she seemed to do, in the early episodes, was ask the other characters questions and set up their jokes. Courteney Cox was doing fine work in the role, so it was not a matter of the acting. Instead, it was that Monica herself was a kind of riddle, lacking a central core that future plotlines could be built around.

Kauffman, herself warm and nurturing, had based Monica at least partially on herself but was troubled by the lack of clarity regarding Monica's motivations. She called a meeting and asked writers to come up with a list of adjectives that might describe Monica. Mike Sikowitz raised his hand and offered, "She's inquisitive?"

It took until "The One Where Underdog Gets Away," the show's ninth episode, to glimpse a path forward. The plot had Monica preparing Thanksgiving dinner to everyone's overly demanding specifications. Monica was channeling writer Jeff Strauss's relationship with Thanksgiving.

Strauss had planned and cooked his own Thanksgiving dinner since college, inviting friends to share the holiday with him. He was, in his own estimation, simultaneously obsessively solicitous and terribly demanding. He was the guy who told all his friends exactly where, when, and how they would be celebrating Thanksgiving, while also cooking potatoes five different ways to satisfy his picky friends. Like Strauss, Monica was trying to control everyone around her while also fruitlessly seeking to meet everyone's needs.

Adam Chase and one or two other writers were hanging out on the set, and they noticed Courteney Cox straightening the furniture in her pretend apartment after everyone else had left. She was playing with

something hidden between the lines of the script, something inherent to her character that had not yet been fully teased out. Monica was freaking out over invisible dust motes, and Chase realized that they had stumbled into a breakthrough.

They brought their accidental discovery back to the writers' room, and Monica, who had previously been opaque as a character, became substantially clearer. The idea of concentrating on Monica and Rachel as roommates, and playing up Rachel's slovenliness against Monica's rage for order, gave Monica's character colors she had previously lacked. Alexa Junge saw it as an ideal opportunity to unleash all of her type-A personality traits and share them with Monica.

And the new take on Monica as an obsessive-compulsive neat freak illuminated a path forward for the character that allowed the writers to move her away from her Riddler status. The idea that Monica had OCD-like tendencies opened up dozens of potential story lines that had previously remained hidden to the writers.

The OCD was a fictional addition, but there was a part of Cox that wanted to take care of her friends, that wanted to guide them to the right decisions. Cox was the one who went around the set telling everyone precisely what model of car phone to purchase. Cox was the one who knew how long it might take to rehearse a scene or for one of her costars to go through makeup. She was the one who could sketch a minute-by-minute plan for the next day's work, factoring in every detail of her five costars' schedules. Cox would clean up her costars' dressing rooms when they got too messy. Monica was not Courteney Cox, but there were elements of Cox's personality that were heightened and exaggerated for the purposes of creating Monica.

The pilot had featured only Monica's apartment, along with a glimpse of Ross's new place. But by the second episode, Kauffman and Crane knew they needed a place for the boys to live as well. The hallway set would come in handy now, as Chandler and Joey were to live directly across the hall. Production designer John Shaffner and set decorator

Greg Grande would need to build and furnish a second apartment. The boys' apartment would have to be smaller, darker, shabbier, and less attractively decorated.

Grande wanted the boys' apartment to flaunt Chandler and Joey's execrable taste. Grande found the ugliest couch he could and then matched it with a workout bench (standard-issue overgrown-adolescent ornamentation) and a pair of unfortunate stools. For Grande, the pièce de résistance was the beige-and-brown cut-pile carpet draped across the floor, which looked like it had suffered a series of catastrophic spills from which it had never been able to recover. Who in their right mind, Grande wondered, would keep such an ugly thing?

Scenes from early episodes had taken place in Chandler's white-collar workplace and in Monica's restaurant, but Kauffman and Crane soon realized that audience interest plummeted as soon as *Friends* followed its characters to work. (This would change some in later seasons, as the show got craftier about its uses of the workplace.) The writers were intent on demonstrating their lives outside of Central Perk, but audiences truly did not want to depart the charmed inner circle. Eventually, the writers came up with a solution. Instead of venturing out, *Friends* would bring its adventures back home, with its characters recounting the tales of what had transpired elsewhere. This would be a show in which stories were often retold instead of depicted.

The workplace would recede into the background on *Friends*, only occasionally glimpsed. Ross had his job at the Museum of Prehistoric History, and later a gig as a professor of paleontology; Phoebe worked as a masseuse; Monica went from an assistant chef to having a kitchen of her own; Joey went out for auditions and won a role on the soap opera *Days of Our Lives* as egotistical doctor Drake Ramoray; Chandler would quit his job to avoid having to worry over the WENUS, the Weekly Estimated Net Usage Systems. (We would see a bit more of the work life of Rachel, whose flourishing career was a key aspect of her character.) There was a shared aura of professional floundering, with Monica losing

her job, Joey's agent suggesting gay porn, and Chandler later desperate for an internship at an advertising firm where he would be a decade older than his colleagues.

Ross, who has somehow managed to complete a doctorate by the time we first meet him, is treated like a walking punch line, his scientific bent proof positive, for his friends, of his irredeemable geekiness. *Friends* knows it can only occasionally rouse itself to express any interest in its characters' professional lives and chooses to make light of it. When everyone at Central Perk offers suggestions about why their bosses seem to hate them, Joey takes umbrage: "Or *maybe* it's because you're all hanging around here at eleven thirty on a Wednesday!"

The cast would get together on Thursday evenings each week to watch the latest episode of the show together as it aired. They would use the opportunity to exchange notes about how to improve the show, and even about each other's performances. At the very start of their time together, Courteney Cox had asked her costars to give her any notes they might have about her performance, and the weekly watch parties extended the custom, giving the actors a place and time of their own to discuss what they wanted to see from the show.

Ross and Rachel's burgeoning relationship was the driver of much of the building enthusiasm for *Friends.* And the slow-burn technique, in which romance was forever being delayed, was incredibly effective at creating momentum for the show. The strategy was clearly descended from that of *Friends'* Must-See TV predecessor *Cheers,* which had Ted Danson's lusty bartender Sam and Shelley Long's intellectual barmaid Diane push and pull at each other for five full seasons. *Cheers* had proved that will-they-or-won't-they could be a highly effective sitcom strategy, wielding romance and emotion as a counterweight to comedy, and using its ebb and flow to keep viewers tuning in consistently, week after week.

The show allows us to stand a half step ahead of its characters. As the first season progressed, audiences watched Ross and Rachel smile at each other, listened to the soft tones of their polite conversations, sensed

something brewing between them, even as Ross was crippled by post-divorce doubt and Rachel was struggling to catch up with the working world she had hoped to bypass entirely.

Ross moped through much of the first season, the loss of Carol still stinging, and the notion of having lost her to a woman the lingering humiliation that he cannot forget. Rachel shook him out of his self-absorption, her presence luring him back to the world. In "The One with the Sonogram at the End," the first episode after the pilot, Ross looked over Rachel's shoulder, moaning in combined pleasure and agony, when she asked him, "Didn't you think you were just going to meet someone, fall in love, and that would be it?"

"The One with the East German Laundry Detergent" (season 1, episode 5) brought the two characters together in quasi-romantic circumstances for the first time since the pilot, for an activity that Ross saw as a date and Rachel treated as laundry day. Rachel, new to the world outside suburban Long Island, admits to being a "laundry virgin." Ross, rising to the occasion with a clever double entendre, tells her, "Don't worry, I'll use the gentle cycle." At the end of the episode, Ross steps up to save Rachel's cart from a pushy interloper, and Rachel unexpectedly kisses him out of gratitude. Ross takes a step back, fondles a pile of sheets, and then walks directly into an open dryer door.

We are jolted out of what we come to believe is our private secret, shared only with Ross, in "The One with the Blackout," when after Ross argues that passion burns out, replaced by trust and security, Ross tells Rachel, "I see a big passion in your future." We can practically see Ross's mental gears turning frenziedly as he parses Rachel's reply of "You're so great"; until Joey, flopped sidelong in a chair, breaks the spell: "It's *never* gonna happen." Joey goes on to explain that Ross has spent too much time in "the friend zone" (a now-familiar, somewhat sexist relationship concept first introduced here) to escape it now: "You're mayor of the zone." "Blackout," which was supposed to be part of a network-wide themed block of episodes (only *Seinfeld* chose not to make use of the

blackout) and featured Chandler trapped in an ATM vestibule with Victoria's Secret model Jill Goodacre, felt to the writing staff like the first episode that got an audience buzzing about *Friends*.

Ross is a wounded teddy bear, pining for an unattainable crush, but there are darker hints of a less likable version of Ross to come. After Rachel meets Italian hunk Paolo (Cosimo Fusco), Ross pulls him aside to tell him that he and Rachel are "kind of a thing," saying, "Rachel and I should be together." There is something creepy about Ross's blatant interference in Rachel's romantic life and in his blithe assumption that he knows what Rachel wants, in the complete absence of any such assurances from the woman he yearns for. Audiences loved Ross, the show's first breakout character, but there were intimations here already of what later audiences would find so off-putting about him. Ross was a romantic, but he was also a particular kind of romantic who believed his emotions conveyed a sense of ownership of his beloved.

———

For Kudrow, the first season was full of "pinch me" moments, where she realized that all the career struggle that had preceded this moment had led her to this privileged place. Kudrow kept pulling the producers to the side in down moments with a single question: "Are the ratings good enough?" She wanted to know if *Friends* was long for this world, or if she would be back to hustling for auditions come next pilot season.

The first genuine test of the show's lasting power would be the "back nine." New series were often green-lit for an initial run of thirteen episodes. This allowed the networks an opportunity to reassess a show's development midway through the season—and to avoid throwing an entire season's worth of money after a disaster. To be picked up for the back nine was to receive a full twenty-two-episode order, rounding out a complete season of the show.

The ratings indicated that *Friends* was adeptly finding an audience a handful of episodes in, so property master Marjorie Coster-Praytor was shocked when, one morning, Crane and Kauffman summoned the

cast and the crew to the stage and announced that they had bad news and good news. "The bad news," Kauffman told them, "is that we did not get picked up for the back nine." A ripple of shock spread through the gathered crowd. Everyone felt that they had done good work on *Friends*. How could it be that they weren't being picked up? Kauffman let the news sink in for a long moment before carrying on: "The good news is we got picked up for eleven."

Cast members were crying with joy at the powerful vote of confidence from NBC, which was only further emphasized when they arrived at work the next morning to find none other than NBC president Warren Littlefield, clad in an apron, serving omelets to the *Friends* team.

For the remainder of the first season, Ross's friends would watch him silently pine for Rachel alongside the audience and provide a stream of acerbic commentary on his longing. Chandler spies on Ross watching Rachel bend over to pour coffee at her new job at Central Perk at the start of "The One with All the Poker" and swiftly bursts his bubble of soulful yearning: "Could you *want* her more?"

Chandler's quip was a reminder that *Friends* created its own language and its own conversational styles. The "Could you . . ." setup, conjoined with Perry's placing the accent on the unexpected *want,* became Chandler's instantly recognizable verbal tic. The writers soon learned never to italicize any word of Chandler's dialogue, as Perry would inevitably select an entirely different word to emphasize. Joey became famous for his three-word come-on, usually delivered as his eyes lavishly caressed a woman's body: "How *you* doin'?" Ross would wind his way with exaggerated slowness through a line, stopping to interrupt his thought, raise an eyebrow, or pause significantly. Perhaps this was what Burrows had warned the cast about when steering them away from catchphrases, but Perry in particular managed to use his off-kilter verbal rhythms to surprise audiences nonetheless.

Of all the first-season episodes, "Poker" is perhaps the most emotionally resonant, with Ross and Rachel sparring for an audience of their friends during a male vs. female poker game. The script, inspired

by the poker games in Burrows's dressing room, expertly toggles between the manufactured drama of the poker table and Rachel's anxious wait for news about a potential job offer. Ross, his masculine braggadocio always a paper-thin membrane covering a deep well of insecurity, crows that he will not be taking it easy on Rachel once the cards are dealt. When the game is interrupted by a call for Rachel, informing her that she did not get the job, Ross's desire to flirtatiously squabble instantly evaporates.

Ross ultimately folds, the camera zooming in on his face as he calmly admits defeat: "When you don't have the cards, you don't have the cards." He then directs Chandler's and Joey's attention to Rachel on the other side of the table, pointing at her and telling them, "But look how happy she is." The three guys look at each other for a long beat, then everyone dives for Ross's cards.

The first season of *Friends* encourages us to follow along behind Ross as his feelings for Rachel grow, and as his seeming incompetence at acting on those feelings also balloons. Rachel keeps taunting Ross with descriptions of her dream man. Rachel is looking for a man who could be "your best friend, but can also make your toes curl." Ross hopes to be just that, even as his sense of his own desirability has been badly wounded by Carol's leaving him for a woman.

Kauffman had entered the inaugural season working on the assumption that *Friends* would wrap up for the year with the birth of Ross and Carol's baby. It was left to Burrows to approach her and gently share the widely held opinion that no one cared about Ross's baby. The show pivoted on Ross and Rachel, and the conclusion of the season had to revolve around their relationship. The birth of Ben was bumped to the penultimate episode of the first season, "The One with the Birth," and the final episode was devoted to Ross and Rachel's fitful romance.

There was a fear among the writers that they were in danger of painting themselves into a corner, with Ross endlessly pining and Rachel forever oblivious, unless they began to advance the plot. There had been talk in the writers' room of having Ross impulsively kiss Rachel

when their car hits a bump on a road trip, and then having an extended discussion of what it meant that they had just kissed. The idea was to evoke memories of Woody Allen and Diane Keaton in *Annie Hall*, and writer Jeff Greenstein spoke up: "Guys, I don't know if I want to see that scene." Greenstein was unsure if Ross and Rachel were like Allen and Keaton, and told his colleagues he was not excited about the proposed conversation.

Crane asked Greenstein what he might prefer instead, and his thoughts turned to the work of Jane Austen. Greenstein's wife had written her senior thesis at UC Berkeley on Austen, and when they had gotten together, he had read all of Austen's novels. "You know," he told the room, "if Jane Austen were writing this story it would go like this: It would be Ross is being called away on some business thing, a paleontological dig or something, and he's gonna miss Rachel's birthday, so he leaves behind some small gift for her, something really specific and personal and beautiful that speaks to the depths of his feelings [for] her. He leaves it behind, he goes on this trip, and Rachel gets the gift, it's so beautiful that she starts to fall in love with him. By the time Ross is scheduled to get back, Rachel can't wait to see him because she finally wants to tell him how much she cares for him, and he gets off the plane with another girl." After a beat, Crane said, "Well, let's do that!" But there were still days of arguments in the writers' room over the finale, even after Greenstein's fix.

At the start of "The One Where Rachel Finds Out," Rachel is immensely touched by Ross's purchasing a beautiful brooch that she admired in a store window some months prior. Chandler unthinkingly takes the bait, offhandedly commenting that Ross has always been partial to bold romantic gestures: "Remember back in college, when he fell in love with Carol and bought her that ridiculously expensive crystal duck?" Director Kevin Bright cuts to Joey looking over at Chandler in near-panic, shifting away from him toward the edge of the couch. "What did you just say?" Rachel demands. Chandler, his chest heaving, clears his throat before responding: "Crystal duck."

The season ends with Rachel, having rushed to the airport to confront Ross, smelling the flowers she has brought for him while waiting for Ross to emerge, an expectant smile teasing across her face. Aniston is remarkable here, her emotional openness heartrending. We know already that her heart is to be broken, with Ross shown kissing an unfamiliar new woman as they both exit the plane, but she doesn't know it yet, and her optimism that love will treat her more gently this time is surprisingly moving.

The first-season cliffhanger, then, is actually less of a cliffhanger than a deliberate withholding of an emotional resolution. We know that Ross and Rachel are going to suffer from a legendarily terrible case of poor timing, and our hearts ache for Rachel, who has finally caught up to Ross just as he vanishes into another relationship.

The first season of *Friends* was that rarest of things in mid-1990s television: a fully formed story with an emotionally satisfying romantic arc and a conclusion that left viewers hungering for more. None of these had been invented by *Friends*—the 1980s drama-comedy hybrid *Moonlighting* had also artfully worked the ebbs and flows of its central relationship— but few of its comedy compatriots sought to craft a story that viewers could return to for laughs and emotional sustenance.

If you watched the first season in the light of what was to come, it was easier to notice that Rachel, who had begun as a runaway bride with only the dimmest sense of the world beyond Bloomingdale's, was enrolled in a crash course in ordinary life. She was quietly finding her own way in the world, with no husband, no boyfriend, and no heavy-handed parental involvement. *Friends* was a show about six buddies aimlessly sitting around and drinking coffee, but it was also one in which life quietly passed by between refills. Its characters, it hinted, were going to be growing up as they made us laugh.

———

Rachel and Ross were not the only romance in the show's first season. The very first thing we were shown in Chandler and Joey's apartment

was the oversize poster of Laurel and Hardy gracing the back wall. Greg Grande had discovered the poster in the Warner Bros. basement, with little sense that it would become one of the most iconic items of décor on the show. In it, Laurel and Hardy were curled up together in a too-small bed. They were each under the covers, with the diminutive Laurel, his swollen chin held in place by a white cloth that gave the appearance of rabbit ears atop his head, swiveling his eyes to take in his bedmate. The hulking Hardy was leaning on one arm, glowering at his friend with barely disguised hostility over some presumed infraction.

There was a hint of menace in this image—would Hardy really do Laurel some damage with that meaty fist posed in front of the bedcovers?—but it was drowned out by the ludicrousness of their pose. What were they doing in bed together? What had happened to the perpetually unlucky Stan? The poster was an encoded version of the relationship between Chandler and Joey, there to be unlocked by anyone familiar with *Way Out West* or *The Music Box*. Chandler and Joey are not only roommates, but in a kind of platonic gay relationship. David Crane saw Chandler and Joey's friendship as mocking some of the emotional deficiencies of heterosexual male friendship, while also smuggling in gay tropes that might otherwise have found no place in a mainstream sitcom.

Friends was quietly tipping its cap to the mismatched slacker heroes of the early sound era, another celibate same-sex couple prone to all manner of confusions, mishaps, accidents, and small-fry disasters. Chandler and Joey had their other friends, to be sure, but *Friends* was pledging itself—at least at this early stage—to the unity of their partnership. In "The One with the Dozen Lasagnas," Joey and Chandler realize they need a new dining table. Joey and Chandler are a couple in disguise here, their discussion about table shopping an only partially camouflaged conversation about the state of their relationship.

In the next scene, the two men are in a furniture store, where Joey pleads with Chandler to simply pick out a table. Joey rejects a bird pattern after mistakenly selecting a patio-furniture set, and then Chandler

turns down some ladybug-themed chairs. "Fine," Joey grouses, "you want to get the birds? Get the birds!" Chandler half turns away, leaning on a wooden chair, and responds like a wife frustrated by her husband's mulishness: "Not like that I won't."

The tenor of the conversation, and the body language, would be instantly familiar to anyone who has ever eavesdropped on a couple fighting in the bedroom section at IKEA. Cut back to their apartment, where the two men, joined by Ross and Monica, crowd around the unseen table. "So, whaddaya think?" asks Chandler. "I think it's the most beautiful table I've ever seen," says Ross as the camera cuts to a shot of their new foosball table. Monica may proceed to wipe the floor with them in their inaugural game, but the foosball table comes to serve as a symbolic stand-in for Chandler and Joey's happily slobbish domestic partnership.

The show spawned its own cult favorites, recurring performers who came in and won the hearts of a dedicated cohort of fans. They were placeholders or temporary solutions to narrative problems that wound up proving more intriguing, or long lasting, than the writers might have initially anticipated, ranging from June Gable as Joey's gravel-voiced agent, Estelle, to Giovanni Ribisi as Phoebe's knucklehead brother, to Paget Brewster as Kathy, a girlfriend of Joey's that Chandler falls for.

During the first season of the show, *Friends'* most popular supporting character was also the one who caused the most dissatisfaction behind the scenes. He was mercurial, prone to unpredictable rages, and untrustworthy as an actor. There was a movement afoot to have him fired from the show, but he was so beloved by audiences that it was hard for *Friends* to let him go. His name was Marcel, and he was a monkey.

Early on, writers Adam Chase and Ira Ungerleider suggested a story line where Ross would adopt a pet to appear more saucy and Mediterranean. Ideas for what kind of animal Ross might take in were batted around, and the writers settled on two options: a monkey and an iguana.

Jeff Strauss had been a biology major in college and had considered becoming a veterinarian. He felt strongly that Ross's getting a monkey would be a major mistake. Strauss launched into a tirade in the writers' room about a monkey making for a ludicrous pet. Monkeys were not cute little people that could be deployed at will to inject some charm into a story line. They spent most of their time masturbating and enjoyed throwing their feces in order to express their dissatisfaction, and what appeared to be a smile was actually a hostile glare.

Strauss lost the battle, and Marcel the monkey was duly introduced as Ross's companion in the tenth episode, "The One with the Monkey." While he didn't love the ways in which Marcel served as Ross's wingman and junior partner, Strauss was relieved that Ross's relationship with the monkey was mostly depicted as an expression of a wounded spirit. Strauss took his children to the zoo and was pleased to hear some of the zookeepers talking to each other about the relative accuracy of the depiction of monkey behavior on the show. It was, Strauss thought, a tiny victory for primate realism.

Almost as soon as Marcel was introduced, the writers of *Friends* were scheming to undo their triumphant mistake. Marcel was wildly popular, and they absolutely hated writing for him. By the time of "The One with Two Parts," Ross was recast as a frustrated father of a reckless son, with Marcel erasing his phone messages and peeing on his newspaper.

Rachel lost Marcel in "The One Where the Monkey Gets Away," and ironically, the monkey got away for real during the episode's preshoot, escaping his handlers and disappearing into the wilds of the stage. With a set that ran four stories high before ascending to the rafters, there was a great deal of ground to cover to coax him back, only further demonstrating the necessity of calling a halt to Marcel's run on the show. Even after he is recovered from the grip of eccentric neighbor Mr. Heckles, who has dressed him in a frilly pink tutu, Ross decides he must send his monkey away to the San Diego Zoo.

Friends rarely went for a self-referential note, but having Marcel

come back as a star in the second season's "The One After the Super-bowl," advertising Monkeyshine beer and appearing in a movie with Jean-Claude Van Damme, was a clever gesture in the direction of America's strange love affair with the monkey. *Friends* grew out of its monkey phase, to the point where Ross could offhandedly comment, some seasons later, "Remember when I had a monkey? What was I thinking?"

For "The One with the East German Laundry Detergent," from early in the first season, Phoebe and Chandler were both supposed to break up with the people they were dating. Phoebe would briskly, efficiently, and painlessly end things with her boyfriend, while Chandler, paragon of romantic disaster, would have to endure the worst breakup in human history.

Strauss began to think about what torments Chandler might have to go through and remembered an ex-girlfriend. She had rapidly sought to escalate the relationship far beyond where Strauss was ready to take it. One day, she called up Strauss and told him that she had already purchased his Christmas present. She knew that he collected Fiestaware pottery and had found the ideal piece to add to his collection. She even described to him what it looked like. That it was currently September, or that they had not been out more than two or three times, was no impediment for her. What if Chandler's girlfriend were to bring him a gift just as he was preparing to end things with her? And so Janice (Maggie Wheeler), soon to be Chandler's foil and his relationship Kryptonite, would enter bearing a pair of Bullwinkle socks for him.

Janice was loud and abrasive, her voice less like fingernails on a chalkboard than like a thousand nails scraping on a thousand different chalkboards. Best—or worst—of all was Wheeler's laugh, a braying, wheezing work of art. Janice was not merely a bad date; she was the encapsulation of every bad date anyone had ever had, amplified and exaggerated until the horror became humor. We felt for Chandler that he had been trapped with such an appalling dud, but Janice's presence also telegraphed something essential about Chandler. Chandler was romantically inept, and Janice was here as his comeuppance.

There was no way of knowing it at the time, but Wheeler was to become one of the show's most memorable recurring characters. She turned up again and again when Chandler was weak or bruised, hopeful once more that their wildly mismatched relationship was about to become a romance for the ages. And one of the most charming aspects of Janice's character, and perhaps one that salvaged her from being a stereotype, was just how highly she thought of herself. Janice did not just think she was a catch; she was downright sure of it. And Chandler, for her, was simultaneously the guy who kept breaking her heart and the man who would, one day, make all her dreams come true.

Janice kept showing up long after Chandler had settled down into marriage, there to flirt with Chandler as he attempts to deposit a sperm sample at the doctor's office or planning to buy the home next door when he and Monica move to suburbia. She was, in her own way, a reminder of all the show's many changes, a comedic aide-mémoire regarding the distance from bad romance to real love.

Where Janice was a perpetually braying foghorn, her spiritual counterpart Gunther (James Michael Tyler) was a silent, lurking presence—so much so that he did not have a single line of dialogue until his thirty-third appearance on the show. Tyler was a barista at a Los Angeles coffee shop called the Bourgeois Pig when he was asked to stand in the background and knowledgeably work the levers of the (nonfunctioning) espresso machine at Central Perk. It took two seasons for Tyler to get his first speaking lines, or even a name for his character.

Gunther served as an ongoing running joke for the show, the outsider whose perpetually foiled attempts at penetrating the inner circle emphasized the charmed status of the sextet. Gunther was background color for *Friends,* present at the characters' parties and gatherings, lurking over their shoulders as they sipped coffee at Central Perk. He was there to be ignored and overlooked, forgotten and taken for granted. Gunther was carrying a torch for Rachel while she was only dimly aware of his existence. (At one point, she tells him that one day, he'll make some man very happy.) He was in a perpetual froth of unrequited love

and hurt feelings. Gunther was like an upside-down Ross, stymied by his love for a woman, and as a comic doppelgänger, he was obscurely threatened by Ross's very existence. ("What does Rachel see in this guy?" he wonders in voice-over as he serves Ross his coffee.)

Kauffman and Crane had rejected the network's suggestion of a "Pat the Cop," who would dispense mature wisdom to the show's characters, but Gunther was their deliberately askew version of the idea. Gunther offered no insight and no comfort, but he served as a helpful reminder for audiences that, unlike him, we were always welcome to hang out.

CHAPTER 6

THE BIGGEST NEW SHOW ON TV

Creating a Sensation in Season 1

David Crane was out to dinner with his parents and his partner, Jeffrey Klarik, over Thanksgiving weekend in 1994 when Klarik suddenly shushed the conversation. "Listen," he told Crane, directing his attention to a nearby table.

"Did you see the one in the Laundromat?" asked one patron.

"And Ross and Rachel?" responded another.

Klarik told Crane, "Remember this moment. Because the rest will be a blur. But people over there are talking about the show." *Friends* was a show whose fans' enthusiasm could be eavesdropped on.

For many of the people involved with the show, there were discrete moments when their work's impact could be experienced in encounters with strangers. These would be cherished, wrapped in paper to be carried back to the Warner Bros. lot, their good feeling the energy that would drive the grueling work to be done.

Marta Kauffman was out shopping with her child on Larchmont Boulevard, near her home in Hancock Park. A fan spotted her *Friends* hat and approached, asking Kauffman if she might tell her what would

happen with Ross and Rachel. She promised she wouldn't tell anyone. On another occasion, Matt LeBlanc was out to lunch with David Schwimmer when a woman spotted Schwimmer. She ran up to their table, practically tossed her baby into Schwimmer's lap, and began frantically digging into her purse in search of a camera so she could take a photograph with him.

Writer and notorious jester Jeff Astrof had a particular coffee shop that he liked getting his coffee from, in no small part because of a pretty waitress named Elizabeth who worked there. Seeking a competitive advantage, Astrof took to chewing meditatively on his pen, staring at his blank notebook page, and musing aloud, "I wonder what Chandler would do?" Elizabeth took the bait and asked Astrof if he was truly a writer for *Friends*. He shyly confirmed that he was, and at the end of a flirtatious conversation, Astrof told her, "I think Chandler will date a girl named Elizabeth."

Astrof brought the story back to the room, as much to share a funny story as to brag, and Crane topped the joke with an acidulous put-down, delivered with as much stern force as he could muster: "Chandler would never date *anyone* named Elizabeth." (Of course, years later, *Ross* would date someone named Elizabeth, but by then Astrof and his waitress crush were long gone.)

In March, near the end of the first season, the cast of *Friends* was summoned for the closest thing to an American version of a royal audience. The six actors were to appear on *The Oprah Winfrey Show* and bathe in the glow of Oprah's love. The appearance would require them to fly to Chicago, and Courteney Cox initially balked, suggesting she would appear via satellite. David Schwimmer, the defender of cast unity above all, insisted that they all appear in person, and Cox agreed to come.

Before the shoot, some of the actors quickly huddled together to discuss how they might respond to the concerns about *Friends*' overwhelming whiteness, which had been a regular subject of media coverage. What would they tell Oprah about why there were no black friends, and moreover, about the lack of diversity on the show in general?

As it turned out, Oprah referenced the racial concerns with delicacy, transforming it into a joke. "I'd like y'all to get a black friend," Winfrey told them. "Maybe I could stop by. In fact, I'm thinking about buying that apartment building next door." Winfrey told the cast that fans were gathering together in groups to watch the show, and Kudrow, for one, was flabbergasted. Apparently the show was a hit. She knew the ratings were good, but ensconced in their bubble on the Warner Bros. lot, she did not realize how passionately Americans were responding to *Friends*.

Crane was taken aback to spot the cast of the show on the cover of *Rolling Stone* in May 1995. He began calculating how much time had passed between shooting the show's pilot and his cast's appearance on the cover of one of the most prominent magazines in the United States. How long ago had it been that Crane had been kept up nights over his worries regarding whether the show would be canceled or not picked up, or whether he would be fired?

It had felt downright greedy to hope for a second season of the show, and now here they were, in the white-hot center of American popular culture, riding in a vintage automobile while kitted out in 1940s retro chic—Schwimmer in a sailor's uniform, Cox in a plunging strapless floral-print, and Perry, eyes bulging, casting an alarmed glance at her while wearing a jaunty straw hat.

Ratings had steadily crept up over the course of the season, from a low 20s share (the percentage of viewers watching television at that hour who were watching *Friends*) for the first handful of episodes to a share consistently at or above 30 for the final third of the season, which ranked it among the most successful series on TV. And summer, when NBC broadcast reruns of the show, allowed fans who had missed out on the beginning of *Friends* to catch up, with ratings ascending even higher.

Adam Chase went home to New Jersey to visit his parents in the interval between seasons, and on his return to Los Angeles, he passed by an airport newsstand filled with *Friends*-themed covers. His first thought was that editors at these magazines were likely going to be in

trouble for running such similar covers simultaneously. His second thought was that his show must suddenly have become a huge hit.

The media's enthusiasm was indicative of a shift in cultural attitudes toward television stars. Prior to *Friends*, there had been a certain ingrained belief in the second-tier status of television stardom. The gathering frenzy around the six stars of *Friends* began the process of resetting what TV stardom might look like. Schwimmer, Aniston, Cox, Perry, LeBlanc, and Kudrow might only have been television stars, but the depth and passion of fans' interest in their new favorites exceeded that directed at any other stars of the mid-1990s.

Old habits were hard to kill off, and an inordinate amount of the media's coverage of *Friends* revolved around a single question: Which of the show's stars were likely to become movie stars? The actors were treated like minor-league baseball phenoms who had won themselves an invitation to the Big Show. The coverage inevitably diminished the scope of *Friends*' accomplishment, treating it like an interim success whose significance would be wiped out if none of its stars could make the leap to movie acting. But all six actors were indeed intent on using *Friends* as a springboard to movie stardom. The summer of 1995, when the show was on hiatus, rapidly filled up with scheduled movie shoots intended to launch the show's performers into the stratosphere.

Schwimmer starred in the *Graduate*-esque romantic comedy *The Pallbearer*, LeBlanc appeared opposite a chimpanzee in the baseball film *Ed*, and Aniston won a plum role in *She's the One*, director Edward Burns's follow-up to the acclaimed *The Brothers McMullen*. None were hits, nor was Matthew Perry's attempt to vault to leading-man status with the romantic comedy *Fools Rush In*, opposite Salma Hayek, one year later.

The only *Friends* star to meet with immediate cinematic success was the one who had already experienced it. Courteney Cox turned in a solid performance as a reporter in Wes Craven's self-referential horror film *Scream*, which wound up grossing over $100 million at the domestic box office in 1996. Journalists pored over the results with the nuance of

elderly Talmudists, intent on parsing the meaning of the message being sent by the American moviegoing populace. Did fans not want to pay to see the *Friends* stars play roles too similar to the ones available for free on network television? Did they not want to see them at all after twenty-four episodes?

The obsessive coverage of the movie transition mostly overlooked two primary facts. First, the *Friends* stars' movies had mostly flopped because they had been inept. They had not been sunk by the lesser wattage of a television actor's stardom. The one that had succeeded, *Scream*, had featured a clever concept, an appealing cast, and a talented director, and had not been sold as "*Friends*, but at the multiplex." And Cox had been a supporting performer, not a stand-alone star. Second, the stars of *Friends*, even after their movie careers' collective failures to launch, were still enormous stars. It was only the stubborn insistence that movie stardom was genuine currency and television stardom counterfeit that made this a subject for consideration.

Warner Bros. and NBC scheduled an avalanche of tie-ins and promotions to cash in on the *Friends* frenzy. There were plans for everything from *Friends*-themed calendars to a *Friends* coffee line. Turn on the TV, and there they were—in character—hawking Diet Coke. Turn on the radio, and that familiar theme song was now omnipresent, dominating the charts.

Coca-Cola approached the showrunners with an amount of money that was hard to turn away from. Crane and Kauffman put the writers to work for an entire week drafting ideas for the Diet Coke commercials, in which the six friends would tout the wonders of the low-calorie soda. The showrunners were still in the first blush of success and inclined to snatch at every business opportunity that came their way, but as Crane and Kauffman both later acknowledged, the commercials were a notable misstep. Kevin Bright, too, believed that the unneeded complexity of the commercials—why did the performers have to appear as their *Friends* characters, rather than as themselves?—fed into the burgeoning *Friends* backlash.

In one commercial, the six friends appeared in a police lineup, swearing their innocence regarding the theft of a missing Diet Coke. In another thirty-second spot, each was interrogated, with Phoebe suggesting candles to lighten the hard-boiled atmosphere and Monica ranting about how she had no alibi because she did not have a boyfriend.

The commercials were perfectly adequate, in and of themselves, but their crass hucksterism felt at odds with *Friends*' warmth. Crane later argued that not only had he put the show at risk by taking the Diet Coke commercials, he had put the actors in a difficult spot by encouraging them to take the gig. Of all the choices he had made over the course of a decade running *Friends,* it was the one he wanted back most.

Kevin Bright had become impressed with the work of the Hasidic Jewish sect Chabad and offered to freshen up their annual telethon to raise money for their drug-and-alcohol-rehabilitation centers, which usually leaned to guest appearances by the likes of Shelley Berman, by cajoling the cast to appear. (The video is worth tracking down, if only to listen to Matt LeBlanc attempt to pronounce *Chabad*.) Matthew Perry and Jennifer Aniston shot a commercial for Windows 95, in which a prototypical tech geek told them "communicating online is the hot thing right now." And Kudrow, Cox, and Aniston filmed a promotional video for the NBA from Monica and Rachel's living room, in which they betrayed a vaguely erotic enthusiasm for old-school NBA short-shorts and swooned over—of all unlikely people—Utah Jazz point guard John Stockton. *Friends*' sudden ubiquity meant that its characters were inescapable, which was not necessarily desirable for a hit show intent on staying popular for years to come.

———

Oprah Winfrey may have delicately tiptoed around it, but the question of *Friends*' lack of diversity remained a recurrent critique of the show. How could a show set in Manhattan be so lily-white? A drumbeat of articles in the mainstream media after the show's first season castigated *Friends* not only for featuring six white protagonists, but for depicting "a

fictional Manhattan where black people are strangely absent from restaurants, museums, health clubs and the streets."

While network dramas like *ER* and *Homicide: Life on the Street* included integrated casts and racially incisive plotlines, comedies like *Friends* rarely featured nonwhite characters, even in supporting or one-off roles. Jonathan Storm of *The Philadelphia Inquirer* totted up the numbers in a 1996 article, determining that of the sixty-four comedies that had appeared on any of the six networks during that season, only twelve had featured racially mixed casts, with forty all-white and twelve all-black shows comprising the remainder.

Friends, third in the Nielsen ratings, ranked ninety-ninth in African-American households. It was telling that *Friends* was programmed in the same time slot as *Living Single*, the Fox sitcom about single African-American women frequently mentioned as a precursor to *Friends*. The *Inquirer* spoke to Brown University professor Sasha Torres, who described *Friends* and its network counterparts as "figuratively and narratively trying to make urban spaces safe for white people." This phenomenon was not exclusive to *Friends* but was predicated on the domestic intimacy of comedy.

"The comedies for some reason just have not been courageous," *ER* executive producer John Wells told the *Los Angeles Times*. "I certainly was determined to do our show with a multiracial and multicultural focus. It's irresponsible not to. It does not mirror the society we live in."

Friends would later address its racial deficiencies by casting Gabrielle Union in a one-off role as a woman Ross and Joey simultaneously date in the seventh season, and Aisha Tyler as a paleontologist attracted to Joey in the ninth and tenth seasons. (There had also been the Asian-American Lauren Tom as Ross's love interest Julie in the second season.) Much of the media's attention, when it came to matters of diversity in the 1990s and early 2000s, was concentrated on the proportion of African-American actors cast in key roles, and the criticism of *Friends* often took the shape of wondering when the show would feature an African-American performer in a major role. The effort was notable,

if demonstrably tardy, but USC professor Todd Boyd described it in a 2003 *Boston Globe* article as "a slap in the face. . . . They're saying, 'We'll do this when we know we're going off the air. We've addressed the critics, now leave us alone.'" *Friends* never really had much of an answer for its whiteness, and its reflexive defensiveness when the subject was broached only increased the sense of discomfort. The show had countless opportunities to improve its track record on diverse casting and mostly failed to respond to the very legitimate critique being proffered.

Friends could not be solely blamed for what had been a preexisting condition on television. But *Friends'* enormous success prompted a rash of imitators intent on similar all-white ensembles, according to Mike Duffy of the *Chicago Tribune*: "The trend has become only more pronounced this season, with the 'Friends' phenomenon sparking a whitebread wave of sitcom clones about young Caucasian chuckleheads."

NBC offered two more urban-living comedies, *Caroline in the City* and *The Single Guy*, in 1995, and ABC and Fox had their own attempts at replicating Central Perk. *The Washington Post's* Tom Shales saw *Friends* as the harbinger of a newly crude era on television and was disturbed by its replicating itself across the network lineup. Shales was resigned to endless *Friends* imitators, but no one was going to get him to chuckle over it: "This year's new hit is certain to inspire the networks to send in the clones. It's the eternal cycle of TV Land—or rather the eternal recycle."

Perhaps the most powerful indicator of *Friends'* remarkable success was what it inspired Charlie Quinn to do. Quinn, the program director at a Nashville radio station, pulled the forty-five-second version of the *Friends* theme song off the telecast and looped it until he had a threeminute song he could play on the air. "I'll Be There for You" rapidly became a runaway hit, and the impromptu song spread from Tennessee around the country.

Friends had made the Rembrandts suddenly famous, but at first, the duo was uninterested in recording a full-length version of the theme song. The money in music was in songwriting, and the band did not

want to record someone else's work. The band's record label, East West Records, insisted, threatening that without "I'll Be There for You," they wouldn't release the band's new album. A compromise was ultimately worked out, and the Rembrandts—Danny Wilde and Phil Solem—were cut in as cowriters of the fuller song, which added new lyrics to the original version, along with Kauffman, Crane, Skloff, and veteran songwriter Allee Willis.

The full-length version of "I'll Be There for You" became a breakout hit in 1995, cracking the top twenty on the *Billboard* charts. The song became the centerpiece of the Rembrandts' album *L.P.,* as well as a *Friends* tie-in soundtrack album, which spliced juicy bits of the show's dialogue with songs by Hootie & the Blowfish, R.E.M., and Paul Westerberg.

———

David Crane had felt little additional pressure heading into the second season. There was a show to be written, and no one's opinion mattered to him other than those of the people in the room and the people on the set. Whether *Friends* was an enormous hit or an underachiever, the problems remained the same: What was our story? How would we get the audience to care? *Friends* might have been one of the top-rated shows on television, it might have occupied far more than its fair share of space on newsstands across America, but work was work, and there would be little to no discussion of *Friends* the phenomenon on the set or in the writers' room. Others noticed changes, though. The stars now had security guards. There were luxury cars in the employee parking lot and discussions of the new homes the cast and crew were buying.

For Crane, *Friends* was merely a television program that employed a group of serious, efficient, and talented people, one of whose many responsibilities was to entirely tune out any and all discussion of the show that took place outside of work. It was remarkable to Crane simply that the show continued to air and that NBC was placing its confidence in their work.

Crane and Kauffman may have been of one mind in their insistence on keeping success at bay, but the executives charged with fostering the show's development did not always heed their message. After the second-season premiere, in which Ross introduced his new girlfriend Julie (Lauren Tom) to the group, Les Moonves, then president of Warner Bros. Television (and soon to become head of a rival network, CBS), came to the *Friends* soundstage and read the show's Nielsen ratings to the cast and crew. Moonves was celebrating *Friends'* remarkable numbers, the strongest indication yet that NBC had another huge hit on its hands. Adam Chase turned to a colleague and said, "I don't know what those numbers mean, but I've never seen this guy before. I think this is a big deal."

Everyone wanted to benefit from the extraordinary popularity of the show, not least among them James Burrows. Burrows had directed the pilot, his imprimatur an enormous help in convincing others to take its chances more seriously. He had found his way to the emotional and comedic heart of the show, and had swiftly and wisely directed it toward the Ross-and-Rachel plot arc that would serve the show for a decade to come. Burrows was already a sitcom veteran where most everyone else associated with the show was a relative newcomer, and when *Friends* became an enormous hit, he expected to be cut in for his fair share of the show's profits.

There were two complaints about Burrows, one large and one relatively small, that prevented this from happening and resulted in his mostly ceasing to direct new episodes of *Friends* after the first season. The small complaint was significant enough. It came courtesy of Kevin Bright and others on the *Friends* team who felt that while Burrows was undeniably a sitcom wizard and had a remarkable gift for understanding comedy, he was always in a hurry. The first take was always perfect in his eyes, and the entire episode, complete with pauses for the writers to adjust lines, would be wrapped by ten P.M. each week—still late by sitcom standards, but downright early in comparison to what would come on *Friends*. Burrows enjoyed maintaining a limber, quick-paced set

where the show's creators would often have preferred to slow down and take notice of how best to improve the final product, even if it took substantially longer.

The proof was in the pudding, and the final results were undeniably good, but Burrows seemed to be in a hurry to get to his vacation home in Mexico each Tuesday night, and this caused resentment among some of the people putting in punishing hours to make *Friends*. It was not that the show suffered under Burrows's watch; it palpably did not. But there was a growing sense that there were opportunities Burrows was leaving behind in his haste to finish each week.

Kevin Bright was the one in the editing bay putting each episode together, and he saw where directors could improve the final product by shooting more or by using different camera setups. Burrows was a superlative director, everyone agreed. But Bright was not only a director; he was also a producer, an editor, and a showrunner, and he wanted to take greater ownership over the shoot itself. It was telling that Bright himself directed the first-season finale, "The One Where Rachel Finds Out." Bright would direct many more episodes in the future.

The larger concern was, as large concerns often are, about money. There was only so much money to go around, and for Burrows to get a big enough piece of the *Friends* pie, Crane, Kauffman, and Bright would have to give up some of what they were to earn. They all liked James Burrows and were appreciative of all he had done to make *Friends* a success. They also agreed that this was their baby and Burrows, while extremely helpful, had played only a small part in its creation. As long as Burrows was around, *Friends* ran the risk of being treated as another show in the distinguished lineage of Jimmy Burrows smash hits. Kevin Bright in particular felt confident that the show would thrive in Burrows's absence just as it had in his presence and was anxious for them to stake a claim for *Friends* as theirs.

Nobody wanted Burrows to leave *Friends* permanently, including Burrows himself, and so room was made for him to come back occasionally after the first season. He would direct the classic "The One with the

Prom Video" in the second season, and three more episodes in the years that followed. When Burrows returned, he would insist on bringing back the wooden post and beam that had served as a separation pillar between the kitchen and living room in Monica and Rachel's apartment, which had been subtly jettisoned after the first season. Burrows preferred having it as visual decoration for his shots, and so the crew would have to lug it out from whatever forgotten storage closet it had been abandoned in since the last time Burrows had been on set.

NBC was insistent on featuring its hottest series in its most important showcase: the slot immediately following the Super Bowl. NBC was going to be broadcasting the game in 1996 and wanted to display its most impressive wares for the captive audience already tuning in to the game. Crane and Kauffman received a call from NBC informing them that they were to receive the plum post–Super Bowl slot. Crane and Kauffman thought it over and determined that given both the length and the time slot, it would not be enough to simply broadcast a traditional episode of the show. They would have to deliver something bigger.

The show recruited a host of famous guest stars, including Brooke Shields, Jean-Claude Van Damme, Chris Isaak, and Julia Roberts, to appear on the hour-long "The One After the Superbowl." Shields would be a delusional stalker who believes that Joey really is his *Days of Our Lives* character, Dr. Drake Ramoray. Van Damme would play himself, with Rachel and Monica squabbling over him after they encounter him on a movie set. Isaak would be a librarian love interest for Phoebe. And Roberts would play an old friend of Chandler's who gets payback for a childhood prank.

Producer Todd Stevens had managed to assemble a mock action-film set on the outdoor back lot, complete with burning cars and vehicles flipped on their sides. The whole effort felt very much like a Van Damme production—unusual for a show generally not particularly committed to veracity or realism.

Director Michael Lembeck was taken aback to spot Brooke Shields's then-boyfriend Andre Agassi arriving on the set with a hulking body-

guard. Agassi and his bodyguard were sitting disconcertingly close to the set as Shields ran through the scene in which she licked Matt Le-Blanc's hand. As soon as Lembeck called cut, Agassi rushed the set and tore into Shields, humiliating her and reducing her to tears before storming out. It was left to Lembeck, along with the cast, to lift Shields's spirits and encourage her to carry on.

Even Julia Roberts—at that point close to the biggest star in the world—lost some of her self-confidence when it came time to face the audience on the Friday evening they were to shoot the episode. Roberts had not been in front of a live audience since she was a teenager, and she was now squeezing Lembeck's hand fiercely. While the director could feel his bones being crushed, he understood his responsibility in the moment was to guide her through it as best he could.

She went out for her first scene with Perry, and while Lembeck massaged his gangrenous hand, he watched her perform. Lembeck felt that if a word bubble could have been appended to her first take, it would have read, "Wait a minute, I can do this!" The second take was superb, but it required her getting through that first take and regaining the confidence needed to face an audience. Stealing Chandler's clothes and then taunting him in a restaurant bathroom, Roberts contributed some of the funniest moments of a deeply uneven episode.

Van Damme showed up for the shoot twelve hours late. What had been scheduled to be a morning shoot with Van Damme on the mock film set was now taking place in the evening, with a very un-*Friends*-like nighttime look to accommodate the new circumstances. Lembeck had his hands full simply coaching Van Damme through his few lines of dialogue and keeping him from disturbing his female costars.

"The One After the Superbowl" wound up as the most-watched episode in the show's history, with 52.9 million viewers, but was hardly the ideal introduction to the show. It was a reminder that the second season of *Friends* was not the first, and could never be. The first season had been an unexpected triumph; the second time around, critics were gunning for the show, and *Friends* was opening the door to criticism

with lesser efforts like "Superbowl." With bloated enterprises like this episode, *Friends* was playing into the hands of critics carping about the show's lowest-common-denominator impulses. Some of this was the blowback that any popular TV show would engender, but some was also prompted by *Friends'* desire to please everyone all the time.

In retrospect, Crane thought the Super Bowl episode was a tremendous opportunity, but one whose final shape did not entirely resemble the show. *Friends* occupied its own rarefied space in American popular culture, one that not only did not need any infusions of star power but could be hindered by stars not up to the caliber, or popularity, of its own performers.

Part of *Friends'* lesser critical status stemmed from its reputation as a photocopy of *Seinfeld*, a pale WASP knockoff. While *Friends* was less groundbreaking a comedy than *Seinfeld*, the particulars of its reputation were misguided. *Seinfeld* was known as an echt-Jewish show, with its fixation on babkas and Upper West Side schlemiels, but the series masked its obviously Jewish characters as other ethnic types. (George is Italian? Costanza, please.)

Friends, by contrast, was more forthright about the ethnic backgrounds of its characters, with Rachel, Ross, and Monica all pegged as Jews of varying types. (Ross and Monica were supposed to be half-Jewish.) Their Jewishness came out most strongly in the flashback episodes, with Ross in his Jewfro and Rachel with her pre-rhinoplasty nose; to be Jewish was, in *Friends'* eyes, to be geeky and unpolished.

The show was required to regularly contort itself in response to the question of what it could and could not say on network television. One of David Crane's most important weekly tasks was his conversation with NBC's standards division. He customarily took the calls in the writers' room, happy to let his staff hear just some of what was required to get their vision to air.

Crane would negotiate over whether he was allotted one *breast* or two in a given episode's dialogue. *Asshole* was verboten, but *ass* was allowed. For a time, NBC banned *Friends* from using the word *penis*, before changing their minds and allowing it again. At other times, the concern was about tonnage. Two mentions of *penis* would be OK, but three was unacceptable. Kauffman and Crane had gotten their television education with HBO, and this sudden outburst of middle-school morality was frustrating.

Could Monica and Rachel be shown squabbling over the last condom in the bathroom drawer? Could a condom wrapper be shown on a bedside table? Kauffman and Crane were perpetually frustrated with the degree of pushback *Friends* received from NBC, especially when compared with *Seinfeld*, which could devote an entire episode to a masturbation contest. Initially, Kauffman and Crane were told that the distinction between the two shows stemmed from when they aired. *Friends*, airing before nine o'clock, attracted a younger audience that NBC had to be mindful of.

Even when *Friends* shifted to nine thirty late in the first season, NBC's attitude hardly budged. When Crane pushed back, NBC executives told him that, having attracted a younger audience, the network was fearful of alienating youthful *Friends* fans by having its characters say and do things that would provoke discomfort.

In response, *Friends* perfected a side glance at raunchy material, avoiding the kind of explicit dialogue that might run into difficulties with Standards and Practices. *Friends* managed the feat of making sex feel wholesome and all-American, a necessary stage in the evolution of the American adult. Sex was the ocean in which *Friends*' characters swam, with actual depictions of sex eschewed in favor of torrents of sexual talk. Conversation was the thing *Friends* enjoyed most, and what could be better to talk about than sex?

Intriguingly, sex talk was never treated as exclusively the province of the men on the show. *Friends*' female characters were allowed to be

casually sexual. Don Ohlmeyer had worried that audiences would judge Monica for her perceived sluttishness, but he had read the crowd wrong. *Friends'* fans were comfortable with equal-opportunity sexual banter.

In a memorable sequence in "The One with Phoebe's Uterus," Monica walks the clueless Chandler through women's seven erogenous zones, laying out one potential sequence by chanting numbers with increasing fervor. "Seven! Seven! Seven!" she shouts before lying back, spent by the encounter with her imagination. After Monica accidentally knocks her nephew Ben's head against a post and encourages Rachel to similarly clobber her head in an effort to soothe him, Rachel coyly notes, "If it's not a headboard, it's just not worth it."

As with Chandler and Joey, much of the sexual banter was actually character banter in disguise, merely another facet of their intimate (at times almost intrusive) knowledge of each other's preferences, peccadilloes, and pet peeves. There would later be easy jokes to be mined about naked prostitutes at Chandler's bachelor party, but there was also a character joke about Joey's presuming that the horror of spending day after day with the same woman would soon have him longing for "the sweet release of death." And it would be sexual banter transformed into character study that would grant *Friends* one of its most enduring episodes, and a notable moment in the depiction of sexuality on American television.

In the fall of 1995, Candace Gingrich was traveling the country as part of the Coming Out Project, which educated young people about gay rights, reminded them of the progress yet to be made, and offered those still in the closet a safe space in which to acknowledge their sexuality.

She was just back from one Coming Out Project trip when a colleague came up to her with a message: "You got a phone call from *Friends*. They want you to be on the show." "Shut the fuck up," Gingrich replied. "That's not funny. Don't mess with me like that." Once Gingrich

was finally convinced *Friends* had actually called, she got in touch with a producer on the show, who explained that they were shooting a lesbian wedding and wanted to cast Gingrich as the officiant. Could she fly out to Los Angeles tomorrow?

Friends was returning to Ross's ex-wife Carol and her partner Susan (Jessica Hecht) with a charming episode devoted to their wedding. For those aware of who she was, the presence of Candace Gingrich on *Friends* was a reminder that there were people in the real world who were only too happy to paint this loving union between two women as the source of all societal dysfunction. Candace was Speaker of the House Newt Gingrich's half sister and had been taken aback, but not surprised, by some comments her brother had recently made about homosexuality, in which he had argued that "it is madness to pretend that families are anything other than heterosexual couples."

David Crane was pleased to have someone known in her own right for her advocacy on behalf of gay rights but also enjoyed the gentle political commentary of employing the sister of the homophobic Speaker of the House to officiate at the most famous (imaginary) lesbian wedding in the history of the United States. Only the preceding month, *Roseanne* had featured a wedding between two of its gay characters, giving the two shows an opportunity to introduce American television to a kind of love that had never before graced prime time. It was telling that in both instances, the gay characters would be in supporting roles; it would not be until 1997 that Ellen DeGeneres would come out on *Ellen*.

There would be no full week of rehearsal for Gingrich, as many of the professional performers asked to appear on the show had gotten. She showed up on the day of the shoot and almost immediately filmed her scenes. During the filming of the reception sequence, Gingrich was standing near Matt LeBlanc, who leaned over and thanked her for appearing and for speaking out about gay and lesbian issues. He had been raised by a single mother, he told her, who had instilled in him a belief in respecting differences.

"The One with the Lesbian Wedding" devotes the bulk of its running time to other plotlines, but the segment devoted to the nuptials is bittersweet and delicate. Carol suffers from a last-minute case of cold feet and thinks of calling off the wedding. It is left to Ross to talk her out of it: "This is your wedding. Do it." The implication, an especially generous one coming from her ex-husband, is that this wedding will be hers in a way that their wedding could never have been. Ross winds up walking Carol down the aisle, in one of the most emotionally nourishing beats of the Ross-Carol plotline. Before *Ellen*'s coming-out episode, before *Will & Grace*, during the first term of a president soon to sign the punitive Defense of Marriage Act, *Friends* was staking its claim to the telling of emotionally complex queer stories.

Friends is not above jokes about the idea of a lesbian wedding, but these are grounded in parodying heterosexual self-absorption. Joey takes in the scene at the wedding and despairs: "It just seems so futile. All these women and—nothing. I feel like Superman without my powers." Chandler responds with one of the best lines of the series, and a perfect summation of his mind-set: "The world is my lesbian wedding." The episode even finds room for a sweet moment between David Schwimmer and Jessica Hecht, with Susan approaching Ross to offer a rare bit of praise: "You did a good thing today. You wanna dance?" Susan offers to let him lead, and they take to the floor to the strains of "Strangers in the Night." Hecht, who sometimes struggled to understand *Friends*' sense of humor regarding her character, loved the scene, finding it a charming respite from the perpetual air of hostility between Susan and Ross.

In retrospect, Crane wished that he had dared to tell "The One with the Lesbian Wedding" from the perspective of the women getting married and not from that of the possessive, jealous ex-husband. A more contemporary sensibility would have demanded it, but the resulting episode was tender and genuine nonetheless.

And *Friends* would later sneakily pay homage to same-sex love, with a single throwaway moment from the end of the third season's "The One

Without the Ski Trip" speaking to *Friends'* quiet frankness. Ross knocked on his ex Carol's door late at night, and Carol answered, flustered and in the midst of cinching her robe shut. She was not sleeping, she tells Ross, and as she does so, her tongue flicks past her teeth, and she reaches up to remove a pubic hair from her mouth. The gesture was unscripted and served as a reminder of Carol and Susan as sexual beings in their own right.

NBC prepared for a deluge of viewer complaints about "Lesbian Wedding" that never arrived. The network hired 104 operators to field calls, and wound up receiving a grand total of 2 complaints that evening. A month later, Reverend Donald Wildmon's acolytes sent in letters of complaint, but the letters made it clear they had not watched the episode in question. NBC affiliates in Ohio and Texas, among others, chose not to air the episode out of fear of the tender sensibilities of their viewers, but those who did watch "The One with the Lesbian Wedding" seemed mostly unfazed by the experience.

It was not until after the episode was aired, and Jane Sibbett was appearing with the likes of Geraldo Rivera to discuss it, that she realized how significant it might be for lesbians who had never seen themselves represented on television before. How much more would it have done for them, Sibbett wondered, if Carol and Susan had also been able to kiss like any other newlyweds?

Sibbett had been raised in a religious home and attended a Presbyterian church in Hollywood at the time she won the role of Carol. Her father had grown more conservative as he aged, and he began hosting a weekly Bible-study class in his home on Thursday nights to ensure that none of his friends would see his daughter playing a lesbian on TV. After "The One with the Lesbian Wedding" aired, she began hearing from many fellow congregants from her childhood, who were writing to tell her she was going to hell. Sibbett was confounded by the response and sad for the childhood friends who had worked themselves up into such a frenzy over the idea of others' happiness.

Some time later, Sibbett would be called, along with Hecht, to accept

an award on behalf of *Friends* from an organization that supported gay families. The group's president rose to speak and observed that if he had been able to see characters like Carol and Susan on television when he had been a child, he might not have attempted suicide on multiple occasions. "The One with the Lesbian Wedding" was imperfect, but its imperfections were embraced by countless people hungering for something that reminded them of themselves on American television.

Friends was more than another television show now. In its embrace of the aggressively normal in its storytelling, it was able to expand the spectrum of normalcy until it could also include a lesbian wedding. Television had the power to change minds.

CHAPTER 7

LOBSTERS

The Ballad of Ross and Rachel, Part 1

The ebbs and flows of Ross and Rachel's relationship would become numerous, and famous, enough to form their own shorthand language: The kiss in the rain. "We were on a break." The eighteen-page letter. "I, Ross, take thee, Rachel." The Las Vegas wedding and the delayed divorce.

There would be ten seasons of diversions, interludes, setbacks, and warfare in total, interspersed with occasional outbursts of romance, before the inevitable, but much-needed, satisfying conclusion. *Cheers'* Sam and Diane, sparring and smooching for five seasons, had set the previous record for maximal sitcom delayed gratification, but Ross and Rachel's delayed happy ending set what is likely an unbreakable record for holding off on the inevitable.

And so *Friends* became something it never expected to be: a master class in postponement. At every turn, when it seemed like each possible impediment to Ross and Rachel's reunion had been removed, another roadblock magically appeared. *Friends* was intended to offer viewers an uncomplicated pleasure. And yet, so much of that pleasure was about

withholding the very thing fans wanted most. The ballad of Ross and Rachel was rarely sad, although there were moments where, like some of the show's characters, we were expected to weep over their missed opportunities. But their romance was intended to serve as the tart, occasionally bitter counterpoint to the show's sweet comedy.

The conclusion of *Friends*' first season had moved Rachel and Ross closer than they had ever been to love, and also further away. Just as Rachel learned of Ross's feelings for her, Ross was off in China, meeting and falling for his colleague Julie. In an abrupt switch, *Friends* inverted its central romantic partnership, with Rachel silently pining and Ross obliviously swanning.

Only Ross would think it was a good idea to go on to his ex-crush, in the second-season opener, "The One with Ross's New Girlfriend," about how she was so "funny and sweet and amazing and adorable." Rachel is now the neurotic and antic one, grabbing the phone out of Ross's hands as he babbles sweet nothings to Julie and abruptly hanging it up, or attempting to convince him that the sexiest thing he could do would be to delay having sex with his girlfriend.

Rachel's jealousy is an unexpected new aspect of her personality and allows the seemingly endless pas de deux of buried emotions to reach a graceful conclusion early in the second season, in "The One Where Ross Finds Out." Rachel goes out on a date and drunkenly borrows another diner's cell phone to call Ross. She leaves a sloppy, strangely triumphant message for him: "Obviously I am over you. I am over you, and that, my friend, is what they call 'closure.'" Spent and sated, she proceeds to toss the cell phone into a nearby ice bucket.

The next morning, a hungover Rachel is hazy on the details of the previous evening, but when Ross begins listening to his voice mail, she belatedly realizes the enormity of her drunken gaffe and leaps onto Ross's back in the hope of wrestling the phone away from his ear. She succeeds in knocking the phone out of his grasp, but it is too late: "You're over me? You're over me? When—when were you . . . under me?"

Aniston has a lovely moment here, moaning and covering her face while summoning the courage to acknowledge her emotional turmoil. She looks down and fusses with a couch pillow while haltingly telling Ross, "Lately, I've, uh, I've sort of had feelings for you." Rachel is breathing hard, nervously blowing her hair out of her face. When Ross asks her, "Now you're over me?" she responds with a soft, breathy question of her own: "Are you over me?" The moment is interrupted by Julie, who is ringing the buzzer and waiting with a taxi down below.

Ross bursts into Central Perk after hours in the next scene, over-wrought from the emotional turmoil, and blames Rachel for revealing her feelings just as he was settling in with Julie. "This ship has sailed," he tells Rachel, and runs off, leaving Rachel crying on the couch.

Aniston is the most appealingly vulnerable of the *Friends* performers, and we feel her hurt in this scene, rejected and trampled and embarrassed all at once. Her sobbing catches Ross's eye as well, as he looks in from outside Central Perk's window. The two stare at each other for a long moment, and Rachel tentatively approaches the door. She briefly battles with a tempestuous lock before swinging both doors wide open. Ross and Rachel kiss in the misty Manhattan rain, Rachel's hands tenderly caressing his face.

Friends always had an innate sense of its audience's desires and a compulsion to fulfill its unspoken promises. The audience had been promised a resolution, and "The One Where Ross Finds Out" delivers. But the show was torn between what its audience wanted and what it was best at, and nowhere was this disjunction clearer than in its handling of Ross and Rachel's romance. The audience, presumably, would have been more than satisfied for the couple to live happily ever after, but almost as soon as *Friends* provided a successful conclusion, it began to walk it back.

Ross, still intellectually torn between Rachel and Julie, begins crafting a pros-and-cons list, observing that Rachel is ditzy, obsessed with her looks, and just a waitress. He is inevitably caught by Rachel, who is

appalled at seeing her deficiencies spelled out so openly: "Imagine the worst things you think about yourself. Now how would you feel if the one person that you trusted the most in the world not only thinks them too, but actually uses them as reasons *not* to be with you?" Ross, an oblivious doofus to the last, charmlessly pleads his case: "I want to be with you in spite of all those things." Rachel is disgusted, and the possibility of their romance appears to fizzle. (Much like the close of the first season, in which Jeff Greenstein had borrowed from Jane Austen to bring Ross and Rachel closer together, this plot development bears notable similarities to Mr. Darcy's first proposal in *Pride and Prejudice*.)

It would take the revelations of "The One with the Prom Video," midway through the second season, to silently plead Ross's case for him, and for Rachel to fully overcome her reservations about Ross. At the start of the episode, Ross listens patiently to Phoebe's explanation of how elderly lobsters hold each other's claws in the tank. She argues that he and Rachel are each other's lobsters. When Ross fumblingly attempts to explain Phoebe's theory to Rachel, she walks off: "We are never going to happen. Accept that."

Later in the episode, when Monica is sorting through childhood bric-a-brac excavated from her parents' house, she comes across a videotape from high school, which she slips into her VCR. Rachel is in a ruffled blue prom dress, her nose markedly larger than it appears now. "How do you zoom out?" we hear Monica's father call out as the camera settles on his daughter's zaftig frame. Cox had to be molded into a specially designed fat suit for the sequence, a process that took hours and left her a sweaty mess by the end of the shoot.

"Some girl ate Monica!" Joey blurts.

"Shut up!" Monica shouts. "The camera adds ten pounds."

Chandler famously responds by asking, "So how many cameras are actually on you?"

Director James Burrows brought in camcorders to shoot the home-video sequence, dirtying the image with extra noise to give it the feel of an old home movie. Producer Todd Stevens was pleased with Aniston's

fake nose but felt that Schwimmer's wig and mustache had the perverse effect of making him look older, not younger.

What initially appears to be a ludicrous flashback is actually a cleverly disguised emotional moment. Ross instantly recognizes the videotape, his face clearly registering that reliving this particular memory will likely be agonizing.

The comedy is not quite over yet, as adolescent Ross makes his first appearance on the screen, with a scraggly mustache and a lush Jewfro. ("Looking good, Mr. Kotter!" Joey calls out, in a joke that likely registers with precisely none of *Friends*' millennial audience.)

When Rachel's date fails to show, Ross's mother suggests that the then-college-aged Ross take her to the prom. We see Ross tripping on his way up the stairs, but there is an emotional charge to spotting him in his father's tuxedo, giving himself a pep talk to "just be cool" as he holds a bouquet of flowers grabbed from a vase.

Ross comes down the stairs just as Rachel and Monica and their dates, their backs to him, troop out the door. Rachel's date has at last shown up, and Ross, no longer needed, gulps in surprise, openmouthed with shock. Not only has he lost his chance to go to the prom with Rachel, she has not even noticed his intention to do so.

Monica, heretofore unaware of her brother's teenage gallantry, sits up, exclaiming, "I can't believe you did that!" And Rachel, rising out of her seat, approaches Ross, who is standing uncomfortably near the door, the camera tracking fluidly along with her. She strides over to him, puts her hands to his chest, and kisses him, to the roars of the audience and the visible pleasure of their friends. Chandler pounds Joey on the back with his fist, Monica wipes her eyes, and Phoebe claps her chair with glee. "See?" she shouts. "He's her lobster!"

Burrows argued fiercely for the blocking of the scene, believing there was no way that Ross would not get up and head toward the door once he realized what they were going to be watching, in a fruitless attempt to maintain his pride. And having Rachel cross the apartment to kiss Ross would mask her intentions until the very last instant. Marta

Kauffman was on the set as "The One with the Prom Video" was shot and listened as the audience erupted in pleasure when Rachel kissed Ross. "That didn't suck," she thought.

Contrary to the fantasies of its fervid fan base, or the woman who had approached Kauffman on Larchmont Boulevard, the creators of *Friends* had not emerged with a fully mapped plotline for the show ready to go. They were only ever a few episodes ahead of the curve, having a broad sense of how a given season might unfold but with many of the specifics remaining to be determined in the writers' room. There was never a detailed sense of where Ross and Rachel would go once they got together, and the show seemed flummoxed about what to do with them once they were involved. Could *Friends* thrive with Ross and Rachel happily in love? And what would such a show look like?

COULD I *BE* WEARING ANY MORE CLOTHES?

Friends and Style

John Shaffner had fond memories of his apartment at 344 West Fourteenth Street, just off Ninth Avenue, a sixth-floor walk-up he shared with his partner Joe Stewart, with transoms over the doors and panel molding on the walls. It had been the grungy, pre-gentrification, "Ford to City: Drop Dead" New York, and when Shaffner was called in to mock up a set for a New York City apartment for *Friends Like Us,* he knew immediately that he wanted to draw on those places and those experiences.

Designing a multicamera television set was much like designing the sets for a play. There were only three walls, and the absence of a fourth wall meant that everything that would have to appear in a room—doors, windows, furniture—would fill a more compressed space. Much of a set designer's work revolved around the art of visual trickery, taking an empty space and creating depth, studding the space with objects of visual interest, finding methods of crafting a foreground, middle ground, and background for actors and directors to work with.

Building a set was meant to do two things, one instantly obvious

and the other not. A set had to solve all the problems introduced by the pilot, but a good set would also establish a template flexible enough to encompass an untold number of future stories, and to make the creation of those new stories as effortless and fruitful as possible.

Shaffner thought it would be true to the New York spirit to have each of the bedroom doors open directly into the main space. Shaffner placed the bathroom at the other end of the living room from the bedrooms, figuring that the path from bedroom to bathroom would allow for all manner of fruitful encounters.

Kevin Bright was also looking for a color palette that extended beyond the traditional neutral colors of most other sitcoms. No grays, beiges, or browns; Bright wanted colors that popped off the screen. Bright had recently painted his own house in vivid colors. He approached Shaffner and asked him: What did he think about trying a purple set?

The kitchen, too, was designed to have the patched-together look familiar from so many Manhattan starter apartments. Figuring that Monica was a foodie, Shaffner upgraded her stove to something a bit more elegant, but everything else stayed scruffy.

Shaffner and Stewart went to lunch with James Burrows on the Paramount lot and showed him the apartment model. Burrows approved but suggested that the apartment have a more interesting window. It might be nice to have something more visually stimulating to look at. Burrows suggested something along the lines of a skylight, and Shaffner and Stewart snuck a look at each other. A skylight might have sounded good but was instantly out of the question. How would a television show feature a window built into the roof when there was no roof to the set?

But something Burrows said nagged at Shaffner, and he began to rethink his setup. The windows were a little ordinary, and could be replaced with something a bit grander. What if, instead of a skylight, they were to feature a kind of artist's-studio window?

For the knowing architectural eye, Monica's place was meant to

resemble a once-grand apartment that had been chopped into smaller pieces. Burrows particularly liked a post and beam that Shaffner had designed as a quasi-separation between the kitchen and the living room. The post and beam appealed to Burrows as a visual trim for the space, an attractive background detail that would subtly remind viewers of the space's forlorn elegance.

Shaffner took the model home and got out his watercolors. He smeared light purple paint all over the model and brought it back to the lot for Bright's perusal. Bright was pleased. He wanted something noticeably different from the flat white rectangles of most network sitcoms. TV preferred everything in shades of blue, and Bright was hoping for something that felt less interchangeable. Shaffner painted the kitchen green and turquoise, colors he believed would work well with lavender.

Having designed Rachel and Monica's apartment, Shaffner now turned his attention to the coffee-shop set. New York was often a spooky, scary place, full of unforeseen difficulties and intimidating strangers. This sitcom New York, though, was intended to be notably gentler. Hardly anyone would lock their door on a show set in a city where 1,946 people had been murdered in the past year. It was to be a New York rendered at the scale of a small town, and the coffee shop would be its town hall, meeting place, and main square. It was the centerpiece of a show intended to reclaim urban life for an affluent white demographic. This was to be their New York—carefully scrubbed clean of all grime and much of its multicultural, many-voiced variety. Shaffner asked a friend who still lived in New York to wander around downtown and take photographs of any coffee shops that looked quirky and that suggested the possibility of settling in for a long chat with a friend.

Shaffner's sets would have to be fleshed out with furniture, décor, and everything else that might be necessary to give off the impression that real people, with their own taste and their own sense of style, lived there. Set decorator Greg Grande came in to put together some boards mocking up what the apartment might look like fully dressed. Grande

had worked with Kauffman and Crane on *Family Album* and had been sent the script for *Friends Like Us* when they were about to shoot their pilot. Grande met with them, and after discussing the characters in depth, they collectively came to the conclusion that they were dealing with twentysomethings with little money to spend. Grande imagined Monica as a young woman who might spend her weekends at thrift shops and garage sales, on the lookout for just the right piece for her apartment.

The coffee shop would be similarly eclectic, with a rotating array of artworks adding some visual dash to the set. Grande wanted it to feel comfortable and welcoming, a community center for a roving crew of urbanites.

In the late 1980s, Greg Grande had frequented the same coffee shop as Kauffman and Crane. He would stop in to grab some coffee at Insomnia Café and would be inspired anew each time by the fabulously quirky décor inside. When it came time to dress the set of the new show's coffee shop, Grande thought again of Insomnia Café and wanted to model the set's look on what he remembered. Grande's job was to outfit the set and make it feel like a place where its characters lived, complete with furniture, rugs, décor, kitchenware, and anything else the audience might see.

Grande had his traditional circuit of haunts he would visit when on the hunt for décor for a new show. He visited the Warner Bros. prop house and was particularly enamored of its third floor, crammed full of Empire chairs, Gothic furniture, and old phonographs. Grande was taken aback by the abundance of inspirational material here and believed that this jumble of mismatched furniture was the precise look he was in search of. The pieces Grande wound up picking out were leftovers one step away from a trip to the dumpster. The couches were ripped, the chairs were tattered, but they had a kind of disheveled beauty to them.

The network executives were appalled. Why would an NBC show meant to appeal to classy, affluent viewers display such threadbare junk? And who would drink their coffee in such a pit? Warren Littlefield

reluctantly accepted the look but was disturbed by the rips in the furniture and insisted that the back of the Central Perk sofa be covered to hide the rip in the fabric. By the third episode, Grande had reupholstered the couch.

Monica's apartment would be exceptionally spacious and elegant for a young woman's home, and Grande wanted to demonstrate her taste and stylishness. Grande was a superb designer, but there was just one problem: He had never been to New York. Shaffner pulled him aside and told him that when you lived in New York and didn't have a lot of money to spare, you would go out the night before trash pickup and scour the streets. There were all manner of hidden gems to be discovered among the detritus, and any New York apartment occupied by twentysomethings would likely be a mix of street-corner finds, family heirlooms hauled out from garages and attics, and thrift-store purchases.

Grande began with the white couch, which he envisioned as being inviting and familiar, the kind of sofa that a friend would happily sink into. He had come across a black-bordered hook rug with a flowered pattern that he saw as being something Monica's grandmother might have left behind for her, along with a wood buffet that might have come out of a garage or storage unit. The dining area would be a similar mélange, with deliberately mismatched chairs and a table of the sort she might find at a Sunday swap meet.

Grande found an antique 1930s hutch that he thought would be a perfect fit for Monica, and a religious tapestry that would go right over it. At the last moment, Grande's superiors got cold feet about the tapestry, and he was left to scramble for a replacement. He flipped through a book about French circus history and came across a vintage poster of a creepy-looking child riding a horse while holding a bugle and toy clown that could make for a suitable replacement. He had the page copied and a poster-size blowup printed to occupy the wall above the hutch.

Practically every New York apartment had a solid metal door, and Shaffner had resigned himself to a visually bland slab on his set. But then he began to think about New York living once more, and was

reminded of the last-minute adjustments endemic to Manhattan life. Umbrellas would be grabbed off the door for a rainstorm, or bags for a trip to the store. Shaffner threw the question to Grande, and he came back a day or two later with something different. "I was thinking of putting this on the door," Grande told Shaffner, and the art director was enormously pleased with Grande's suggestion: an empty rectangular picture frame, to be hung from a hook on the back of the door.

The frame was undoubtedly an extension of what Shaffner and Grande had come to develop as Monica's style: a quirky, tongue-in-cheek décor by turns classy and jaunty. But there was symbolic heft to this find, which would end up becoming one of the show's most iconic accent pieces.

The frame, notably, was empty. There were no pictures of parents or lovers or children fitted into its contours, nor was the frame sitting atop a table or on a shelf, where we might have naturally expected it. The place of pride where one might honor the most important people in one's life had no one inside of it. Moreover, it had been ironically subverted, removed from the piano or mantel, where it might have sat in the kind of middle-class home most of the show's characters had grown up in, and flung up against a door. The markers of middle-class achievement had been undone and remade. This was a home whose residents did not yet have anyone they had pledged their lives, and picture frames, to.

Nor, for that matter, did they have any interest, as of yet, in living in the kind of home that would make a point of inviting visitors to consider the bonds of love tying it together. This was a place where picture frames might flap in the breeze or rattle against a hastily closed door. This was a place where the fusty rules of the past—of courtship and marriage and child rearing—might be violated, or rewritten.

———

Hairdressers everywhere were in agreement. No matter who asked, no matter how politely it was requested, they would not do it anymore. A

success had become a fad, which had become a national mania, and it was time to call a halt to it. "I like to see a photo," Reny Salamon, co-owner of the Los Angeles hair salon Estilo, which had been ground zero of the phenomenon, told the *Los Angeles Times* in 1997, "as long as it isn't of Jennifer Aniston circa 1994. We're way over that cut, and we won't do it here anymore." Rebecca Eckler of the *National Post* of Canada, interviewing the show's hairstylist Richard Marin, had told Marin, "My own hairdresser said to me, 'I will cut your hair any way you want. But I refuse to give you the Jennifer Aniston cut. So don't even ask.'"

What prompted this outburst of unexpected rudeness from the hairstylists of North America? Only the most popular new hairstyle for women since Farrah Fawcett's curly blond locks swept the nation in the era of *Charlie's Angels.*

The Rachel began as an attempt to temper Jennifer Aniston's unruly hair. Aniston had approached Chris McMillan, proprietor of a well-regarded Beverly Hills salon, during the first season of *Friends.* Her hair had always been kinky and long, and she was looking for something more elegant. When *Friends* premiered, Aniston had long hair, and a handful of episodes in, McMillan started to trim it. He came up with the idea of combining partial bangs with a layered look. He would trim it at the bottom, layer it, pin it, and then use a blow-dryer to give it a smooth finish.

The result was a complex but eye-catching style that made it appear as if a stylist had grown bored at the last second with his work and decided to conjoin two different hairdos. (McMillan would later acknowledge that he was high when he created the Rachel.) The front half surrounded Aniston's face, a side part with matching half-moons of hair that ran the spectrum from blond to dirty blond to brown. Aniston would sometimes wear it with a barrette, emphasizing the girlish quality of the look, like something the most popular girl in seventh grade might wear for the first day of school.

The rear was back-combed, forming a puffy curl that ascended into a small wave before falling down to her shoulders. One could almost

imagine Rachel as one of the auxiliary members of a less prominent sixties girl group, the rear portion of her hair staying dismayingly immobile as she swayed to her latest single. The result was an exceedingly careful coif that looked ever-so-slightly mussed, as if Aniston had just awoken after a brief nap in one of the chairs at Central Perk. It was a woman's look that channeled a certain youthful appeal.

Soon after Aniston debuted the look on the show, the phones at NBC began to ring regularly with requests for information about Aniston's hairstyle. McMillan began to hear from women who would gladly pay top dollar for a turn in his chair if they would come out looking like Jennifer Aniston.

Women flew from New York, from Chicago, and from Dallas to visit McMillan at his salon. "It's crazy and ridiculous and they're out of their minds," McMillan told the *Los Angeles Times* in the summer of 1995. McMillan was booked four to six weeks ahead of time, but he was not the only Los Angeles hairstylist who was suddenly spending his working hours talking about the intricacies of *Friends* episodes.

Even salons that had nothing to do with the creation of the Rachel found a hefty percentage of their work now coming from attempts to re-create it. Michael Okin told the *Times* that fifteen of the fifty visitors in a single week to his Melrose Avenue salon, Yutaka, had requested the Rachel. Forty percent of the patrons of the José Eber Salon in Beverly Hills asked for the Rachel. Stylists gladly accepted the business—at first.

The success of the Rachel was a reflection of the triumph of television over its elder sibling, the movies. Time was, people had looked to movie stars to dictate their fashion choices. The American sales of men's undershirts had famously collapsed after Clark Gable removed his button-down in 1934's Best Picture–winning *It Happened One Night* to reveal bare skin. Audrey Hepburn's fondness for the designs of Hubert de Givenchy had helped to make Givenchy a globally famous brand. Television, in comparison, was a more domestic aesthetic, inclined toward the mundane. It was a form crammed full of housewives and working stiffs in unprepossessing clothing, intentionally designed to

reflect a clean-scrubbed version of white, middle-class, middle-American, middlebrow aesthetics.

The Mary Tyler Moore Show and *Moonlighting* and *Murphy Brown* had paved the way, but it was *Friends* that would serve as the culmination of a trend toward uniting television and fashion. Audiences might have been charmed by a performer's look in a favorite movie, but they would return to a favorite television show week after week. Familiarity bred a kind of hunger for imitation.

The fashion triumph of *Friends* was not solely due to the Rachel. It was a product of what *Vogue* described as "the trendiest walk-in closet in America." That closet belonged to Debra McGuire, the show's costume designer. It was crammed full of pieces from Calvin Klein, BCBG Max Azria, True Grit, and Façonnable, not to mention endless pairs of Birkenstocks and Dr. Martens. There was, *Vogue* reported after a visit to the closet, an entire wall that was "a jumble of funky, retro pocketbooks."

McGuire went in for her initial interview to be costume designer on *Friends* in an olive-green wool Versace suit jacket with hefty shoulder pads and a matching miniskirt, olive-green tights, and chocolate-brown suede Karl Lagerfeld shoes, all of which she had borrowed from a friend. At the end of the interview, Marta Kauffman turned to McGuire and told her that she loved her style and wanted to see something just like it on the show. McGuire chuckled to herself at the thought that someone else's clothes had helped her win a job as costume designer.

McGuire had been trained as an artist and had been running a jewelry company in New York when she first dabbled in costume design. For an avant-garde theater spectacle about the court of King Louis XIII, she had traveled to every store she could think of in New York, looking for white petticoats. She wound up with thousands of petticoats, purchased for ten cents apiece, and a sense of the combination of artistry and mass production that was costume design.

A studio executive in Los Angeles had suggested she come west to see what film work might interest her, and after a PA stint on the Steve

Martin film *My Blue Heaven*, she had fallen into a gig as a costume designer on network movies of the week. McGuire struggled with a sense of disbelief at the entertainment industry. Were people genuinely earning a living for doing this? It seemed far too amusing to be paid work.

When McGuire was hired for *Friends*, she made an effort to differentiate its six protagonists by giving each of them a look of their own. Television, McGuire thought, was a two-dimensional medium and could be approached like a painting. It was all a matter of color and texture, and working in tandem with Greg Grande and John Shaffner, the screen could be decorated like a palette.

Marta Kauffman's initial impulse was to dress the show's characters in jeans and move on. It would be a nod to realism—what more could these characters afford?—and to her own New York life. McGuire insisted otherwise.

McGuire had spent much of the 1980s living in Japan, and what little she had seen of American television had offended her sensibilities. Everything was so drab and careful, designed not to stand out in any way. McGuire was looking to do something notably different. It was her idea that the clothing the show's characters wore should be aspirational. McGuire wanted her characters to look glamorous more than she cared about their realistically portraying twentysomething style.

For the pilot, McGuire had less than one week to dress her characters, and she searched the costume department at Warner Bros. for a wedding dress to introduce Rachel. McGuire's daughter had been born on a Thursday, and on the following Monday morning, she was toting her around in a basket as she browsed the racks. She discovered a creamy, lacy confection that she thought might be perfect for a spoiled Long Island girl mapping out her dream wedding. (It would also show off Aniston's shoulders to maximal effect.)

Each character was assigned their own color and their own place on the preppy-to-hippie spectrum. The show was like a tableau, and McGuire wanted to dress the characters so that no matter who might be in

a given scene, there would be an ebb and flow of patterns and colors and styles.

Chandler would regularly wear sweater vests, along with a black button-down with a gray racing stripe that would come to be his early-season calling card. The shirt reminded McGuire of ones her father had worn when she was a child and had some of the retro flair she was hoping to associate with the show's look. Joey was intended to be soft and huggable in sweaters, a deliberate reaction to the leather-jacketed player of the pilot. Ross would be dressed in corduroys and tweeds.

The female characters were distinguished by their preferred colors. Rachel went with greens and blues; Monica leaned toward red, black, and gray. Phoebe preferred yellows and purples, mixed patterns, skirts, and unstructured pieces.

The clothing was meant to be an essential part of the story, subtly reflecting the script. When Monica was unemployed, her clothing selections were intended to reflect both her diminished circumstances and her no longer needing to dress daily for work. The look was meant to be emulatable.

At the start, McGuire made a significant portion of the clothing her characters would wear. Handcrafted clothing required numerous fittings to get the tailoring right, and as the show progressed, and the demands on the actors' time swelled, the actors balked at the additional work required of them. In later seasons, McGuire would only make special items, like wedding dresses; everything else would be off-the-rack.

She was invested in each of her characters' looks, but the audience established its preferences early on. The boys were handsomely dressed but visually dull, and while Phoebe and Monica were appealing, it was Rachel Green who captivated a nation of young women looking for inspiration about what it meant to dress themselves fashionably. Only Rachel would eventually inspire Internet scholars to document and rank each of the 703 outfits she wore over *Friends*' ten seasons.

Why were fans so captivated by Rachel's looks? Aniston was

beautiful, to be sure, and, playing a fashionable character, was more likely to dress herself stylishly than her compatriots. But the fascination with Rachel's look also spoke to something at the core of *Friends'* appeal: its service as a manual to adulthood.

Rachel was a role model for the aspiring adults of Generation X. Her life might occasionally have been a mess, her romantic instincts sometimes misguided, but she never looked anything less than stunning along the way. At times, Rachel came perilously close to the movie stereotype of the beautiful woman whose humanizing flaw is her relentless klutziness, but she was more than that. Rachel was our down-home Audrey Hepburn, our entry-level Grace Kelly.

McGuire's preference for rarely repeating an outfit emphasized a latent belief of *Friends*, and a part of its fashion allure: the notion that there was a right outfit for every occasion. The show may have begun as a portrait of postcollegiate "welcome to the real world" ennui, but it rapidly shifted gears toward encroaching maturity, and the clothing choices followed behind. We watched Rachel to see what we might look like as a woman in the workforce, or a woman in love, or a new mother, or a woman scorned, or a woman with a killer new job. To do so was to glance into a highly flattering mirror that showed us only from the right angle, in the right light.

Marta Kauffman was invested in the selection of clothing for the show, and one of McGuire's weekly tasks was to oversee the "rack check," in which Kauffman ran through all the different costumes selected for the next episode. Kauffman generally approved of McGuire's taste, but there were times when Kauffman worried that a particular outfit might be too distracting, pulling viewers' attention away from the dialogue, and so a standout item might be replaced by something a bit more demure.

Friends stuck fairly rigorously to a predetermined color palette for each character, and so it surprised McGuire when the actors approached her with last-minute requests. If something felt too tight or seemed unsuitable, they might ask for a replacement and wonder why they couldn't

wear something in black. McGuire, mentally wielding her carefully designed color fields, would point out that Monica was wearing black in the scene.

She realized that even late in the show's run, the actors remained blissfully unaware of the thought that had gone into the costume design. This was, perhaps, how it was intended to be; with few exceptions, and other than for the most carefully trained eye, the costumes were merely another silent expression of the characters' personalities.

McGuire and her team would visit thrift stores and consignment shops and mass-market retailers and designer emporiums in search of inspiration. Merely providing dozens of new costumes for *Friends'* characters every week was an enormous undertaking.

One notable, and entertaining, exception to the profusion of styles came with "The One Where No One's Ready," from the third season. Ross's anxiety over shepherding his friends out the door for a work event spilled over into a dispute between Joey and Chandler. An escalating series of schemes leads to Chandler's disposing of all of Joey's underwear, forcing him to wear a rented tuxedo with nothing of his own to serve as protection. Joey swears revenge and comes back wearing all of Chandler's clothes—and still without underwear.

McGuire and her colleagues took everything from Chandler's wardrobe and stitched together a Frankenstein's-monster costume, layering the pieces until they were satisfied with the final result. Then they sewed it all together until it had become a kind of two-piece LeBlanc could step into. It was a quick change, coming as it did in the middle of a scene, and their stitch job made it a cinch for LeBlanc to pull off a hilarious adjustment.

Friends was such a fashion phenomenon that fans would even take it upon themselves to request items they had only glimpsed. For "The One with the Lesbian Wedding," McGuire had designed a wedding dress for Carol to wear. It was made from cream-colored raw silk, with a striking off-the-shoulder design that accentuated Jane Sibbett's long, elegant neck. After the show aired, McGuire began getting calls from women

hoping to order the wedding dress she had designed. McGuire worked with one bride who would fly in from Boston for dress fittings. *Friends* helped to make McGuire the kind of designer who could charge upward of $6,000 for a wedding gown and as much as $3,500 for a suit.

Her growing reputation helped McGuire to open her own shop in Pacific Palisades and start her own fashion line. She designed Lisa Kudrow's wedding dress, another off-the-shoulder number made from ivory satin, and the lavender dress Courteney Cox wore to the Emmys in 1995. The red-carpet business dried up once designers began offering their gowns free of charge, so McGuire transitioned to making clothing for directors and directors' spouses for awards shows. She also made Marta Kauffman's wardrobe for fund-raisers and other events.

McGuire was terribly dismayed when a *Vogue* profile of her in 1996 included unflattering references by the author to Kudrow, implying that her figure was dumpier and more in need of being covered up than the more sylphlike Cox and Aniston. Kudrow was stung by the mention, and her fellow actors rallied to her side in support. McGuire's relationship with the performers she dressed was never quite the same afterward, even though she had not been the one to make the nasty remark about Kudrow.

In season 2 and beyond, we knew *Friends'* characters were growing up because we watched them dress more maturely, more sensibly, more like the adults they were becoming. Rachel in particular went from unemployed former future housewife to coffee-shop waitress to fashion-company employee. Fashion entered the lexicon of the show itself, with Rachel working at Bloomingdale's, then Ralph Lauren. McGuire knew she had to feature some Ralph Lauren clothing—it was called for in the script—but preferred to limit their exposure on the show. It was important to her that *Friends* not become a show that was exclusively outfitted by any one designer. McGuire still wanted Rachel to be able to look alluring and sexy but preferred a wardrobe that a working woman in her twenties might enjoy having. *Friends* intended to make the experience of being young and driftless a universal one, and essential to that

process was the desire to visually demonstrate the process of encroaching maturity.

The Rachel eventually gave way to other hairstyles, another outfit in the closet of *Friends*' discarded looks. Even as the show moved on, intent on keeping its style forever fresh, women continued showing up at salons asking to be remade as Rachel Green. *Friends*' success had spilled off the television screen and into the world at large. The show was more than a hit; it was now a phenomenon. Instead of seeking to reflect the world back to its viewers, it had remade the world after its own image. Everywhere you went, there was *Friends*.

CHAPTER 9

WE WERE ON A BREAK

The Ballad of Ross and Rachel, Part 2

The writers worked out a superlatively dirty joke for Ross and Rachel's first time having sex in the second season's "The One Where Ross and Rachel . . . You Know" that belied some of the showrunners' repeated complaints about *Friends'* being prevented from telling the kinds of jokes they were getting away with on *Seinfeld*. Ross invites Rachel to his job at the Museum of Prehistoric History (a stand-in for the Museum of Natural History), animal-skin blanket and juice boxes in hand, and shows her the (surprisingly dim) stars. (Kevin Bright was terribly disappointed with how the light-show sequence turned out, complaining so bitterly about the botched job that producer Todd Stevens momentarily worried he might lose his job over it.) As they begin taking off their clothes and rolling around on the floor, Rachel pauses and comforts Ross, telling him it's no big deal. Ross pauses, momentarily confused, and then tells her, "Oh, no. You just rolled over the juice box."

Much like *Seinfeld's* "The Contest," an extended joke about jerking off that never used the word *masturbate, Friends* was getting away with

a joke about premature ejaculation by a careful elision of giveaway words. It might be the moment, or it might merely be good acting, but Aniston and Schwimmer feel as if they are laughing for real here, swept up in their characters' sense of relief at momentary sexual disaster averted. Later, David Crane was convinced that writer Greg Malins had come up with the joke, while Malins was sure it was Mike Sikowitz, and Sikowitz was positive it was Crane. This was symbolic of the writing process on the show, where no one could or would take credit for a classic joke.

There were obvious markers to reach—first kiss, first time having sex—and *Friends* did them well and humorously, but Ross and Rachel's relationship never really settled into a period of calm. Even in its earliest moments, there were intimations that the romantically inept Ross was going to be surprisingly controlling and forbidding. In "The One Where Joey Moves Out," he hectors Rachel about having gotten a tattoo, before considering the possibilities and softening: "Is it sore, or can ya . . . do stuff?" The thought of her "meaningless animal sex," as Rachel calls it, with her ex-boyfriend Paolo (admittedly, an infelicitous phrase to use with your current boyfriend) drives him to distraction.

Ross unspools an entire plan for their future, complete with two children (one boy and one girl) and a home in Scarsdale, so they can be far enough from their parents to breathe but close enough to call on them to babysit. "One minute, I'm holding Ben like a football," Rachel complains, referring to Ross's son, "the next thing I know, I've got two kids, I'm living in Scarsdale, complaining about the taxes!" Ross agrees to slow his roll, enjoying the relationship for what it is and not what he intends it to be, but their burgeoning romance is poisoned by Ross's creeping jealousy.

Needy and insecure, Ross is the high school geek who still cannot believe that a beautiful woman might give him the time of day and is transformed into a sexist stereotype by his insecurity. Ross is instantly jealous when he hears about someone who might offer Rachel a job: "Sounds like Mark something wants to have some sex."

"Don't you trust her?" Monica asks her brother, attempting to slap some sense into him. "Then get over yourself. Grow up!"

Monica's intercession is unsuccessful, for Ross remains every bit as distrustful once Rachel starts her new job. He calls her at work, accusatory: "What's Mark doing answering your phone?" Ross is called on the carpet for his flagrant misbehavior, and he acknowledges his weaknesses. Still reeling from the loss of his ex-wife, he is apprehensive someone will take Rachel away from him, just as Carol was taken. (Central Perk barista Gunther, eavesdropping on the conversation, mumbles his own incantation: "Let it be me, let it be me.")

By the middle of the third season, Ross has toppled over into outright hostility toward Rachel's non-Ross-related pursuits. Ross is strangely resentful of Rachel's career ambitions. He was once critical of her being "just a waitress," but when she finds professional purpose, he calls it "just a job."

Ross is a good friend but a bad boyfriend, and after winning Rachel over, he begins to take her for granted. Ross's low point comes when he invades Rachel's office at a stressful moment during the workday in "The One Where Ross and Rachel Take a Break," lighting candles for a lavish lunch spread as Rachel silently fumes. ("Excuse me," she tells a caller, "I'm going to have to call you back. I've got Shemp in my office.") "I don't feel like I even have a girlfriend anymore," Ross whines, and Rachel, drained, later suggests that they take "a break from us."

Ross famously misinterprets Rachel's suggestion, first thinking she means they should get frozen yogurt and then believing he is a sexual free agent. Ross calls that evening and hears that Mark is at her apartment, and heads out to a party, where he is yanked onto the dance floor by lovely copy-shop employee Chloe (Angela Featherstone), whom Joey and Chandler have been semi-creepily enthusing about for much of the season.

There is a clever, subtle callback here to the beginning of Ross and Rachel's romance, with U2's "With or Without You" playing when Chloe gets Ross to dance with her. "I like this song," Ross mutters, and viewers

may remember that Ross dedicated this very song to Rachel over the radio when seeking to apologize for his callous pros-and-cons behavior the previous season. Even in his moment of forgetting Rachel, some part of Ross is reminded of her.

In truth, the writing staff had hit a wall and realized that coupling up Ross and Rachel might have been emotionally satisfying for the audience, but it was destroying their narrative momentum. Kauffman and Crane had known from the outset that they would have to split up Ross and Rachel. It was just a matter of when. Without the engine of Ross and Rachel's longing, the show was in danger of becoming fatally bland.

"We were on a break!" soon became one of *Friends'* trustiest punch lines, revisited and resuscitated numerous times over the course of the show, but "The One with the Morning After" is actually among the rawest, most emotional episodes of the series. Rachel, her moment of pique having passed, was trying to call Ross while he was about to sleep with Chloe, and the next morning, she stops by his apartment as he attempts to hide her from sight. Ross feels guilty and plans to confess, but Chandler talks him out of it: "At least wait until the timing's right. And that's what deathbeds are for."

Rachel finds out and is furious with Ross for his presumption and his cruelty. She trains the intensity of her gaze on Ross's inadequacies, and her boyfriend withers under the laser beam of her contempt. "A mistake?" she echoes, parroting his sad excuse for his behavior. "What were you trying to put it in, her purse?" Their friends are trapped in Monica's bedroom as Ross and Rachel vainly attempt to work it out, eavesdropping on the death throes of their romance.

Ross and Rachel's friends serve as a surrogate audience to their dispute, their hopes and fears channeling the audience's own. "They're going to get through this, aren't they?" wonders Phoebe.

"Yeah, come on, it's Ross and Rachel," answers Chandler. "They've got to."

"What if they don't?" asks Monica.

There is an unstated understanding that even this will be overcome,

the show's triumphant romance upheld at all costs, but this is a decoy. Ross and Rachel will not work things out, and their break will become permanent. "This can't be it," Ross tells Rachel, to which she replies, "Then how come it is?" The camera pulls out on their standing still in Rachel's living room, frozen in the realization that there is nothing left to say.

CHAPTER 10

HOW MANY CAMERAS ARE ACTUALLY ON YOU?

Contract Negotiations

David Schwimmer, as the first breakout star from the show, was also the first to be approached about reupping his contract for the third season in 1996. NBC executives expected some challenges but figured Schwimmer would be more than happy to reap a financial windfall from the most successful television series of its time. What they did not bank on was David Schwimmer.

Schwimmer's mother, Arlene Coleman-Schwimmer, was a successful divorce lawyer, and young David had grown up in a house where discussions of fair allocations of assets were dinner-table talk. Moreover, after attending Northwestern University, Schwimmer had founded the Lookingglass Theatre Company in Chicago. The Lookingglass was an artistic collective in which resources were shared, and the notion of one actor's being paid more than another was anathema. At Lookingglass, no one made enough to support themselves—the actors were all holding down second jobs to get by—but each actor was paid the same. Good theater came out of a sense of community, and *Friends* was not only a

hit television show; it was a theatrical ensemble, in which six performers would have to work together, week in and week out, on new plays. Schwimmer was pushing for his costars to think of themselves as "a union of the six of [them]."

Schwimmer knew that each of his costars had signed a different contract (although they all ran the same five years). He also knew that he was neither the highest-paid actor on the show nor the lowest-paid one. "OK, I'm being advised to go in for more money," he later told Warren Littlefield about his thought process at the time. "But for me, it goes against everything I truly believe in, in terms of ensemble. The six of us are all leads on the show. We are all here for the same amount of hours. The story lines are always balanced."

Schwimmer was emboldened by Warner Bros.' audacity in publicly bragging about the windfall profits that were due to them for *Friends'* syndication rights. The studio was sharing its belief that in two years' time, when *Friends* was eligible for syndication, it would receive around $4 million per episode for approximately ninety episodes—an enormous windfall. Merely the first two seasons alone would garner $192 million in syndication payments. How could it make sense for Warner Bros. and the show's creators to reap hundreds of millions of dollars from *Friends'* success while its stars were left with so little in comparison?

Now Schwimmer was being offered the financial comfort that was many actors' dream, and he hesitated, thinking of his costars. How could he sit at the rehearsal table, working with his friends and colleagues, knowing that he had gotten a lucrative payday and they had not? So Schwimmer approached his costars and did the unthinkable: He asked them to talk about their salaries.

"Here's the deal," he told them. "I'm being advised to ask for more money, but I think, instead of that, we should all go in together. There's this expectation that I'm going in to ask for a pay raise. I think we should use this opportunity to talk openly about the six of us being paid the same." He suggested they threaten to walk off the set if their demands were not met.

When *Friends* was being cast, none of the show's performers, with the exception of Courteney Cox, had prior hits, and even Cox was not truly a bona fide star yet. But after two seasons, the six stars of *Friends* held similarly lofty places in the Hollywood firmament, with each the subject of unending professional, romantic, and personal speculation. And yet, given the realities of television acting and the pay scale, they were being paid notably different salaries for what amounted to the same work. Each actor had signed a five-year contract, locking them in at what was now a criminally low rate (beginning at $22,500 per episode) for performers who were regularly splashed across magazine front covers and whose show dominated the weekly Nielsen ratings, coming in eighth place for the 1994–95 season and third in 1995–96. (By comparison, the supporting cast of *Seinfeld* were receiving $150,000 per episode, soon to be quadrupled to $600,000.)

In making the argument, Schwimmer had the benefit of the show's own structure and balance on his side. *Friends* was a show with six equal costars. Lines and plots were parceled out equally to each of the performers, so how could it make sense for them to be paid differing amounts for the same work? Coleman-Schwimmer treated her son's costars like so many jilted spouses, insisting they know the value of their labor and suggesting that they negotiate in unison. They agreed to ask for $100,000 per episode, which would more than double the highest previous salary for any actor on the show.

Warner Bros. had a history of stonewalling what it perceived to be excessive contract demands. In addition, the failure of cinematic vehicles like *The Pallbearer* and *Ed* rendered the stars' supposed feature-film bankability substantially more precarious than it might previously have been assumed to be.

Friends was still in the early flush of its success, and there was little doubt that everyone wanted the show to return for a fourth season. It was fairly common practice for networks to offer early contract extensions to simultaneously reward their stars and keep a show's key players locked in. NBC countered with an offer of $80,000 per episode for the

following seasons. Even though Schwimmer (and his mother) had guided the negotiation process, the show's stars felt the need to deny that any one actor was leading the charge. This was undoubtedly out of a desire to avoid singling anyone out as responsible for their demands but also spoke to their preference for equality in all things.

Matthew Perry later told *Entertainment Weekly* that Schwimmer had never threatened to leave the show without a raise: "It was the year to renegotiate and we thought it was best for the dynamic of the show if we did it together. We didn't want one person making a fortune and someone else making nothing. Public perception of us changed a little because of it, I think, and that's not good."

The enormous numbers under discussion transformed the *Friends* cast into another example in the ongoing national fascination with, and panic over, excess pay. The negotiation was going on just two years after Major League Baseball had canceled its World Series for the first time ever, with players on strike for a more generous labor deal and owners fearful about overpaying stars in free agency. It was also a moment in which the media was fretfully reporting about movie stars like Jim Carrey cracking the $20-million-per-film barrier. Americans loved a success story, and also loved to complain about out-of-touch elites and their excessive salaries.

It would have been possible for Schwimmer, or Jennifer Aniston, to do better if they negotiated alone, but the results spoke for themselves. After a five-hour late-night session, the union of six walked away with a new four-year deal that began with a collective salary bump to $75,000 per episode starting with the third season. The new contract included a salary increase for each forthcoming season, with $85,000 for the fourth season, $100,000 for the fifth, and $125,000 for the sixth. The numbers were substantial, but the joint deal also meant that each *Friends* star was now being paid as well as the lowest-paid cast member would have been.

The deal also gave Warner Bros. and NBC an additional guaranteed year of *Friends*, with the initial five-year contract now replaced by one

that included a sixth season as well. The show was clearly going to continue beyond its first five years, and so purchasing a sixth season—even at a cost of $18 million for just above-the-line acting talent—was well worth it. An additional year of syndication rights alone would be worth, by Warner Bros.' calculations, $100 million.

Meanwhile, the creators of *Friends* were being offered their own opportunities for enrichment—and they were intent on grabbing them. This, they were told, was the next step. If you had a hit television show, the logical play—the *only* play—was to produce another show, and another, and another, until you ran a mini-empire of smash hits. After three seasons of *Friends*, the show appeared to be a well-oiled machine that would only require occasional maintenance to keep running indefinitely. Crane and Kauffman's representatives pushed them to branch out and start up a new series for NBC. The network was hungry for more original material from them, hoping to offset the likely impending disappearance of *Seinfeld* and *Mad About You* with some new smash hits.

The two writers went off and came back with a proposal for a series about a romance expert whose own romantic life comes crashing down to earth when her husband leaves her. *Friends* had been cunningly modeled on *Cheers*, and so Kauffman and Crane's next show would seek to borrow some of *Cheers*'s fairy dust by casting none other than Kirstie Alley.

The combination of Bright/Kauffman/Crane Productions' savvy comedic instincts and the star wattage of Alley fairly guaranteed another smash hit for NBC, and *Veronica's Closet* debuted in the fall of 1997 in the prime slot immediately following *Seinfeld*.

For David Crane, being a budding mogul meant not doing the thing he was best at in the world so he could play a role he did not particularly want to play. Crane was instructed to delegate the work of *Friends* to others while he devoted himself to getting *Veronica's Closet* off the ground. Crane found that he was continually leaving rooms in which he

wanted to stay in order to enter rooms he did not particularly want to be in.

"Why are you doing this?" his partner, Jeffrey Klarik, asked him. "You're so happy. Why are you doing this?" Crane could not come up with a suitable answer, other than "I'm supposed to."

Crane would pull off the same trick in both rooms, entering and listening quietly as a particular joke or story point was the subject of ardent debate. When the conversation reached a temporary lull, Crane would weave together the differing strands of ideas into one perfectly taut and pleasing rope of plot. Heads would nod at this remarkable feat of writerly ingenuity. Then he would leave, and the writers would collectively panic: Had anyone written all of that down?

It would have been a manageable difficulty if it had only been Crane who preferred his firstborn to his newborn, but Kauffman and Bright also found that they preferred *Friends* to *Veronica's Closet*. Crane and Kauffman drove the writers just as hard in the *Veronica's Closet* room as they did for *Friends*. And many of the writers had either already written for *Friends* or would go on to do so. As much of themselves as they poured into *Veronica's Closet*, they never cracked the code of what the show was to be about or who it was for. The best team of writers in the world could not do that work for them, and so *Veronica's Closet* floundered.

Friends had rapidly come to understand what it was best at, and *Veronica's Closet*, stuffed full of potential, could not manage the same trick. It was, ultimately, less about what went wrong with *Veronica's Closet* and more about what had gone right with *Friends*. It simply did not matter how many talented, hardworking, brilliant people you might gather together; creating great television was at least partially a matter of blind luck. *Veronica's Closet*, writer Ellen Kreamer (who would soon go on to work on *Friends*) thought, suffered from never entirely being able to figure out just what it was.

Matters only got worse with the premiere of *Jesse* the following season. *Friends* veteran Ira Ungerleider created the show, starring Christina

Applegate as a single mother juggling a new boyfriend, a newly returned ex-husband, and a cranky father whose bar she worked at. The general consensus was that if Crane and Kauffman were able to devote themselves to *Veronica's Closet* with the same tenacity they gave to *Friends*, it could be a solid piece of television comedy. Kevin Bright believed *Jesse* lacked that potential, even with Kauffman and Crane's involvement, and that it had been a mistake to empower an idea they had not originated, especially one that he saw as being worse than mediocre.

Veronica's Closet lasted three seasons; *Jesse* only made it two. The promise of a future Bright/Kauffman/Crane empire had fizzled unceremoniously, and David Crane, for one, could not have been any more pleased about it. The truth was, the life of the television mogul was not for him. Crane understood that he was not meant to be a supervisor. Other showrunners could transform into superintendents, overseeing others' writing, but the contracting of Crane's world felt nothing short of wonderful. Nothing could distract him now from the business of writing *Friends*.

CHAPTER 11

THE FIFTH DENTIST

Long Days and Longer Nights Inside the Writers' Room

Every writer knew the sinking feeling in the pit of their stomach. David Crane would enter the room, toting a script full of notes scribbled in the margins. He would sit down in his chair and begin drumming his fingers on the table before announcing, "All right, we've got a lot of really good stuff here." The assembled writers would silently groan, knowing that this was Crane-ian code for a full script rewrite. Everything was out, and it was time to start again.

"Good enough" was not a concept Crane, or Marta Kauffman, understood or accepted. One day during the first season, writer Jeff Astrof approached Crane with a proposal. "Look," he told Crane, "right now we work one hundred percent of the allotted time and we have a show that's one hundred. I believe that if we worked fifty percent of the time we'd have a show that's seventy-five, so maybe we work seventy-five percent of the time and have a show that's like a ninety." Crane instantly rejected the proposal: "Absolutely not. The show has to be one hundred." There might have been a faster way to get the work done. But this was Marta Kauffman and David Crane's show, and their room.

After hiring their staff for the first season, Crane and Kauffman gathered the writers to deliver a pep talk, and a challenge. "Comedy is king," Crane told the assembled writers. "This is a show where we want everything to be as funny as it can be." For writers in their midtwenties, many of whom were on their first or second jobs in the industry, this was a thrilling proclamation. Writers like the team of Astrof and Mike Sikowitz had always felt deeply competitive about crafting the best possible joke and getting it into the script—Astrof's concerns about the punishing schedule notwithstanding—and Crane was seemingly opening the doors wide to all competitors.

Sikowitz soon realized that Kauffman and Crane felt confident about being able to supply the emotional backbone for the show, leading the process of designing the season-long arcs for each character, and were counting on their writing staff to jam their scripts full of as many killer jokes as possible. It was a remarkable feeling to be given the green light to simply be funny. The planning of emotional beats was a major part of the preparatory work for the season and would be done by the writers' room as a whole, but it was understood that Kauffman and Crane were the ablest writers when it came to finding the nuances of feeling that would hook viewers.

The *Friends* writers' room was simultaneously a party room and a prison cell, a wild daily gathering whose participants, like the dinner guests in Luis Buñuel's *The Exterminating Angel,* could never leave. Participants were thrilled to be a part of the work of writing *Friends.* Each day was a marvel, and it was an honor to be granted the opportunity to work alongside such gifted, committed, fiercely original imaginations. But it was simply not possible to avoid occasionally sighing and wishing to go home.

Adam Chase was astounded by the regular fourteen-to-sixteen-hour days around the giant desk in the seventh-floor boardroom, which on occasion stretched to a full twenty-four-hour shift, like a doctor on call or a factory worker earning overtime pay. But for Chase, the drudgery was also a moveable feast, an ongoing party that he was lucky enough

to be invited to on a daily basis. A good deal of the pleasure came from Crane and Kauffman's willingness to let relative newcomers like Chase play as near-equals.

On many shows, there was one overhanging question lingering behind any discussion in the writers' room: "What's the pitch?" If you weren't coming in with a distinct, carefully worked-out resolution to the problem you were chewing over, there simply was no time to devote to your musings. The showrunner would be annoyed at your having wasted their time, and the conversation would rapidly move on to more fertile territory.

This was never how *Friends* worked. Crane and Kauffman were only too pleased to have any one of their writers, however young or inexperienced, bring the discussion to a halt with a question or concern. Kauffman and Crane would listen and then open it up to the room. How do we solve this problem?

This was in part because Crane and Kauffman themselves were still relatively new to the ways of television. They had never been writers in someone else's room, having gone directly from theater to freelancing to running *Dream On*. Crane, by his own estimation, lacked time-management skills, content to let his staff wander far afield before returning to the task at hand.

The remarkable thing about the *Friends* writers' room, Chase believed, was its complete allergy to compromise. Not only would Kauffman and Crane never admit defeat and accept what they deemed a mediocre line or joke, neither would any of the members of their staff. (On one rare occasion, after an exceedingly poor run-through, Crane had asked NBC if they might skip that week's episode. NBC said they would take a new episode in whatever shape it was in, and "The One Where Rachel Smokes" proceeded to air.)

Friends' style was adapted from *Seinfeld*'s interlocked model, in which each episode had an A, B, and C plot (Carol is pregnant; Monica is cooking for her parents; Rachel has misplaced her engagement ring). This created the challenge of intertwining separate stories, but it also

prompted an insatiable hunger for story lines. A single season of *Friends* would require seventy-two separate plots, each with its own introduction and resolution, each with its own array of jokes and emotional moments. And fully plotted stories would regularly be tossed out because they flopped in rehearsals or during a shoot. The sheer volume of polished material that the writers of *Friends* had to come up with placed inordinate pressure on the writers' room to work in sync and to pick up each other's slack.

On other shows, more emphasis would be placed on individual effort. Writers would go off on their own and craft scripts, and while the room might polish them, they would remain demonstrably the product of an individual's effort. *Friends* was different. Writers would write the first drafts and ultimately be granted credit for the episode. But the true work was done in the room, together. Everyone was responsible for improving each line, each joke, each emotional beat of the show, and it would never be enough to simply do your own work.

Writers would have to endure the process of watching their scripts be slowly, steadily dismantled and rebuilt. To bristle at the process, or to attempt to defend a rejected joke, was counterproductive and would reflect poorly on the writer who attempted it. Writers soon learned that it was far better to jump in and help fix your own script than attempt to protect your original work. This was a team, and anyone who insisted on publicly totting up their batting average would soon find themselves riding the end of the bench. (Later in the show's run, there were joke rubber stamps passed out to the staff that read, "I Pitched That!")

The *Friends* writers' room was, as some of its participants described it, a remarkable feat of alchemy, in which a dozen talented individuals transformed into a team that was far greater than the sum of its parts. Crane and Kauffman were responsible for hiring writers who each had their own preferred writing style and voice, and ensuring that they complemented each other. It was like an arranged marriage between a dozen different people, and should have been as impossible. Instead,

there was a kind of magic present in the room, where writers competing to tell the best joke were also able to carve out their own voices.

Sitting at opposite ends of the conference-room table, Kauffman and Crane were curators of the staff's efforts. Rather than looking for a fully formed idea that could be inserted directly into the script, they were happy to gather the shards of their writers' inspiration. They would take one idea from here and one joke from there, and begin assembling workable material. And if they hadn't found something they were pleased with, they would tell the writers to keep looking. Their writers' lack of experience was a bonus, not a problem. More than anything, Crane and Kauffman did not want to hear from their writers that this was the way it had always been done on *Who's the Boss?* They preferred the company of young writers who did not know about How It Was Done on Television.

The result was an atmosphere that was simultaneously competitive and cooperative. Mike Sikowitz would have times when he drove home to West Hollywood after a long day on the Burbank lot with a feeling of intense disappointment over not having managed to get a single solid joke into the script that day. "What's wrong with me?" he would think. "I used to be funny." On the days where Sikowitz successfully logged some killer jokes, he would make the same drive home feeling like he was the king of the world. Being in the *Friends* writers' room, Sikowitz thought, was like an emotional stock market. Some days you made a killing, and others you lost your shirt.

It was fun to be in a room of raconteurs, entertainers, and one-liner machines bantering, debating, and performing for each other. But there also was no specified end to the workday, no moment when the writers would punch out and head home. Ordering dinner at the office was a matter of course. All-nighters were a fairly standard occurrence. On David Lagana's first day on the job as a writers' assistant, he showed up for work at nine thirty A.M. and left for home at six forty-five the next morning. The last day of the workweek was widely known as Fraturday, as it

often did not end until Saturday morning. "I think I just saw your beard grow," Alexa Junge told Mike Sikowitz during one late night.

The writers would entertain themselves with antics like tossing a small toy football back and forth for hours without letting it drop (which would inspire the episode "The One with the Ball") or offering cash inducements to eat an entire jar of garlic pickles. They would play video games to blow off steam or watch the latest installment of *The Osbournes*. And then there were Taste Test Wednesdays, when Scott Silveri or one of the other showrunners would send an assistant to the grocery store to purchase, say, every brand of plain potato chip. The writers would try each variety and vote on their favorites, and then the singular best potato chip would be declared, to the merriment of the assembled judges.

On days when it became clear that it would be another late night, the writers would put on their preferred jam, Chuck Mangione's jazz-fusion hit "Feels So Good," on their boombox and listen to it as the sun went down. Sometimes, their dinner order would arrive at the same time, and the writers would burst into Mangione-inspired song: "The food is here, the food is here." It was no surprise, given what passed for entertainment there, that the room transformed everyone, as Ellen Kreamer thought, into a slightly fatter, greasier-looking version of themselves. Even years later, Kreamer would find that the sound of a crinkling takeout bag would be enough to bring her momentary joy.

One late night, writer Shana Goldberg-Meehan, who joined the show in the fourth season, entered the room, took note of the roiling discontent, and told fellow writers Kreamer and Robert Carlock that they had thirty seconds to go "apeshit crazy" before they got back to work. Kreamer and Carlock jumped on tables and tore the room apart for precisely thirty seconds. It was also the late nights when the conversation in the room, fueled by boredom and exhaustion, often turned to its bawdiest and most puerile, for which there would be notable long-term consequences.

On the rare evenings when he was able to leave the office early

(early for *Friends,* about ten thirty P.M.), Adam Chase would get home, smoke some weed, and turn on the eleven P.M. rerun of *Law & Order.* Working on *Friends* was so intense that Chase needed some time to decompress at the end of the day, but he found that his mind was still coming up with jokes—only now they were for Jerry Orbach's Detective Lennie Briscoe.

Chase was later introduced to René Balcer, a *Law & Order* producer, who suggested Chase try his hand at some punch-ups for their jokes. In one, Briscoe was talking to a medical examiner standing next to a body with a javelin sticking out of its chest. "What made you go into this line of work?" Briscoe asked. The best the *Law & Order* crew could come up with was "To meet charming detectives like you." Chase, whose comic sensibility had been forged in the fires of *Friends,* knew he had a better answer: "Free javelins."

Jeff Astrof would look out through the room's wall of windows during the endless days working over scripts in the first season, and watch sets being built for the Michael Jordan–starring Looney Tunes film *Space Jam* (1996). He was surprised to find himself staring at the construction workers and thinking to himself, "Now, that's a cool job." There was a profession in which one's progress could be assessed on a daily basis, in which there were no notes or comments from one's superiors. At the end of one's labors, there was a physical object that had not existed prior to the start of one's work. The idea of a working life without a constant stream of notes and suggestions and rewrites was deeply tempting to Astrof.

Astrof would joke that, on those regular early-morning drives home, he would encounter himself returning to the office, ripping a hole in the space-time continuum. Crane would regularly endure the deeply unpleasant experience of driving home from the Valley to Brentwood during the A.M. rush hour, making what would normally be an easy reverse commute into a harrowing drive. Crane would find himself drifting off to sleep at red lights and resorted to calling his partner, Jeffrey Klarik,

on his car phone and demanding that he chat with him in order to keep him awake on the drive home. Writers would learn what it looked like to see the sun come up over the Warner Bros. lot.

Kauffman, who had two young children, particularly feared having a story collapse during run-through, since this would inevitably lead to another very late night. Kauffman had a private rule: She would not miss her children's bedtime two nights in a row. On late nights, Kauffman would drive home, put her children to bed, and then return to the office. On *very* late nights, Kauffman would drive home as the sun came up, shower, feed her children breakfast and get them dressed for school, and head back to work.

Sometimes, the best jokes would emerge out of the late-late-night sessions, when writers were sagging in their chairs or napping on one of the couches. They would be staring out the windows as days turned into nights, and the glimpses of the world going on without them on the streets below would be transformed, with the sun's departure, into a mirror reflecting their own faces back at them.

Exhaustion had the propensity to tear away the expected response and sometimes reveal the odder pitch lurking underneath. One late night during the first season, the staff was talking through the episode "The One Where the Monkey Gets Away," in which Rachel accidentally allows Ross's monkey, Marcel, to escape and everyone fans out to search for him.

There was a scene in which Joey and Chandler would knock on some attractive neighbors' door. Joey and Chandler would be enticed by the radiantly beautiful women but would carry on with their search. The staff was at a loss as to what joke might work best there.

Astrof, half-conscious, muttered something to himself, and Adam Chase, hearing his comment, quieted the room: "Wait. What did you just say? Say that again." Astrof repeated his suggested line for Joey: "We promised we'd find this monkey. If you see him, he's about yea high, and answers to the name Marcel, so if we could get some pictures of you,

you'd really be helping us out." It was a left-field joke, only made possible by a room too tired, at three or four A.M., to deliver the more obvious punch lines.

Kauffman and Crane were willing to trust their writers' enthusiasm, even when they didn't entirely share it. They would rarely simply veto a story line, preferring to push back against their writers when they felt a pitch was too juvenile or emotionally barren. Greg Malins's pitch about an obstetrician who would enter the room offering an array of facts about Fonzie from *Happy Days* while delivering Phoebe's triplets so thoroughly amused the writers that it made the final version of "The One Hundredth." Crane insisted that the idea made no sense at all, but he was willing to be won over by his writers' enthusiasm.

At other times, the writers could not overcome Kauffman and Crane's skepticism, as with their suggestion for a story line in which Phoebe's gusto for Chinese food leads her to attempt to marry it. "I just find myself not caring," Kauffman would regularly respond to pitches that she felt lacked an emotional through-line. Writer Andrew Reich, trained to write jokes, found it enormously beneficial to have Kauffman and Crane ask questions like "What does Rachel want in this scene?" On occasion, the actors would nix plotlines they could not stomach, as with a story in which Chandler would sneak into a gay bar because he loved the chef's tuna melts. Matthew Perry said no, and the story was shelved.

The atmosphere in the room called for quick wits and a hunger to leap on any opening with the biggest possible joke. Sikowitz remembered one moment in the first season when the writers were approaching a wide-open setup and pondering their choices. In "The One with All the Poker," Rachel was going to enter the room bubbling with excitement, saying, "Guess what, guess what, guess what!" It was an ideal opportunity for a Chandler witticism, but what might he say?

Quicker than Sikowitz could even form a cogent thought, Jeff Astrof burst out with a line: "The fifth dentist caved, and now they're all recommending Trident?" Sikowitz was stunned. Had Astrof known somehow?

Had he prepared the joke in advance? It was a *huge* joke, guaranteed to get an audience response, and Sikowitz had been nowhere near coming up with anything, let alone something as good as that line. It was maddening to be surrounded with people who were that good at being funny.

Sikowitz had his moment later in the process of writing "Poker," when a similar opening announced itself. "Could you *want* her more?" Chandler asks Ross at Central Perk, gesturing offscreen with a rolled-up newspaper. Ross, feigning ignorance, asks, "Who?" Sikowitz leapt in and suggested a line for Chandler: "Dee, the sarcastic sister from *What's Happening!!*" Sikowitz was terribly pleased to have buzzed first on that answer.

For Sikowitz, there was simply nothing better than the sensation of Matt LeBlanc coming over and asking of a particular joke, "Whose was that?" and being able to take the credit. LeBlanc would call them "bombs," meaning a joke that had knocked an audience flat with laughter. He and Matthew Perry in particular hungered for bombs and were intensely pleased when a script gave them an opportunity to dazzle an audience.

Crane and Kauffman had recruited a staff that cared deeply about their characters and took passionate stands about what might have appeared, to less zealous outsiders, as fleeting details. When, early in the first season, the character of Paolo, the hunky Italian lover Rachel meets in "The One with the Blackout," was initially proposed, writer Jeff Greenstein balked. The Latin lover was a tired trope, he insisted, and the show should avoid such lazy, secondhand characters. The room was tied up for most of a day debating how to find a less obvious boyfriend for Rachel to serve as an impediment to her getting together with Ross. For a time, there was serious discussion of transforming Paolo into an Inuit visitor to New York, but the prospect of a stud in mukluks was ultimately deemed to be a bridge too far for audiences.

Jeff Strauss believed that Crane thought of the writers' room as an expansion of his brain. This was not to say that Crane was anxious to take credit for anyone else's work, but rather that, when the room was

working in the fashion it was supposed to, Crane would turn to the writers to ably and rapidly flesh out every emotional, uproarious, tender, or bawdy idea he might have, or wish he had.

Crane and Kauffman were gentle and encouraging of their writers, who saw them as figures they wanted to please, and occasionally rebel against. They were ill inclined to crack the whip or insist on getting back to work. They were also perfectionists. Every line had to be the absolute best it could possibly be. Every plot had to be ironclad.

The writers liked to pretend that Crane, who had been born in 1957, had actually come of age in the 1950s, and they poked fun at what seemed to them to be his advanced age (he was thirty-seven when *Friends* premiered) by breaking into the dramatic "DUH-duh-duh" opening of the jazz classic "Sing, Sing, Sing" or fondly reminiscing about that time they had all thought Thomas Dewey was going to be elected president. Crane was like their good-natured dad, willing to withstand the constant ribbing since it emerged from a place of love, even though in some cases he was only a few years older than the writers on his staff.

The writing process was intensely collaborative. Writers might be assigned to craft a first draft of a given script, but by Adam Chase's estimation, 98 percent of the work was actually done in the room. Often, an idea would be filtered through numerous writers, who would add their own flourishes. During the second season, conversation turned to Phoebe while they were writing the episode "The One with the Baby on the Bus." Chase suggested Phoebe play a song called "Smelly Cat." David Crane began to sing the title, and Jeff Astrof chimed in with the line "What are they feeding you?" Someone else contributed the kicker "It's not your fault," and the pillars of "Smelly Cat," which would be Phoebe's most fondly remembered song, had been rapidly assembled.

And the writing staff felt a distinct, and at times surprisingly intense, sense of ownership over their work. During the filming of "The One with the Baby on the Bus," Chase was watching Lisa Kudrow perform "Smelly Cat" and growing increasingly distressed. Kudrow was as funny as ever, but when she reached the chorus, Kudrow was hitting the

second word: "Smelly *cat*, smelly *cat*, what are they feeding you?" Chase was insistent that emphasizing *smelly* would be notably funnier and pulled David Crane aside to share his concerns: "I think it's funnier if she hits the first word." Crane was nonplussed: "You seriously want me to go out between takes, in front of a studio audience, and give her that note?"

Chase panicked—what happened to no-name writers who gave acting notes to the stars of their shows?—but held firm. Crane was always willing to go out on a ledge for his writers and gamely stepped onstage to share Chase's suggestion with Kudrow. The scene was, by collective agreement, funnier after Kudrow began emphasizing *smelly* instead of *cat*. But Crane approached Chase after the shoot and told him, "Look, you've got to pick your moments. Because sometimes you're right, but a lot of the time, it's not worth it. If it's three percent funnier, it's not worth it. This time, I'll give it to you."

The writers and cast were working in tandem, and their devotion to delivering the best version of that joke was a notable part of their shared effort. Chase was still early enough in his career that he was fixated on the precise words of the script. What he had written, he thought, was the best possible version of a joke, and it would be a shameful mistake to shoot it any other way but the one the writers had come up with.

The room was like a vampire, forever hungering for fresh blood to suck. And the writers themselves were often content to bite off hunks of their own flesh and transform it into fodder for their characters. The *Friends* characters were the writers' stand-ins and doppelgängers, their adventures and discoveries simultaneously reflections of the writers' own lives and romanticized versions of their more humdrum existences. There was something simultaneously terrifying and cathartic, as Jeff Strauss saw it, about this filtered version of the writers' own reality being passed along to the characters and dispatched to the audience through their television screens.

The trick was not only to mine your own life, but to know which parts were serviceable for the show, which characters might be best

served with the autobiographical morsel, and how a funny anecdote might be extended, exaggerated, or adjusted.

Adam Chase had once been in an upscale clothing store with a female friend who suggested a pair of expensive leather pants. Wanting to impress her, he tried them on, and then was swayed by the blandishments of the beautiful store clerk, who told him the pants looked great on him. Six hundred dollars later, Chase owned a pair of pants he would likely never wear again.

The incident was a terrific start but needed more to serve *Friends'* needs. The writers went to work and began to think about what might happen if someone were not only to purchase the leather pants but get stuck in them. The memorable plotline of "The One with All the Resolutions," in which Ross uses a variety of bathroom products in a fruitless attempt to wiggle out of his uncomfortably tight pants ("The lotion and the powder have made a *paste!*") was born.

Stories could come from anywhere. Ted Cohen had once entered a steam room at the gym with his glasses on and had accidentally sat on a fellow patron's knee, inspiring Chandler's sitting on his father-in-law's lap in the sauna in "The One with Phoebe's Cookies." Andrew Reich remembered visiting a friend named Katie who lived in a walk-up apartment with a very narrow staircase. When he got up to Katie's apartment, he noticed she had an oversize couch and wondered just how she had managed to get it up those stairs. Reich brought this thoroughly unremarkable observation back to the room, where it eventually mutated into the memorable "Pivot!" couch-moving sequence from "The One with the Cop."

Comedy writers had a relationship to the world that differed notably from that of civilians. Where the average person sought to bury moments of profound embarrassment or failure, a comedy writer might look at the most humbling or humiliating moments as potential material. One day early in the show's run, Adam Chase was playing with Marta Kauffman's son, Sam, then a toddler, who was visiting the set. He was picking up Sam, tossing him in the air, and then catching him. On

about the third attempt, Chase sent Sam hurtling directly into a metal door frame.

Chase saw his career flash before his eyes, convinced that he would be instantly fired from his job for endangering the life of his boss's son. Sam ran off to find his mother, crying hysterically, and Chase went with him, seeking to apologize to Kauffman. She comforted her son but was otherwise unruffled: "I drop him on his head all the time." The incident would eventually serve the third-season episode "The One with the Giant Poking Device," in which Monica accidentally hits Ben's head against a wooden pillar, and he proceeds to dub her "Monica Bang."

And when there was nothing left to mine in your own life, it was time to move on to your friends' shenanigans. Greg Malins remembered hearing about the time when his friend Sebastian Jones had just moved to Los Angeles, carrying a plastic bag filled with his clothing to their mutual friend Brian Boyle's apartment. One day, when Jones was out, Boyle emptied the bag on the floor and proceeded to don every item of Jones's clothing. When Jones came back home, Boyle gestured to himself and said, "Look, I'm wearing all your clothes."

Boyle's prank became Joey's revenge in "The One Where No One's Ready," refitted with a far superior punch line: "Look at me, I'm Chandler. Could I *be* wearing any more clothes?" (Adding to the air of self-referentiality, both Jones and Boyle would join the *Friends* writing staff in later seasons.) Neither Crane nor Kauffman was familiar with the term *going commando,* but when the entire staff urged them to include it, asserting that their audience would instantly understand the reference, they acceded. (Eventually, the *Oxford English Dictionary* would credit *Friends* with one of the earliest recorded usages of the term.)

The squabbles and absurdities of the writers' room found their way into scripts as well. On one occasion, a late-night session was interrupted by someone from the show's office, who poked their head in to tell Greg Malins his fiancée was on the phone. After Malins left the room, writer Michael Borkow said, "Huh. *Wapah!*" All the other writers turned to Borkow, confused. He responded, "You know. He's running

out to take a phone call. He's whipped. *Wapah!*" The joke was less about Malins's being "whipped" than a kind of meta-joke about the Stockholm syndrome of the room, in which even taking a phone call felt like a major retreat from commitment. What was funny, though, was the sound that came out of Borkow's mouth.

Chase responded, "That's not the whip sound. This is the whip sound," doing a more traditional "hoo-*pssshh*" crack of the whip. Borkow agreed: "That's what I just did. '*Wapah!*'" Borkow's inability to make a convincing whip-cracking noise became Chandler's struggle in the fourth season's "The One with All the Wedding Dresses."

Kauffman notwithstanding, the *Friends* writers' room was, at the outset, an exceedingly male place, its tastes and interests formed by the concerns of funny young men. (In later years, the staff would have a more even gender balance.) It was left to the few women in the room to push back against plotlines that dismayed them, but while Crane and Kauffman made space for their concerns, this, too, came with a cost.

In the second season, when preparations were commencing for the high-pressure Super Bowl episode, writer Alexa Junge, at the time one of only two female writers on the staff other than Kauffman, took umbrage at what she perceived to be the hackneyed and sexist plotline that pitted Monica and Rachel against each other in competition for movie star Jean-Claude Van Damme. "You know," she told the other writers, "if they're friends they're not going to do that. That's bad for the sisterhood. We would never do that."

Junge was disturbed by the girl-fight vibe of the episode, complete with the wardrobe choices. Why were Monica and Rachel wearing flimsy T-shirts on a cold set on what was supposed to be a winter day, their nipples instantly visible beneath their clothing?

Junge's feminist feathers were ruffled, and she told Crane that she thought the plotline was beneath the show's lofty standards. Crane heard her out and told her, "Listen, I don't exactly understand what some of the politics you're saying are and I get that you're really riled up about it and we actually are going to do this story, but over the course of

the day, could you just stop me when something's offensive to you?" Junge felt like she had been put in a difficult position, hired against her will to serve as feminist scold and designated spoilsport, but she dutifully communicated her concerns to Crane over the course of the shoot. (The T-shirts stayed.)

Much of the writing staff was locked in on crafting killer jokes, but to serve in Marta Kauffman and David Crane's writers' room was to receive an ongoing lesson in the balance between comedy and drama. Huge jokes were the white whale they were all hunting, but the romantic through-line that gave episodes like "The One with All the Poker" their meaning clarified that all the jokes in the world could never convince an audience to care about the show's characters.

Kauffman and Crane were permanent reminders in the writers' room that as much as this crew of mostly single, mostly twentysomething smart alecks might have been allergic to sentiment, it was that very sentiment that would win audiences over to *Friends*' side. The room generally agreed that, along with Crane, Kauffman and Junge were among the best at providing the emotional nuances the show needed. Without Ross and Rachel, and the audience's desire to see their relationship through, viewers would never have bothered with the show, no matter how many bombs Chandler or Joey might have dropped.

This was television on the *Cheers* model: joke, joke, joke, joke, until suddenly the ground falls away and a moment of unexpected sentiment retroactively justifies and enriches all the effortless humor that preceded it. Kauffman and Crane's script craft doubled as a series of lessons in humanity, offered free of charge to their youthful staff. For Sikowitz, moments like Ross's tossing a poker game to give Rachel a much-needed victory in "The One with All the Poker" would catch in his throat unexpectedly, and he would find himself saying, "Oh wow—that was cool."

PART III

· · ·

IT *IS* A BIG DEAL

The Show Hits Its Stride
(Seasons 4 through 7)

CHAPTER 12

LIGHTNING ROUND

A Look at the Making of an Exemplary Episode

In 2009, when *TV Guide* named the one hundred greatest television episodes of all time, it settled on a single *Friends* episode to inhabit the twenty-first slot: "The One with the Embryos," from the show's fourth season. Fanatics might differ about which *Friends* episode reigns as the series' all-time best—others might vouch for "The One with the Prom Video" or "The One with All the Poker"—but in its belly laughs and its bursts of emotion, in its skillful intermingling of divergent plotlines, and in its surprise denouement, "The One with the Embryos" serves as a template for all that *Friends* did best.

Producing a television show sometimes required adjusting to real-world circumstances. *Friends'* characters were played by actors who lived lives off the set that had to be accommodated, hidden, or transformed. When it came to the fourth season of *Friends,* the tricky encumbrance that the show's writers had to somehow wrestle with was that Lisa Kudrow was pregnant. Some shows had attempted to cover up their star's real-life pregnancy with loose clothing and a sudden interest in carrying around bowling balls and dictionaries (as *Friends* itself would

do, after a fashion, with Courteney Cox in its tenth season). Others chose to make their characters pregnant as well.

Kudrow's pregnancy was an opportunity, and a dare. Phoebe was by far the most outrageous of the *Friends* characters and invited the possibility of more unusual circumstances than other characters could have. Phoebe had already discovered a thumb in her can of soda, demonstrated her skepticism about the theory of evolution to Ross, and once whistled at a man and accidentally sent him into a coma. She had been temporarily haunted by the soul of an elderly Jewish woman named Mrs. Adelman.

Phoebe was the receptacle for many of *Friends'* quirkiest impulses, extending the range of the show's comic abilities. She was gleefully, willfully obtuse at times, quizzing Pretenders lead singer Chrissie Hynde about her knowledge of chords or stalking her stalker. She was also demonstrably kind in a fashion not regularly granted to the other characters, giving a homeless woman $1,000 and gently informing Rachel that her boyfriend Paolo had made a pass at her.

The writers often enjoyed writing for Phoebe most, as she required the least tethering to demonstrable reality. Kudrow's daffy sensibility made it seem as if she were laughing at a joke that only she had heard. She appeared to exist on a notably different frequency than her friends, one that the writers frequently turned to as a counterpoint to the more emotionally nuanced existences of the other characters. By the fourth season, Phoebe was past due for her own emotional plotline.

Early in the season, writers began batting around ideas, and the suggestion bubbled up that Phoebe might serve as a surrogate for her brother, Frank Jr. (Giovanni Ribisi, who had also starred in Crane and Kauffman's *Family Album*), and his middle-aged wife, Alice (Debra Jo Rupp). But might Phoebe have more than one baby? Could she have twins? Could she have quintuplets?

Some writers were arguing that Phoebe could have eight babies and that an instant brood in her belly might make for a hilariously over-the-top plotline. Others insisted that eight was far too many and that the

story needed to be tempered so as to avoid being too physically danger-ous or too unbelievable. They eventually settled on three as the right number—ludicrous enough to be funny but not stretching the bounds of credulity.

Writer Jill Condon was in the shower one morning, pondering the story, when she had a brainstorm: Phoebe should talk to the embryos. She should hold the petri dish with the embryos and implore them to hold on for her brother and sister-in-law's sake. There was never any guarantee, on a show as team-written as *Friends,* that any idea would make it into the script, but as soon as Condon thought of it, she was confident that, unless she was wildly wrong, this moment was likely to make it onto television. It was just what the episode needed. Sure enough, when Condon pitched the idea to the room, David Crane re-sponded enthusiastically: "Let's definitely put that in."

The sentiment in the writers' room was that so overtly sentimental a story needed a more straightforward, comedic B-plot. Seth Kurland emerged with the idea of pitting the remaining characters against each other in a trivia contest, inspired by some screenwriter friends, includ-ing future *Kiss Kiss Bang Bang* director Shane Black, who had held a similar competition, which they called the Pad O' Jeopardy, in their apartment, dubbed the Pad O' Guys. Given how extensively the *Friends* characters were invested in each other's lives, wouldn't it be funny to see what they did and did not know about each other?

The writers determined that it would work best as a male vs. female competition, with each team trying to stump the other with the hardest questions they could come up with about their friends. But what could they bet that would provide significant enough stakes to care about? Someone proposed Monica and Rachel betting their apartment on the outcome of the contest, and a quiet moan rippled through the room. This was a flagrant instance of "schmuck bait" storytelling at its most obvious.

"Schmuck bait" was something that tempted the more gullible members of the audience with the promise of enormous changes that

more discerning watchers would instantly realize could never actually happen. Schmuck-bait storytelling was a prime example of the kind of lazy, clichéd, corner-cutting work *Friends* eschewed. The writers agreed that they were all better than that.

Then David Crane piped up: "Let's just keep the guys in the girls' apartment." And what had been a tremor of dissatisfaction over bland writing transformed into excitement over a genuine surprise in the works. Condon believed that one of the greatest pleasures television could deliver was a plot development that viewers did not see coming. Very early in the process of writing "The One with the Embryos" (which Crane would later wish he had called "The One with the Contest"), almost the entire writing staff got caught up in the joy of planning a well-executed twist. The girls were going to lose their apartment. Marta Kauffman never bought it, arguing that it stretched the bounds of credulity, but allowed everyone to carry on nonetheless.

"The One with the Embryos" wound up being one of the fastest *Friends* episodes to come together, and, according to Andrew Reich, one of the most enjoyable. "Embryos" departs from *Friends* orthodoxy by eschewing the traditional A-B-C story split; this episode has no C plotline, toggling between only two stories. After a late-night disruption courtesy of Joey and Chandler's chick ("The vet seems to think that she's becoming a rooster. We're getting a second opinion"), the boys gather in Monica and Rachel's apartment the next day and take in the lay of the land.

Joey instantly knows that Monica is wearing her "old-lady underpants" because today is laundry day. Chandler tops him, pointing to Monica and noting that she prefers to eat Tic Tacs in even numbers (a habit that actually belonged to Condon's father) and revealing that Rachel's grocery bag contains a half-eaten box of cookies. Chandler bets the girls $10 that he and Joey can guess all five of the other items in Rachel's bag. They easily rattle off the first four (apples, tortilla chips, diet soda, yogurt), then are stymied by the fifth.

Chandler whispers urgently in Joey's ear, who shakes his head fiercely: "No, no—not for like another two weeks." Joey, a savant of women's bodies, finds that his wisdom extends to knowledge of their menstrual cycles, but this wicked joke also reveals something about the intense awareness of each other's lives that is the bread and butter of *Friends*. The secret of *Friends* is that, ultimately, there are no secrets. Everything eventually sees the light, including what day Rachel is due to have her period. They agree to hold a competition, with Ross as host and quizmaster, and $100 now on the line.

In the next scene, Phoebe is in the doctor's office, where she is surprised to discover that she is having five embryos implanted simultaneously. Frank Jr. and Alice are using all their savings on this one round of implantation, and Phoebe realizes the stakes for her brother.

The remaining friends sit around at home with dreamy looks, taking in the idea of Phoebe's carrying a baby, before jumping up excitedly when Ross makes his announcement: "The test is ready." There will be ten questions for each team, broken down into four categories: Fears and Pet Peeves, Ancient History, Literature, and It's All Relative. The early questions are handled with flair. Monica's pet peeve is animals dressed as humans, and Chandler is scared by Michael Flatley. ("His legs flail about as if independent from his body," Chandler moans.)

Ross asks Monica and Rachel what name appears on the address label of Joey and Chandler's *TV Guide*. Rachel leaps up and says it's Chandler's magazine, only to be corrected by Ross. The *TV Guide* is addressed, he tells her, to Chanandler Bong. Monica, intense as ever, turns to Rachel with displeasure: "Rachel, use your head." Chandler gently corrects Ross, telling him that the *TV Guide* is actually addressed to "*Miss* Chanandler Bong."

Phoebe is back with the embryos and greets them politely, waving at their petri dish: "I'm hoping to be your uterus for the next nine months." She decides to give them a pep talk before they are inserted into her: "We're doing this for Frank and Alice, who you know—you've

been there! You know, they want you so much, so when you guys get in there, really grab on." It is a surprisingly emotional moment, with Kudrow, dressed in a hospital gown, shot from above to emphasize her heavy eyelids and the creases lining her forehead. There are laughs in this sequence, but we feel Phoebe's emotion here, her desire to come through for her family in a moment of need.

During the writing process for the episode, Condon obsessively labored over Phoebe's speech to the embryos and felt like she never got it quite right. Once she brought her script back to the room, Crane took a look at the speech and, along with Wil Calhoun, one of the few writers with children, began searching for a more emotional tenor. Condon was still worrying over the sequence and approached Crane. Would it be all right, she wondered, if she took another crack at Phoebe's dialogue? It still was not quite the moment she had envisioned in her mind when the initial burst of inspiration had struck in the shower. Crane agreed, and Condon was moved by his remarkable generosity. He was the boss, but he would never be the one to say that once his golden hands had touched a scene, it was perfect. If someone was volunteering to work even harder on a scene to get it right, Crane would gladly accept their labor.

Back in the apartment, after the name of Chandler's father's all-male burlesque show comes up (Viva Las Gaygas), Ross announces, with the appropriate ring of fervor, the commencement of "the Lightning Round." (He has even made small lightning bolts on his notecards.) The intensity has been cranked up a notch, with Monica telling the boys, "You guys are dead. I am so good at lightning rounds." Chandler has been inspired to compete as well and rouses himself from his usual slumber of apathy to form a solid comeback: "I majored in lightning rounds."

"Wanna bet?" Monica asks. "I'm so confused as to what we've been doing so far," Chandler cracks, but Monica has a bigger pot in mind. Ross, playing the unctuous game-show host, if only in his mind, restates every offer and counteroffer in a hushed tone. When Monica suggests that the boys get rid of the rooster if they win, Rachel is intrigued by the stakes: "Ooh, that's interesting." Rachel then proceeds to up the stakes,

wanting the duck thrown in as well ("He gets the other one all riled up"). Chandler accepts, suggesting that if he and Joey win, they get Monica and Rachel's apartment. Monica is at her best when she is at her most crazed, and Cox demonstrates the control freak's buried desire to throw caution to the wind. Risk is her drug.

The trivia game demonstrates Ross's sustained attention to the pasts and foibles of his friends that aligns with the show's. *Friends* is a show about loyalty. "The One with the Embryos" is so successful because it is, among other things, a demonstration of that loyalty and that deep knowledge. It was also an opportunity for the audience to insert themselves into the action. The audience was committed to *Friends* like the show's characters were committed to each other, and the characters' impressive familiarity with the mundane details of each other's lives was a symbolic stand-in for the audience's bottomless interest in accruing that same knowledge.

Fans hungered to know as much about *Friends'* characters as they did, and the brief lightning-round peek into the secrets of their lives was profoundly pleasurable not just because it was funny, but because it satiated the audience's cravings. We, too, wanted to know that Rachel claimed her favorite movie was *Dangerous Liaisons* when it was really *Weekend at Bernie's*, or that Monica's nickname had once been Big Fat Goalie, or the precise number of differing categories of towels Monica had. (Joey and Chandler begin listing some of them—Everyday Use, Fancy, Guest, Fancy Guest—before Joey correctly blurts out "eleven.")

Joey and Chandler acquit themselves well, and it is now Rachel and Monica's turn to answer questions. They know that Joey's imaginary friend was Maurice the space cowboy but are unaware that Chandler was nineteen when he first touched a woman's breast. They are en route to victory when Ross stumps them with a hilariously basic question: "What is Chandler Bing's job?" Amy Toomin and Condon's script brilliantly plays off a latent ambiguity in the show, in which we occasionally see Chandler at work but rarely understand what he is actually doing, beyond its being some fatally bland white-collar drudgery. We, too, cannot

really say what it is that Chandler does for a living, and the surprise question is a reminder that the show does not care all that much, either.

Rachel and Monica freeze, then clutch at each other. "Oh gosh," Rachel moans, "it has something to do with numbers."

"And processing!" Monica shouts.

"And he carries a briefcase," Rachel unhelpfully adds. Ross jumps in to tell them that they need this answer or they will lose the game.

"It has something to do with—transponding," says Monica, circling her hands around an invisible globe.

"Oh! Oh! Oh!" Rachel leaps and points in Chandler's direction. "He's a transpond—transpondster!"

Aniston's bobble on the final word underscores the ludicrousness of the moment, in which Rachel has convinced herself her friend has a job she struggles to even pronounce. Monica swivels in her direction, stunned and appalled: "That's not even a word!" Ross's game clock lets out a tinny beep, and Monica releases a primal howl of shock and dismay. Meanwhile, Joey and Chandler leap into the air with delight, their impulsive bet paying off in a fashion they could never have conceived of.

Monica is sure she can salvage the situation and offers to go double-or-nothing. Chandler responds with fake politesse, quietly telling her, "I would never bet this apartment. It's too nice." Rachel declares that she refuses to move, and Monica berates her, telling her that their loss is entirely her fault. (Needless to say, Monica could not come up with Chandler's job title, either.) "That is a boys' apartment," Rachel complains about her proposed new home. "It's dirty and it smells!"

For *Friends*, the differing plots were meant to not merely exist in parallel with each other but intersect, and occasionally echo, each other. Phoebe appears in the next scene, lying upside down in one of Monica and Rachel's chairs ("I'm going to let gravity do its job") and strumming a guitar as she sings to the embryos inside her: "Are you in there, little fetus? In nine months will you come greet us? I will buy you some Adidas."

Frank Jr. and Alice come over with a dubious gift of a lollipop and a

home-pregnancy test, and Alice, in true teacher fashion, makes a corny joke out of asking if Phoebe is in the mood to take a one-question exam. Phoebe reluctantly agrees, and disappears into the bathroom as the apartment argument flares up once more.

In one of the most iconic moments of *Friends'* ten-year run, destined to be repeated in practically every future montage sequence for the show, Chandler is wheeled in riding Joey's dog sculpture, a slacker monarch wielding a sandwich as his scepter. Jill Condon was fixated on the horrifying ceramic dog that Joey had purchased for his short-lived uptown apartment in "The One Where Eddie Moves In" and that had been rescued by Ross when the repo men had arrived to take it away. It was the ideal symbol of the boys' tacky sensibility and precisely the kind of piece that would upend Monica's tasteful décor. What if Chandler came into his new apartment riding the ceramic dog? Assistant director Ben Weiss placed the dog on a dolly and had it rolled into the apartment.

Writing for television meant imagining words and actions that would be carried out by actors. The results were rarely as viscerally satisfying as the pleasure of solving a narrative problem. But in this case, when Condon stood on the set and watched the door to the apartment open and Matthew Perry fling his arms wide with glee, she felt a rush of satisfaction. This was every bit as good as she had hoped it would be.

"You are mean boys who are just being mean!" Rachel childishly grouses at Chandler's lavish display of triumph. Chandler continues to milk the situation for every ounce of aggravation he can, mock-pleading with everyone: "Would you all stop yelling in our apartment? You are *ruining* moving day for us." That Chandler is eating a sandwich as he speaks undercuts his authority, and also emphasizes the extent to which this entire apartment switch is a marvelous lark for the boys at the same time that it is a life-changing catastrophe for Rachel and Monica.

The shouting is reaching a new crescendo of outrage and displeasure when Phoebe, forgotten already, reemerges from the bathroom with a white stick in hand, anxious to share her news: "You guys, you're going to have a baby. They're going to have a baby!" Frank Jr., clad in an

unflattering gray Members Only jacket zipped up to his throat, raises his arms in *Rocky*-esque triumph: "My sister's going to have my baby!" Everyone spontaneously gathers to enfold Phoebe in a group hug.

"The One with the Embryos" craftily alternates between its major and minor plots, between weightless twentysomething antics and significant life changes. Condon and Toomin's script expertly switches between the two, letting us sink into the endlessly charming mire of the apartment competition before yanking the floor out with Phoebe's unexpected announcement.

Friends is charming for its big-picture portrait of how being young and confused and free gradually evolves into being older and wiser and more rooted, but also for its abiding interest in the absurdities of youth. Phoebe's announcement is the emotional high point of "The One with the Embryos," but the episode prefers to end with an image of Joey and Chandler, ensconced in their new apartment, simultaneously leaning back in their painfully ugly, overstuffed leather recliners, releasing twin grunts of pleasure. (The presence of the chairs themselves was inspired by Ira Ungerleider's attempt, once upon a time, to stay in his La-Z-Boy for an entire weekend.) They proceed to lean back even farther, now both practically recumbent and giddy with pleasure. This is their home now.

"Embryos" was a triumph for emphasizing a certain tendency in *Friends'* handling of its characters that had previously gone mostly unmentioned. What prior sitcom had expressed so deep an interest in its protagonists' past lives? Most sitcoms existed in an eternal present, where little change was encouraged or acknowledged, and the past was generally a single, flat narrative arc—Mary Richards moving to Minneapolis, or Gilligan and his friends washing up on a desert island. The idea of mining characters' histories for narrative material was foreign to the sitcom. But from the very outset, *Friends* was telling us about what had already happened to its characters elsewhere.

"The One Where Monica Gets a Roommate"—Rachel (Jennifer Aniston) arrives at Central Perk in her wedding dress in the series' pilot episode, having fled her own wedding. NBCU Photo Bank © 1994/NBCUniversal/Getty Images

"The One Where Ross and Rachel . . . You Know"—Chandler and Joey's goofy, deeply committed friendship was only enhanced by the arrival of their matching Barcaloungers. Their grunts of satisfaction at fully reclining were the perfect expression of their doofusy delight in small pleasures. *Paul Drinkwater/NBC/NBCU Photo Bank © 1996/NBCUniversal/Getty Images*

"The One Where No One's Ready"—"I'm Chandler. Could I *be* wearing any more clothes?" Joey (Matt LeBlanc) does lunges in front of his roommate, Chandler (Matthew Perry), while clad in the entirety of his wardrobe. NBCU Photo Bank © 1996/NBCUniversal/Getty Images

"The One with the Embryos"—Chandler and Joey celebrate their incredible good fortune at winning the trivia contest and taking possession of Rachel and Monica's apartment. *J. Delvalle © 1998/NBCUniversal/Getty Images*

"The One in Vegas"—Ross (David Schwimmer) pleads for absolution in a Las Vegas hotel room as Rachel (Jennifer Aniston) displays her surprisingly trim goatee, drawn on with a Sharpie as a prank gone terribly wrong. NBC/NBCU Photo Bank © 1999/NBCUniversal/Getty Images

MATTHEW 8/19

SCHWIM 11-2

Polaroids taken on set of the show's stars Matthew Perry, Matt LeBlanc, Jennifer Aniston, and David Schwimmer. (David Crane appears in the background of Aniston's shot.)

Jennifer Aniston and set decorator Greg Grande wielding celebratory cigars on set.

465·265 D

465-265 D

Polaroids taken of the kitchen and living room of Chandler
and Joey's apartment. The famed Laurel and Hardy
poster appears on the wall behind the television.

466 621 (97·98)

Photos taken of the kitchen and living room sets of Monica
and Rachel's apartment. Note the "Cookie Time" clock
and the chef figurine on the stove.

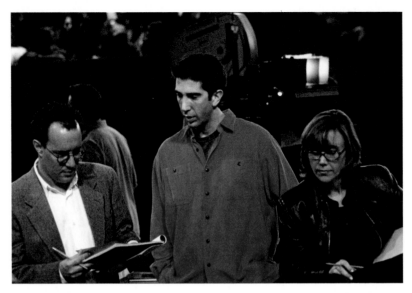

David Schwimmer, directing the episode "The One on the Last Night," looks over David Crane's shoulder as Crane consults the script. NBC/NBCU Photo Bank © 1999/NBCUniversal/Getty Images

"The One Where the Stripper Cries"—The show particularly enjoyed mocking 1980s fashion in its flashback episodes. Note the very uncomfortable fat suit worn by Monica (Courteney Cox). NBCU Photo Bank © 2004/NBCUniversal/ Getty Images

David Crane accepts the Emmy for Outstanding Comedy Series at the 2002 Emmys, flanked by *Friends* cocreators Kevin Bright and Marta Kauffman. Frank Micelotta/ImageDirect © 2002/NBCUniversal/Getty Images

The cast and creators of Friends, along with Warner Bros.' executives, gather in front of the *Friends* stage during the tenth and final season of the show. The back row includes (beginning third from left) David Crane, Marta Kauffman, and Kevin Bright. NBC/NBCU Photo Bank © 2004/NBCUniversal/Getty Images

The cast of *Friends* (minus Matthew Perry) feting James Burrows at a televised 2016 tribute to the legendary director's legacy. Chris Haston/NBCU Photo Bank © 2016/NBCUniversal/Getty Images

The show parceled out bits of the past in tantalizingly small dollops. "The One with the Embryos" gave us a heaping helping of information, but most episodes preferred to stop at a stray reference or two, understanding that the past was an endlessly renewable storytelling resource that it would be wise to use sparingly.

The technique allowed *Friends* to gesture at a seemingly bottomless reservoir of past adventures. For each character, the glimpses of their past, in both flashback episodes and persistent chatter, offered some additional clarity about their lives prior to Rachel's arrival at Central Perk.

The characters were obsessed with their pasts: with how to re-create them, undo them, or eclipse them. Over ten seasons, we learn that Chandler attended an all-boys boarding school, where he played the clarinet, was voted class clown, and thought scale models were cool. His father liked to dress in fishnet stockings and was caught making out with the pool boy. He was once kidnapped by his father after Cub Scouts, took a mime class in college, and broke up with his summer-camp girlfriend because she had gotten fat. He regularly wet the bed after his parents got divorced.

Rachel's father purchased her a boat when she was fifteen (her pony was sick, she explained). She was prom queen, class president, and homecoming queen; had sex with Billy Dreskin on her father's bed in high school; kissed her sorority sister (played by Winona Ryder) after drinking too much sangria senior year of college; and developed a crush on Joey the first time they met.

Monica weighed two hundred pounds at the age of eleven, and in her earlier, lighter years, enjoyed riding the family dog, Chichi. She hated Ross as a kid and once broke his nose while playing football, and her eating habits taught Ross the mantra "Eat fast or don't eat." Her ex-boyfriend Kip was once a key part of their group, only to be excommunicated after the two broke up.

Joey, whose early life we know the least of, once sold T-shirts during spring break in Daytona Beach, played a copy-machine repairman in a porn film, and assumed on their first meeting that Chandler was gay.

He had seven dark-haired, outspoken sisters whom Chandler could not keep track of, and his father regularly cheated on his mother—with her blessing, as it turned out.

Phoebe and Monica were once roommates, but Phoebe moved out because of Monica's neat-freak tendencies. Phoebe's stepfather was in prison, and she believed her father was a tree surgeon living in a hut in Burma. (He was actually, as she later discovered, a pharmacist in up-state New York.) Her stepfather would sell blood on her birthdays in order to afford food for the family. She dwelled on the streets of New York starting at the age of fourteen, never attended high school, and once lived in Prague. She was living in a Gremlin at the age of eighteen with a guy named Cindy who enjoyed talking to his own hand. She got hepatitis from a pimp's spitting in her mouth, and as a teenager un-knowingly mugged Ross on his way out of a comic-book store. She mar-ried a gay ice dancer (Steve Zahn) who turned out to be not entirely gay.

Ross's childhood report cards were all A's except for gym class. He skipped fourth grade. As a child, he enjoyed dressing up in his mother's clothes, pretending to be a middle-aged woman named Bea. He was once so jealous that it was Monica's birthday that he yanked on his tes-ticles and had to go to the emergency room.

Ross was a painfully awkward adolescent in love with beautiful queen bee Rachel. In high school, he belonged to the "I Hate Rachel Green Club" along with his friend Will (Brad Pitt). He received a 1450 on his SATs, or so he said; Monica reminded him that he actually got a 1250.

As a junior in college, he went to Disneyland with Chandler and ate ten tacos from a hibachi in a stranger's trunk in the parking lot, causing the park to temporarily be renamed "the Crappiest Place on Earth." In an alternate-universe episode, he once had a threesome with Carol and Susan in which he was mostly left holding the women's coats.

The deliciously slow drip of information about the show's characters was a brilliant strategy of encouraging viewers to think of *Friends* as an extension of their own social life. Crane was adamant from the outset

that he would not engage in the blatant exposition that many other sit-coms felt the need for. There was nothing more loathsome, in his mind, than the kind of pandering that shows often did in order to rapidly explain how their characters knew each other.

Crane refused to immediately clarify just how it was that these six characters had become a crew and preferred to let it unfold over the course of the first few episodes, to the dissatisfaction of the critics who reviewed the show. That deliberate reticence, in which the show held back information from its audience, encouraged *Friends*' desire to continue filling in details long after another show would have settled into an eternal present.

The past was prologue for *Friends* because it was a helpful participant in the illusion the show sought to form. *Friends* was silently devoted to the proposition that its characters were our friends. Watching a new episode was like coming home.

CHAPTER 13

THAT ONE DIDN'T SUCK

Producing the Show

On the day during the 1997–98 season Tate Donovan first came to the *Friends* set as a performer, ready to play Rachel Green's new love interest, Joshua, he believed he knew where to go. When the production assistant tasked with escorting Donovan offered to show him to where he would get prepared, Donovan began heading toward the dressing rooms. "We've got a lot of actors," the production assistant told Donovan, guiding him in another direction.

Donovan followed him down a long corridor, out of the soundstage, and along an alleyway. They finally arrived at a trailer that Donovan thought would have been appropriate for a bit player from the 1940s. It was a rickety wooden contraption with a ragged bit of carpeting on the floor, no running water, and no air-conditioning. It was swelteringly hot. Donovan saw his wardrobe inside and a note from the producers that read, "Welcome to the show! We're so happy to have you!" Donovan gulped and made his way inside, ready to prepare himself for his performance.

All dressed, Donovan returned to the soundstage, where the cast

was gathered, silently staring at him, expectant. When nothing was forthcoming from Donovan, a collective groan emerged from the stars of *Friends*. "You're the worst!" one of them shouted. "You're the worst person to play a practical joke on! You won't even complain about the worst dressing room in the world!"

The idea of guest-starring on *Friends* was stressful, with Donovan, a regular in the show's privileged inner sphere in its early years as Jennifer Aniston's longtime boyfriend, feeling concerned about being perceived as an idiot who fell into a role on his girlfriend's show and tripped over his own shoelaces. Donovan could only imagine how much more stressful it would have to be to carry the show, and to know that tens of millions of lay critics would be assessing your performance, week in and week out. He began taking mental notes to see how they coped with the challenge of *Friends*.

By the time Donovan met Aniston, *Friends* was already a phenomenon, and its stars had formed a closed circle to protect themselves against the prying eyes of the world. Donovan would hang out in Aniston's dressing room before rehearsal was about to begin and watch Matthew Perry amble by, his pants around his ankles, pretending as if nothing was the matter. Comedically speaking, at least, Perry was the leader of the group. Everyone had adopted Perry's semisarcastic, stating-the-obvious-with-a-twist style as their own when the six actors hung out together.

Courteney Cox had been the most famous performer on the show when it premiered and could have seen herself as having the most to protect, but Donovan was amazed at how much she might reveal about herself in a ten-minute conversation. He would come away fully caught up on her diet problems, her cosmetic regimen, her personal life, and a host of other topics to boot.

Donovan particularly liked Lisa Kudrow and her husband. He and Aniston spent a Christmas in Hawaii together with them, and Donovan found them easy to talk to. The three of them found they had a great deal to say to each other about theater and books and culture.

Matt LeBlanc was the kind of guy who would wrap his arm around you and make you feel welcome wherever you were. Of all the show's stars, David Schwimmer was the toughest to befriend, initially. Schwimmer, who eventually warmed up, was every bit as competitive in real life as Ross was in the first season's "The One with All the Poker." Donovan remembered playing volleyball with Schwimmer and being taken aback to find Schwimmer maniacally spiking the ball, as if he were intent on ritually slaughtering his opponents.

And as a regular attendee at the weekly tapings of *Friends*, Donovan would sit in the audience and watch his girlfriend perform, and be stunned by her versatility. Not only was Aniston beautiful, he thought, she was an incredibly gifted actor. And while Donovan suspected comedy was not even her strongest suit as an actor, she was remarkably good in every scene she was in.

Given the intense pressure of the outside world, it was substantially easier for the stars of *Friends* to share their private lives with their costars as well. There was an entire solar system of false or misleading or intrusive information out there about each of them, and a nation of hungry gossip readers desperate for a glimpse of their favorite friends. All of which made it more pleasant to celebrate birthdays together or get together at each other's houses on weekends. The tabloid stress made them even closer than they might have been otherwise. It was an education to be inside the bubble of stardom.

———

After the first season, which worked on a Tuesday shooting schedule to accommodate James Burrows, *Friends* episodes were traditionally made over a five-day stretch, beginning on Mondays with a table read and ending in front of an audience on Friday evenings. The first three days were devoted to rehearsal, with the cast and director walking through the week's script. Those Mondays, Tuesdays, and Wednesdays made television feel like a theatrical production, with no cameras or technical crew present. It was the actors alone in a room with that week's chosen

director, working through the scenes, figuring out blocking, entrances and exits, and the nuances of line delivery. The director would also sit in on a tone meeting with Kauffman and Crane, in which they would be walked through the nuances of the script. Early in the season, the script would have been long since completed. By the end of the season, scripts would still be labored over in the writers' room until just before the week started.

Kauffman saw every possible variety of acting prep during her tenure at *Friends*. Sometimes actors would come in and nail their performance during the first table read, and then spend the entire week trying to get back to where they had started. Others would whiff at the table read but steadily build their performance until they were ready by Friday.

At the end of the day on Tuesday and Wednesday, the cast would do a full run-through of the episode for the writing staff. This was generally the first opportunity the writing staff had to see their script performed, and the run-through would serve as a chance for both the writers and the performers to identify which parts of the script did and did not work. The run-throughs on Tuesdays and Wednesdays would also give the writers and showrunners an opportunity to provide notes to the directors. If they felt that certain lines were not being struck properly or wanted to change the orientation of certain scenes, they would speak to that week's director and make suggestions about how to rework a given moment. The cast could also ask questions or make suggestions about potential changes to the script.

Most weeks, the writer of the episode—the person who had been designated by Crane and Kauffman to get the writing credit, the team nature of the effort notwithstanding—would be on set, there to field questions and concerns from the performers. "Is there a better joke here?" they would sometimes be asked, and the writer would bring the request back upstairs to be fulfilled. Everyone was expected to be professionally and emotionally invested in making the show the best it could be. Producer Todd Stevens had once been disturbed by a persistent hum

of background noise during a run-through, and had stormed backstage to discover a crew member eating Triscuits with peanut butter and watching television. Stevens fired him on the spot.

During this early part of the week, potential weaknesses with the story were identified, and the writing staff was dispatched to repair faulty or misshapen lines, or offer alternate suggestions for actors struggling with a particular word or phrase. There were times, as well, when entire plotlines fell apart on first impact with performance, and the writers would have to leap into action to repair a damaged story line or replace it wholesale—even as they were engaged in writing new episodes for the weeks to come.

In the pre-Internet era, production assistants would have to physically deliver updated copies of the script to the performers, producers, crew members, network execs, and Warner Bros. staff assigned to the show. Starting from the table read, each night ended with a PA delivering three hundred updated scripts to people's homes and offices, whether it was ten P.M. or five A.M.

Scripts would come in in various states of repair, often depending on their placement in the season. Early in the season, the cast would often work with crisp scripts that had been polished in the off-season. By the end of the season, the pressure of writing twenty-four new scripts each season began to add up, and it was notably more likely that unpolished or crude material might be in need of major revisions. Tuesday's run-through would generally send the writers back to repair or adjust their script, often substantially, and Wednesday's run-through reflected those changes.

Meanwhile, the producers and crew were busy preparing new sets for that week's episode. Some episodes might not venture beyond Central Perk and the familiar apartment sets. Others might require new workplaces, doctors' offices, apartments, or even more. The tackle-football game in "The One with the Football" demanded the use of an entire second soundstage to fill the role of a public park.

The crew often faced significant challenges turning around needed

props and sets under such conditions. During the week of shooting "The One with the Dollhouse," property master Marjorie Coster-Praytor had to spend her time traveling from shoe store to shoe store and asking if she could purchase any shoeboxes from them. To design a charmingly homemade dollhouse for Phoebe, she would need about ten shoeboxes. And since the dollhouse would eventually catch fire, Coster-Praytor had to build six separate models, meaning she was in search of sixty shoeboxes in total. When shoe stores could not provide enough, Coster-Praytor was reduced to begging wardrobe for spare shoeboxes.

Meanwhile, she was also shopping for a Victorian-style dollhouse that might serve as Monica's cherished inheritance, finding one she liked at a miniature-specialty store and asking them to refurbish it to her specifications. Miracles like this would have to be accomplished every week on *Friends*. At the end of the episode, Coster-Praytor burst into tears watching Phoebe's dollhouse, over which she had taken such pains, burn.

And sometimes the crew's work was a collective endeavor. Coster-Praytor was tasked with the challenge of determining just what the giant poking device, used to prod Monica and Rachel's recumbent, and possibly dead, neighbor Ugly Naked Guy in "The One with the Giant Poking Device," might be made from. It was ultimately Matt LeBlanc, who loved to visit the props department and see what they were working on, who suggested just the right type of aluminum to purchase.

Thursday was camera lock-in day. The work of the prior three days was presented to the crew, who layered in their contributions. The camera crew took note of, and occasionally adjusted, the blocking. The sound crew figured out how best to capture the dialogue. There were further rehearsals, but the process no longer felt like a theatrical production. This was now clearly a television show, and many of the decisions and fixes made on Thursdays came from taking the preceding three days' work and translating it for the necessities of television.

Kauffman spent Thursdays working with the actors on set, making

sure that they understood the writers' intentions with a given scene and bringing material back to the writers to rework if the actors were still struggling with it. After the day's run-through, Kauffman huddled with the director and gave them notes to pass along to the actors. The actors occasionally approached Kauffman directly, looking for guidance about what the writers were looking for.

Many parents worked on the *Friends* crew, Marta Kauffman among them, and Kauffman arranged for a room on the soundstage to be repurposed as a nursery. Parents could bring in their babies or toddlers along with a caregiver, providing a day-care-like environment that might partially offset the long hours that came with working on *Friends*. Kauffman particularly enjoyed the early evenings, when writers would often bring in their families, as well, and the sound of children running down the hallways would echo through the *Friends* offices. Writer Michael Curtis once spotted his five-year-old son playing Nintendo 64 in a back room with Matt LeBlanc, Matthew Perry, and David Schwimmer, and told himself regretfully: "He's never going to remember this."

Fridays got a somewhat later start, with the cast and director arriving in the early afternoon for a camera refresh, where the crew ensured that every aspect of the forthcoming shoot was in its proper place. Everyone took a lengthy break for an early dinner while the audience was invited in for the shoot. Kauffman, accompanied by costume designer Debra McGuire, made it a regular habit to light Shabbat candles on the set.

The shoot for a three-camera show like *Friends* generally took place in precisely the same order as the script—another way in which the production of a sitcom came to resemble a play. Shooting a single twenty-two-minute episode might take eight hours, lasting until midnight or later, depending on the necessity for last-minute script changes. The shoots would regularly run two or three hours longer than they had in the Burrows era.

In other circumstances, the showrunners' perfectionist tendencies

might have been tempered by the fear that the audience would grow weary of the process and leave. Any further laughs coming from such a diminished audience would sound tinny and weak, even with a solid joke. But *Friends*—at least after its first season—never had to worry about such matters.

Friends was so popular that not only did it easily fill its studio audience, it had an entire second audience waiting in the wings on the Warner Bros. lot, content with watching on closed-circuit television. If anyone left, feeling like five hours was enough time to spend watching the *Friends* cast and crew put an episode together, replacement viewers could be drafted from the secondary audience. *Friends* fans were so devoted that they were willing to make a night of the probability of watching on closed-circuit TV, like a replacement juror sequestered alongside the rest of the jury.

The audience were arbiters of their success. If they received hearty laughs from the studio audience, the *Friends* staff was confident that the television audience would receive it with similar enthusiasm. The passionate devotion of their fans gave *Friends* a freedom other shows did not even know they lacked. On other soundstages, there might be a brisk writers' colloquium if a particular joke was not landing with audiences. The writers might be tasked with coming up with a better way of phrasing a joke, or even replacing a joke entirely if it was felt to be particularly clunky. *Friends'* showrunners, by comparison, had the luxury of stopping a taping midway through and rewriting an entire scene that wasn't working.

The writers would gather in a circle near the stage and huddle together, with Crane leading the impromptu conversation. The mood would be tense. Something the writers had carefully constructed had broken apart in public and would now have to be fixed as hundreds of people watched.

The idea of not only writing an episode of television but doing it against an incredibly short deadline, and in front of an audience of

strangers watching you do it, was terrifying for the writers forced to endure this trial by fire. A writers' assistant would be present, typing rapidly on a laptop to capture the staccato back-and-forth of suggestions for how to improve a scene. It was, Adam Chase thought, as if they had all already leapt off the cliff together. Having done that, they might as well do their best to aim for the water. And all the while, the audience would be watching Crane and the writers, as if they were junior-varsity performers called in to substitute for the fan favorites.

The lines would also have to be run by the actors. Andrew Reich was initially flummoxed by Lisa Kudrow's blank-faced response to one proposed change. As he began babbling about other suggestions, and panicking that Kudrow hated him, he realized she was just repeating the line to herself in her head. "Oh, yeah—that's funny," she told him. "Got it."

Once everyone was satisfied with a replacement scene, the new lines would be printed out, and the pages would be held up for the actors to study. They might look at the new script for thirty seconds and then declare themselves ready. An hour after the shoot was over, they would likely lack even the foggiest memory of what lines they had delivered, but in that moment, they drew on their ability to flash-memorize anything put before them.

Jeff Strauss, part of the first-season writing staff, was struck by the differences between *Friends*' natural tendencies and those of other television series. On other shows, Strauss knew, there was often a tendency to let talented performers carry weak material. The writers might know a particular joke or sequence was not up to par, but without the time to fix it, they would hope that their actors would be able to sell the scene nonetheless. Kauffman and Crane and Burrows were comfortable giving notes to their performers on the stage during a shoot, but it was noticeable to Strauss that their first instinct, when called in for triage on a malfunctioning scene, was to ask whether the writing might be improved, and if so, how it might be improved.

This was so thoroughly established as *Friends'* modus operandi that Strauss noticed the actors internalizing this state of affairs. After one particular run-through that had not gone well, Lisa Kudrow approached Strauss with a request. "Don't rewrite that," she asked him. "Let us do that better. We can do that better." Even early in the first season, the writers' room was unofficially considered the creative hub of *Friends* and the place where major changes were likely to be made.

Jennifer Aniston had a mantra that she would sometimes repeat after a particular scene hadn't worked on the first attempt. "Give me a second to find the funny," she would ask, and take a moment to recalibrate what she was doing. Sometimes, another actor would suggest an adjustment, and they would redo the scene with slight modifications. During the filming of "The One Where Ross Got High," David Schwimmer cracked up his costars by improvising the line "It tastes like feet" as they gamely attempted to swallow Rachel's misbegotten trifle. (Only Joey happily scarfs it down, running through a list of its ingredients as proof of its quality: "Custard? Good. Jam? Good. Meat? Good.")

"Well, that one didn't suck!" Kauffman and Chase would tell each other as another week's episode went into the can. And after the shoot was over, Kevin Bright would take the reins. The raw material would be sent over to the editing bay, and Bright would oversee the process of transforming the scenes they had shot into a crisply edited episode. *Friends* episodes often ran a few minutes long, and a major part of Bright's work was to trim away lesser jokes while leaving in both the best comic material and all the necessary emotional beats.

It would not always be easy to follow in James Burrows's footsteps and direct an episode of *Friends*. Some directors, like Gary Halvorson, fit in smoothly, while others found themselves overwhelmed by the work of steering so enormous a ship. Even experienced television directors could be surprised by the amount of work involved in helming *Friends*, and Bright and the crew were present to smoothly fill in if the job became too much. Having directed the first-season finale, Bright

stepped up to become a regular on the show, ultimately directing fifty-four episodes.

The crew could use the directors' call list as a cheat sheet for the emotional high points of the season to come. They knew that Bright would likely be directing the tent-pole episodes of the season, including the finale, and could use his assignments to guess which were likely to be the crucial installments. He might have been gunning for an Emmy, but he was also protecting the franchise. *Friends* could not afford to blow a big moment.

By his own estimation, Bright went too far in his attempt to erase the ghost of James Burrows. Where Burrows had been loose and reactive, Bright sought to capture the perfect shot in every scene. Bright initially neglected the needs of the actors, who rapidly grew frustrated with the excessive demands his style put on their time. A major part of Kevin Bright's ongoing education in the work of the television director was an appreciation that the best shot was not solely in the auteur's eye; it was also a matter of keeping his actors fresh and energetic. There was more to Burrows's loose style than he might have at first acknowledged.

A crucial element of many shoots was incorporating the guest performers who were to appear on *Friends* that week. The show's fixation on guest stars was something of a paradox. Early on, it had discovered that the audience really only wanted to see its six stars banter with each other. And yet, *Friends* was invested from the very start in familiar actors' playing supporting roles on the show. This was *Friends* goosing its own motor, using star power to provide a jolt to the ratings, but it was often the least compelling part of the episodes in which they appeared and a drag on the series as a whole.

Elliott Gould showed up in the second episode as Monica and Ross's father, and in the seasons that followed, everyone from Charlton Heston to Susan Sarandon to Reese Witherspoon was recruited to appear on the

show. *Friends* featured some of the biggest stars of the 1990s and early 2000s, from Julia Roberts to George Clooney to Alec Baldwin to Winona Ryder to Brad Pitt to Ben Stiller to Gary Oldman. Kevin Bright suspected that many stars were excited about appearing on *Friends* because of their children. A role on *Friends* would be something that stars' children could watch them in and even brag to their friends about.

Some were comedians given the chance to shine in a small role, like *Kids in the Hall* veteran Kevin McDonald, who played an herbalist Ross visits to clear up a mysterious growth on his butt, or *American Pie* star Jennifer Coolidge, who played an expat friend of Phoebe and Monica's who returns with a mysterious, Madonna-esque British accent. Others were familiar television faces, like *Full House*'s John Stamos as Chandler's sperm-donor recruit, or *Sex and the City*'s Kristin Davis as a girlfriend of Joey's with whom Phoebe and Rachel fall in love. The show incorporated boldface names from a previous generation, like Heston (playing himself, complete with gun and holster, in "The One with Joey's Dirty Day") and *That Girl* star Marlo Thomas as Rachel's mother. On other occasions, there was the dim bulb of recognition going off somewhere in the back of our minds: Isn't that Punky Brewster herself, Soleil Moon Frye, as the woman who likes to punch Joey a little too hard?

Perhaps the most memorable supporting role was granted to Tom Selleck, who played Richard, an ophthalmologist and family friend whom Monica falls for early in the second season. Richard is witty and self-contained and charming, and his character is a distinct rebuke to the callow boyfriends that streamed through the show before his arrival. Selleck, familiar to audiences from *Magnum, P.I.*, is a paragon of coolheaded masculinity, and his presence on *Friends* is a rolling joke, causing Joey and Chandler to seek to prove their own (admittedly questionable) manliness. In "The One Where Old Yeller Dies," Chandler begins growing a weedy mustache, and Joey rolls cigars between his fingers, each striving in his own puppy-love fashion to imitate Richard. But the age gap between Monica and Richard lingers. Richard hangs out

with Chandler and Joey, attending a Rangers game with them, but is dismayed to discover they think of him less as an older brother and more as a cool dad.

(Monica would later pursue Richard's son Timothy [Michael Vartan], a fellow ophthalmologist, further burnishing her credentials as a woman with a preference for inappropriate men. Ross once offhandedly remarks that if Monica and Timothy ever married, she could tell their children that she slept with their grandfather.)

In most cases, the writers would start with a character and then begin a discussion about who might play the role. Sometimes, they would know just whom they had in mind for a role. They knew they wanted Aniston's then-husband Brad Pitt as the Rachel Green–hating Thanksgiving guest for the eighth season's "The One with the Rumor," and they were intent on recruiting Kathleen Turner for the role of Chandler's father.

Producer Todd Stevens would often be charged with managing guest stars' tight schedules or handling their demands. Heston's scene was wrapped in only one hour. Marlo Thomas showed up on set with an entourage of assistants and a list of needs but was professional as soon as the cameras rolled. Some potential guest stars never made it to casting. There was talk of recruiting Owen Wilson to play a role, but after the writers read an interview in which Wilson said his biggest fault was giving writers a hard time, everyone collectively agreed that life was too short to deal with Owen Wilson's demands on the twentieth episode of the season.

The success of *Friends* transformed the set into a walled garden, beautiful but forbidding. Actors who had been on the show in its more playful early years noticed an increased distance from its stars in later seasons. The stars now read lines together in their dressing rooms. Guest stars were not included in these rehearsals, and while everyone was cordial and polite, there was little chance to get to know their costars or socialize with them. The set had been transformed into a refuge, a second home where its stars could be protected from the hunger of stardom.

The character actors were often amusing in small roles, but many of the above-the-line stars temporarily imported for *Friends* left an unpleasant aftertaste. Most gave solid performances, but their appearances implied that *Friends* was less a television show than a receptacle designed to maximize Nielsen ratings. Their presence felt like a contradiction in terms for a show that believed in the alchemical properties of its own stars. What were they here for, after all? *Friends* felt less confident in its own abilities when they showed up, and while past sitcoms had also occasionally leaned on star power to drum up excitement, the never-ending parade of guest stars made *Friends* sometimes feel like a marketing scheme and not a television show.

David Crane felt that Sean Penn had been particularly ill served by the show. What was the purpose of bringing in an Oscar-winning actor and then having him play a milquetoast boyfriend of Phoebe's? It was a role that anyone could have played, and Penn was not able to add much to the part, through no fault of his own. Similarly, Alec Baldwin would later demonstrate how brilliant a comedian he could be on another NBC sitcom, *30 Rock*, but was mostly wasted as another overly polite boyfriend of Phoebe's, who puts off her friends with his relentless optimism. The writers also sometimes boxed themselves into a corner with arcs they began but were never entirely sure how to conclude. Writer Andrew Reich thought Michael Rapaport's exit from the show, at the end of an arc as Phoebe's police-officer boyfriend, was particularly undignified; after shooting a bird from bed, he disappeared, never to return.

Actors did not always like how they were cast, either. During the third season of *Friends*, *Swingers* star Jon Favreau, who had auditioned for the role of Chandler, was cast as Pete, a regular customer of Monica's who enters into a halting romance with her. Pete was intended to be an Internet 1.0 dot-com billionaire, and the writers had in mind a sweet but geeky overgrown kid whom Monica slowly warms to.

Favreau never particularly liked the character and was not inclined

to play up the nerd-chic aspects of Pete that Crane and the writers had in mind. Eventually, Favreau's reluctance pushed Crane to adjust Pete's character arc. Favreau wanted Pete to be cooler than they had intended, and they agreed that Pete would discover a latent desire to be an ultimate fighting champion. The plotline was never one of *Friends'* most coherent (although Monica's uncovering the payment for a ring that turns out to be an ultimate fighting ring was a clever touch), but it kept Favreau pleased.

The most successful guest performances were by those performers who were able to slot themselves into the show's hothouse atmosphere and could capably play to type—or against it. Pitt was superb in the eighth season's "The One with the Rumor" as a high school classmate with a longstanding grudge against Rachel, leaning into the audience's knowledge of his relationship with Aniston to make something rich and joyous of his hatred. Sarandon is similarly sharp as an older soap opera actress who takes Joey under her wing, and then romances him, in "The One with Joey's New Brain."

It was easy to forget, too, how even movie stars could be rattled by the hunger of the live audience. Movie audiences were imaginary strangers, watching in a far-off theater at some future date; television audiences were sitting in front of you, thrilled and judgmental.

When Charlie Sheen appeared in the second season's "The One with the Chicken Pox," playing Phoebe's sailor boyfriend, director Michael Lembeck told Sheen that they would surprise the audience with his appearance. He should plan to wait for a roar of delighted applause on his arrival and pause for laughter after each line, so as not to step on any of his laughs.

Lembeck sat back and watched Sheen's entrance, and was puzzled when, after he delivered his first line, his gaze began to drift toward the camera aisle. Lembeck called cut, telling the audience that something had gone wrong with the cameras and they would need a minute to reset.

Lembeck pulled Sheen aside and asked him, "What's going on? Why are you looking at me?"

"Can you look at my legs?" Sheen asked.

"What are you talking about?" Lembeck replied, puzzled.

"Look at my legs!" Sheen insisted.

Lembeck looked down, and Sheen's legs were rattling. The star of *Platoon* and *Wall Street* was so nervous to be on the *Friends* soundstage that his body was shaking uncontrollably. Lembeck drafted Sheen's brother, actor Emilio Estevez, who was in the audience, to set up two director's chairs off in a corner and rub his back and quietly coax him to return to the stage.

This was a challenge, too, for performers not used to the rhythms of filming *Friends*. Kristin Dattilo, who played a pizza deliverywoman in "The One Where Ross Can't Flirt," struggled with the remarkable response some of the punch lines would get from the audience. After Ross flailingly attempted to banter with her about the properties of gas, she and David Schwimmer had to hold for upward of three minutes until the raucous audience settled down enough for them to continue. Dattilo had to remind herself not to break character. She had been in numerous sitcoms before but had never faced an audience as rowdy, or as excited to laugh, as that of *Friends*.

Friends depended on the wider audience's appreciation of these stars, but there were moments when the show miscalculated. Director Michael Lembeck remembered instructing Chris Isaak to pause for a roar of excitement when he took the stage in "The One After the Superbowl," and then being taken aback when the audience was entirely silent. They did not know who Isaak was.

Acting on *Friends*, whether as a star or a guest performer, meant coming face-to-face with the astounding power of the audience's love and desire, and a fear of what it might mean to let the audience down. Kristin Dattilo was in her dressing room preparing before the shoot when she was interrupted by the disarming sensation of the floor

beneath her shaking. Dattilo briefly wondered if Los Angeles had been struck by another earthquake before realizing that it was only the show's audience, anxiously anticipating the show, stomping their feet in unison. She was feeling in her body, as her bones rattled, what everyone else could only intuit: the passion that audiences had for *Friends*.

IT'S NOT OVER UNTIL SOMEONE SAYS I DO

The Ballad of Ross and Rachel, Part 3

Having given fans their happy ending, *Friends* audaciously snatched it back and demanded that audiences make their peace without Ross and Rachel. The door never fully closed on them, and the show repeatedly juked and feinted in the direction of bringing them back together without ever really doing so. It comes as a shock to later realize, near the end of the show's run, in thinking about Ross and Rachel as perpetually on the verge of getting back together, that they had in fact been apart for two-thirds of the show.

Ross and Rachel alternated between tenderness and juvenile bickering, never able to settle into a comfortable routine as friends. At the close of the third season, audiences were left to wonder which door Ross would enter at the beach house where the crew was staying: Rachel's or that of his girlfriend Bonnie (Christine Taylor). Ross and Rachel had kissed after she admitted she had broken up with him because she was mad, and all seemed on the brink of being restored.

The writers themselves did not know how they would resolve the cliffhanger; they weren't sure which door Ross would enter at the start

of the next season. So it was something of a surprise even to them that the fourth-season opener, "The One with the Jellyfish," would dispatch their romance with such brutal efficiency. Rachel's hopeful smile as he approaches her after choosing her door is heartbreaking, but soon, she hands Ross an eighteen-page letter to read at the end of a late night spent talking, and Ross accidentally falls asleep partway through.

"Does it?" Rachel asks him the next morning, and Ross, utterly clueless, stumbles his way into an answer: "It . . . does." Rachel hugs him with relief, and it is not until Ross finally reads the entire letter that he understands what he has agreed to. "It so does not!" he sulks to himself. Ross now realizes he has been asked if he can accept full responsibility for what went wrong in their relationship, so that Rachel can begin to trust him again. (The precise question, however strangely phrased, was "Does that seem like something you can do?") When Rachel gently slaps his face while telling him that he just needed a bit of maturity and perspective to see the error of his ways, Ross snaps.

There is an immediate cut to the kitchen, where Monica overhears Ross returning to his mantra, now delivered at maximal volume: "WE WERE ON A BREAK!" Ross goes on to critique not just the message but the medium itself: "It was five thirty in the morning. And you had *rambled* on for eighteen pages." He pauses, bending over to pick up his shoes before delivering the coup de grâce: "Front and back!"

The two lovers seem to bring out the absolute worst in each other, with Ross a petulant, whining pedant and Rachel a frosty queen bee. "I can't believe I even thought of getting back together with you," Rachel tells him. "We are so over." Ross makes a sad face and pretends to cry before snapping back into martial severity: "Fine by me!"

Rachel and Ross are apart but continue to define themselves by each other's absence. In "The One with Joey's New Girlfriend," they each wind up in an imaginary relationship—Rachel with a college student, Ross with a woman who is actually just using his services as a babysitter—out of the desire to reduce the other to hopeless jealousy.

Even when more serious relationships develop, they are continually

haunted by what once was. Ross begins to date visiting Brit Emily (Helen Baxendale), and when the two unexpectedly get engaged, Rachel tries her best to make her peace with it. "I'm happy for them," she announces, before getting flustered and aiming her sights a bit lower: "I'm working on it."

Rachel plans to skip the wedding, telling Monica, "It's Ross. How can I watch him get married?" "I'm not in love with Ross," she later says to Phoebe, fleshing out her thoughts. "I'm not going to Ross's wedding because he's my ex-boyfriend and that would be really uncomfortable, not because I'm still in love with him."

Rachel aggressively trims some flowers with a pair of scissors as she carries on: "Hey, I like Ross as much as the next guy. Clearly, I have feelings for him, but feelings don't mean love. Yeah, I still have loving feelings for Ross, you know—yeah! I have continuing feelings of love, but that doesn't mean that I'm still *in* love with him. I have sexual feelings for him, but I *do* love him." Rachel finally hears herself and leaps out of her chair, appalled: "Why didn't you tell me?"

Friends keeps its attention on Ross and Rachel by framing its emotional story lines through the perspective of their onetime and potentially future love. Ross is off to London to get married—to someone else—and somehow the show's big question is whether Rachel will attend. Admittedly, she has fantasies of breaking up the marriage before it even begins: "It's not over until someone says I do."

Even after Rachel arrives in London and merely offers Ross her fondest wishes, he cannot seem to shake the image of her from his mind, or the sound of her name from his lips. The fourth-season finale, "The One with Ross's Wedding," ends with Ross, gazing into Emily's eyes, repeating the minister's words with one crucial, accidental substitution: "I, Ross, take thee, Rachel . . ."

The writers did not know until late in the season just how they would end the wedding episode; they merely trusted themselves to come up with something memorable. Schwimmer was running lines when instead of saying, "Emily, the taxi's here," he said, "Rachel, the

taxi's here." Greg Malins turned to David Crane and said, "That's what happens." Ross would get his bride-to-be's name wrong. In that pre-Internet era, the writers frantically quizzed each other: Did anyone remember a plot turn like this before on television?

For someone who appears to live his life in a low hum of constant anxiety, flop sweat perpetually dripping off his forehead, Ross is notably calm in this moment of maximal erroneousness. He smiles sheepishly before restarting, this time taking care to actually insert the name of the woman he is set to marry. It is as if his mouth has spoken a truth that the rest of him is not ready to acknowledge, and he is momentarily at peace.

THEY DON'T KNOW THAT WE KNOW THEY KNOW WE KNOW

Bringing Chandler and Monica Together

It began as a whim. The process of mapping out a season of *Friends* was exhaustive, and the show's writers were intent on trotting out every possibility for a story arc, however dim its chances might be of making it to air. So when the second season was being planned, one of the writers tossed out an idea: "What if we get Chandler and Monica together?"

The thought was intended less as a permanent shift in the gravity of the series and more as a fun plotline, good for a few episodes before the status quo snapped back into place. But given how much of the first season was dedicated to Ross and Rachel's fitful courtship, and how much of the second season would likely continue along that track, the general consensus was that it would be far too much of a good thing to work in two romantic relationships among the show's six protagonists. Writer Shana Goldberg-Meehan thought it seemed "a little desperate."

The idea of bringing Monica and Chandler together was dropped, not to return until planning commenced for season 4. The showrunners were planning a season that would culminate in a visit to London, and Crane and Kauffman had determined that Ross would be marrying

someone—just whom, they did not know yet—in Britain. But what else might happen there?

The writers were put to work on hashing out plots, and an idea formed that Ross's getting married—for the second time, no less—would send the perpetually single Monica into an emotional tailspin. Worse yet, her disapproving parents would be there to further stir the pot. Her parents' hectoring could lead her to drink to excess at the wedding, but what else might she do?

Late one night, toward the end of the season, when stories had begun to run dry and inspiration was in short supply, the writers broke up into two rooms and were instructed to come back with ideas for the impending London episodes. When the room reconvened, a proposal emerged that Chandler and Monica would sleep together in London.

Almost instantly, the writers' room split into two divergent groups. On one side were the skeptics, who felt the show had enough romantic plotlines already. Creating another romantic encounter between the show's main characters would only feed the *Friends* naysayers, convinced that the series was merely an excuse to slap its attractive characters together. A Chandler-Monica plotline smacked of lazy storytelling, of simply running through all of *Friends'* romantic permutations until none were left. There was a fear, as well, that bringing Chandler and Monica together would be perceived as near-incestuous. *Friends* had done so much to establish a sibling vibe between its main characters, and to violate this might offend or dismay the show's audience.

Gathered on the other side of the debate were those writers who felt this was the ideal moment to hook up Chandler and Monica. Monica was feeling gloomy and self-pitying, and might seize on Chandler as an emotional chew toy in a dark moment.

Jill Condon, who came down firmly on the pro side of the debate, was thinking about destination weddings and the ways in which they could prompt people to act in ways they otherwise might not. Condon felt that if Chandler and Monica were together at Monica's apartment, inertia would forbid their taking so drastic a step, but being in another

country, surrounded by all the trappings of wedded bliss, would be another matter entirely.

No punches were thrown, but the two sides each felt passionate, and the argument in the writers' room carried on for some time, with each sure that the other was making a potentially series-altering mistake. Finally, those in favor of bringing Chandler and Monica together won out, with a consensus building around the idea of trotting this out as a wholly unexpected surprise.

Crucially, this idea was always and only intended to be a temporary one. At first, it was presumed that it would be a season-ending stinger—a hilarious capper for season 4, leaving fans buzzing but unlikely to result in any further developments. A few highly oblique hints earlier in the season alluded to the possibility of Chandler and Monica's getting together when it was still only under consideration. In the opening episode of the fourth season, "The One with the Jellyfish," where the six friends are on their beach trip, Chandler good-naturedly teases Monica about their going out together.

As they lie side by side on the beach, Chandler reframes the discussion: "All right, there's a nuclear holocaust. I'm the last man on earth. Would you go out with me?" Monica's response is priceless in its lack of enthusiasm: "Eh." Monica is later stung by a jellyfish, and Chandler, we eventually learn, must urinate on her to relieve the pain. At the close of the episode, Chandler comically pleads his case one final time, and Monica partially bends, offering Chandler her fondness and little more: "OK, all right. I think you're great. I think you're sweet and you're smart, and I love you." She pauses, and then presses on: "But you will always be the guy who peed on me."

Friends appeared to be closing the door on Chandler and Monica, although a lovelorn Chandler, heartbroken over his crush on Kathy, touchingly asked to sleep on her couch in "The One with Joey's New Girlfriend." Then the planning for London commenced in earnest, and the writers decided to expand the Chandler-Monica surprise. There would still be the shock of seeing them together in bed, but now we

would also get a touch of the aftermath—of their twin panic attacks at the thought of what they had done and of how their friends might respond if they found out.

London happened in large part because of VHS sales. *Friends* was an enormous hit across the world. Overseas, Warner Bros. had sought to capitalize on the success of *Friends* by releasing the show on videocassette for home viewers. (The show was on the air in numerous foreign countries, including the UK, Ireland, Australia, New Zealand, Canada, the Philippines, India, Greece, and Albania.) Word trickled out to Kevin Bright that Warner Bros. had sold $125 million worth of *Friends* videocassettes in the United Kingdom alone. He realized it was past time to rethink the potential of television on home video. He proposed a *Friends* video compilation for the American market to Warner Bros., who were initially lukewarm to the idea. The British were collectors, he was told, and Americans would refuse to pay for something they were already receiving for free. Eventually, Bright proposed including deleted scenes from episodes, and *The Best of Friends Volume 1* wound up selling over a million copies in the US.

Bright began thinking about the vast British audience for *Friends* videocassettes and came to the realization that finding a credible reason for *Friends* to film in London could make for a remarkable coup. And once he commenced planning, he decided that it might be more feasible than he had initially thought. If *Friends* were to film its fourth-season finale, in which Ross was to get married, on the lot in Los Angeles, they would still have to build all-new sets for the church, reception hall, and hotel rooms. The differences in cost between building the sets on the Warner Bros. lot and in Britain would be minimal.

Still, the cost of transporting hundreds of crew members across the Atlantic, along with thousands of pounds of equipment, was prohibitive. Bright was approached by Virgin mogul and virtuoso self-promoter Richard Branson, who offered to provide seventy-five upper-class tickets on his Virgin airline with only one proviso: He wanted to appear on the

show. Bright gulped, and agreed to approach the show's writing staff with an awkward request: Please find a role that Richard Branson might play.

Set decorator Greg Grande went out to London a month early to scout locations and prepare sets. The wedding would take place in a burned-out church. And while the scenes would ultimately be shot on a soundstage, Grande toured local churches in search of aesthetic inspiration. Over the course of the next two weeks, Grande tracked down elegant wrought-iron gates, candelabras, and chandeliers for a ruined-Gothic vibe. He put stones and rocks to work as rubble inside the church set, and when standard-issue church pews would not fit the space, Grande made use of damaged chairs and furniture to preserve the charred aesthetic. He even designed special double-wicked candles that would give off a fuller-bodied, brighter light. (The show remembered everything, it seemed, except to have Ross's son, Ben, attend his father's wedding.)

Jill Condon was walking through LAX with the cast and crew on their way to London and was stunned to see the cameras stalking the stars' every move. She knew how enormously popular they were, but it was something else entirely to be exposed firsthand to their fishbowl existence. She didn't know how they managed.

The writers worked daily with the actors but rarely spent time with them, and London was an opportunity for the two wings of the show to interact under less stressful circumstances. Condon was pleasantly surprised to discover how much she enjoyed talking to Lisa Kudrow, or how Jennifer Aniston would squeeze her arm as she walked by on set, just two overworked, exhausted young women sharing a moment together.

Everywhere they went in London, the cast and crew were shadowed by hordes of fans, directed by newspaper and radio reports pointing them to the day's location. Paparazzi were swarming, and Todd Stevens grew concerned about the physical well-being of his cast. He had been concerned that not enough security was being provided for London, and when they were surrounded by screaming fans, he felt he had been

proved right. The fans were persistent, but they were also easily won over. After the stars took photos with some of the crowd, they willingly departed, allowing the shoot to continue.

The writers came up with a funny solution to the Branson conundrum, casting him as a souvenir salesman who gets Joey to purchase a ludicrous Union Jack top hat. Branson was no actor, though, and one of the prime challenges of the London shoot was working with the mogul until he could credibly deliver his fistful of lines.

As it happened, the London episodes would be filmed three times, before three different studio audiences, along with location shots near Westminster Abbey and the Tower of London. The plan was designed more for the sake of inclusiveness than necessity. Given the overseas trip, the show's producers thought it would be a nice gesture to give as many fans as possible the opportunity to see a live performance.

The schedule also created an accidental test group, where an audience of die-hard *Friends* fans would be let in on the secret of Monica and Chandler, and their response gauged. Would there be groans of disbelief at the disappointing plot twist, or would they appreciate the surprise?

Every *Friends* staffer and crew member present in London would remember the roar of approval when Monica poked her head out from under the covers in Chandler's hotel room. The cheers and hoots of delight went on and on, drowning out the performers and shaking the room. For Crane and many of the writers present, the feeling was that the cheers would never end, that bringing Chandler and Monica together as a kind of present for the fans was a stroke of inspiration that could never be topped or replicated. And this happened not just at the first taping, but at each of the three tapings of the episode.

Crane marveled at the length and intensity of the cheers for the big reveal, which rolled out in wave after wave of excitement and jubilation. The show would end up having to trim a full minute of audience appreciation out of the final cut, leaving only a fraction of the applause for viewers at home to take in.

Jill Condon was intently watching the faces of the five hundred or

so fans present for each taping and carefully studying their responses to the big reveal. The fans, Condon thought, were so thoroughly, uncomplicatedly thrilled that she understood the future plans for the show had suddenly, unexpectedly changed. The fans had not only bought Chandler and Monica sleeping together; they loved it. The plan, going into the season, had been that at most, Chandler and Monica would be a one-off. Now Condon turned to her writing partner Amy Toomin and offered a prediction: "They're going to be a couple." The audible pleasure of the London crowds had clinched it.

Even when the writers returned after the hiatus to sketch out the fifth season, the plans for Chandler and Monica remained modest. The string would be played out over the first four episodes, with Monica and Chandler's increasingly frantic efforts to keep their friendship with benefits secret from the rest of the crew ultimately leading to the extinguishing of their brief romance. But the stories had a life of their own.

The writers found that they loved writing for Chandler and Monica together. Their relationship introduced colors to their personalities that had previously been undefined. Neurotic sad-sack Chandler now found himself unexpectedly flummoxed by a meaningful romantic relationship. And obsessive-compulsive Monica was now blessed with a foil who might deflate her controlling tendencies.

It spoke to *Friends*' recurring desire to surprise its audience that another plot thread discussed, and ultimately dropped, during the fifth season involved the entire cast relocating to Minnesota. The idea was that Chandler would be unexpectedly transferred to Minnesota at work. Since there was no urgent reason for the characters to stay in New York, each of his friends would ultimately choose to join him there, and *Friends* would keep them in Minnesota for half a season. They would discover a magical Midwestern respite from New York, with cheap apartments, friendly neighbors, and subzero temperatures. Everyone knew you could not relocate an iconic show to a frigid destination 1,500 miles away, which was precisely why many of the writers argued they should do it.

At first, it was a joke, but as the room bantered about it, everyone got more and more enthusiastic about the possibilities. There could be jokes about searching for a coffee place to replace Central Perk. They had begun to work out how they would eventually get all the characters back to New York. They could even reshoot the credits sequence in a frozen fountain!

Giddy with excitement, they approached Crane, who responded pithily: "Are you out of your mind?" The Minnesota interlude was shelved.

———

Chandler had begun the series as the painfully awkward amateur comedian, the one who might tell the jokes but would never get the girl. When Rachel acknowledges having a sex dream in the first season's "The One with the Ick Factor," Chandler notes, "In my dreams, I'm surprisingly inadequate." In "The One with the Lesbian Wedding," the coffeehouse conversation turns to which of the crew will likely be last to marry, and without saying a word, everyone's eyes turn to Chandler.

Chandler was sexually and emotionally frustrated, and this was the source of his humor, as well as his simmering dissatisfaction. He memorably lashes out at Ross in "The One with the List" as Ross attempts to choose between Rachel and Julie: "Oh, I know this must be so hard. Oh no, two women love me. They're both gorgeous and sexy. My wallet's too small for my fifties, and my diamond shoes are too tight!" Chandler knows this will never be his problem.

He is threatened by other men's potency. When he begins to date Joey's ex-girlfriend Kathy in "The One with Phoebe's Uterus," he finds himself worrying about how he might compare with his roommate: "We share a wall. So either he's great in bed or she just liked to agree with him a lot."

There is also a less attractive undercurrent to the show that critiques Chandler's effeminacy as a barrier to romantic triumph; he was regularly shown violating the masculine code via wearing a towel on his

head after a bath or blotting his ChapStick with a tissue. Chandler was the one who had to be coached about how not to let his wrist relax *too* much.

Chandler and Joey's relationship notwithstanding, *Friends* was consumed by the specter of gay panic—of what would happen when its male characters were forced to confront the possibility of sexual intimacy with another man. *Friends'* romantically irresolute leading men wrestled with the fear that their masculinity was subject to misinterpretation. Early in the first season, in "The One Where Nana Dies Twice," Chandler is taken aback when a colleague tries to set him up with a male coworker.

Chandler, intriguingly, is not horrified to be confused for gay. It is less a mark of Cain than a mistaken identity that he hopes to understand. If he comes off as less inadvertently gay, Chandler thinks, it might be possible to reverse a lifelong cold streak with women. And if people are going to assume he is gay, then at the very least he should be set up with a higher-quality male suitor—a Brian, and not a Lowell.

Chandler is not gay, but he is perpetually being called out by his friends for his flickering manhood. Chandler is forever catching himself getting *too* enthusiastic about another man. Chandler glimpses a picture of Rachel's coworker Tag in "The One with Rachel's Assistant" and cannot restrain his excitement: "Wo-ho-ho!"

And yet, Chandler and Joey are allowed to be emotional with each other in a manner mostly closed to other male television characters. Chandler is quiet and awkward in the second season's "The One Where Joey Moves Out," unsure what to do with his unruly emotions as his roommate prepares to leave for a bachelor pad of his own. And when Joey finally departs, there is a beautiful self-consciousness to the moment, with neither of the men sure how to acknowledge the weight of the situation.

When Joey makes a move toward the door, Chandler scoots back to the kitchen counter, running his hands through his hair. "Take care," Joey tells Chandler, waving his hand half-heartedly toward him.

Chandler haltingly steps forward to instigate a hug and then retreats, licking his lips nervously, as if the moment has come and gone. Joey closes the door, and Chandler is left alone with his feelings for a long few seconds before Joey bursts back in and grips him in a bear hug. Chandler smiles in relief and claps his hand gratefully to Joey's hand atop his chest.

Chandler and Joey genuinely, uncomplicatedly love each other, and *Friends* insists that we care about their emotions as much as we might about anyone else's. It was, in its own way, quietly revolutionary, and a product of Marta Kauffman and David Crane's insistence on treating the spectrum of sexuality as funny and entirely normal.

In one of the series' most affecting episodes, albeit one essentially erased by later developments, Chandler was forced to confront the ghost of his future. Through the first season and a half of the show, the well-named Mr. Heckles (Larry Hankin) shows up unpredictably to rattle and annoy his upstairs neighbors. In "The One Where Heckles Dies," from *Friends*' second season, it is Chandler who finds himself unexpectedly moved by the resonances between the dead man and himself. Chandler digs through Heckles's things and finds a high school yearbook in which Heckles, too, was voted class clown. He flips through Heckles's "Big Book of Grievances" and leaps back in alarm when he finds himself pounding on the upstairs ceiling with a broom, just as Heckles did. This, Chandler realizes, is his fate: "This is me. This is what I do. I'm going to end up alone just like he did."

Chandler is now wearing Heckles's bathrobe, nearly shouting at his friends about the future he glimpses for himself: "You'll see. You guys are all going to go off and get married, and I'm going to end up alone." He asks Joey if he plans to invite him to spend the holidays with his family in the future. "Heckles Dies" is one of the left-field gems of *Friends*, taking what could have been a hackneyed sitcom plot and transforming it into a cry for help. Fittingly, the episode reaches its peak when Monica kneels next to Chandler's chair and seeks to soothe him: "You know what you want now. Most guys don't even have a clue. You

are ready to take risks, you're ready to be vulnerable and intimate with someone." And seasons later, it is Monica who will save him from what might have been.

On *Friends*, no secret could stay hidden for long, but the writers decided that it would be amusing to give Chandler and Monica an extended opportunity to protect their clandestine relationship from the gaze of others. Upon their return to New York in "The One After Ross Says Rachel," Monica feelingly tells Chandler that their time together in London meant a lot to her, as she was going through a difficult time with Ross's wedding. Chandler responds in kind, after a fashion, telling Monica that it meant a great deal to him as well: "You're really hot." The end of a meaningful but brief fling has arrived, with everyone's feelings accounted for, until Chandler bursts back into the room with a question: "I'm still on London time. Does that count?"

In the next episode, "The One with All the Kissing," Monica hides under the water when Joey walks in on her in the tub with Chandler. Chandler must explain why he has suddenly been seized with the urge to take a bath—and in Monica and Rachel's apartment, no less. Joey asks Chandler if he would like some takeout chicken, and he demurs, anxious to get rid of him. But when Monica pops up breathlessly from underwater, she requests some chicken, and Chandler must call Joey back to the bathroom to place his order. Chandler asks for a Coke, and then howls in pain before switching to a Diet Coke (possibly a callback to the stars' misguided ad campaign for the beverage). Once again, *Friends* has managed to tell a fabulously dirty joke without saying a word; one imagines a piqued Monica yanking on Chandler's balls to get a reduced-calorie cola.

Chandler, we rapidly understand, is a man thrown into the deep end without first learning to swim, scrabbling for a foothold that will not reveal itself. On his way to work, he absentmindedly kisses Monica, and then must kiss Rachel and Phoebe as well, passing it off as a newly acquired European affectation. The sequence emerged from an experience of writer Wil Calhoun's, when he was just beginning to date his

future wife. Calhoun had once absentmindedly kissed her before their relationship was public knowledge, and he thought that Chandler could make a similar mistake.

Chandler has never been entirely comfortable with physical expression, so watching him attempt casual kissing comes with an added frisson of delicious awkwardness. Monica, too, is not entirely limber in the ways of relationships; when Rachel and Phoebe complain of Chandler's new Maurice Chevalier impression, she chimes in, too: "It makes me wanna puke." And Chandler does not yet understand the distinction between a girlfriend and a buddy. At the end of the episode, he tells Monica that it's too bad that Rachel and Phoebe did not, in addition to witnessing them kissing, also see them having sex (the implication being that Chandler would then have a sexual free pass with them as well). Monica tilts her head skeptically and asks, "Do you know anything about women?" Chandler thinks it over and offers a disarmingly honest answer: "No."

Chandler is not underselling himself in the slightest; he genuinely has no idea how to comport himself in a relationship. After Monica asks him to come switch rooms during a weekend getaway, he is frustrated at missing a high-speed chase on television and tells her to give it a rest: "Jeez, relax, Mom." You can hear the audience audibly gasp at Chandler's relationship faux pas.

Chandler's first instinct on being cornered is to lash out with his wit. After a disastrous secret weekend getaway in "The One with the Kips," during which he and Monica each pretend to be attending a work event, Monica complains that no one appreciated the food at her wholly imaginary chef convention. Chandler, clearly thinking of his and Monica's floundering relationship, acidly observes that "maybe it was the kind of food that tasted good at first, but then made everybody vomit and have diarrhea." (Joey catches them in their lie by noticing their similar stories of spotting Donald Trump while waiting for an elevator, an anecdote that, needless to say, plays notably differently in 2019 than it did in 1998.)

But *Friends* finds an emotional truth, and not just a funny argu-

ment, in this outburst. Chandler comes in assuming that Monica is planning to break up with him as a result of their fight. Monica disabuses him of that notion, realizing something about her newly minted boyfriend as she speaks: "Chandler, that's crazy. If you give up every time you have a fight with someone, you'd never be with anyone longer than—*ohhh*." Monica lifts her palm, then slaps it forcefully on her thigh, having understood that this might be the source of Chandler's lifelong relationship drought. She puts her arms around him and squeezes his shoulders: "Welcome to an adult relationship." (Chandler smiles, then moves back a half step: "We're in a relationship?")

The clumsy attempts at deception carry on for more than half of the fifth season, with both Chandler and Monica scrambling to protect their secret from the prying eyes of their friends. Chandler comes home from work with champagne, and when he discovers the gang together at Monica's, he releases a Three Stooges noise of disappointment, followed by a hastily composed cover story: "I'm so glad you guys are all here. My office finally got wrinkle-free fax paper."

Joey is put to work as a coconspirator in their cover-up, pressed into service as the fall guy in their increasingly slapdash excuses. "All right," Joey says, reluctantly agreeing to Monica's demands, "but you do it with me once." (Joey's overgrown-frat-boy antics, including this half-hearted demand to have sex with Monica, his longtime friend and his roommate's girlfriend, might play a bit differently in 2019.) When a pair of Chandler's boxer shorts is discovered at Monica's, Joey grumblingly takes the blame: "I'm Joey. I'm disgusting. I take my underwear off in other people's homes." Later, Joey's date spots Chandler and Monica's video-camera setup, presumably for recording one of their trysts, and storms off, convinced he wants to tape them having sex. "I'm Joey," he says wearily. "I'm disgusting. I make low-budget adult films."

At the apex of "The One with Ross's Sandwich," the season's ninth episode, Rachel discovers a nude Polaroid of Monica and accuses Joey of taking the pictures through a peephole. Chandler, embarrassed by all the punches his roommate has taken for him, steps in and says Joey is a

sex addict. This leads to an escalating cavalcade of faux revelations, beginning with Joey's "acknowledging" that he slept with Monica in London. (Chandler cringes but tells Monica, "Well, let's see what everybody thinks of that.") Rachel asks Monica about the underwear, and she shamefacedly tells everyone that she was keeping it as a souvenir, going on to say that she set up the camera to "entice" Joey: "I'm Monica. I'm disgusting. I stalk guys and keep their underpants."

Eventually, in "The One with All the Resolutions," Rachel figures it out, listening in on one of Monica's phone calls after she announces she is off to do the laundry yet again. She picks up the phone and hears Chandler chuckling at their deception: "Laundry—is that my new nickname?"

Rachel and Joey feel each other out, circling each other warily like gunslingers before a duel.

"Do you know something?" Joey asks, and Rachel asks him the same question.

"I might know something," Joey answers.

"I might know something too," says Rachel.

But neither feels able to reveal what they know, and they slowly turn toward each other: "You don't know."

The charade culminates in one of the most joyous and comedically rewarding half hours of television of the 1990s, "The One Where Everybody Finds Out." Phoebe is helping Ross move into his new apartment, conveniently located within eye line of Rachel and Monica's windows. Phoebe spots Chandler and Monica across the way and waves, then sees them reach for each other. Phoebe turns around in horror-movie shock: "My eyes!"

She retreats to Central Perk, where she compares notes with Rachel and Joey. "I think it's great—for him," she decides. "She might be able to do better." Joey argues forcefully for telling Chandler and Monica that they all know, but Phoebe suggests they have "a little fun of [their] own" and keep their secret a secret. Phoebe wins out, of course, and commences flirting outrageously with Chandler in the hopes of prodding him into revelation.

She squeezes his arm, cooing: "Hello, Mr. Bicep!" Phoebe shamelessly vamps for Chandler's benefit, seducing him in capital letters so large that even he cannot miss them: "You know how sometimes you're looking for something and you just don't even see that it's right there in front of you, sipping coffee? Oh no, have I said too much?"

Monica's enthusiasm for this transformation of romance into a competitive sport is palpable: "They think they are so *slick* messing with us. But see, they don't know that we know that they know." Chandler joins in the excitement: "The messers become the messees!"

The remainder of "The One Where Everybody Finds Out" is transformed into an extended staring contest, with no one among the hypercompetitive gang willing to blink first. Chandler and Monica call Phoebe with a proposition, which she reports to her compatriots: "He wants me to come over and feel his bicep and more." Rachel is initially shocked, then suspicious: "Joey, do they know that we know?"

Phoebe memorably summarizes the state of play: "They don't know that we know they know we know." She is sent back over, approaching Chandler in her slinkiest fashion, but her stilted choice of words indicates that the idea of sex with Chandler Bing is not much of a turn-on: "I'm really looking forward to you and me having sexual intercourse."

Phoebe and Chandler feel pressured into following through on their date, with Monica preparing her boyfriend by spraying Binaca in his mouth. "I want this to happen," Phoebe murmurs, and Chandler agrees. Each unwilling partner silently drinks more and more wine as they wait to see who will give in first. "When you say things like that," Phoebe says, elevating the stakes, "it makes me want to rip that . . . sweater vest right off." Chandler suggests moving to the bedroom, and Phoebe assents, although she says, "First I want to take off my clothes and have you rub lotion on me."

The hilarity of "The One Where Everybody Finds Out" stems from its air of reversal, of transforming the feverish excitement that persistently surrounds all mention of sex on *Friends* into something awkward and nauseating. There is a near-incestuous sense that Chandler and

Phoebe's mock flirtation is a violation of the rules of propriety. Joey suggests that Phoebe show Chandler her bra, since he is afraid of them, and she dutifully follows his suggestion. "Come here," Chandler responds. "I'm very happy we're going to have all the sex." "You should be," Phoebe says, proud as ever of her erotic skills. "I'm very bendy."

Both Phoebe and Chandler are visibly fighting off their natural revulsion while continuing forward with their charade. He stiffly puts his arm around her waist. She grabs his butt, and he reaches out awkwardly for her breast before losing his nerve and settling for her shoulder. Chandler shudders as he kisses Phoebe, his lips pushed out awkwardly in an attempt to keep her as far as possible from the remainder of his body, then pulls back, deflated: "OK, OK, OK, fine, you win! I can't have sex with you." "And why not?" asks Phoebe, intent on extracting the truth from him.

And here *Friends* executes one of its favored maneuvers, choosing a moment of maximal hilarity to unfold a new layer of emotional nuance. Chandler responds to Phoebe by saying, "Because I'm in love with Monica." Monica comes out of the bathroom, where she was hiding for the entirety of Chandler and Phoebe's abortive date, and the newly minted couple say "I love you" to each other for the first time. (Or is it? Chandler blurted it out earlier in the season, in "The One with All the Thanksgivings," and while he attempted to walk it back, later Internet wags would judge *Friends* as having goofed. But the first "I love you" was more of a playful "thank you" that Monica treated as a telling flub by her boyfriend, and the second was meant to be more serious.)

"The One Where Everybody Finds Out" was an unexpected fulcrum for the show, neatly dividing what came before it from what emerged afterward. Before its surprisingly fulfilling conclusion, we had assumed, right alongside Chandler, that this was a humorous and diverting fling, with little resonance for the show at large. But one thing *Friends* never receives enough credit for is its ability to introduce genuine shifts in its tenor—with abiding consequences for its characters. When Monica walks out of the bathroom and embraces Chandler, *Friends* embraces a

new relationship—one that will, in some ways, supersede the heretofore-ubiquitous Ross and Rachel.

————————

There were two available perspectives on *Friends:* the exterior and the interior. These often overlapped, although insiders knew far more of the nuts and bolts of how the show was made, and outsiders might remember more of the show's plotlines, treating as gospel what the show's cast and crew often could hardly remember the next week. It was likely only the people on the set, week after week, who would think of an episode like "The One with Chandler's Work Laugh," from the fifth season of the show, as particularly sad. To watch Chandler on television was to laugh at someone who was consistently amusing; to observe Matthew Perry at work in the late 1990s was to bear witness to something else entirely.

Perry had dreamed of being a star since he discovered acting as a teenager newly arrived in Los Angeles—since before that, even, when he was practicing his backhand as a ranked Canadian junior tennis star and imagined himself as the next Jimmy Connors. Perry was only twenty-four when he was cast on *Friends,* and the show's success rocketed him from an up-and-coming but mostly anonymous supporting actor on series like *Silver Spoons* and *Growing Pains* to a star whose face was splashed across the covers of magazines everywhere.

The accolades were appreciated but ultimately unfulfilling. The emptiness, he would later say, had gotten him to take his first drink, and then made drinking a regular habit in the evenings, when work was over. Perry didn't drink to act out at parties or lash out; he drank quietly, steadily, and privately. And after a jet-skiing mishap in 1997, Perry was prescribed Vicodin for the pain by a doctor.

The pills swept away all manner of pain, and even after Perry had healed physically, the Vicodin was a constant friend. Later, Perry would acknowledge that the middle of *Friends'* run was mostly a blur, saying it was hard to remember much of anything that had happened between the third and sixth seasons of the show.

Perry had made a promise to himself that he would never drink or do drugs on the *Friends* set, and he held to that. But he would regularly come to work hungover. Perry did his utmost to keep his struggles with addiction a secret from his colleagues and costars, but the truth was that those travails were etched on his face. Some weeks, he would appear bloated, his face puffy and his chin sagging under the weight of formerly invisible jowls as if he had been doing nothing but bingeing on French fries and doughnuts since the last episode. Other weeks, Perry was painfully thin, looking like a man who had gone through an extreme diet or been stranded on a desert island for some unspecified amount of time.

Perry would come to set to shoot his scenes while craving the next high, and his costars were forced to acclimate themselves to the sight of Perry shaking and sweating while trying to remember his lines. The seventh season of the show would be the hardest. Perry was in denial about the extent of his problems, and the offers of assistance from his costars were routinely dismissed. Lisa Kudrow would later describe the experience as "just hopelessly standing on the sidelines."

There was a rehab visit in 1997, for the pills, and another in 2000, for both the pills and the drinking, but neither took. In May 2000, Perry was hospitalized with pancreatitis, a condition exacerbated by heavy drinking or drug use. It took until 2001 for Perry to get clean, when a third stint in rehab proved successful at weaning the actor off his dependence on alcohol and opioids.

Perry's fellow cast members were mostly understanding. He was their friend, and he was going through torments of his own, and they wanted to do everything they could for him. *Friends* was also their livelihood. All their good intentions notwithstanding, it was incredibly challenging to work with a fellow actor who was coming to work while still noticeably under the influence. Perry was hurting himself, but he was also jeopardizing the future of their show. At times, Perry's coworkers on the *Friends* set were sad over his plight, and at other times, they were angry about what he was forcing the rest of them to cope with.

There was kindness in the show's care for Perry, as well as an innate

caution about the potentially dire consequences to *Friends'* future if they ignored Perry's health. The show was a family, they believed, and they would not abandon any member of their family in a time of need. For some, drug addiction was a moral failing; for Kevin Bright, it was simply a disease, and one that benefited from love and attention and treatment.

There were moments when Bright, Kauffman, and Crane were faced with an agonizing question: Should Matthew Perry be fired from *Friends*? It was a question of the health of not only the show but one of their lead actors. Was it good for Perry to be the star of a hit TV show? *Friends'* ensemble model meant there was no real way to replace any one of them, nor could the show carry on in a cast member's absence without doing severe damage to its established model. Bright worried that fame had given Perry so much but also prevented him from taking stock of how much damage he was doing to his body. Each of these conversations ended in the same place: They were committed to Matthew Perry. He was integral to their show, and they could continue to look out for him as part of their television family.

Once Perry returned from rehab, Bright, Kauffman, and Crane considered it part of their job to keep an eye on their actor. Were there any signs of his relapsing? What could be done to keep Perry protected from his own worst impulses? It was a testament to the character of *Friends'* creators that they remained loyal to Matthew Perry for ten seasons.

———

There was not a singular moment of realization for David Crane that the path of the show had been reoriented by Chandler and Monica. Instead, there was a snowballing sensation, where one successful episode after another unspooled from the writers' room, and there was an increasing consensus that wondered, "Why stop?" Pairing off Chandler and Monica, Crane felt, gave the show new life, and many of the writers who worked on the later seasons agreed.

What had begun as a temporary plotline for the show kept expanding, taking on added dimensions until two characters on *Friends* were

declaring their love for each other, and those characters were not Ross and Rachel. The emotional tenor of Chandler and Monica's relationship was distinctly cooler than Ross and Rachel's. It was placid where theirs was stormy, convivial where theirs was frequently abrasive, and solid where theirs was porous. While there was never a moment when particular decisions were made about how Chandler and Monica's relationship might work, there was a general agreement that there was only room for one Ross and Rachel on *Friends*.

Crane still worried about how Chandler and Monica could avoid what he feared could be a fatal domesticity. He was worried that fans would grouse at a world that seemed to only contain six characters and forced them to pair off with each other in increasingly illogical combinations.

Chandler and Monica had to be something different, to contribute a different tone to the show. Crane felt that the show had to earn Chandler and Monica, to make it worth the audience's while to spend time with another couple. Chandler remained a hopeless relationship doofus, and Monica was controlling and inflexible, but there was an easy warmth between them that had only intermittently existed for Ross and Rachel. Chandler and Monica acted as if they were sharing a private joke, and that air of quiet intimacy pervaded the entire series. With Chandler and Monica's relationship, *Friends* became a more mature show than it had ever been before.

Chandler, in Crane's estimation, had always been flip, inclined to keep the world at bay with a protective shield of humor. Dating Monica exposed him to the intensity of his own feelings and forced him to confront everything he had previously sought to avoid. Chandler remains inept when it comes to knowing what women want. He blithely declares that the best reason for a couple to get married is pregnancy. (Being sorry comes in fourth.)

He is still terrified of commitment, but a sense that his relationship with Monica is protected from the dings of the outside world keeps it

going. He tells Monica he is ready for commitment, then clarifies the truth for Phoebe's ears: "Still terrified. I'll take care of it. No problem." And Monica struggles to think of Chandler as an object of erotic or emotional contemplation. When Rachel cracks a joke in "The One in Barbados Part 1," at the end of the ninth season, about how she was "just lusting after Chandler," Monica responds with a sarcastic "Yeah, right."

There is a tenderness between Chandler and Monica that was heretofore absent from the show—with the possible exception of some of the gentler moments between Chandler and Joey in the early seasons. Ross and Rachel feel fated in the stars and woefully mismatched here on planet Earth; Chandler and Monica feel like an odd match in theory but work wonderfully well in practice.

Chandler and Monica flirt with marriage in Las Vegas before their thunder is stolen by a drunken Ross and Rachel (about which more later). Instead, they return home and proceed carefully through the stages of relationship intimacy. Chandler suggests unpacking at Monica's, and she remains clueless about his not-so-hidden meaning until he spells it out fully for her. They break the news to Joey, who assumes that Monica is pregnant. Chandler balks, then hilariously looks over to Monica for confirmation. Monica fruitlessly prods the emotionally inert Chandler to get him to cry. (In a clever coda, he finally cracks when pondering the emotional roller coaster of Rachel and Ross: "I just don't see why those two can't work things out.")

The emotional floodgates now presumably opened, Chandler gets teary eyed when a jewelry-store clerk mock-proposes to him with the ring he is considering purchasing for Monica. *Friends* knows that we know, and we know that they know we know, what emotional markers lie in wait for us. Chandler and Monica's relationship is studded with false starts and surprise developments. Chandler plans an elaborate proposal at a fancy restaurant in "The One with the Proposal," only to be derailed by the unexpected presence of Monica's ex-boyfriend Richard (Tom Selleck) at the next table. Chandler squelches his proposal and

begins talking excitedly of antimarriage websites and the unnaturalness of monogamy to throw Monica off the scent. Richard's mere presence alone is enough to rattle Chandler.

Monica winds up having one last flirtation with Richard. Chandler hears she has left Manhattan and is staying with her parents. He enters their apartment to discover that Monica has filled the room with candles: "You wanted it to be a surprise." Monica proceeds to get down on one knee, beginning to propose before getting teary and calling for help: "There's a reason why girls don't do this!" The slightly sexist moment ends sweetly when Chandler gets down on one knee and fills in: "I thought that it mattered, what I said or where I said it. Then I realized, the only thing that matters is that you make me happier than I ever thought I could be. And if you let me, I will spend the rest of my life trying to make you feel the same way."

The show is at its worst in the run-up to Monica and Chandler's wedding, and with its inept handling of Chandler's transgender father. Monica and Chandler travel to Las Vegas to ask Chandler's father, Charles (played by Kathleen Turner), to attend their wedding in "The One with Chandler's Dad" and act like clueless rubes at the drag show where Charles performs as Helena Handbasket. "Waiter?" Monica tentatively calls to the (presumably) trans server. "-tress?" Rarely have *Friends'* characters felt squarer than they do here.

Having Elliott Gould's Jack Geller express interest in meeting his daughter's future in-law by saying, "I've never seen one before," is tacky and cruel in the extreme. Similarly, although perhaps slightly more justified as a catty remark from an ex, Chandler's mother (Morgan Fairchild) wonders if Charles has "a little too much penis to be wearing a dress like that."

Monica may insist she is incapable of handling the work of proposing marriage, but there is a pleasing egalitarianism to her relationship with Chandler. Being a kind of mismatched couple from the outset, they silently agree to make it up as they go along, with no set pattern of gendered expectations necessarily determining who will do what. Monica

craves children, but Chandler is the one who unspools an elaborate fantasy about a house in the suburbs with kids on bicycles, a cat with a bell, and an apartment for Joey above the garage. (Note the reversal from earlier seasons, where Chandler pleads with Joey to be invited to *his* family's future celebrations.) Monica begins the process of getting engaged, and Chandler finishes it. Chandler, clueless as he is in the matter of relationships, must take his cues from Monica, and from his oft-defective instincts about how men and women relate to each other.

While Chandler and Monica's squabbling, about the perils of smoking or Monica's intensity while playing Ping-Pong, was a constant, it was often resolved with quiet acceptance rather than anger or a sense of betrayal. In "The One with the Red Sweater," just after their wedding, Chandler is busted for taking fake photos to replace the disposable cameras he lost, and Monica is caught in the act of opening all the wedding presents, and they agree to call it even.

In "The One with the Sharks," Monica surprises Chandler in his hotel room during a work trip to Tulsa and believes she has seen him "molesting himself" to "shark porn." Rather than dial her divorce lawyer, Monica rents a video and pops it in the VCR: "Do you want me to fast-forward to something toothier?"

Chandler eventually corrects Monica, telling her that he was actually pleasuring himself to "old-fashioned American girl-on-girl action," but what stands out is Monica's act of trust in her husband: She tells him, "Let me be a part of this," even as she believes that "this" is, as Rachel describes it, getting his jollies to *Jaws*. The episode is exaggerated even by the standards of *Friends* (does *anyone* get their jollies to *Jaws*?) but underlines a crucial point about Chandler and Monica: that they are willing to go out on a ledge for each other.

The second half of *Friends* would come to be dominated by Chandler and Monica's burgeoning relationship, and its air of easy warmth would reinvigorate the show. The writers were tasked with finding situations to put Chandler and Monica in that would stretch or challenge them, but the conflicts were smaller and more limited than those

granted to Ross and Rachel earlier in the series. Chandler and Monica fight over whether to spend Chandler's carefully hoarded savings on the wedding; Chandler has erectile dysfunction; Phoebe introduces Monica to a British foodie she believes will be Monica's soul mate.

Friends still leaned occasionally on the crisis-and-resolution model, with Chandler the runaway groom taking off before the wedding and needing to be hauled back in to walk down the aisle. But the richer thread of *Friends* story lines grows out of the audience's expectations for Chandler and Monica's relationship, and the ways in which the show subverts or undermines those expectations. Someone does have a baby soon after their wedding, but it is the single Rachel, impregnated by Ross after a secretive one-night stand. Monica thinks she will freak out her husband while they wait for Rachel to give birth by telling him that it is time for them, too, to think of starting a family. Instead, Chandler surprises her by calmly agreeing.

Friends does not withhold the expected happy ending—this was not that kind of show—but provides it in a manner that encompasses and withstands heartache. Chandler and Monica struggle to conceive, and must eventually come to grips with infertility. "It means that my guys won't get off their Barcaloungers and you have a uterus that is prepared to kill the ones that do," Chandler tells Monica in "The One with the Fertility Test," after spending the day fitfully attempting to masturbate in a doctor's office. ("It's not OK to do it in a doctor's office," Monica hectors him, "but it is OK to do it in a parked car behind a Taco Bell?") *Friends* was a fantasy of adult life as an extension of adolescence, all hormones and cliques, but it was intent on delivering its happy endings only upon completion of its round of meaningfully adult disappointment.

The last two seasons of *Friends* were weighed down by Chandler and Monica's setbacks and regrets. After giving up on having children of their own, Chandler and Monica commence the adoption process, only to find themselves hamstrung once more. Joey insists on dropping off a handwritten letter to the adoption agency in "The One Where Rachel's Sister Babysits," and his clumsy use of the thesaurus ("they are

warm, nice people with big hearts" becomes "they are humid, prepossessing homo sapiens with full-sized aortic pumps") convinces Chandler and Monica that their chances of adopting a child have been torpedoed once and for all. "We're gonna be one of those old couples that collects orchids or has a lot of birds," Monica moans. Even when Chandler calls the agency and tries to resolve their concerns, Monica remains despondent: "Just tell me on the way to the bird store."

Later, in "The One with the Birth Mother," the adoption manager is convinced that Chandler is a doctor and Monica is a reverend, and refuses to hear otherwise. "I could perform an operation on you and prove it if you'd like," Chandler offers. He winds up delivering a lovely speech to the birth mother: "I love my wife more than anything in this world. It kills me that I can't give her a baby. I really want a kid. And when that day finally comes, I'll learn how to be a good dad. But my wife, she's already there. She's a mother. Without a baby."

The uncertainty on *Friends,* as it neared its conclusion, stemmed primarily from the fraught question of Ross and Rachel's relationship, but it was Chandler and Monica who provided its emotional resonance. They were the ones who were prompting the sudden, lurching adjustments to maturity. The show was growing up alongside its audience. But as Chandler and Monica wrestled with marriage and child rearing, Ross and Rachel were still wrestling with the same twentysomething emotional turmoil they had at the very start of *Friends.*

CHAPTER 16

PIVOT

The Ballad of Ross and Rachel, Part 4

The season after London brings the return of panicky Ross, and much of its non-Chandler-and-Monica plot is occupied with his performative ritual of self-abasement to prove to the justifiably suspicious Emily that he is committed to their relationship. He pledges to stop seeing Rachel socially, to the intense dismay of their friends. Rachel, honoring Ross's fidelity, hides out in her room rather than be caught by Emily—happily hectoring Ross by speakerphone from across the Atlantic Ocean— eating in the same room as her former boyfriend. But the truth will out, and once again, a season finale maneuvers Ross and Rachel into acknowledging the ferocity of their attraction.

When "The One in Vegas" begins, Joey is stranded in Las Vegas, his much-ballyhooed film shoot having unexpectedly disintegrated. Joey is reduced to working as a gladiator at Caesars Palace, posing with tourists for their snapshots. On a call home, Joey begs Chandler not to come out to Nevada to apologize in person for having failed to summon the necessary belief in his cinematic dreams, but Monica surprises Chandler with a pair of plane tickets for their upcoming first anniversary, and Phoebe,

still mad over having missed the trip to London due to her pregnancy (and Kudrow's real-life one), plans to accompany them. Rachel and Ross both have flimsy reasons for being unable to fly out with their three friends (Rachel has a work presentation, and Ross has tickets to a Van Gogh exhibit), so they agree to fly out the next day. (Who does Ross go to these intellectual events with? It seems unlikely that any of his friends would ever go with him.)

Monica has confided in Phoebe that she saw her ex-boyfriend Richard (Tom Selleck) and had lunch with him the day before, and when Phoebe accidentally spills the tea on the airplane, Chandler is incensed, although he manfully attempts to mask it, clenching his jaw and contorting his mouth in a failing effort to keep his cool. "You grabbed a *bite*," he parrots back to Monica, somehow making *bite* sound like an obscure word from a foreign language. "I think we should see other people," Chandler joked after Monica tried to sell him on a portmanteau like "an-Nevada-versary" to describe their trip, but now he is genuinely concerned about the health of their relationship and trying desperately to hide it.

Meanwhile, Rachel, intrigued by Phoebe's offhand suggestion that the only reason anyone ever wants alone time in their apartment is to prance around naked, proceeds to do just that. She has forgotten, or conveniently overlooked, that the windows of Ross's new apartment could be seen from hers. Ross, flipping through a coffee-table book, is distracted by Rachel's impromptu show and rapidly convinces himself that he is its intended audience. "What kind of game is she playing?" he wonders to himself, while also being perhaps the only man in America who would refer to himself, in his own thoughts, as "Dr. Geller."

In the next scene, Ross is knocking on Rachel's door, leaning on the door frame and barely suppressing a knowing smirk: "Hey." He hardly gives Rachel a chance to say hello before laying out some ground rules: "This is just about tonight. I don't want to go through with this if it's going to raise the question of us." Ross is already taking off his shoes and disrobing when Rachel disabuses him of the idea that they are about to

have a sexual holiday. Now thoroughly ashamed, he hastily picks up his clothes and flees for the door, all the while denying he ever thought Rachel wanted to have sex with him.

Chandler and Monica almost make up in the next scene before she promises that next time, she'll make sure to let him know before she sees Richard. Chandler demands that she never see him again, and the two part angrily.

Rachel and Ross are now sitting together on the plane to Las Vegas, and as Rachel daintily removes her sweater, she mocks him: "Just letting you know this is not an invitation to the physical act of love." Rachel tells him she is not embarrassed about last night, being more secure than he is, generally speaking, and Ross proceeds to test her claim by unexpectedly shouting for the other passengers to hear: "Hey, lady, I don't care how much you want it, OK? I am not going to have sex with you in the bathroom." Matters escalate from there, with Rachel kissing the balding man in the next row on the head and then blaming it on Ross when he turns around: "I think he just really likes you." Ross tells their seatmate that Rachel is that teacher who had a baby with her student, and Rachel proceeds to call the flight attendant before dumping water into Ross's lap. Her friend has had an accident, she tells her; does she have any spare pants he might borrow?

By the end of the flight, Rachel has fallen asleep on Ross's shoulder, and he looks down at the pen in his hand, getting a twinkle in his eye that rapidly transforms into an evil glimmer. (Ross never knows when to quit.) In the final scene of the first half of the two-part episode, Rachel says good-bye to the flight attendant while entirely unaware of the handlebar mustache and goatee drawn on her face with indelible ink.

Rachel discovers Ross's prank when they arrive at Caesars Palace, and Phoebe assumes they have come from a rowdy costume party. Ross adopts a mock-apologetic tone as Rachel stalks off: "Rach, wait! The men's room is that way."

At the same time, Chandler has spotted Monica overseeing a raucous session at the craps table and stalks off with his weekend bag: "See

you later, Mon." He is hurt over Richard and believes he sees the writing on the wall: "I know he's the love of your life." "Not anymore," Monica responds, and Chandler softens, abandoning his plans to flee the city. Monica picks up his bag and is taken aback: "OK, this is empty." "I wanted to make a dramatic scene," Chandler responds, "but I hate packing."

Now it is Monica and Chandler together at the craps table, with Chandler's task to pick out numbers to roll, and to up the ante with each roll. If she rolls an eight, they will buy everyone at the table a steak dinner (Chandler chuckles when Monica asks if they will really do that); if she rolls another, they will rent the largest suite at the hotel. Where can Chandler go from here? "You roll another hard eight and we get married, here, tonight." The audience roars, and Monica turns to face Chandler, a look of disbelief on her face. She shushes the table fiercely: "Shut up! It just got interesting."

She asks Chandler to repeat himself and asks if he is serious, and he responds, "Yes. I love you. I've never loved anybody as much as I love you." Monica rolls, and one of the dice flies under the table. Monica and Chandler crouch to study the die, which leans against the table, poised partway between the 4 and the 5. "It's a four," declares Chandler huskily, and Monica's face melts into a smile: "I think so too."

As Chandler and Monica gallop toward marriage, Ross and Rachel are getting steadily drunker in their hotel room. Rachel picks up the phone to restock: "Hello, Vegas, we would like some more alcohol, and you know what else, we would like some more beers." Only after finishing her order does she realize she has forgotten to dial. Ross and Rachel are both disheveled by now, and Ross cajoles Rachel into visiting the casino by agreeing to let her draw on his face with the same indelible marker. Ross struts through Caesars Palace with cat's whiskers straddling his nose and "ROSS" stamped on his forehead.

The entirety of "The One in Vegas" has duped us into believing that the A-plot here is Chandler and Monica, and the B-plot is Ross and Rachel. It is Chandler and Monica who are celebrating an anniversary,

who are fighting over their relationship, who are talking marriage. Ross and Rachel are doodling on each other's faces and playing sophomoric pranks on each other, so we can rest assured that "The One in Vegas" will not be advancing their story in any meaningful way. And then *Friends* plays another one of the tricks it enjoys pulling on its audience.

Chandler and Monica have prepared for their impromptu nuptials by gathering their something old, new, borrowed, and blue at the casino gift shop. Monica "borrows" a sweatshirt by sticking it under her shirt, and Chandler hurries her along when she sighs over her imaginary pregnancy: "OK, one thing at a time." Chandler enters the twenty-four-hour wedding chapel at a jaunty angle, strolling in like a visiting English aristocrat in middle-management leisurewear: "Hello, one marriage please." Chandler jumps out of his seat as the exit music plays for the couple preceding them, clapping his hands and declaring, "OK, this is it, we're going to get married." Monica clasps his wrist and asks, "Are you sure you want to do this?"

Their last-second tête-à-tête is interrupted by a noise at the chapel door, where none other than Ross and Rachel are stumbling out, Rachel's plastic bouquet of flowers tapping against Ross's arm. They proceed to drunkenly throw rice on each other ("Hello, Mrs. Ross!" "Why, hello, Mr. Rachel!") before turning their separate ways, each presumably intending to vomit alone for their first act as a married couple. Monica and Chandler turn to each other in shock, and the season ends.

Once again, we have been hoodwinked into looking away from Ross and Rachel, only to discover that their story is at the center of *Friends*. We have been tricked into letting Ross and Rachel surprise us once more.

Sixth-season opener "The One After Vegas" milks a good deal of humor out of Ross and Rachel's being completely unaware of their hasty, drunken marriage. Where Rachel is horrified and intent on immediately undoing it, Ross takes a perverse kind of pleasure in silently walking around knowing that he is actually married to Rachel. He spends a good chunk of the first half of the season obsessing over the notion of being a man who has been divorced three times before the age of thirty and

rejects that identity. Ross sees himself as now down at the bottom of the dating barrel, with only quadruple divorcés, murderers, and geologists to keep him company. He tells Rachel he has gone ahead and filed for the divorce when in fact he has not.

When Rachel catches him out in his lies of omission, she tells Ross she has never been this mad with him before. Ross has a knack for always knowing precisely the wrong thing to say: "What about the time I said we were on a break?" He pleads with Rachel to cooperate with their sham marriage: "How is this going to affect you, really?" Ross knows the way to his pseudo-wife's heart. He offers to let her put together a wedding registry and keep all the gifts.

So why do we root for Ross and Rachel to wind up together, given all the carnage of their abortive relationship and its many failed reboots? The answer speaks to the triumph of hope over experience and our innate desire for happy endings. Ross and Rachel were so calamitously ill disposed toward each other that the show had seen fit to establish a second couple (albeit one that had started as merely a brief interlude) simply to restore some order to *Friends*' notion of what a romantic relationship might be. Ross and Rachel were constantly being jostled out of alignment by circumstance, but the show was silently promising us that even a single moment where their heartbeats could pause and align might be enough to reset their entire relationship.

We knew, intellectually, that Ross and Rachel were not quite right for each other, an ill-suited match of temperaments and interests, but we rooted for Ross and Rachel because we were rooting for the idea of love, for the idea that two people could find their way to each other, no matter the obstacles. This was a deeply powerful sentiment, whether you were, like Ross, a two-time divorcé, or a fifteen-year-old boy nursing his first crush.

Ross and Rachel's story was, more than anything else, a remarkable exercise in continuity. It would take 236 half hours to resolve the question of Ross and Rachel, to determine whether we would get the happy ending we craved or not.

In truth, this was not quite right; we knew that *Friends* would ultimately grant us that happy ending, but we did not know when or how. *Friends'* Ross and Rachel story line was an exercise in delayed gratification. Seen from one perspective, *Friends* was ludicrous. What couple, even a fictional one, waited ten years to figure out if they wanted to actually be together or not? But *Friends* asked for patience. It asked us to withstand our hunger for immediate resolution. There was no real end; there was just the next installment.

CHAPTER 17

NOT ACTIONABLE

Lyle v. Friends and the Long Tail of a Lawsuit

Amaani Lyle sat on the table, her legs folded underneath her. Producer Todd Stevens had received her résumé and invited her for an interview to be a writers' assistant on *Friends*. She met with Adam Chase and Greg Malins, who were in chairs across the room, and the entire meeting was the three of them bantering and trading jokes. They offered her the job, and the twenty-six-year-old Lyle cried tears of joy at the thought of being a writers' assistant for the sixth season of one of the most beloved series on television. This was going to be great.

The job of writers' assistant was simultaneously grueling and invigorating. The main responsibility of the writers' assistant was to assiduously monitor the conversation in the writers' room and write down any relevant ideas or thoughts the writers spit out. Often, the writers would want to go back and review ideas that had come up a minute or an hour prior, and a detailed record of the discussion was essential to the work of comedy writing. Writers' assistants could never zone out, never lose the thread of the conversation.

The work was invigorating, though, because serving as a writers'

assistant was the only trusted route to becoming a television writer. Assistants were universally understood to be writers-in-training and were invited to offer pitches or story suggestions—occasionally. Too much, and the writers might conclude that you were not doing your actual job of transcription. The assistant's job was a kind of writing boot camp, placing young writers in the vicinity of the work they hoped to soon be doing themselves. Assistants sought to survive the punishing period of service before they could be welcomed into the inner circle.

Lyle was familiar with the demands of a life in the arts. Her father, Bobby Lyle, was a celebrated jazz musician who had worked with the likes of Bette Midler, Al Jarreau, and Anita Baker. She grew up in Los Angeles, attending the UCLA Lab School with the likes of Leonardo DiCaprio, and was one of the few African-American students at the Oakwood School, where she had taken drum lessons and performed in plays. After high school, Lyle attended Emerson College in Boston (Kevin Bright's alma mater), where she initially saw herself as an actor or director. But writing was something she had always been good at, and she became enamored of the dry, deadpan humor of Steven Wright and early Woody Allen. After working on independent films, a stint as a travel writer for AOL, and a job booking talent for a talk show hosted by Tim Conway Jr., Lyle was hired by Nickelodeon as a writers' assistant.

During the brief interview, Chase and Malins had mentioned that *Friends* was a raunchy show, full of sexual innuendo, and that working in the writers' room would likely require a comfort with sexual banter. Lyle indicated that this wouldn't be a problem, saying it would be nothing she had not encountered already at Nickelodeon.

After a month or two on the job, Lyle realized just how difficult working on *Friends* was going to be. The hours were punishing. Even six seasons in, eighteen-hour days were still happening regularly. While others working jobs with more normal hours might have been putting their children to bed or turning on *Frasier,* the writers on *Friends* were settling in for the second half of their workday.

It was the nighttime, Lyle believed, when the wheels started to

come off. She noticed a peculiar dynamic, wherein certain male writers, likely frustrated with the endless hours imposed by Crane and Kauffman, began to waste others' time with extended diatribes and rants. Lyle felt trapped in the room as writers acted out, delaying her and everyone else from getting to go home. While most women happily took part in the writers' room discussions, their contributions every bit as raunchy as their male colleagues', other women on the *Friends* writing staff over the course of its run found it a workplace environment that discouraged them from staying on.

Writing a show like *Friends* undoubtedly required a dirty mind, and Lyle had no objection to that. But the writers would hit a plateau each evening and transition from working to trying to make each other laugh with scurrilous or scatological jokes. Lyle was not a wilting lily, but she saw the jokes as reflective of a certain brand of unthinking humor that dominated the room.

All the writers then on staff would later strongly dispute her account in their depositions, describing most of it as wild mischaracterizations and outright lies. They had never made any sexual comments about the actors on the show, as Lyle claimed. Finding comedy was never precise, and the hunt required numerous tangents and interludes before locking on to anything usable. In some of the specifics of her later account, Lyle seemed to be missing the relaxed-workaholic tone of the writers' room, in which joking asides were often transformed into usable material for the show. For *Friends,* at least, the crudeness was an integral part of the work.

Lyle did not complain at first. Instead, she wanted to contribute her own original ideas to the show, like casting her father's then-wife, *Days of Our Lives* star Tanya Boyd, as a potential love interest for Joey. Lyle was taken aback to be called into the office by Todd Stevens shortly after and told that there were concerns about the pace of her typing. Some writers felt Lyle was too slow and was getting ahead of herself by pitching story ideas so early in her tenure. It was necessary for her to first grasp how to do her own job before taking on theirs. Lyle was surprised

because she had gotten generally positive feedback from the writers and, if anything, had been critiqued for typing too much.

After the meeting, Lyle tracked down Malins, who told her she was looking down at her screen too often while typing. Lyle responded that she was often being asked to delete material she had already typed, which was why she was studying her screen. She offered to bring out her notes for review. The show ended up purchasing a typing program so she could improve her speed and fully capture the conversation in the writers' room. Nonetheless, they ended up issuing a number of warnings to Lyle about her typing.

Lyle was fired a short time later, along with a male writers' assistant who had also been warned about the quality of his work, after only four months on the job, told she was still typing too slowly to capture all the material in the writers' room. Lyle sought a meeting with some of her superiors at *Friends* to understand why she had been fired. She never received a response from Marta Kauffman, which particularly stung. She had attended the same schools as Kauffman's children. Didn't a female showrunner have some responsibility to her female employees?

The manner of Lyle's dismissal was mystifying to her. But it was what came next that made Lyle's name a familiar one to law students. After being fired, Lyle planned to let the situation go. But she started talking to a friend whose mother was a coach and counselor, and she strongly suggested hiring a lawyer. This struck her as a textbook example of a hostile workplace. Lyle agreed to file a lawsuit. She was not claiming that anyone had harassed her or made sexual remarks toward her; rather, she was arguing that the talk in the writers' room crossed a line.

About a month after she was fired, Lyle was invited to a party at the home of *Friends* writer Shana Goldberg-Meehan. She thought it was strange to be invited to a party with the same people who had dismissed her from her job but attended regardless with her sister. At the party, she was approached by Chase and Malins, who offered their apologies. They

were sorry for how things had played out and wanted to wish her the best. Lyle was flabbergasted. She still did not understand why she had been let go in the first place, and they had provided no further clarity.

Lyle's lawsuit was rapidly dismissed, and jobs in the entertainment industry were hard to come by. (Lyle's former Nickelodeon colleague Imani Walker was having trouble getting jobs, too, and she suspected it was because employers were confusing her with Lyle.) Lyle realized that her ambitions—to travel the world, to write—could be fulfilled elsewhere. She wanted to complete her education, and she wanted to become physically fit. She joined the military and spent the last months of 2001 at basic training in Texas.

Some months afterward, she was in a small town in Germany called Spangdahlem, about two hours west of Frankfurt. Lyle was now an editor for a military publication called *The Eifel Times*, traveling to cover military operations and training exercises in Germany and elsewhere. The subject of the *Friends* lawsuit never came up with her colleagues.

In April 2004, Lyle was just back from a trip to the Netherlands, where she had observed a military operation, when she received an email from her friend Alex Saltikoff, who was in Air Force public affairs with her, congratulating her on the great article on CNN. Lyle was confused. Why was CNN picking up her story on American military maneuvers in Holland?

Lyle's four-year-old lawsuit had unexpectedly been resuscitated by an appeals-court judge, who brought back the charges of sexual harassment but not the accusations of racial and gender discrimination. Publications from *Elle* to ABC News wanted to tell her story. Peter Jennings traveled to Spangdahlem to meet with Lyle. She refused to be interviewed on-screen, though, so the best Jennings could do was to get some B-roll footage of his walking with Lyle. Howard Stern devoted time on his show to her, referring to her as a prude for expressing her discomfort.

The court's decision limited the lawsuit to the sexual-harassment aspect of her complaint, despite the fact that Lyle was more troubled

about her dismissal than about the humor in the writers' room. There was seemingly no interest in the industry in hiring her, and she thought it highly unlikely that she would be able to get back into television now. It was incumbent on *Friends,* she thought, to reimburse her for the forced change to her career trajectory.

Warner Bros. dug up an old typing test Lyle had taken for a temp job that showed she only typed fourteen words per minute to back up their case about her being a slow typist. Lyle said she had been sick that day and cajoled to take the test merely as a formality before being assigned a temp gig.

Other accusations were more troubling. In discovery, testimony was given about Lyle's visiting anti-Semitic websites on her work computer while in the writers' room, which she disputed.

Years later, writers would make reference to Lyle's nonexistent gang affiliations and to her being involved in selling drugs. These accusations were troubling because they felt as if they were not meant to apply to Amaani Lyle, graduate of the Oakwood School, emerging television writer, and *Friends* alumna; they were meant to describe some other, imaginary African-American woman.

Trolls tracked down Lyle's address and telephone number in Germany, and she began to receive hate mail. People took the time to address and mail international letters calling Amaani Lyle a "dumb humorless bitch," a "humorless cunt," "dyke," or just "nigger."

On the one hand, the defense argued that Lyle's claims were not grounded in any fact. On the other hand, television writing required a free space where frank discussion was allowed and encouraged, and any encroachment on such freedom would irredeemably cripple the artistic creativity that flourished in Hollywood.

But which was it? Had the events detailed by Lyle taken place and been a necessary part of the job, or had they not taken place? The counterclaims acknowledged the sexual speech in the room but denied the specific details of the stories alleged by Lyle. Some of the writers wanted to put forward a simpler argument: that working on a comedy series

didn't always look like working. Often, a crude or sexual story would be introduced before being refined and filtered into something that could serve for *Friends*. None of this, they would argue, constituted a hostile work environment.

To help make their case, the defendants called on some of the most prominent names in television to come out in their defense. An amicus curiae brief arguing that crude talk was a part of the creative work being done in writers' rooms made its way around Hollywood. Lyle was stunned to realize that many of her idols now knew who she was—but had come out against her. No budding writer wanted to be known by the likes of *All in the Family*'s Norman Lear or *The West Wing*'s Aaron Sorkin—both signatories to the brief—as a killjoy intent on damaging the art of television.

Lyle's case was ultimately dismissed for a second time, with the California supreme court ruling that she had not been subjected to sexual harassment. "There is no dispute that sexually coarse and vulgar language was used regularly in the *Friends* writers' room," the court observed in its ruling. "But the use of sexually coarse and vulgar language in the workplace is not actionable per se."

The defense mounted by *Friends* was successful but also transformed an argument into a matter of intellectual principle. The amicus brief was right to defend the freedom of the writers' room, but in explicitly making a case for the necessity of brutish humor, it opened a loophole a mile wide in future efforts to police the behavior of men in positions of power in Hollywood.

It is important to remember that no one was targeted by any of the conversation in the *Friends* writers' room. Women were not singled out for abuse or made the subject of unwanted advances. It was undoubtedly a reasonable expectation that writers for *Friends* be comfortable discussing human sexuality. This was a show, after all, whose broadcast episodes included references to premature ejaculation and impotence, and whose second episode considered the importance of foreplay to sex. The question remained, though, of whether there were lines that should not be

crossed or topics that had best not be raised in the room. How was good comedy made? Did it require a fearless willingness to say anything? Or could limitations be placed without affecting the final product?

Amaani Lyle forced Hollywood to consider these questions, and the industry very much did not want to do anything of the sort. It wanted to carry on as it always had and firmly resented anyone who pushed it to see matters from another angle. Women in Hollywood would have to be the ones to adjust to the status quo—not vice versa.

It was impossible to know if Amaani Lyle would have become another Norman Lear or Shonda Rhimes. The odds were against her, as they were against everyone in Hollywood not named Norman Lear or Shonda Rhimes. But what was incontrovertible was that after Amaani Lyle saw fit to complain about the nature of her employment, practically all of Hollywood disputed her claim. To Lyle, it felt as if the industry were rising up on its hind legs and roaring in her direction.

Over a decade passed, and the worm turned in the entertainment industry, with notable consequences. The argument that had been made against Amaani Lyle had, as she saw it, turned into a noose that entrapped all of Hollywood. There was a new sensitivity to the travails of women in the workforce. And Amaani Lyle, forty-four-year-old military lifer, master sergeant in the Air Force reserves, began to dream, ever so tentatively, of picking up the shattered pieces of her career. She would not be a writers' assistant again, or even a writer, but wouldn't it be nice to create her own show? But Lyle suspected that even now, even with all the gallons of ink and floods of tears spilled over the victims of Hollywood, she was still blackballed. She was not one of them now, and perhaps never had been.

———

The long tail of the *Lyle* decision would have unexpected repercussions for the industry. Lyle was stunned to hear from friends in law school that her case was being studied in class, presented as a crucial ruling

defending the freedom of creative thinkers to express themselves in un-traditional fashion. The *Lyle* case had freed Hollywood from apprehension over the kinds of mundane concerns its male employees might have faced had they been working in a corporate office park.

In the fall of 2017, when lingering horror over the election of serial sexual harasser Donald Trump to the presidency began encouraging women in Hollywood to speak up about the abuse they faced in their careers, it rapidly became clear that dozens of abusers in positions of power had depended on a culture of silence to escape detection, such as *NCIS: New Orleans* showrunner Brad Kern, who had referred to a working mother on his writing staff who needed to pump breast milk at the office as a "cow in the field." The freedoms of creativity had been abused, with consequences ranging from brutish or demeaning talk to sexual harassment to sexual assault. Almost a year into the #MeToo movement, a scathing article in *The New Yorker* detailed unwanted sexual advances by none other than Leslie Moonves, the head of CBS and onetime Warner Bros. president who had championed *Friends* from the outset. Moonves was eventually forced to step down from CBS after numerous women came forward with allegations of sexual assault.

By shoving Lyle away, Hollywood had unwittingly opened space for abusers, who felt newly empowered to misbehave. "Creative necessity" was a new catchall concept, introduced to writers as a potential get-out-of-jail-free card that rendered all manner of misconduct crucial to the creative process.

The Writers Guild would go on to inform its members, in the wake of Weinstein and his fellow predators, that "the decision does not permit such talk to be aimed at an individual in the room. Indeed, it acknowledges that objectionable talk may, in some circumstances, be enough to create a hostile work environment." The law may have been in accordance with the Writers Guild's read of the *Friends* decision, but the popular understanding of the decision was something else entirely and may have prompted, or allowed for, some of the very behavior it barred.

The news concentrated on the boldface male names toppled from their positions of power. But the more compelling, and far sadder, story was about women. How many women might have been living different lives, pursuing different dreams, if only they had been treated differently?

PART IV

. . .

IS THAT WHAT A DINOSAUR WOULD DO?

Seasons 8 through 10
(and Beyond)

CHAPTER 18

YOU'VE BEEN BAMBOOZLED!

Raising the Question of Whether *Friends* Could Handle a Third Couple

Keeping a sitcom going was childishly easy and mind-numbingly difficult, all at once. Once the characters and settings had been fitted into place, it was possible for a roomful of comedy writers to come up with an infinite array of jokes, propelling even the most mediocre sitcom forward indefinitely. And yet, the very structure that provided the roof over the sitcom's head could also serve as its prison. It would be exceedingly hard to shift characters off the tracks that had been laid out for them. To refresh was to run the risk of betraying an audience that had come to expect a particular kind of treat and was in the mood for nothing else.

Ross had already been paired off before with Rachel, and Chandler and Monica were now a couple. The show's lifetime cap on serious relationships between characters was seemingly close. But audiences were ill inclined to invest in romantic relationships with new characters, who had little of the history they had already accrued with their familiar friends. Ross and Rachel and Phoebe and even Joey had their share of notable romances after Chandler and Monica got together, but those

relationships always felt somewhat flimsy, comedic contrivances rather than the start of something serious.

Audiences wanted the characters to grow but also wanted them to do it in the company of their friends, which made for a tricky dance. Part of maturity—at least part of the maturity that shows like *Friends* envisioned—was settling down, but if audiences didn't want to see the show's beloved characters wind up with strangers, how to square this particular circle?

The show promoted a series of work-arounds to this challenge, allowing its characters to mature in tandem with their cohort. In season 9, Phoebe would be paired off with Mike Hannigan, played by the endlessly winning Paul Rudd. While he was superb on the show, even someone as gifted as Rudd felt decidedly secondary in the presence of the charmed circle of *Friends*.

David Crane was attracted to two simultaneous, and often contradictory, beliefs. The first was that they should surprise the audience and avoid delivering the overly expected plot twist. This was especially relevant the longer the show progressed, with marriage and children calling each character to their overly cozy embrace—something Crane hoped to hold off for as long as possible. The second was that *Friends* had promised its audience that, whatever the curves and switchbacks it carved on its circuitous route, it would eventually give them what they wanted. Crane was professionally and emotionally invested in the idea of satisfying the audience, but he was also constitutionally ill inclined toward doing so without complications. He was starting to wonder: What if Joey developed feelings for Rachel?

It was one thing for Rachel to fall for her hunky assistant or Ross to get entangled with a comely college student. To take Rachel and manufacture an unexpected romance with another friend who was not Ross was to rattle the audience with the force of what they had not expected and likely did not want. Nonetheless, the idea of trying out Rachel with Joey had been nagging at Crane for some time. Monica and Chandler had gotten married, and *Friends* had sidestepped Monica's expected

pregnancy by getting Rachel pregnant instead. Now that Rachel was pregnant, and Ross was revealed to be the father, it was practically de rigueur that the two finally, at long last, get married.

Crane wanted a roadblock placed in the way of Ross and Rachel redux, and what more substantial complication than to have another friend develop feelings for Rachel? Chandler was out of the question (although that might have made for a *very* interesting alternate-universe plotline), and while Joey had been coarsened over time into a dumb-actor stereotype, pairing him off with Rachel might reawaken some of his dormant sentimental streak.

The idea was totally wrong, and Crane knew it. Joey and Rachel did not belong together. *Friends'* audience did not want to see them together. And the show's actors were making a highly persuasive argument against embracing this plotline. "You can't do that!" Crane remembered their telling him, united in their antipathy toward this idea. "That's like having a crush on your sister!" They went on, exercised by their displeasure: "It's like playing with fire!" Crane agreed with them but believed playing with fire was exciting. There was a reason children had to be warned away from doing it.

Crane saw it as putting up a temporary structure composed of equal parts solid and crumbling bricks. Joey's love for, and fidelity toward, Rachel as a friend would suddenly blossom into something deeper. It was wrong, Crane felt, for Rachel to even consider dating someone else as she was carrying Ross's baby. Ultimately, Rachel and Joey would serve as a privileged interlude, a speed bump delaying what might otherwise have been an inevitable conclusion, but Crane believed it would also allow the audience to see Joey in a new, heartbreaking light.

Joey had been, from the very start, an unapologetic horndog, eternally single and in search of the next conquest. He was the guy who had a nickname for his penis (the Little General, upgraded from the Little Major). When Ross attempts to defuse Joey's discomfort at Carol's breast-feeding his son, describing it as the most natural, beautiful thing in the world, Joey responds, missing the point entirely, with, "Yeah, we

know, but there's a baby sucking on it." When newly minted stock guru Monica announces her motto is "Get out before they go down," Joey smiles into his cereal and responds, "That is so not my motto." Joey was kind—we saw him befriending a single mother in the hospital in "The One with the Birth"—but he was also allergic to commitment and inclined to see women as inducements to pleasure and little more.

The show itself had understood the thought of Joey and Rachel to be taboo. In "The One with Rachel's Book," from the seventh season, Joey had discovered his new roommate's taste for erotic fiction and, intrigued and flustered, sought to embarrass her by declaring it a kind of feminine pornography. Rachel's sexuality is confounding to Joey, and he returns to it time and again until Rachel unexpectedly turns the tables on him. If he is so interested in her sexual expression, then why don't they just do it? "Come on, Joey," she coos at him, "sex me up." Cornered like every cowardly catcaller, Joey nervously backs away from the threat of unchecked feminine eros: "I don't want to. I'm scared."

The eighth season begins in a swirl of conflicting stories and confusing developments in the aftermath of Chandler and Monica's wedding. After finding a positive pregnancy test, everyone knows someone is pregnant, but no one is quite sure just who. The courtly Joey gets it in his head that it is Phoebe who is shortly to become a mother, and he approaches her, taking her hand in his and soulfully wooing her: "It's a scary world out there. Especially for a single mom. I always felt that you and I have a special bond, so . . ." He drops to one knee and takes out a ring box: "Phoebe Buffay, will you marry me?" The truth is sorted out, although not before Phoebe vigorously and enthusiastically accepts his proposal. (When Monica points out that he might notice something is amiss when no baby arrives in nine months, Phoebe replies, "It's Joey!" She then turns to him and mouths, "Love you.")

Joey proceeds to undo some of the audience's goodwill toward his exceedingly gracious gesture by repeating the same speech, verbatim, this time for Rachel. Rachel lets him down gently: "You are so, so sweet, honey, but I'm not looking for a husband." (Surprisingly, given where she

starts on the series, Rachel flourishes into the most plainspoken feminist voice on *Friends*.)

Some dormant chivalrous gene has been awakened in Joey nonetheless, and a handful of episodes later, in "The One with the Stain," he expresses his disappointment at the prospect of Rachel's leaving in his own inimitable Tribbiani fashion, calling her "the hottest roommate [he] ever had." (Joey's roommates have included a dancer played by model Elle Macpherson, so the compliment is genuine.) Joey sets up a crib in the living room and even offers the baby the use of his beloved stuffed animal Huggsy.

Joey is simultaneously courtly and crude, and while he occasionally rankles Rachel with his Catholic-schoolboy mentality, as when he tells her, "You can't be a single mother alone," he is mostly intent on pledging his support.

Rachel is pregnant and miserable at the start of "The One Where Joey Dates Rachel." She is worrying over the impending birth, and Joey's asking for a restaurant recommendation reminds her how much she misses getting dressed up and going out on a date. Joey, discovering his latent gallantry, offers to take Rachel out on a date of her own, and Rachel, pleased to be invited, agrees.

In the next scene, Rachel is preparing herself in the bathroom when there is a knock on the door. She calls out to Joey to tell him to answer it, but when he does not respond, she clomps to the door, where Joey sprawls across the door frame. He offers her lilies—her favorite flower—and a brownie. The gesture is sweet, even when Joey admits that the brownie is "actually just a bag. It's a long walk from the flower shop, and I was starting to feel faint."

Rachel complains of "a hint of morning sickness and I'm wearing underwear that goes up to about there," slapping the waistband against her chest. She is trying to break the illusion, but Joey is insistent on treating this like a real date. "So, nice place you got here," he observes as he struts around the apartment, taking it all in. "Foosball, huh? Pizza box. Subscription to *Playboy*—my kind of woman." Rachel tells him these

258 · GENERATION FRIENDS

belong to her roommate, and Joey asks if he is good-looking. She says he is, and he says it "must be tough to keep your hands off him." Joey is enjoying the role-playing so much that when Rachel jokes, "I'm pretty sure he's gay," he bristles: "No no, he's not, why are you trying to ruin the game?"

In the next scene, Rachel corners the waitress and requests a different side dish to go with her filet mignon instead of steamed vegetables: "Is there any way that I could substitute the three-pound lobster?" Joey proves his bona fides as a thoughtful date by ordering the same meal for himself.

Rachel begins talking about getting him the rent check, and Joey demands she stop. They are on a date and must act like it. "Wow," Rachel tells Joey, "I get to see what Joey Tribbiani is like on a date. So, do you have any moves?" Joey tells her that he does not, that he just acts like himself—then bursts out laughing: "I couldn't even get through that." He has two go-to moves. The first is arranging to have a bottle of wine sent over by a "fan," followed by his saying, "This is so embarrassing." The second is to lean in and murmur, "I was going to wait until the end of the night to kiss you, but you're just so beautiful." He asks Rachel what her move is, and she tells him it is to ask, "So, where'd you grow up?" Joey is unimpressed: "Rach, you're lucky you're hot." But she insists that he respond to her question and its follow-ups, and after a minute or two of delving into the complexities of his relationship with his father, he stops himself, amazed. Rachel gets up to go to the bathroom, telling him as she passes him, "And now you're watching me walk away." "So simple!" Joey exclaims.

As they arrive home, Joey enthuses about their evening, saying it was the best date he's ever been on: "I never knew I could enjoy the non-sex part of a date so much." Rachel asks about "end-of-the-night moves," and Joey reluctantly shares his secret: raspberry-flavored lip balm to "make my lips look irresistible." Joey has made himself vulnerable by revealing the actorly tricks of the trade necessary to be a ladies' man and asks Rachel to open herself up. She resists, then reluctantly agrees, asking Joey to stand up. "When we're at the door, I lightly press my lips

against his," she says, putting her finger up to his chin, "and then move into his body just for a second, and then I make this sound." Rachel releases a low moan, and then immediately relinquishes the stage, insisting that it really does work.

Joey needs no such assurance, rendered entirely unable to speak by her brief performance. Rachel gives him a brisk peck on the cheek and says good night, and Joey is left blinking in the living room, his brow furrowed. He tries to physically shake off the spell Rachel appears to have cast on him, seemingly without much success.

This still feels like a joke—Rachel can even have Joey catching feelings!—but the next scene between them recasts the moment in another light entirely. Rachel suggests that they watch *Cujo*, one of Joey's favorite films, together. Joey agrees before Rachel reminds him of his big date that night. She then goes on to ask him a question: "After our date last night, did you feel a little weird?" Joey enthusiastically chimes in: "Oh my God, you did too? It totally freaked me out. What was that?" Joey is referring to his emotions—a foreign country of which he is only dimly aware, like Sri Lanka—but soon realizes Rachel is talking about the lobster, which made her sick all night. Joey covers up, saying he was sick, too: "Yeah, you don't want to look in my hamper."

Joey is out that night with a sultry, dark-haired, short-skirted beauty who is practically the epitome of what we know of Joey's taste, but he struggles to feign enthusiasm for her dull Stephen Baldwin anecdotes. She heads off to the bathroom, and Joey takes in the view, his long, low exhalation an acknowledgment that, if forced, he could settle for this. Nonetheless, he returns home early from his date. Rachel is watching *Cujo*, and Joey is appalled that she would watch such a scary film alone. He pulls up a stool, and she asks him, "What are you doing over there? Come sit here. You protect me." Joey perches on the edge of Rachel's chair, and she drapes her blanket over him. When Cujo appears again, she pulls him down beside her, covering her face and cowering: "Seriously, how could you watch this? Aren't you scared?" The camera pulls in on Joey's face as he admits a fear of an entirely different kind: "Terrified." He

slowly, reluctantly wraps his arms around her, only just beginning to take in the feelings he hardly knows how to acknowledge.

Echoing Ross's earlier misstep when contemplating dating Rachel, Joey crafts a list of his dislikes but (in what is perhaps intended as a reminder of Joey's inherent kindness) comes up with only one item: Rachel made him switch to light mayonnaise. Joey's brain is engaged in a losing battle with his heart, pleading with him that all is well as we hear him shakily tell Rachel (in voice-over), "I love you."

Joey is convinced, much like the show itself, that Rachel and Ross are destined to wind up together, and so what use can his feelings be in the face of such fated romance? The show tilts the playing field away from Ross, with Joey the natural caretaker and gentle presence soothing Rachel's turbulent pregnancy. He is the one who knows pickles make her sick and happily accepts the job of scarfing down her sandwich to remove it from her sight.

Ross is possessive and judgmental (he keeps referring to her as "Rachel who's carrying my baby," implying a certain sense of ownership), and Joey is gentle and giving. Joey ultimately tells Rachel how he feels, breaking the news gently to her while at dinner: "I think I'm falling in love with you." Rachel looks behind her, convinced this is all a particularly foolish practical joke, before understanding dawns and she seeks the words to let Joey down easily: "I love you so much, but . . ." It is surprising to see Joey, the ever-vigilant lothario, now helpless in the face of unrequited love. He delicately cuts off Rachel, telling her he knew it was coming, and when she worries about losing him, he reassures her: "Hey hey, you can't—ever."

The Joey/Rachel story line is a three-handed dance, with Ross the invisible partner crowding their every step. Before even telling Rachel of his feelings, Joey assures Ross that he has no intentions of pursuing Rachel: "I am never going to act on this Rachel thing." After Joey imagines Rachel taking a break from childbirth to tell him that he was "the best sex I've ever had," he pictures the baby coming out with Ross's face on it.

Joey's feelings appear to die away, and *Friends* feints in the direction of dropping the plotline before the eighth-season finale, "The One Where Rachel Has a Baby," in which Ross reconsiders the possibility of romance with Rachel. You might mess everything up, Phoebe tells him, "or you might get everything you've wanted since you were fifteen." Joey, meanwhile, is holding a despondent postpartum Rachel's hand, promising her, "You are never, ever going to be alone." Joey discovers the heirloom ring that Ross's mother gave him earlier in the episode, fruitlessly encouraging him to propose to the mother of his baby, and swivels to face Rachel. Without his saying anything, Rachel believes he is proposing and replies, "Oh my God—OK."

Friends, as always, revels in the bafflement of its audience, delivering the plot twist that it was not suspecting while withholding the one it anticipated. And this will not be the last instance in the Rachel/Joey saga in which the end is not the end. The ninth-season curtain-raiser, "The One Where No One Proposes," begins with only Joey aware that no one has intentionally proposed to anyone else.

Ross, eternal lover of love, the man married more times than he can rightfully keep track of, is almost convinced that he has proposed to Rachel before Joey clears the air. He apologizes profusely to Rachel for the confusion and almost instantly reverts into the clueless horndog we expect. He watches the baby nurse and exclaims, "Man, that kid is going to town!" Order has been restored, and Joey is once more a bystander to the ever-fluid romance of Ross and Rachel, who are now living together.

Later in the ninth season, Joey hits on Phoebe when she serves as an extra on his show, telling her, "Sorry, I'm just so used to hitting on the extras." Almost every extra on the show chimes in that they slept with Joey, too. We are being granted a privileged glimpse of Joey's softer side at roughly the same time in the series that his caddishness is being emphasized for laughs. The interlude with Rachel is a canny attempt to humanize Joey, but he is doomed to remain clueless as ever when it comes to treating women outside of their charmed circle respectfully.

But *Friends* is not content with static relationships or preordained outcomes, and Rachel soon moves back into Joey's apartment. It takes him until the fifth morning to remember to wear pajamas, but there is an easy comfort between him and Rachel that is noticeably lacking in the fraught, jealous, strangely hostile face-off with Ross.

In another reversal, it is now Rachel who finds herself nursing unexpected feelings for Joey. It is Rachel who dreams of forbidden erotic encounters and is surprised by the ferocity of her unconscious desires. It is now Joey who blithely tells Rachel that the only time he was ever in love was with her, saying, "And that makes me think about all those times I wanted to grab you and kiss you, but you didn't know, so I would just pretend everything was cool, but really it was killing me."

Now Joey is channeling Rachel's feelings without knowing it, and Rachel is squirming with discomfort at having to keep a secret. (This plotline echoes an earlier reversal, when Rachel was carrying a torch for Ross after he began dating Julie.)

In the ninth-season finale, "The One in Barbados," Joey is dating paleontologist Charlie (Aisha Tyler), who finds herself attracted to Ross. Joey is frustrated by his bad run of dating luck and castigates himself for always going after the wrong girl as he flops onto his bed. Rachel, speaking with exceeding gentleness, tells him this has not always been true, but Joey, his heightened agitation demanding motion and action, is out the door and into the hotel hallway almost before she has finished speaking.

Joey, increasingly slow on the uptake as *Friends* progresses, finally catches Rachel's meaning and returns to find her still standing, biting her thumb, her eyebrow slightly raised, as if to say, "Whaddaya think?" It is a striking moment for Aniston, full of the delicacy and sensitivity and faint erotic charge with which she invests Rachel. In her combative, frustrating encounters with Ross, Rachel is often driven to fury and alpha-girl swagger, but we see here a gentler, more emotionally open Rachel.

Once more, Joey and Rachel's relationship is somehow all about their missing partner, with Joey's telling her, "I couldn't do it to Ross," and their awkwardly shaking hands like strangers at a mediocre dinner party. Joey retreats to the hotel lobby, where he spots Ross and Charlie clandestinely making out behind an array of potted plants, and his chivalry instantly melts away. Not only is Ross not pining for Rachel, he is making out with Joey's own girlfriend to boot. Joey watches them, marinating in his sadness, and takes to his heels. He walks away from the sight of his abandoned relationship and knocks on Rachel's door. She looks at him, he kisses her, and the door closes on them and the season.

There is a good deal of soap opera in this transformation, with elements of infidelity and betrayal that would not be out of place on Joey's own show, *Days of Our Lives*. We sense that all this is deemed necessary to justify so total an inversion of the accepted order of *Friends* as to allow the concept of Joey and Rachel together to seem acceptable. In truth, it is not, and the opening of the tenth season emphasizes the fundamental juvenility of the entire endeavor, including their friends' histrionic responses.

Everyone in "The One After Joey and Rachel Kiss" is engaged in surveillance. Chandler and Monica lead the charge, proposing to press glasses to the walls to spy on Joey and Rachel. Even this is ultimately not enough for them, and they burst through the door to talk to Rachel about this violation of the sextet's unspoken rules.

"We kissed for ten minutes and now we're talking to our friends about it," Rachel grouses, "so I guess this is sixth grade!" There *is* something distinctly middle school about all this, with romantic and sexual behavior being policed by others insistent on knowing every detail even before anything has happened. And Ross is like a particularly distracting ghost, present in every room no matter how fervently they wish him away.

Everyone pleads with Rachel and Joey to talk to Ross first before proceeding, even though, as Rachel tells Joey, she and Ross have not dated for six years. Both Rachel and Joey picture themselves kissing

Ross as they embrace. When the flesh-and-blood Ross finds Joey on the plane ride home, desperate to talk to him about the long-since-forgotten Charlie, the air is thick once more with unspoken secrets. Joey is magnanimous about Charlie, channeling the very words he hopes to hear Ross say about him and Rachel: "You guys make way more sense than her and I ever did."

Ross inevitably feels pressured to manifest a calm he does not feel upon learning their secret. Walking in on them kissing, Schwimmer puts on a strangled high-pitched voice, as if he were trying out for a traveling production of *Cats*, and insists on the two freshly minted couples having dinner together the next night: "I'm making fajitas!"

Rachel and Joey are doomed by the gods of narrative contrivance, and as soon as *Friends* prepares its audience for the prospect of Joey and Rachel in earnest, it wipes their relationship away. Joey tells Rachel his ideal first date, which ends with his feeling her up on the carriage ride home. ("Feel me up?" "In a carriage!") The ghost of Ross still refuses to be dismissed, with their incredibly awkward couples' get-together (in which Ross insists on pretending to be introduced to Joey's new girlfriend) ending with Joey's looking after a drunken and disheveled Ross.

Rachel and Joey are in agreement at long last about wanting to try having a relationship, but while their minds are in accord, their bodies, tellingly, betray their distinct uncertainty. Rachel finds herself continually slapping Joey's hand away as they kiss, and Joey, the master of the one-handed bra removal, fumbles with Rachel's bra strap. Sex, on *Friends*, is the ultimate arbiter of truth, and Joey's and Rachel's bodies betray a truth that they are unable or unwilling to admit: They do not belong together.

Joey, the much-lauded icon of masculine vigor, cannot find it in himself to have sex with Rachel, and as they forlornly discuss the idea of being "one of those couples that never has sex," the end of their relationship appears as unexpectedly as its beginning. "I love you," Joey tells Rachel, but when Rachel says it back, it is leached of any and all erotic

heat. There is nothing left to see here. Rachel and Joey retreat into their earlier pattern, this interlude erased from the historical record.

And when *Friends* headed for its conclusion in season 10, it was understood that only Joey would be left without a romantic happy ending. To be sure, some of this was to keep a door ajar for a spin-off series, in which Joey would be at liberty to start a new life in Los Angeles, but it was also reflective of what had happened to LeBlanc's character over the second half of the show. There were concerns among the producers that Joey had been rendered progressively more foolish as the show unfolded, with the writers leaving him to wander in the wilderness before belatedly understanding a reference or a joke. This was what happened to you on *Friends* when you were unlucky enough not to find love.

Joey's temporary alteration was too abrupt, demanding that we accept a serial pickup artist's blossoming seemingly overnight into an unrequited lover. It is telling that, soon after wrapping the Rachel-and-Joey plotline, Joey's starry-eyed romantic side retreats, never to be seen again.

To tell a story over the course of a decade, and to continually seek to surprise the audience, is to almost inevitably stumble into narrative cul-de-sacs. The gap between surprise and misstep is far narrower than it might appear from the exterior. *Friends* was good at subtly shifting the ground underneath its characters' feet, so that Chandler could slowly, steadily transition from lonely and desperate to dedicated family man without ever pushing the audience to rebel against this change in tone. But the story of Rachel and Joey never really works, because the audience struggled to accept the late-blooming transformation of a character it believed it already knew in full. Accepting it, too, would have meant acknowledging that Ross and Rachel were not meant to be—something that *Friends* fans were not willing to do. Joey's alteration was a misstep, if an occasionally compelling one, but does it not speak to *Friends*' strengths that there were ultimately so few of these lapses over the course of a decade?

CHAPTER 19

NEVER OFF THE TABLE

How *Friends* Was Belatedly Invited to the Emmy Party

In September 2001, the writers of *Friends* were planning to send Monica and Chandler on a honeymoon. The writers scripted what seemed to be a funny B plotline. Chandler and Monica would bicker over the necessary lead time needed for arriving at the airport, and obsessive Monica would hold up the security line in order to maintain her streak of never setting off the metal detector. Chandler would spot a sign prohibiting joking about bombing and lean in to an airport worker: "You don't have to worry about me, ma'am. I take my bombs *very* seriously."

Chandler is instantly taken away and vainly strives to convince a pair of skeptical federal agents he means no harm: "I mean, I know the sign says no jokes about bombs, but shouldn't the sign really say, 'No bombs'?" The entire plotline was harmless airport humor, casting Chandler in the familiar role of hapless joker facing a distinctly unamused pair of foils, but on the morning of September 11, 2001, reports filtered onto the *Friends* set about an airplane that had crashed into one of the towers of the World Trade Center.

That September morning, David Crane had been at the gym. He

had seen the television reports and had called his partner, Jeffrey Klarik, to register his difficulty processing what he was seeing taking place in the city he once called home. As he was saying good-bye, Crane told Klarik that it was time to head into the office. Klarik firmly told him that not only would he not be going into the office, *no one* would be going into the office that day.

Crane, Kauffman, and Bright were all former New Yorkers and felt a deep affinity for the city. Moreover, their show was set in New York, which raised the question of how, if at all, *Friends* would acknowledge the deaths of three thousand people in the same city where Ross, Rachel, Monica, Chandler, Joey, and Phoebe bantered and drank coffee.

Ultimately, *Friends* decided that an extremely minimal response was wisest. The producers excised all glimpses of the World Trade Center from its interstitial sequences but otherwise made no explicit reference to the calamity. Crane felt strongly that *Friends* was not the show to address the destruction of the World Trade Center. Even if they had wanted to, it was unclear how the scope of a comedy series like theirs could be expanded to incorporate a tragedy like this. (Years later, a spec script for *Seinfeld*, written by Billy Domineau, in which the characters muddle their way through 9/11 was a brief Internet sensation. George asks a firefighter whether all the hoopla is exciting for him, and Kramer realizes that his old pal Mohamed Atta borrowed his box cutter to hijack an airplane and fly it into the World Trade Center.) This was someone else's job. Crane was aware of the hunger for comfort food in the face of horror, and he was proud to have the responsibility of creating the thing that would take Americans' minds off death and terrorism and war for thirty minutes each week.

Friends also had a story emergency of a most unusual kind. Normally, stories went bust when the writing staff realized they weren't getting the laughs they were looking for or something else went wrong onstage. Here, the story was still fine, but the world had changed.

The original bomb-centered plotline had to be completely excised

from the episode scheduled to run October 11, 2001, "The One Where Rachel Tells . . ." The writers were put to work on crafting a replacement story line, preferably using the same sets, and came up with a plot about Chandler and Monica competing with another set of honeymooners for all the trip perks (first-class seats and hotel upgrades) on offer. It was not *Friends*' most inspired moment, but at least it avoided reminding audiences of the horrors they had so recently experienced.

After September 11, Kevin Bright had the idea of inviting one hundred first responders and their families to Los Angeles to attend a taping of the show. Firefighters traveled across the country, from the real New York, still horrifically scarred from the attacks on lower Manhattan, to the New York of the mind located on the Warner Bros. lot in Los Angeles to receive some comfort, and to offer some comfort to everyone still in mourning for their city.

They came bearing sweatshirts and T-shirts for the cast and crew, and in the resulting episode, "The One Where Chandler Takes a Bath," Joey eats his morning bowl of Frosted Flakes while wearing an FDNY T-shirt honoring the memory of Captain Billy Burke. *Friends* said nothing explicitly about Burke or about the thousands of others murdered in the collapse of the World Trade Center, but intrepid viewers would be able to find his *New York Times* obituary and read of the forty-six-year-old firefighter who would regularly ride his bike to his firehouse, who had spent a quarter of a century as a lifeguard, and who had "ordered [his men] out of the north tower" on September 11 "while he continued searching for people to rescue." *Friends*' New York would carry on as it had, but it quietly acknowledged the thousands like Burke who never came home.

In the wake of horror, *Friends* went on much as it had been, albeit with metal detectors on the lot and, for a short time, show-night audiences made up of extras and Warner Bros. employees. Its characters proceeded with their lives with no hint of genuine New Yorkers' feelings of terror, determination, fear, or grief. And truthfully, *Friends*' emotional

landscape would have been overwhelmed by immersion in too much reality. *Friends* had always been a hothouse environment, its characters protected from certain forms of blight.

There simply could not be three thousand dead people in the streets of *Friends*' New York. Whether this was a failing of the show or an expression of its stubborn strengths remained an open question, but it marked a decided positive shift in the show's reception. The 2001–02 season found *Friends* receiving its highest ratings since the second season. Where most series plateaued and then never returned to peak levels of viewership, *Friends* had found new life in its eighth season. Having ascended to fourth place for its third and fourth seasons, and second in its fifth season, it dropped to fifth place in the Nielsen ratings for its sixth and seventh seasons, but it was the highest-rated show on television for the first time in the 2001–02 season.

The show still generated remarkable revenue for both NBC and Warner Bros., with NBC taking in $250 million in ad sales for the 2001–02 season alone. Syndication, moreover, had generated around $400 million for Warners, with a further $1 billion in ads sold to run alongside those syndicated broadcasts. *Friends* was on the air in 175 countries, dubbed or subtitled into 40 other languages.

Friends was also the beneficiary of a belated sense that it had long been deserving of awards recognition it had yet to receive. The show had never won the Emmy for Outstanding Comedy Series. Over its first seven seasons, the only *Friends* cast member to receive an Emmy had been Lisa Kudrow in 1998. (Besides Kudrow, only Schwimmer and Aniston had even been nominated; Matthew Perry, Matt LeBlanc, and Courteney Cox had been snubbed for seven years running.)

Friends had won a smattering of other Emmys, including director Michael Lembeck's for "The One After the Superbowl" and guest-acting prizes for Bruce Willis and Christina Applegate, but was mostly shut out from the major awards by the likes of *Frasier* and *Everybody Loves Raymond*.

In 2002 the streak was finally reversed, with *Friends* at last taking

home the Emmy for best comedy and Jennifer Aniston winning for best actress in a comedy. *Friends* was benefiting from the simultaneous confluence of two burgeoning trends. First, in the aftermath of September 11, audiences were unexpectedly hungering for comfort. Much of the media coverage in the days and weeks after the destruction of the World Trade Center had raised the possibility of the death of irony and satire, and the return of a new seriousness that American culture had been said to have abandoned. None of this came to fruition, and *Friends* embodied the lingering pleasures of the antebellum era: its interest in matters of the heart, its occasionally syrupy wholesomeness, and its purposeful lightness.

Additionally, the continuing success of *Friends*, at a point when most other shows had either gone to their eternal slumber or entered a period of terminal obsolescence, was a necessary reminder of its remarkable achievements. Whether you loved it, hated it, or found it merely a tolerable way to pass thirty minutes on a Thursday evening, *Friends* proved itself to have a lasting appeal that few could have anticipated when it premiered in the fall of 1994. The Emmy win was understood less as a celebration of its most recent season, which included the divisive Joey-and-Rachel plotline, than a lifetime-achievement award honoring the show's superlative run. *Friends* was in its twilight, and a realization was creeping in that the show had never been properly feted for all its accomplishments.

CHAPTER 20

THE DOOR TO THE PAST

The Ballad of Ross and Rachel, Part 5

Friends found inventive ways to keep Ross and Rachel tangled up in each other's romantic lives, even as their actual relationship receded ever further into the past. Rachel briefly dated the father (Bruce Willis) of Ross's college-student girlfriend (Alexandra Holden). In "The One with Monica's Thunder," Monica stumbles on Ross and Rachel contemplating a "bonus night" of pleasure, making out in the hallway outside her apartment moments after she and Chandler have gotten engaged: "I'm sorry. Apparently I've opened the door to the past."

The eighth season begins with the question of the paternity of Rachel's forthcoming baby resolved and Ross established as the father. With the show flirting with Rachel and Joey's finding love, Ross and Rachel are now less a couple in the making than bickering spouses, fighting over everything from their daughter's name to the role of Braxton Hicks contractions in the birthing process ("No uterus, no opinion," she memorably tells him).

There are still moments of tenderness, of pained recollection of what was and optimism about what might be. We see it in Rachel's

elaborate descriptions of her imaginary engagement and wedding to Ross in "The One in Massapequa," with its appearances by Stevie Wonder and Annie Leibovitz, and its planetarium proposal with "Will Marry You Me?" written in the stars.

Ross and Rachel are tipping their hands here; like us, they, too, imagine that a happy ending is written in the stars for them, as much as life appears to be yanking them apart. Ross wants to do better this time than he did with his oldest, Ben: "Every time I have to drop him off at Carol and Susan's, it breaks my heart a little." For this as-yet-unborn child, he imagines a life in which everyone is in bed together on a Sunday morning, fighting over the science section of the newspaper. Left unstated, but strongly implied, is that Rachel is next to him in the bed.

Ross appears to be resigning himself to a life without Rachel, but as always, we like Ross best in his wistful, nostalgic mode. In "The One Where Joey Speaks French," Ross comforts Rachel after her father has a heart attack and takes pleasure in visiting her childhood bedroom.

"Rachel Green is very happy you're in her room," Rachel purrs in response, and while this particular interlude ends in recriminations, with Ross turning down no-strings-attached sex for noble reasons and Rachel frustrated with his inability to comfort her in the manner she requests, this reminder of the sheer length and scope of their relationship jump-starts the final round of their romantic face-off.

Ross and Rachel squabble like preteens with anger-management issues, not parents raising a child together. They soon reconcile, and Rachel, her eyes glittering with emotion, tells Ross, "Just so you know, with us, it's never off the table." This moment is perhaps the most explicit statement yet of what *Friends* has made clear all along—that however far apart they might be, Ross and Rachel always remain within sight of happiness.

Their bouts of childishness notwithstanding, Ross and Rachel have matured, and the final few episodes of *Friends* find them searching for a path to happiness, as cluttered and tangled as the way has become. Rachel is willing to consider Ross anew but decides to take a once-in-a-

lifetime career opportunity in Paris. "I can't believe she's actually leaving," groans Ross. "How am I gonna say good-bye to Rachel?" (Chandler agrees with the sentiment, comparing it to when *Melrose Place* was canceled.)

There is still time for one last classic *Friends* blowout, with Ross deeply miffed at Rachel when she appears to skip over him at her going-away party while offering lavish good-byes to her other friends. "After all we've been through," he blusters, "I can't believe *this* is how you want to leave things between us. Have a good time in Paris."

Ross storms off, and in a later scene in "The One with Rachel's Going Away Party," Rachel visits his apartment to chide him for his lack of faith: "I cannot believe that after ten years, you do not know one thing about me!" She goes on: "It is too *damn* hard, Ross. I can't even begin to explain to you how much I am going to miss you. When I think about not seeing you every day, it makes me not want to go, OK? So if you think that I didn't say good-bye to you because you don't mean as much to me as everybody else, you're wrong. It's because you mean more to me. So there! All right. There's your good-bye."

So much of the missed-connections aspect of *Friends* had stemmed from Ross and Rachel's cosmically bad timing. Here, at last, was the prospect of their each being willing to acknowledge that they were anxious and lovelorn and cared deeply about how the other thought of them. They had spilled oceans of words in a fruitless attempt to convince each other of their love, or of its impossibility, and Ross's first instinct is to retreat to words once more: "You can't . . ."

But there are no words left, and anyway, words are not the right response at this moment. He kisses her. Rachel notably pauses, gauging her internal response, then kisses him back. But there are still twists to be revealed.

BILLION-DOLLAR SITCOM

Further Contract Negotiations, Debating the Issue
of Whether Anyone Could Afford More Seasons of *Friends*

Friends was a fixture of the NBC schedule for so long that the contract showdown of 1996 was only the first of four face-offs between the show's stars and Warner Bros. Once again, the astronomical sums of money at play encouraged *Friends'* stars to be aggressive in their demands. And the discussions that began midway through *Friends'* run would play a major part in determining the ultimate length of the series.

In July 1999, after *Friends* wrapped its fifth season, the show's stars summoned their managers, lawyers, and agents for a secretive meeting. The goal was to hammer out a strategy for approaching Warner Bros. with a set of collective contract demands—$125,000 per episode was nice money, but the previous year, *Mad About You* stars Helen Hunt and Paul Reiser had received an astounding salary bump, being paid $1 million per episode for their final season. *Mad About You* was a quality show and had only two stars to *Friends'* six, but in what conceivable universe should the stars of the sixtieth-ranked show in the Nielsen ratings have been paid eight times what the stars of the second-ranked show received?

There were still ten months until the contract extension they had negotiated in 1996 would expire, which should have provided more than enough time for their representatives to hammer out a new contract. Lisa Kudrow came in with a different suggestion: Do nothing.

Kudrow believed that their position would be best served by letting the clock nearly run out before beginning talks. Warner Bros. and NBC would be so hungry for more *Friends* that they would likely accede to all the stars' demands. The other performers' representatives hated Kudrow's plan. What was the point, they wondered, of unnecessarily agitating the very people they would have to negotiate with? Why drag out the process when it could be streamlined? But Kudrow's more combative proposal carried the day, and the start of negotiations was intentionally delayed until the next spring.

In the fall of 1999, as the show's sixth season was under way, word circulated in the press that the six stars would once again be negotiating their new contracts in unison. *Friends'* closest competitor in the Nielsen ratings, and its Thursday-night compatriot for more than half a decade, *ER*, had extended star Eriq La Salle's contract for three additional seasons at a reported price of $27 million. Moreover, Warner Bros. had negotiated with NBC to provide another two seasons of *Friends*, in an agreement that would bring in $220 million. If Warner Bros. was making more than $5 million for each new episode of *Friends*, shouldn't its most famous faces receive a good chunk of those earnings? There was a reasonable argument to be made that rather than being overpaid, the *Friends* stars were still underpaid.

By February 2000, the two sides' positions had been clarified. In remarks to the press, Kudrow made clear that *Friends* would only return if all six actors agreed on a new contract. This was both admirable loyalty and savvy judgment, eliminating one potential line of counterattack: summarily firing one of the show's actors and hoping to see the remainder come crawling back to the negotiating table. Kudrow was turning up the heat on Warner Bros. by opting for a position of studious neutrality regarding the future of *Friends*: "If we all decide we don't

want to come back it'll be fine with me and I'll just get on with my life. . . . If we sign up for another season, I'm fine with that, too, because it is such fun going to work every day."

Producer Todd Stevens would come into the show's office during this period and steer his way around Kevin Bright, whom he knew to be consumed with the contract negotiations. He figured that the less he knew, the better off he would be. That way, when news of the stars' contract status broke in the press—and it inevitably would—Bright would not be giving him the stink-eye.

The actors selected Aniston and Cox's manager Sandy Wernick to represent them in the negotiations. He came in with a steep, and painfully brief, bid: $1 million per episode for just one more season, the seventh. Not only did the six actors want an enormous pay raise, they also wanted their pay retroactively increased for the season they were wrapping. This would mean that Warner Bros. and NBC would be back in the same position one year from now, needing to meet their stars' demands to ensure another season of *Friends*. They countered with an offer of $600,000 per episode for two more seasons of the show.

The negotiations dragged on for long enough that the show's writers had to begin preparing for the possibility that the upcoming sixth-season finale would also serve as the series finale. There was still no deal by the time the sixth season finished shooting, and by early May, NBC began to grow genuinely fearful that *Friends* would wrap permanently. NBC pulled all discussion of *Friends* from the upcoming upfronts in New York, removing images of the show's stars from a mural that would feature the network's biggest names.

NBC and Warner Bros. were publicly declaring themselves resigned to the loss of *Friends* from their broadcast schedules while privately scrambling to meet the stars' demands. Warner Bros. told the network that they would have to chip in almost $6 million per episode from the seventh season on. They also approached Bright/Kauffman/Crane and insisted that the show's creators share some of the back-end profits with their cast.

By this point, the deal, while not quite at the $1-million-per-episode mark carved out by Hunt and Reiser, had reached approximately $20 million per season per actor. Over the course of the two-year contract, they would each stand to make $40 million. On Friday, NBC had informed all the parties involved in the negotiation that Sunday at noon was the drop-dead time. If no deal had been reached by then, NBC would regretfully have to move on without *Friends*.

Early that Sunday, at around one thirty in the morning, the six actors and their representatives got on a conference call to make their final decision. Given the negotiating tactic they had employed, this decision would be more convoluted than usual. If everyone did not agree, there would be no deal. In the end, it was Schwimmer and Kudrow who were most unsure about carrying on with *Friends*.

Even though her recent film *Hanging Up* had done negligible business, Kudrow saw herself as a budding movie star after prominent roles in *The Opposite of Sex* and *Analyze This*, ready to leave television behind. And Schwimmer had always considered himself more of a misplaced theater geek, adrift in Hollywood. But the money so dramatically eclipsed what any of them could earn in the movies—let alone the theater—that it was hard to justify not spending two more years on *Friends* and earning enough money for a lifetime.

The other four stars rallied to convince Kudrow and Schwimmer to stay on. Not only was there an inordinate amount of money to be made, the six actors actually still enjoyed each other's company and enjoyed the work they did. And it would be hard to imagine a schedule more tailored to their comfort. They only worked four days a week now, with less rehearsal time built into the schedule and the producers' making sure to leave plenty of leeway for their stars to shoot films, even during the season.

After a long night of negotiation, Wernick called Warner Bros. at three A.M., only hours before the deadline, to tell them the deal was done. Some of the negotiators were stunned that the decision had been made so near the deadline, given that so much time had elapsed in

which the six actors could have made up their minds about whether to come back. One unnamed source told *Entertainment Weekly:* "It's an asinine time to decide whether to do something. . . . They've known about it for a year, and the night before they're deciding whether they want to stay?"

The cast wound up with a new two-year contract that would pay them $750,000 per episode, ensuring that *Friends* would run at least eight seasons. NBC was relieved, and also inclined to poke some fun at their erstwhile adversaries. The next day, when the fall schedule for the 2000–01 season was unveiled, West Coast president Scott Sassa called for the six people most responsible for closing the *Friends* deal. Six actors with briefcases took to the stage, with the last one, executing a series of backflips, introduced as "Schwimmer's lawyer."

The shorter contract meant that only about eighteen months would pass before the same figures were negotiating again, seeking to bring the show back for a ninth season. In the intervening time, a split had begun to form between the corporate partners involved with *Friends.* Warner Bros. had already lavishly recouped their investment through their syndication deal. *Friends* would bring in more than $1 billion for Warner Bros. even without future seasons, so the prospect of another twenty-four episodes of the show was less attractive to them than it was to NBC, which desperately wanted another season of elite ratings. The stars asked for $1 million per episode—Reiser and Hunt levels, but for all six stars.

NBC had had years to develop new hits to eventually take over Thursday nights, but with the exception of *Will & Grace,* the cupboard was mostly bare. There were concerns once more that Kudrow and Schwimmer were likely to be the holdouts, with Kudrow said to be most likely to bail given the paucity of worthy story lines for Phoebe as *Friends* was consumed with the Rachel/Joey plotline. Once again, Warner Bros. wanted to recoup some of their future investment with greater buy-in from their partners. This time, given the differing financial interests of the studio and the network, Warner Bros. wanted to break even on the

deal immediately, rather than losing money in the moment even if future profits would more than cancel out the debt.

In its last seasons, *Friends* existed in a simultaneous state of unprecedented success and unsettling limbo. *Friends* was one of the most popular comedy series to ever appear on American television, and its appeal was growing as it approached double digits. The costs of keeping all interested parties happy had risen so dramatically that no one could be sure that the current contract would not be the last one to be signed. The $1 million figure was astounding, but was met by NBC and Warner Bros. for one more season.

During the ninth season, the default assumption was that this would be *Friends'* last hurrah. There likely was neither the money nor the interest from either Warner Bros. or NBC in any more beyond this season, and writers were planning how to end the show suitably. Marta Kauffman and David Crane had quietly been informed that this would likely be the last season, as NBC was not comfortable spending the money it would cost for a tenth season. Crane was philosophical about the news. It had been a good run, and all he had ever asked was to have advance notice of when the show was to end, so he and the writers could craft a suitable conclusion. Negotiations continued apace regardless, and as the discussions unfolded, it became clear that NBC very much wanted one final season of the show.

There was one last negotiation deadline, this time on a shoot night. Kevin Bright was frustrated at the lack of progress and the lack of clarity about his show's future, and he yanked the six stars into a room next to the stage for an impromptu meeting. This was it, he reminded them. All the decision-makers were here, and it was time to settle on whether there would be a tenth and final season of *Friends*. That entire evening, between takes, Bright and the cast would quickly convene and pick up the conversation where they had left off. The two sides ultimately settled on $1 million per episode for a foreshortened final season of only seventeen episodes. It would be ten seasons and, finally, done.

CHAPTER 22

LIGHTNING IN A BOTTLE

Saying Good-bye to the Show

From the moment the actors signed on to return for a tenth and final season, David Crane knew that the time had at last arrived to consider how *Friends* would end. The ninth season had hardly begun before the tenth was negotiated, so this was Crane's first extended opportunity to ponder the show's conclusion. It would require not only bringing Ross and Rachel back together but also striking the right final note for the show's six characters. How could the show say farewell to its six-headed friendship while also confidently sending its characters forward into the future?

"Do you realize a quarter of our lives have been spent on this show?" Crane asked prop master Marjorie Coster-Praytor during the final season. Coster-Praytor was struck by *Friends'* having thrived for so long that it occupied a significant portion not only of its cast and crew's careers, but of their lives as well.

Crane knew immediately that there were two emotional beats the final episode would have to strike, with Ross and Rachel's reunion followed by a farewell to all the characters. A plot thread from earlier in

the tenth season laid the groundwork: Chandler and Monica were, at long last, moving out of the apartment and to a home in the suburbs. We knew that the apartment had belonged to Monica or one of the friends for more than ten years, and so it made emotional sense for everyone to gather there one final time before it passed into the hands of strangers.

There had been a sadness in the writers' room that entire final season. The tenth season had come as a gift, an unexpected bonus, but with it came a profound sense of finality. This experience, this impromptu family that had been formed during late nights and early mornings on the Warner Bros. lot, was coming to an end. Everyone knew that this intense enmeshing in a collective goal would never return. There would be other shows, and other challenges, but how many of them would be overseen by the likes of David Crane and Marta Kauffman?

As a tribute, the writing staff decided to hire a skywriter to convey their gratitude to Crane and Kauffman for the opportunity they had been given. The writers trooped outside on a cloudy spring day, Crane and Kauffman in tow, waiting impatiently for their final message to appear in the sky: "Thank you from the writers to Marta and David."

The somber mood, the understanding that meaningful things were coming to an end, weighed down the writers' room. Ted Cohen found himself leaving the room to avoid bursting into tears in front of his colleagues. One writer began pitching a story about Ross's saying good-bye to the apartment and broke down in tears. Writer Sherry Bilsing broke into laughter, sure that this was just another bit. It took her a minute to realize the emotions were real, but by then Crane had already gotten out of his seat and gone over to console the writer.

Real and imaginary endings, real and imaginary farewells, were getting twisted together. The writers were constructing an imaginary send-off to their characters while thinking of the very real good-byes they would be saying to the people they had worked with for years. "This is lightning in a bottle," Bilsing remembered Ted Cohen telling her, leaning on the same image that so many others involved with *Friends* had turned to. "We had the perfect cast, the perfect writing

team, everything. Crew. This whole thing was a family-type experience that is so rare."

The space crunch for available studios on the Warner Bros. lot meant that a new show would be moving into Studio 24 immediately. Central Perk, whose couch and easy chairs had been occupied for ten years, would be disappearing forever as soon as the last scene taking place in the coffee shop was completed, which happened early in the first part of the two-part finale.

In the scene, Ross was moping over Rachel's imminent departure, and Phoebe and Joey were trying to convince him to speak up before she left. Just as Ross summons the courage, he is preempted by Gunther, who chooses that moment to tell Rachel that he is in love with her. Ross, understandably flummoxed, lets Rachel leave.

After a scene, the actors would usually step off the stage briskly and move on to the next scene, but this time, they could not get up from the couch. How many times had they sat in these very places, trading banter? How many millions of minutes had television viewers collectively spent watching them sitting here? The amount was unfathomably large, and the idea that there would never be another opportunity like this one was ineluctably bittersweet. Instead of being shooed off the set, Schwimmer and Aniston were soon joined there by Crane, Kauffman, and Bright, and by the rest of the *Friends* team.

The actors and crew and producers and writers gathered on the stage and exchanged hugs and shared anecdotes about all the moments they had spent together on this very set, telling the stories of these imaginary characters who had taken a very real hold on the affections of millions of television viewers.

The audience waited patiently, no doubt shedding some tears of their own, as they stared at this rip in the façade of emotionless television professionalism. After a lengthy interlude, the actors felt ready to resume the shoot, but their faces had to be redone first. The tears had smudged their makeup.

After the shoot was over, everyone came back on the stage and

drank tequila while they watched the crew dismantle Central Perk. At the very end, when the walls were about to come down, someone pulled out a pen and everyone passed it around, signing their names to the back of the set.

David Crane had told himself all along that the finale was merely another episode, merely one more opportunity to solve a story problem. Crane and the writers wanted the finale to be perfect and to deliver the satisfying conclusion the fans hungered for, and the pressure got to him. He developed a nasty case of shingles, presumably from the stress of *Friends*' coming to an end. Finales mattered. When a show failed its audience, or was understood to do so, as with the *Seinfeld* finale, it colored fans' recollections of the entire series. Crane wanted *Friends* to go out on top.

The final shoot was chaotic and emotional all at once. The *Friends* finale was the hottest ticket in Los Angeles in the spring of 2004. Everyone at NBC and Warner Bros. wanted to be present for the last episode of a television legend. The finale was also an impromptu reunion for staffers who had long since departed the show but still felt an emotional connection to Crane and Kauffman and to *Friends*. The floor in front of the audience was so crowded with returning visitors that the camera crew had to ask people to move out of their way so the cameras could get through. The cast would regularly pause to let a wave of emotion wash over them, and the audience, caught up in the moment, would whoop and holler and express their love.

The episode neatly wrapped up the story lines that viewers had been following for a decade, with Ross and Rachel reaching a resolution at long last (about which more momentarily) and Chandler and Monica preparing to leave their apartment with their newborn son and daughter. In a symbolic gesture, Joey and Chandler's foosball table is destroyed, the emblem of an era's coming to an end.

The final scenes also contained a handful of comic nuggets for the die-hard fans. The movers arrive, and Monica pulls them aside to direct

their attention to the ugly white ceramic dog. It was part of Joey's hideous new-apartment décor since all the way back in the second season's "The One Where Eddie Moves In," was ridden like a conquering steed by Chandler after he and Joey won the apartment in "The One with the Embryos," and then became Chandler's. "If that falls off the truck," Monica tells them, surreptitiously passing along a generous tip, "it wouldn't be the worst thing."

Phoebe notes that, at one point, every one of them lived in this apartment. When Ross says he never did, his sister reminds him of the summer he lived with their grandmother and tried to make it as a dancer (a callback to Ross's energetic but lackluster dance moves in "The One with the Routine"). "Do you realize," Ross tells her, "we almost made it ten years without that coming up?" The audience is presented with the gift of one last reminiscence, one last funny anecdote to chuckle over when the show faded to black.

At last, each of them takes out their keys to the apartment and leaves them on the countertop for the building superintendent, Mr. Treeger. (Mike Hagerty, who played Mr. Treeger, did not appear in the finale but was touched to hear his character's name invoked at the very end of the show.) Everyone takes their leave, silently and feelingly, and Rachel asks the crew, "Should we get some coffee?" Chandler is given one final joke (pitched by Andrew Reich), momentarily dispersing the nostalgic fog: "Sure—where?"

Joey helps to carry the stroller down the stairs, and the camera pans around the now-empty, strangely silent apartment, past the six keys laid out in the kitchen, coming to rest on the famous picture frame on the back of the door. Everyone is gone, and we are given one last moment to take in the familiar details of the apartment and be struck by the unnatural quiet. Life will go on, we know, both ours and those of the characters we have grown so attached to—but it will not go on here, not anymore.

When it was all over and the last moments of *Friends* had been

filmed, everyone gathered once more, crying and hugging and feeling strangely somber about this triumphant moment in their lives. Warner Bros. wanted back their own props, and the Smithsonian had come calling, looking for memorabilia from the show to display in Washington. The museum wound up taking away Chandler's and Monica's wedding rings, invitations to the characters' weddings, and Phoebe's dollhouse from the episode "The One with the Dollhouse." Coster-Praytor, who had designed the dollhouse, wondered how long it could possibly last in a museum, given that the Tootsie Roll-away bed was made out of a genuine Tootsie Roll. What condition would the candy be in twenty years from now?

After the finale was completed, Warner Bros. hosted a gala wrap party the likes of which no one could remember attending. Kevin Bright had never seen an ice chute that dispensed vodka before. It was like a scene from a big-budget movie about a hit television show, ostentatious in a way that was rarely encountered in real life. Sheryl Crow performed for the crowd of celebrants, only some of whom had any personal or professional connection to *Friends*. The cast took turns reading the lackluster testing reports from the pilot. Everyone enjoyed themselves thoroughly, but there was a sense, for some of the inner circle, that it might have been nice to have a more ordinary wrap party, for the people who had labored so long together to enjoy each other's company for a few more hours before parting ways.

The critics were half-hearted in their enthusiasm for the show, even as the final episode was about to air on May 6, 2004. "NBC's send-off has been the most overwrought and prolonged farewell since Violetta's death scene in *La Traviata*," complained the *New York Times*' Alessandra Stanley. "The network's bathos has drained much of the fun out of tonight's two-hour finale." Stanley poked fun at the breathless ad campaign for the finale, which she described as using "the hushed, lugubrious tones usually associated with a space-shuttle disaster or an assassination."

Having established her preference for what she saw as the more sophisticated humor of *Frasier*, also ending its decade-long run that

month, Stanley adroitly tapped into what she saw as the source of *Friends'* appeal. It was a show about the economic boom of the mid-1990s and the reclamation of New York from the chaos and disorder of the 1970s and early 1980s. "*Friends* didn't just ride the economic recovery. It tapped into the country's rediscovery of New York at the dawn of the Giuliani shape-up-or-ship-out era. Suddenly, and in large part because of *Friends,* Manhattan once again looked like a safe, fun and romantic place to be."

While *Friends* had led to imitators like *Will & Grace,* which Stanley saw as aping its predecessor's sensibility, the networks had never been able to create replacement hits. "Viewers grieving over the end of *Friends* and *Frasier* are not just bidding farewell to their favorite sitcoms, they are mourning the genre itself, and that may well justify some hoopla and hyperbole."

Slate's Chris Suellentrop disagreed with Stanley's diagnosis, seeing the death-of-the-sitcom mournfulness as misguided. *Friends,* he argued, was not a sitcom at all: "It's a soapcom, a soap opera masquerading as a situation comedy. The earworm theme song, the laugh track, and the gooey sentimentalism all conspire to fool viewers and critics into thinking they're watching a family sitcom like *Growing Pains* or *Family Ties* updated for urban tribes (a *Golden Girls* for the pre-retirement set). But the beautiful people with opulent lifestyles, the explicit sexual content . . . the long multi-episode story arcs, and each season's cliffhanger ending are the show's real hallmarks. *Days of Our Lives* isn't the only soap opera that Joey has a role in. And this one's got jokes to boot."

Before the finale, *Dateline* ran a two-hour special about the impending end of *Friends* that featured the cast and creators discussing their feelings on wrapping up the show and its impact on the television landscape. The barrage of commercials and marketing hoopla was so intense even others under the network umbrella began to poke fun at the hype machine. On *Late Night with Conan O'Brien,* a faux audience member shouted at the host, "I've had it up to here with all you NBC whores talking about *Friends!*"

The night the finale aired, the cast and crew gathered back on the lot to watch it on television. It was a smaller, more intimate crowd, but it was challenging for some to get back in the mood to say good-bye. For David Crane, they had already wrapped, had already edited the final episode, had already watched it countless times. It was hard to fully comprehend that everyone else was only getting to say good-bye to the show now.

Fifty-two point three million viewers tuned in for the *Friends* finale, the fourth-largest finale audience in television history (behind *M*A*S*H*, *Cheers*, and *Seinfeld*). Television-nostalgia network TV Land chose to go dark during the one-hour broadcast, paying tribute to another show entering the pantheon of beloved television series past.

That night, Jay Leno feigned surprise for the cameras as he poked around on the shelves of a (now-reconstructed) Central Perk on *The Tonight Show*. "This is cool!" he enthused, standing in front of the famous orange couch. Leno introduced a bit with purported former guest stars' reminiscences of their time on the show. "I almost joined the cast of *Friends* a couple of years ago," said a smirking, reptilian Donald Trump, "but then NBC realized they couldn't afford seven billionaires on one show." "I auditioned for *Friends* a long time ago," slyly drawled Snoop Dogg, "and the response I got was they had enough black people on the show." Quentin Tarantino claimed to have directed the first episode, where he killed off nineteen of the original twenty-five cast members. The sketch ended with another sitcom legend, Homer Simpson, who celebrated the news that he would finally get his wish to appear on the show—next season.

Tom Shales of *The Washington Post*, a perpetual *Friends* detractor, was disgusted by what he saw as the shameless intermingling of journalism and commerce exemplified by the *Dateline* special. "At NBC they seem to care much less about programming than they do about promotion," Shales observed. "How NBC News executives can stand up and loudly proclaim their independence after a special two-hour version of *Dateline* that was nothing but a *Friends* puff is stupefying."

Shales was offended not only by the inappropriate treatment of publicity as news but by this treatment's being given to *Friends*, a show he remained baffled by after ten seasons. "The *Friends* finale was designed to be no worse but certainly no better than the average *Friends* episode. The parting of the ways at the end of the show seemed trivial and unaffecting compared with, say, the parting of the Bunkers, Archie and Edith, from their daughter and son-in-law, or the parting of the Ricardos and the Mertzes when Ricky and Lucy moved to the country—and that wasn't even a series finale, just a turning point."

Of course, the emotion of the finale was dependent on ten years of accumulated feeling, none of which Shales shared. "*Friends*," he acidly argued, "was not so much creatively conceived as cunningly concocted. It was less a show than a hunk of commerce—a commercial for a generation that was interrupted by commercials for sponsors' products." The idea of a commercial for a generation offended Shales's sensibilities, but was this really so different from Warren Littlefield's desire, all the way back in 1994, for a new series that spoke to the fears and desires of a generation that had previously been little represented on television?

In his *Slate* article, Suellentrop argued that *Friends* was something other than a sitcom, noting that *Friends* regularly extended its plotlines over multiple episodes, expecting viewers to be familiar with all its past narrative twists and turns. The show, he said, had more in common with a serial drama like *The X-Files* than other sitcoms: "Episodes are occasionally self-contained, but most expand upon series-long story arcs that grow more convoluted and harder for non-devotees to follow with each passing season."

In 2004, it was only just beginning to become clear that this model, in fact, would serve as the future of television, ranging from direct imitators like *How I Met Your Mother* to Peak TV gems like *BoJack Horseman* and *Crazy Ex-Girlfriend*. One of *Friends*' great insights was that the era in which fans would tune in to be painlessly amused for thirty minutes was now over. Something, some emotional nuance or narrative complication, would have to keep them invested.

"You don't tune in to *Friends* to watch wacky hijinks—Will Chandler get stuck in an ATM booth? Will Phoebe land a music video?—but to find out *what happens next* in a plotline you've been following," argued Suellentrop. To which Marta Kauffman and David Crane would likely reply that this had been the intention all along. The comedy and the drama had always been intertwined, and critics' belated realization that *Friends* was something other than a standard-issue sitcom was only their catching up, at long last, with what the show's audience understood all along.

CHAPTER 23

OFF THE PLANE

The Ballad of Ross and Rachel, Part 6

Ross and Rachel share a postcoital moment at the start of the series finale, "The Last One." "This guy at work gave me *Sex for Dummies* as a joke," Ross tells her after she compliments his "new moves." "Who's laughing now?" Later on, Rachel, still exultant, holds hands with Ross and tells him, "I woke up today with the biggest smile on my face." Ross has already talked himself around to the understanding that he wants to be with Rachel now (Phoebe exuberantly remarks, "I feel like I'm in a musical") and is poleaxed when she goes on: "It was just the perfect way to say good-bye."

Ross has built up a decade of collected wishy-washiness to overcome, and to properly hit all its beats, the finale must feature a moment of genuine, unfeigned clarity. Joey, snapping back to his traditional role as adjunct relationship therapist after his brief tenure as romantic rival, offers Ross some advice shortly after Chandler and Monica's twins arrive home for the first time. Rachel has just left without Ross's taking the opportunity to share his feelings, and Joey gives him an out by suggesting to him that this last night together might be the ideal way to get

over Rachel. "I don't want to get over her," Ross declares. "I want to be with her!" The audience roars, and the path is cleared for the last of the show's now-trademark races for romance.

Ross dashes to the airport to intercept Rachel before she flies off to Paris.

After an interlude at the wrong airport, he finds Rachel, about to board the plane. (Emma is to follow with Rachel's mother.) Ross at last says the things he should have said long prior: "The thing is, don't go. Please stay with me. I am so in love with you. Please don't go. I know, I know, I shouldn't have waited till now to say it, but that was stupid. I'm sorry, but I'm telling you now, I love you. Do not get on this plane." Rachel is touched but already drifting away: "I can't do this right now. I'm sorry." She boards the plane, and Ross is left undone, hugging Phoebe forlornly, his eyes pricked by tears.

A somber Ross returns home, only to discover an answering-machine message in which Rachel calls to apologize. She loves him, too, and we hear her clambering out of her seat and struggling to deboard the plane before it takes off. "Did she get off the plane?" he asks the machine, fumbling with its buttons. "I got off the plane," we hear a disembodied voice say, and there is Rachel, standing at the door. It is a nice moment of resolution for the show, a calming finale to a decade of Sturm und Drang.

"This is it," they both agree, and even Ross's callback/joke—"unless we're on a break"—is one final reminder of what was and no longer will be. "Don't make jokes now," Ross chides himself, and we can understand this as a kind of final word about the show as well. Always both a comedy and a soap opera, *Friends* ends by telling itself to cease with the jokes. There will be no further jokes beyond this point, the show is informing us, at least in part because humor, in the world of *Friends,* always threatens to undo or undermine romance. This will be a happy ending—period.

There was something to be said, too, about the way in which *Friends*

had unconsciously adopted the mind-set of Ross when it came to its central romance. Ross and Rachel had previously broken up because Ross had been unable to treat his girlfriend's career with the respect it deserved. And here, once more, was Rachel on the cusp of a major career opportunity, being forced to consider what she valued more: her job or her relationship. (It was an intriguing, if coincidental, development that both *Friends* and *Sex and the City* ended that same year, with its protagonists balancing romance and work, New York and Paris.)

Rachel picks Ross and New York, continuity over change, but perhaps we might spare a moment for what Rachel gives up. The potentially life-changing job with Louis Vuitton in Paris is abandoned, presumably in favor of a return to the same job Rachel had already held. Why did it have to be an either/or for Rachel alone? If Ross had wanted to be with Rachel at all costs, why hadn't he offered to pack up and join her and their daughter in Paris?

To interrogate a fictional television show for its proposed life choices is, by definition, ludicrous, and yet it is telling what *Friends* leaves out. It is Rachel who must squeeze herself into the show's happy ending, must silently make her peace with what a lifetime with Ross will likely keep her from. It is a happy ending, but one that quietly skates past a lingering disappointment that the show chooses not to acknowledge or attend to.

These concerns notwithstanding, we have, at long last, after 236 episodes of murkiness and disorder, arrived at a moment of clarity. David Crane had long thought about the relationship between television writers and their audiences. Each show had its own DNA and its own compact that it formed with its fans.

Crane had thought a good deal about *Seinfeld*'s finale and believed that, whatever its imperfections, the pitch had probably felt emotionally and comedically perfect for a conclusion to so acidulous a series. *Friends*, Crane knew, was not that show. It would best serve its audience by giving them what they craved, but doing it in a fashion that managed to

deliver its happy ending as an unexpected surprise. For Crane, the arrival of Rachel at Ross's door—"I got off the plane"—was one of the finale's crucial moments. He hoped that there had been enough obstacles to the couple's happiness, enough ambiguity about what might happen, that the expected thing still felt like a stroke of good fortune.

CHAPTER 24

I'LL BE THERE FOR YOU

Life After *Friends*

Kevin Bright was pleased to have his next project lined up even before *Friends* was finished. *Joey*, which he was to produce, was practically destined to be the next *Frasier*. This was a spin-off that felt guaranteed to put together a lengthy run on NBC. Viewers would certainly be watching Matt LeBlanc on Thursday nights well into the 2010s. Bright was sure that *Joey*, which would debut in the fall of 2004, would fill the gaping hole left behind by *Friends*. Instead of pairing up with Kauffman and Crane, though, Bright was working with longtime *Friends* writers (and married couple) Shana Goldberg-Meehan and Scott Silveri, who would serve as the showrunners. It was an arranged marriage where the earlier union had been a love match.

Bright, Kauffman, and Crane had dreamed about how to prolong the union they had fallen into on *Dream On* and wound up with *Friends*. Here, one of the show's architects was being paired with longtime writers on *Friends* who had impressive track records writing for the show but whose comedic sensibilities did not align with Bright's. Bright, Kauffman, and Crane had spent more than a decade working together and

were long accustomed to listening respectfully to each other and to accommodating each other's strongly held beliefs. The new triumvirate did not have that same record of compromise and collaboration.

Bright believed that fans turned to *Joey* in the hopes that it would preserve and extend the pleasing aura of *Friends*. The pilot, with David Crane's participation, was very good, Bright thought, but after that, the show set out on a wildly misplaced tack and could never recover from this initial stumble. From the very start, Bright felt that Goldberg-Meehan and Silveri had misunderstood the appeal of their protagonist and were warping Joey beyond all recognition, with Bright little able to rectify the situation.

In moving Joey cross-country from New York to Los Angeles, the perpetual playboy was morphing into a family man. Bright was convinced that *Joey* was going to disappoint its natural audience. Who wanted to see Joey paired with his twenty-year-old rocket-scientist nephew and his sister (even if she was played by *The Sopranos'* Drea de Matteo)? Who wanted to see Joey in a committed relationship? Bright was convinced that Joey had been neutered, and what was intended to be a clever *Frasier*-style reimagining was instead guaranteed to let down *Friends* fans.

By streaming-era standards, *Joey* did very solid business. It was the thirty-fifth-highest-rated network show of the 2004–05 season, drawing an average of 10.7 million viewers. While this was less than half of the audience for the final season of *Friends*, it was still an impressive number, and one that could have been built on. The ratings were fine, if disappointing, but it was increasingly clear that the show had not found its voice, and was not likely to do so, either. Bright found it painful to work on *Joey* week after week, knowing that it was not *Friends* and that it was proving itself ill suited to ever become *Friends*.

Like its predecessors *Veronica's Closet* and *Jesse*, *Joey* was proof that the presence of *Friends* alumni was no guarantee. There had rarely been a show in television history as fast-tracked for success as *Joey*, but NBC wound up canceling it after less than two seasons. In the end, *Friends*

would be the last of the big hits, the last sitcom to draw the kind of audience it did. Later successes like *The Big Bang Theory* would only manage half of *Friends'* audience at its peak.

―――――――

There was a latent desire to see the stars of *Friends* as we wanted them to be and not as they were. After *Joey's* cancellation, Matt LeBlanc returned in 2011 as the star of the Showtime comedy series *Episodes*, created by Crane and his partner, Jeffrey Klarik. In the preceding years, neither Crane nor LeBlanc had struck gold with their *Friends* follow-ups. *Joey* had been canceled and Crane's *Friends* successor *The Class* (2006), treated as another easy shoo-in for success, never made it out of the gate. It demonstrated once more Crane's gift for casting, featuring future stars Lizzy Caplan, Lucy Punch, Jesse Tyler Ferguson, and Jason Ritter, but the high school–reunion comedy limped through a single season before being canceled by CBS.

Episodes (Showtime, 2011–17) was less a return to *Friends* than a metafictional representation of its legacy and its hold on our memories. We might have been watching a comedy on premium cable now, not on NBC, but we were still wrestling with the specter of Joey Tribbiani. In the series, a husband-and-wife team of critically acclaimed television writers find their highbrow comedy about a witty university dean ("So you're saying it's *The History Boys* meets you saying it's not *The History Boys*?") is sideswiped by the network's insistence that they retool the role so Matt LeBlanc can star on the show. "For the erudite, verbally dexterous headmaster of an elite boys' academy," cocreator Sean Lincoln (Stephen Mangan) complains, "he's suggesting . . . *Joey*?"

Matt is narcissistic, self-absorbed, and sexually insatiable. The show he comes to star in, now retitled *Pucks* and concerning a hockey coach, is insufferably bad, but Matt has a certain rough wisdom about the eternal verities of television. He provides his showrunners, only familiar with the brief seasons of British television, with a rapid-fire education in American TV after they present their plan for a tender not-quite-love

story between their protagonist and a lesbian colleague: "That's *one* season for us. *Friends* did two hundred thirty-six episodes. You gotta give yourself places for stories to go. How long do you think Ross and Rachel would've lasted if Rachel had been a lesbian? Or Sam and Diane on *Cheers*? Or Frasier and . . . I don't know, I never watched that show."

Episodes was an opportunity for Crane and LeBlanc to luxuriate in all they had accomplished and to send up the grotesque, inside-out version of fame it had engendered. This was not, nor would it ever be, a documentary about the aftermath of *Friends,* nor was it about the real-life Matt LeBlanc. Instead, it was about our own fervid imaginings of what the "real" Joey might be like.

It was about getting close to our memories of *Friends* and enjoying an extended fan-fiction interlude about what it might be like to have once been a part of television history. It was watching as Matt is prodded to say "Howyoudoin'" to the woman he is having sex with, or asked whether Jennifer Aniston would be likely to attend his funeral. It was recruiting his former castmates to do a guest appearance on his show, and winding up with Gunther.

How did you carry on after the story was over? *Episodes* was an advanced course in television comedy, with Matt LeBlanc—or "Matt LeBlanc"—the professor and master of ceremonies. By contrast, Valerie Cherish, the has-been sitcom star embodied by Lisa Kudrow in HBO's *The Comeback* (2005, with a second season in 2014), was required to endure an unending slate of torments in her quixotic quest for fame. Each episode would begin in renewed hope before crashing down once more into chaos and humiliation. To hunger for stardom was sheer folly, and Valerie, the onetime "It Girl," was willing to endure all manner of embarrassment in the hopes of returning to the blissful cocoon she had once inhabited. "This is *my* comeback!" she tells the unseen audience, but even as she revels in her much-hoped-for return to success, a director is already calling for a retake. Fame is an illusion.

The echoes between Valerie and Kudrow (whose middle name is

Valerie) were there to be mined. Both were faced with the question of what to do when the cameras swiveled away. Kudrow, of course, was substantially more famous (and wealthy) than Valerie, but there was a shared awareness of the psychic costs of fame. Once you had it, it was hard to let it go.

Matthew Perry had the splashiest return to television, coming back in 2006 as the star of Aaron Sorkin's post–*West Wing* vehicle *Studio 60 on the Sunset Strip*. The series was to be loosely based on *Saturday Night Live*, with Perry and *West Wing* veteran Bradley Whitford as the yin-and-yang showrunners of a topical sketch-comedy show. In theory, the union of Perry and Sorkin was an ideal fit. Perry had always been the ablest comic jouster on *Friends*, and his motormouthed enthusiasm and improvisational skills would serve him well in working with Sorkin.

Perry was quite good on *Studio 60*, and if it had been a better, more self-aware show, he would have been stellar. But *Studio 60* never quite figured out what it was about, or whom it was for, and veered early on into another version of *The West Wing* instead of its own story. The show only lasted one season before it was canceled. Perry was a creature of television and made a number of attempts to return to a weekly network series without ever finding a vehicle worthy of his gifts. In *Mr. Sunshine* (2011), he was the manager of a basketball arena with a propensity for hosting unusual events; in *Go On* (2012), he was a radio host coping with the loss of his wife; in *The Odd Couple* (2015), he took on the slobbish Oscar Madison role in an updated version of the Neil Simon chestnut. A superlative performer, Perry has yet to find the vehicle that can even approach *Friends*. Where LeBlanc and Kudrow thrived by mocking their stardom, Perry sought to re-create it, and fell short.

Throughout the negotiations for *Friends*, David Schwimmer had perpetually exhibited the least enthusiasm for television stardom, and his post-*Friends* arc demonstrated the veracity of his claims. Schwimmer only appeared intermittently on television after *Friends* ended, and only once as the star of a new show. His AMC series *Feed the Beast* (2016),

about friends who open a restaurant together, came and went without much notice, but Schwimmer's guest runs on other series were more memorable. He was superbly cranky as Larry David's costar in the show-within-the-show production of *The Producers* on the fourth season of *Curb Your Enthusiasm* in 2004, playing off his demanding reputation; and was the surprising moral conscience of *The People v. O.J. Simpson* (2016), playing Simpson's longtime friend and lawyer Robert Kardashian. (The YouTube supercuts of Schwimmer calling O.J. "Juice" were the best comic work Schwimmer had done in years.)

To star on *Friends* was to simultaneously flourish and wither under the white-hot spotlight of the celebrity media, so it was a clever touch for Courteney Cox to make her next starring role as the editor of a gossip magazine. The gritty FX series *Dirt* (2007) never quite took off, and Cox returned to straightforward comedy with *Cougar Town* (2009), which began as a topical series about older women on the prowl for younger men and then gracefully transitioned into another hangout series about a group of friends who enjoyed aimless banter and romantic tension.

In the intervening time, Marta Kauffman had executive-produced a drama on the WB network, *Related*, and had produced a number of documentary films, including *Hava Nagila (The Movie)* and *Blessed Is the Match: The Life and Death of Hannah Senesh*. Kauffman's post-*Friends* comedy series *Grace and Frankie* (2015) imagined the lives of two women (played by Jane Fonda and Lily Tomlin) who are stunned to discover their respective forty-year marriages at an end when their husbands, longtime law partners, run off together. Grace and Frankie are forced out of their comfortable bourgeois lives and into unexpected new arrangements as roommates and matrons of their now-blended families. (Kauffman herself would divorce her husband of thirty-one years in 2015.) *Friends* had appealed to Kauffman and Crane for the variety of permutations its characters could undergo; as a twenty-first-century family show, *Grace and Frankie* could bring its ex-lovers and newly minted stepsiblings together in surprising ways. Tomlin and Fonda were

like post-retirement-age versions of Rachel Green in the *Friends* pilot, newly single and forced to stumble their way forward in an unfamiliar world.

———————

When *Friends*, and then *Joey*, came to an end, Kevin Bright had proved beyond all doubt his remarkable skills at producing television. There was nothing left to prove, no mountain left to climb. *Friends* had generated enough income to likely ensure Bright and his family's financial comfort for life. This was a remarkable achievement for a man who was not quite fifty years old, but it was also a surprising burden. Only a few people in rarefied enterprises, ranging from former presidents to Jerry Seinfeld, had to face the question of what to do for an encore after having already done the thing they would be remembered for. What came next?

Bright had put his life on hold for over a decade while he produced *Friends* and *Joey*. It was an incredible, once-in-a-lifetime opportunity, one that anyone in television would gladly sacrifice anything to grab hold of, but it was one thing to conceive of such sacrifices in the abstract and another to grapple with their reality.

Bright and his wife, Claudia, had young children when *Friends* premiered, and producing a juggernaut like *Friends* had meant ten years of late nights, ten years of missing dinners and parent-teacher conferences and games and performances. It meant not being available to have dinner with his wife on a weeknight, or sit around with his sons and watch a baseball game or read a book before bedtime.

When *Joey* ended, and the adrenaline necessary to produce new episodes of a hit series, week after week, for more than ten years finally subsided, Bright took stock of his life and realized that he had missed a significant chunk of his children's childhood. While he had shored up NBC's Thursday nights, his children had grown from small boys to young men.

There was no flexible-hours version of television, no home-for-dinner model. Making a successful television show was a sixty-to-eighty-hour-per-week job. (For that matter, so was making an unsuccessful television show.) You had to invest all of yourself into your work, and when the weekend came around, you were too tired to do much of anything other than recuperate for Monday morning.

Joey had been a terribly unpleasant experience for Bright, and when it was over, his life fell apart. He separated from his wife and left Los Angeles, taking a position at his alma mater, Emerson College, teaching students about television. Bright chose Emerson to be close to his sons, both of whom were in college on the East Coast, and he felt good about being the parent nearest to them during their college years.

Friends' success, and *Joey's* failure, allowed Bright to understand that his heart was no longer in television. There were people in the industry who were defined by their work, who could not carry on without its assurance of their place in the world. There were also, Bright acknowledged, many people who had to keep working in television to provide for their families. But Bright no longer had to do those things, and the idea of striving to create another hit television show—to find another opportunity that would keep him apart from his family—was wildly unappealing.

After four years, Bright reconciled with his wife and returned to Los Angeles. He was tremendously proud of all he had accomplished in television but also knew that he likely wouldn't be doing it anymore. He made a film about a student of his at the Perkins School for the Blind in Massachusetts, and another about the last months of his father's life. It was rewarding to tell different stories and to work at a less punishing pace. There was life after *Friends,* but there would be no more television for him.

———

There was a cost to *Friends.* In the popular imagination, stardom was the dream that propelled you, or the fantasy that kept you going. It was the ultimate transformation, overhauling what had once been

the dreary weight of ordinariness into something airy and imbued with magic. The six erstwhile ordinary citizens who had been turned into representatives of Generation X ascendant had been forced to wrestle with the unexpected costs of overnight success.

Matt LeBlanc would speak to the media, in the years after *Friends,* about the toll that the show's success had taken on them. "We could never leave that stage, metaphorically speaking," LeBlanc told Warren Littlefield. "Still can't. Still on that stage. That will follow us around forever." It was only too easy to dismiss his comments as the sour grapes of the privileged, but LeBlanc's testimony spoke to something profound they had experienced. Some of it was undoubtedly the complexity of wrestling with being not yet forty years old and already aware of how the first line of their obituaries would read. More than that, though, it was also reflective of a hollowness born of fame. Fame's tentacles kept stars from experiencing life as they had remembered it from before its embrace, and after fame began to recede, stars no longer knew how to comport themselves without its presence.

Jennifer Aniston was easily the cast member whose significance to American popular culture receded the least. Long after *Friends* went off the air, Aniston was still an omnipresent figure, in films, in advertisements for Smartwater and Aveeno, and in wall-to-wall tabloid coverage of her personal life. Aniston was a star, but she was single, lonely, and barren—or so the tabloids had us believe. There was something punitive and cruel about Aniston's treatment in the press in the years after *Friends,* as if she had collectively let us all down by not doing the expected thing. After her split from then-husband Brad Pitt, Yahoo! quoted an anonymous friend of Aniston's who told them, "He wanted kids— like, yesterday. But she's so eager for a post-'Friends' film career, she can't stop to hear her biological clock ticking."

Aniston was studied by a sexist press and found deficient, her failings somehow letting the rest of us off the hook for our own. If this beautiful, successful, charming woman could not find her way to having a family, then our colorless lives were redeemed. "The makers of *The*

Break-Up want to prevent the rest of the world from seeing what Brad Pitt and Vince Vaughn have already passed on: Jennifer Aniston's boobs," read one remarkably catty "Page Six" lede from 2007.

And reports of Aniston's purported pregnancies were heavy on the ground. According to a *Star* magazine report from 2012, Aniston was having a girl with then-fiancé Justin Theroux and had cried "tears of joy" upon learning she was pregnant. Moreover, she had insisted on keeping the news secret out of fear of "jinxing" the pregnancy through the public fuss over her impending baby.

None of this was true. Celebrity publications were perfectly content to publish fan fiction about Jennifer Aniston and pass it off as reportage. *Us Weekly* reported functionally the same story in 2013, with a bombshell splashed across the cover: "Jen's big secret: PREGNANT! After years of trying, she's finally going to be a mom at 44. How she's prepping for baby—and a wedding!"

The moral and journalistic failings of celebrity publications were well known, but the repeated interest in reporting a certain subset of stories about Jennifer Aniston, regardless of their lack of truth, was a compelling study in misogyny intermingled with the unconscious public hunger for a carefully circumscribed happy ending.

This hunger, once it was studied carefully, revealed itself as a direct, if entirely accidental, product of the work of David Crane and Marta Kauffman. Much of America had met Jennifer Aniston as she burst through the door of Central Perk in a wedding dress, fleeing a bad marriage and in search of a different kind of companionship. We had gotten to know Aniston as Rachel Green and had never been able to fully separate the two. Jennifer was Rachel, and Rachel was Jennifer. An audience hungering for happy endings was not satisfied by the one provided by *Friends;* it wanted a similar happy ending in real life, with Brad Pitt or Justin Theroux or Vince Vaughn substituting for Ross Geller. Jennifer Aniston was treated as if she were the real-world extension of a fictional character created by Kauffman and Crane.

In the years after *Friends* concluded, a good deal of gossip coverage was directed toward the question of whether there would ever be a *Friends* reunion. In 2006, there were reports that NBC was closing in on a deal for four one-hour specials, with the stars to be paid $5 million each, but this project never came to fruition. Soon, attention turned to a *Friends* movie, which was said to be in the works.

The breathless reporting mostly ignored the fairly obvious questions overhanging such an effort: Who was hungering for a *Friends* reunion on the big screen, only a few short years after the series' conclusion? Where would the story go after the long-withheld happy endings it delivered? And how could a three-camera sitcom transform itself into a feature film without abandoning some of the core aesthetic and comedic principles on which it had modeled itself?

Given any sustained thought, it soon became clear that a *Friends* film would be logically and artistically incoherent and practically impossible to execute. The rumors lingered, with one or another star singled out as the roadblock preventing the project from moving forward. Lisa Kudrow sought to scotch the rumors with deliberately misplaced enthusiasm, telling the press she thought the best possible *Friends* film would be a spoof along the lines of the successful *Brady Bunch* movies, and that she was curious who would be cast to play her role—in ten or twenty years.

What had once been a fairly ludicrous idea grew substantially more plausible after *Sex and the City* successfully made the transition to the big screen. Kim Cattrall had been targeted by the press for her hesitance to commit to an *SATC* film, and Jennifer Aniston was now being pegged as the Cattrall figure keeping the public from getting the thing they purportedly wanted. "The movie star reportedly does not want to be typecast as Rachel Green," "Page Six" reported in 2008. "Is Jennifer Aniston the next Kim Cattrall? Courteney [Cox] needs to schedule a

meeting with SJP [*Sex and the City* star Sarah Jessica Parker] and get this diva straightened out." It was a gratuitously nasty swipe.

In the end, the only reunions would take place on television, where they belonged, as when David Schwimmer showed up opposite Matt LeBlanc on *Episodes*, or when late-night host Jimmy Kimmel, playing Ross in his own *Friends* fanfic script, cast Aniston as Rachel once more to pay homage to his erotic prowess, and Courteney Cox and Lisa Kudrow dropped in to echo his claims.

———

A few years ago, costume designer Debra McGuire received a phone call from a young man. His wife's birthday was coming up soon, and he was looking to buy her the yellow dress. McGuire knew what he was referring to without requiring any further explanation. Of all her designs, this one was what people were most curious about. It was a strapless yellow dress with a slit up to mid-thigh that Jennifer Aniston had worn in the season-five episode "The One with All the Kissing."

People still called and emailed asking where they could buy this dress, and McGuire hated to be the one to tell them it was from a British label called IDOL that had gone out of business years prior. The thing to do, she told the man, was to take a screenshot and bring it in to a local seamstress. McGuire would tell him what fabric had been used, and a new version of Rachel's dress could be made.

It was astounding to still be fielding questions like these, almost two decades after viewers had first caught a glimpse of the IDOL dress. It spoke to the devoted attachment some *Friends* viewers had to their favorite show that they clamored to re-create it in their own lives. Rachel Green was no longer, but fans still wanted to insert themselves into Rachel Green's life.

———

In 2008, veteran director Roger Christiansen was on a panel at the Shanghai Television Festival with Carlton Cuse, the cocreator of *Lost*,

and other prominent television creators who were also serving on the festival's jury, and had been asked to take questions from the media. He was astounded when question after question was about *Friends*, which he had directed for two episodes.

China was fascinated by all matters *Friends*. Christiansen later learned that for many of the country's college students, *Friends* was a time-tested method of studying English. They could watch Chandler and Phoebe and learn colloquial English. (*The New York Times* would report, in similar fashion, about Major League Baseball players learning English by watching the show. Wilmer Flores of the New York Mets would watch *Friends* episodes until he arrived at the stadium for a game, and then pick up where he had left off after the game. Flores's walk-up song when he batted? "I'll Be There for You.")

A passionate fan named Du Xin, who would ask visitors to refer to him as "Gunther," built a scale version of Central Perk in a sixth-floor Beijing apartment. Guests were invited to sample treats that had been mentioned on the show, and the space featured the familiar Central Perk logo painted on the window and an orange couch practically identical to the one on television. (The television, needless to say, was showing *Friends* reruns.) Xin had also commandeered the next-door apartment and transformed it into a version of Joey and Chandler's apartment, complete with a poorly measured entertainment unit.

———

For a time, Jessica Hecht felt like the work she was doing on *Friends*, playing Ross's ex-wife Carol's new partner, Susan, was unsophisticated. She knew the show was good, knew there were talented comedic performers like David Schwimmer featured on it, but she didn't think much of what she herself was contributing to the grand patchwork of American culture. One day, she was talking to her brother-in-law, who was then chief emergency-room physician at a large urban hospital. Wasn't it silly, she told him, to spend her time on such a trifle?

Her brother-in-law turned to face her and stared at her for a long

beat. "Do you know how many people are lying in an emergency room, terrified, and watch *Friends* to relax?" he asked her. At that moment, something clicked for Hecht. *Friends* was many things, and among them was this: It was something that provided people, whether lying in hospital beds or on their couches, exhausted at the end of a long day or mourning the loss of a close friend, a momentary respite from their own lives. This was, in the end, no small thing, and Hecht was grateful to have played a role, however small, in creating something that offered that gift to those who needed it.

TASTING THE TRIFLE

Friends Discovers a New Audience

When Kaily Smith started dating her future husband, Adam, in 2010, they would unwind in the evenings by watching *Friends*. Adam had never been into *Friends* before meeting Kaily, but in short order, he was the one who would ask as bedtime approached: "Aren't we watching *Friends* tonight?" Smith, highly organized and efficient, thought of herself as a Monica, and Adam was a Chandler type, the yang to her yin.

After Adam proposed and Smith accepted, the question arose of how to share the good news with their family and friends. They talked about taking engagement photos, potentially for a save-the-date card, and Adam suggested a fountain, like the one in *Friends*' credits. Smith, an aspiring actress and producer, creatively misheard his suggestion as shooting *at* the *Friends* fountain. It turned out that the iconic fountain was on an auxiliary Warner Bros. lot and was available for rent.

Kaily and Adam brought in lighting and a few familiar props—a couch and a lamp. The engaged couple played the parts of their favorite sitcom stars, cavorting in the fountain and twirling umbrellas. Adam spit out water à la Chandler, and Smith's mother and some other friends

filled out the ranks of the friends, covering their faces with their umbrellas so as not to distract from the happy couple. Smith's manager called in a favor and asked Courteney Cox to record a video greeting Kaily and Adam before their shoot: "I hear you guys are the real-life Monica and Chandler."

To be a *Friends* fan was to do more than watch; it was to insert yourself into a narrative and find your place in it. It was to declare yourself a Monica, or a Phoebe, or a Ross. (Well, probably not a Ross.) Not everyone could afford to rent out the Warner Bros. lot to shoot their engagement photos after the fashion of *Friends,* but what did it say about the dedication of the show's fans that *someone* did?

Writer Wil Calhoun's daughter Bren grew up and went off to college at Louisiana State University. Returning to Los Angeles on winter break, she asked her father to watch *Friends* with her. "You want to watch *Friends?*" Calhoun asked her, surprised.

Calhoun had never known his daughter to be a fan, but he happily agreed and turned on an episode of the show on Netflix. He was stunned when she began to quote lines back to the screen. Calhoun turned to his daughter and asked, "You know the lines to this TV show?" "Dad," she replied, "everybody does this." At her sorority, they hosted a weekly *Friends* night, and by this point, practically everyone knew the *Friends* dialogue backward and forward.

What was true of the LSU sorority system was true of America at large. Most shows, no matter how successful, disappeared after their initial run into a nostalgic mist. Appreciative fans might tune in for a late-night rerun of *M*A*S*H* or *Cheers,* but outside of a small band of budding comedy aesthetes, few younger fans would take pains to discover a show that predated their own era of television. *Friends* was the exception to all this. A younger generation of fans has embraced *Friends* as their own. They binged the show on Netflix, obsessed over Ross and Rachel, memorized favorite lines, and created memes inspired by the

show. (There was a particularly good *30 Rock* joke, as well, with Alec Baldwin's Jack Donaghy preparing for a television appearance by binge-ing the first season of *Friends* and obsessing over Ross and Rachel's chemistry.)

A substantial swath of the twenty-first-century Internet is devoted to all matters *Friends*, which would be down a significant chunk of its content without the ability to create *Friends* listicles. More than that, there is an expectation of mass *Friends* literacy. BuzzFeed could publish a story in which the author had decided to prepare Rachel's trifle from the episode "The One Where Ross Got High," assuming that enough readers would be not only familiar with the reference but curious about just how a trifle composed of equal parts jam, custard, beef, and peas might taste.

Friends had premiered when the Internet was still a novelty, a toy Chandler could play with to meet women on his shiny new laptop. By the time the show went off the air, the Internet had become a place to chew over *Friends*, to identify with it, to mock it, to question its choices, to undermine its assumptions, to celebrate its reign and to pontificate.

In the summer of 2017, a corner of the Internet was seized by a tweetstorm by Claire Willett obsessing over one particular *Friends* plot-line: the brief, abortive romance between Rachel and Joey. In Willett's argument, Rachel and Joey were far better suited for each other than Rachel and Ross ever had been. Over the course of one hundred densely detailed tweets, Willett laid out a case for Rachel and Joey, arguing that Joey was more respectful of Rachel's needs and desires than Ross, and that their relationship had naturally blossomed in a manner that Rachel and Ross's never had. Ross, in her estimation, continually comes up short: "49/Joey knows what it feels like to be grasping for your big break. But name ONE THING Ross ever did to unselfishly help Rachel's career." Joey, by contrast, is more devoted to the actual, flesh-and-blood Rachel: "84/Joey: respecting Rachel's feelings. Ross: needing to win ev-ery fucking time." Willett concluded by suggesting that *Friends* had

erred in not ultimately bringing Rachel and Joey together, instead of Rachel and Ross: "99/But a S10 surprise twist where Rachel and Joey end up realizing THEY were each other's lobster all along WOULD HAVE CHANGED SITCOM TV."

Willett's argument is compelling, and remarkable in the depth of its fervor (one hundred tweets!), but it is also worth noting the extent of Willett's assumption of an audience knowledgeable enough to follow her argument about a two-decade-old series. Not only does Willett expect her readers to remember the details of *Friends'* romantic plots, she also casually drops references that only readers deeply familiar with its jokes and worldview would grasp. After all, the idea of Ross and Rachel as each other's "lobsters" had come up in a single episode that had premiered in the mid-1990s. It expressed a remarkable faith in the shared passion of a new, Twitter-fed audience and its devotion to the nuances of a show that premiered the same year as *Models Inc., Chicago Hope,* and *Babylon 5.*

Other Internet sleuths sought to revisit little-remembered nooks and crannies of the show or "discover" new details about *Friends.* One well-circulated article took notice of the hidden reason the couch at Central Perk was always available: a small RESERVED sign nestled amid the cups and saucers on the coffee table. Another spotted a moment in which a stand-in could be glimpsed sitting in Courteney Cox's place in a Central Perk scene. That these relatively inconsequential discoveries and slip-ups could prompt entire articles of their own demonstrated a latent hunger for new *Friends* material, even years after the final episode.

One intrepid *Bustle* writer ranked all 703 of Rachel Green's outfits worn over 10 seasons of the show. Season 2's worst outfit involved a silver quilted jacket that she described as "The One Where Rachel Auditions for *The Fast & the Furious*"; season 4's favorite was a slinky black dress with sheer sleeves. The amount of research required for this effort had to have been heroic, and it was unlikely that another show (other than perhaps *Sex and the City*) would have inspired so thorough a deep

dive. It could safely be assumed that readers would not only be familiar with *Friends* but know its characters and the general outline of its plot. The Internet footprint of *Friends* began in the knowledge that everyone had already seen the show. This was not an introductory course; it was an advanced seminar.

The Internet was a place to share the love. It was a place to buy a hoodie that read "WE WERE ON A BREAK!" or a mug inscribed "YOU'RE MY LOBSTER." The tools of the contemporary Internet allowed collective desire to become imaginary wish fulfillment. There would never be a *Friends* movie, but there genuinely was a (fake) *Friends* movie trailer that made the rounds, with scenes from *Episodes* and other shows featuring *Friends* stars edited together into something resembling a heart-tugging new movie with the six familiar faces.

The overall impulse of twenty-first-century *Friends* chat was two-fold: laudatory and revisionist. It was understood that most of the milquetoast fans had fallen away and were unlikely to be interested in discussing a show they had moderately liked over a decade ago. It was only the superfans who were left, and unlike the fans of nearly every other show ever made, their ranks were growing.

New audiences were discovering *Friends* long after its premiere, and their impressions were inevitably colored by the passage of time and by changing social mores. A notable subset of contemporary social media was devoted to revisiting *Friends* and questioning its underlying assumptions. Why were there so few minorities on the show? Why was the show so offensive about Chandler's transgender father? And did Ross and Rachel even belong together?

The desire for more, and better, and different *Friends* was epitomized by director Alan Yang, who pointedly recast the show with an all-star black cast in his music video for Jay Z's "Moonlight" (2017). In this brisk recap of "The One Where No One's Ready," Jerrod Carmichael was Ross, Issa Rae was Rachel, Tessa Thompson was Monica, Tiffany Haddish was Phoebe, and Lil Rel Howery and Lakeith Stanfield dueled over their favorite easy chair as Joey and Chandler, respectively. The set

is remarkably realistic, and the actors deliver their lines crisply, but a horror-movie buzz of dread lingers, prompted by a recurring musical drone in the background.

Hannibal Buress shows up to tell Carmichael the video idea, which Carmichael described as potentially "subversive," is "wack as shit . . . episodes of *Seinfeld* [sic] but with black people." Carmichael and Rae eventually slip off the set and into a private dance of their own, away from the show's stifling whiteness. "Moonlight" (the title itself a reference to Hollywood's grudging, belated kudos for African-American artistry) is a critique that poses as a celebration.

Much of the Internet's *Friends* energy was devoted, like "Moonlight," to revisiting the show in the light of the societal, political, and cultural changes of the past twenty years. Had *Friends* aged well? What were its blind spots? Much virtual ink was spilled over *Friends'* perceived sexism, its racism, its transphobia, its curiously blinkered view of 1990s New York. A *Slate* article from 2015 looked at Chandler Bing and wondered: "Could he *be* a bigger creep?" It made for a fascinating virtual colloquium, in which devotees and newcomers studied a much-loved artwork of the recent past and assessed its limitations.

Some of it was intended to mourn the deficiencies of a show they loved; some was intended to attack fans for admiring a show that they believed failed to treat everyone with dignity. Both began from the same position of silently acknowledging that *Friends* was that rare cultural expression that had mattered for as long as it had, continued to matter now, and would likely matter deep into the future. *Friends* was relevant in a way that other products of the 1990s mostly were not, and its supporters and detractors were beginning from a place of hushed or grudging respect for that reality.

There was still a pent-up desire to argue with *Friends*, to insist that better decisions should have been made. For younger audiences, *Friends* was not a museum piece; it was a living text, to be wrestled with, pondered, reimagined.

The anti-Ross sentiment held by Willett and others was born out of

a hard-eyed look at the character's often-juvenile and insecure behavior, but it also attested to a desire to tear down some of the traditional scaffolding that surrounded *Friends* and watch it afresh. If *Friends* was insistent that Ross and Rachel were destined to end up together, some fans wanted to push back by arguing that they wanted nothing of the sort. Ross was the whipping boy for many members of the new generation of *Friends* fans, who found his often-callous treatment of Rachel (from his jealousy regarding her coworker Mark to his secretly delaying their divorce) too much for them to handle. It was also reflective of a latent need to make *Friends* their own, to experience it differently from those older fans who had watched it live or recorded new episodes on fresh VHS cassettes.

It is unlikely that when the writers hired to staff the show first gathered in the spring of 1994 they imagined their plot decisions being investigated for contradictions or mistakes nearly a quarter-century later, but the likes of *Cosmopolitan* were on the case, wondering how it could be that Rachel and Chandler have to be introduced in the pilot when later flashbacks demonstrated that they had met on at least four occasions in high school and college. They had even made out: "It's unlikely they wouldn't recollect *any* of this, no?"

This was nowhere near the most obscure point dredged up in the story. How had Rachel been able to use an old key to unlock Chandler and Monica's door in "The One with the Late Thanksgiving" when the locks had been changed two seasons prior? How could Ross have said that he had only ever been with Carol when he had also apparently slept with the cleaning lady in college? Did Phoebe know French or not? And what was up with Ross's telling people he didn't like ice cream when he had been witnessed, on two separate occasions, eating ice cream?

It was too easy to poke fun at this investigative-journalism approach to a television show, and the show's creators and writers could never have anticipated the sustained level of interest in quarter-century-old plotlines and jokes, but there was something remarkable in this level of attention to detail. The average viewer tuning in for a few minutes

before bed was unlikely to spot all the times Ross had been described as being twenty-nine (which ranged across the third, fourth, and fifth seasons) and tabulate the discrepancies. It attested to the passion of *Friends*' viewers both that they were able to raise these questions and that there was an audience interested in hearing them.

At the same time, there was an urge to document *Friends*' deviations from contemporary liberal orthodoxy. The era in which the show had been produced—the Clintonian nineties, complete with Democratic presidents enacting welfare reform and First Ladies railing against "superpredators"—felt impossibly distant to the young writers and lay television scholars intent on revisiting *Friends*. The show was to be studied in the light of changing attitudes regarding race, gender, and sexuality, and often found wanting.

Compared to many of the shows of its era—and even of the current era—*Friends* did notably well at including its female characters on equal terms. Women were not relegated to supporting roles, nor did they lack for adventures that did not revolve around men and romance (this show easily passes the Bechdel Test), even though much of the show concerned itself with sex and relationships. In that regard, Marta Kauffman and David Crane's desire to give equal play to their three female leads was prescient.

But *Friends* was subject to withering criticism of its approach to homosexuality, and its gay jokes in particular. "*Friends:* 10 Times the Classic Sitcom Was Problematic," read one headline from *The Independent*, and VH1 ran a blog post in 2015 that was pointedly titled "Sorry to Ruin Your Fond Memories, but *Friends* Was Homophobic AF." The author points to moments where jokes leaned on gay and lesbian stereotypes, like Carol enjoying drinking beer out of a can, or Ross panicking when he saw his son, Ben, playing with a Barbie and swapping it out for a G.I. Joe. In the latter case, it seemed tendentious to argue that this was clear evidence of the show's homophobia, as opposed to Ross's. Other examples, like Ross's quizzing Sandy (Freddie Prinze Jr.), the newly hired nanny, about whether he was gay, were perhaps more justified as

evidence of homophobia, although again perhaps more of a black mark against Ross than the show itself.

Fans wanted *Friends* to be perfect, wanted it to remain as shiny and stress-free as it had been in the 1990s. Glimpses of its political and social failings were troubling, particularly in a changed culture in which some viewed even a single misstep as enough to spell an end for a performer or artwork. The criticism stemmed from a broader initiative to take a hard look at the beloved materials of the past and highlight their shortcomings, but it emerged from the same place of reflexive devotion that buoyed its most passionate fans. Love it or hate it, *Friends* still mattered.

———

A pop-up version of Central Perk opened in Manhattan in 2014, with fans willing to wait for two hours to have their picture taken on the famous orange couch. As Adam Sternbergh noted in a *New York* magazine story, *Friends*—and more specifically the Central Perk set rebuilt on the lot—had become the prime attraction on the Warner Bros. studio tour. Couples would get engaged at Central Perk. Visitors would regularly burst into tears when first walking onto the set.

With syndication and DVD boxed sets, *Friends* has remained in the public eye since 2004, but Netflix's streaming deal elevated the show to new heights. Sternbergh estimated that Netflix had paid approximately $116 million for the rights to the show in 2014. It was a potentially counterintuitive decision, given that *Friends* was still in syndication and was attracting an audience of sixteen million viewers a week—which would have made it the ninth-highest-rated program on the air in 2015, were it not a twenty-year-old sitcom in perpetual reruns. By all measurements, the Netflix deal should have been a dreadful miscalculation. Instead, it drove enormous numbers of new fans toward the show. In 2019, Netflix agreed to pay an eye-popping $100 million for one more year of streaming rights to the show, in advance of WarnerMedia's likely reclaiming of *Friends* for its own forthcoming streaming service.

What is it about *Friends* that speaks to teenagers and twentysome-

things in the era of Black Lives Matter and President Donald Trump? Many of them had not even been born when Rachel first burst into Central Perk in her wedding dress. How is it that a quarter-century-old show still speaks to wave after wave of new fans?

Friends was the ur-product of the 1990s, the long decade between the fall of the Berlin Wall and the collapse of the World Trade Center. In that span, there was a sturdy belief in the permanent triumph of capitalism and democracy, and a conviction that the American way of life was not only right and just but permanent. None of this was visibly present in *Friends*—there were no episodes in which Ross and Phoebe debated the efficacy of the free-market system—but it was the silent foundation that allowed *Friends* to take the form it did.

When *Friends* premiered, its fixation on the emotional turmoil of its characters reflected a brave new world in which young Americans, no longer troubled by the Cold War and its harbingers of impending doom, could afford to concentrate solely on their own self-expression. The end of history meant that we could all now obsess over the one who got away, or the threat of permanent bachelorhood, without worrying about nuclear holocaust or totalitarian oppression. And New York had changed, too. This was not a show set in the grubby city of *Taxi*; it was a sitcom for the gentrification of Manhattan and its reclamation for white, middle-class arrivistes.

By the time *Friends* premiered on Netflix in 2015, it reemerged in a changed world. The United States was about to enter a period of unprecedented turmoil, prompted by a former reality-television star who had promulgated racist lies about the president of the United States and was now campaigning for the presidency himself with a blend of racial animus, strongman bluster, and vaguely articulated promises directed toward the white working class of the country.

The American economy had collapsed almost a decade earlier under the weight of its own hubris, a victim of its bad investments in abstruse deals no one had understood and a misplaced belief in the inherent wisdom of the markets. There was a peculiar idea going around the country, propelled primarily by some of the same baby boomers who

had set off these interlocking crises, that the millennial generation was uniquely entitled and self-absorbed, unable to fend for itself or take responsibility for their lives. This was precisely wrong. Where the baby boomer generation had been assured, at every step of the way, that the path to future success would be smoothed for them, millennials knew that no one was going to help. The future would not necessarily be rosy.

In this light, *Friends* is less a promise for the future than a pleasing fantasy in which to take cover. The country was in crisis, and there was no longer even the semblance of a guarantee that matters would not get worse before they got better—if they ever did. *Friends* has found a new audience searching for an escape from the cycle of news alerts and Twitter threads. It is a place in which bad news is temporary and friendship eternal. It is a place whose sturdiness stems from a belief in the idea of planning for a well-marked, easily achievable future that looked, in the second decade of the twenty-first century, increasingly remarkable.

It is also—perhaps peculiarly for those of us who only recently lived through the era it seeks to depict—a nostalgic tour of the past, intended to siphon off some of the unbearable pressure of the present with a brief jaunt into a gentler moment. "The world of *Friends* is notable, to modern eyes," wrote *New York*'s Sternbergh, "for what it encompasses about being young and single and carefree in the city but also for what it doesn't encompass: social media, smartphones, student debt, the sexual politics of Tinder, moving back in with your parents as a matter of course, and a national mood that vacillates between anxiety and defeatism."

Sternbergh argues that *Friends*' enduring appeal is related to technological changes that rendered American life substantially different from what it had been. "I admit, I do find myself occasionally nostalgic for that moment right before the internet became all-encompassing, when you could only ever hang out with your friends in real life—and you never said IRL, because what other life would you be talking about, if not your 'real' one?" Sternbergh was surprised that younger fans were embracing the show for similar reasons and concluded that *Friends* appealed to them by demonstrating an older model of companionship that

felt cozy and intimate: "In hindsight, that era seems idyllic by comparison: a fantasy life where friends gather on a sofa, not on WhatsApp."

Moreover, *Friends* had been proven right in staking its fortunes on telling the stories of twentysomethings. Whatever its evasions and exaggerations, *Friends* touched on many of the milestones in the lives of young adults: first jobs and first serious relationships, marriage and child rearing. Its story line could serve as a model for younger fans to emulate or to imagine themselves into. *This* was how adulthood looked and felt, or at least how they wanted it to look and feel. *Friends* promised that whatever challenges maturity might bring—heartache and loneliness and professional turmoil—it would be experienced in the company of one's bosom companions. All was change, but friendship was eternal. This was a powerful assurance in an era that lacked so many other certainties.

Friends told its young audience that while adulthood could be frightening, its fears could be assuaged by the presence of one's friends. We would face life's challenges together. This was, to be sure, fanciful; who kept all their friends forever? Who had a spouse and children but hung out with their crew all the time? And yet there was a certain bedrock truth to *Friends*, acknowledging and amplifying the growing importance of young Americans' social spheres to their quality of life. With Americans' getting married older and older, or in many cases not at all, hanging out with your friends was less a brief interlude between periods of domestic harmony and more and more a reflection of a way of life. Younger fans were watching *Friends* and taking mental notes, accruing pointers and inspiration about how they might live.

Friends is ultimately both fantasy and reality. It offers fans the opportunity to luxuriate in its vast empty spaces, left unfilled by professional, financial, or familial concerns. It allows young people to dream of a life in which the primary thing that occupied them would be their friends and relationships. Its outlines increasingly resemble the world young people reside in for a term roughly bookended by their college

graduations and their wedding days. And who knew if either of those would ever come anymore?

Shortly after communing with the *Friends* pilgrims of the West Village in the winter of 2018, I was standing in a cramped hallway in the basement of a Lutheran church on Forty-Sixth Street, listening to Nirvana bash out "Smells Like Teen Spirit" one more time. The crowd was about 70 percent women and 95 percent white, and many of the people present seemed to be there for a celebration or a mother–teen daughter bonding experience. There were holiday lights and plastic plants strung along the walls, and the counter at the far end sold an assortment of alcoholic beverages, along with T-shirts that read "Ross-Rachel-Chandler-Monica-Joey-Phoebe-GUNTHER."

If the T-shirts were not indication enough, we were all gathered for *Friends! The Musical Parody*, performed nightly at the St. Luke's Theatre, and twice on Saturday nights, for an audience of knowing *Friends* devotees. From a cursory look around at the audience, it appeared that many of those present had not been born yet in September 1994, when *Friends* premiered on NBC. Nirvana gave way to C+C Music Factory and Stone Temple Pilots (what, no Hootie & the Blowfish?), and then the lights dimmed.

The show was, in one sense at least, a remarkable accomplishment. It took ten seasons and two hundred thirty-six episodes of *Friends* and boiled them down to a single two-hour musical while maintaining the series' rough emotional arc. Here were our six friends back once more, even if seeing the resemblance required some of our own goodwill. In his leather vest, Joey looked more like Fonzie from *Happy Days*, and a joke about "rehab weight" (presumably directed at Matthew Perry) was required to justify the presence of the heavyset actor playing Chandler.

The performers took varying positions on the necessity of capturing the essence of the characters they were embodying. Ross sounded more

like Woody Allen than David Schwimmer, and Monica, who had an impressive, full-bodied singing voice, did not do much of a Monica. But Rachel had clearly done her homework, getting Jennifer Aniston's vocal inflections exactly right (while also still somehow sounding vaguely Southern).

Was the acting troupe honoring the memory of *Friends* or burlesquing its excesses and flaws? The preshow musical numbers had been there to unwittingly set a mood. This was an evening of uncut 1990s nostalgia, an opportunity to immerse ourselves in an era before mass terrorism on American soil, before government-sanctioned torture, before a misbegotten war in Iraq, and before the celebrity Chandler and Monica had run into on their secretive weekend getaway became, impossibly, the president of the United States. *Friends* was our escape, and the show knew it.

The audience was keyed in to all the references and on numerous occasions—encouraged, perhaps, by the booze they had purchased before the show—shouted out lines before the actors. When Rachel told Ross that she was over him now, echoing a story line from the second season, practically everyone in the audience began to unspool Ross's response: "When were you . . . under me?" The biggest laughs were for the moments where the musical sought to talk back cattily to the show, as when Joey, in act 2, got noticeably and continually stupider, or when Rachel had a post-breakup burst of self-awareness: "Look at me. I'm out of control, I'm eating bread and staring out a window."

The funniest moments in the show were pegged to identifying *Friends'* narrative weaknesses and converting them into song. "We don't have any black friends," Ross noted as part of a hip-hop-flavored breakdown early in the show. "Every friend group in New York eats breakfast together every day," Monica casually observed later on. And one of the biggest cheers of the night came when Ross answered the question of why he never said anything to Rachel about his feelings: "Because I'm a pussy."

There were also rare moments when something that had never quite been a part of the show sounded just plausible enough to ask us to

jog our memories. Had Chandler ever told Monica, "Could I *be* any more in love with you?" After the actors ran once more through the litany of "they don't know that we know they know we know," familiar from "The One Where Everybody Finds Out," they all collectively paused, having lost their breath from the effort.

The laugh lines were a diversion, though, deflecting attention from the genuine purpose of *Friends! The Musical Parody*. This musical was intent, above all, on re-creating the feeling of watching *Friends*. Monica and Chandler unexpectedly found love once more, and Rachel and Ross, after two hours of "Will They or Won't They?" (the title of a song in the show), made their way back to each other. And the audience found their own measure of comfort in the presence of these friends, long gone and yet never entirely absent.

"We'll be there for you," they sang in the finale, "when you have insomnia and can't sleep. We'll be there for you, when your heart's broken by a creep." It sounded like a promise well worth it to the 150 or so people who had shelled out $60 and upward to spend a night with a knockoff of their favorite sitcom. The crowd streamed out, singing along with Shania Twain, and Joey—or this Joey, at least—made himself available for selfies with the excited fans still standing on Forty-Sixth Street long after the show had ended.

Friends! The Musical Parody was being acted just steps from Times Square, and this was only apropos. The show belonged in the crass heart of American popular culture, a short cab ride away for every tourist visiting New York and intent on bringing a piece of its artificial heart back home with them. This was the power of fandom. It could get you up out of your apartment, or your hotel room, in search of a familiar kick. It could induce you to spend an evening gently mocking a show you clearly loved—although, intriguingly, never mocking the fans who loved it—in order to rhetorically justify the reliving of the delirious highs that the show once offered.

We left the cocoon of *Friends*—or of *Friends! The Musical Parody*—and were spit out into the maw of Times Square. I walked back to the

train thinking about the playwright who had written the show and the performers who had assiduously rehearsed, memorized the lines, and invited their friends and family to the premiere. There was something touching about the amount of effort that had gone into this act of love, this collective expression of memory and fondness. We gathered so we could all remember together, and in remembering, collectively appreciate the thing we had all once loved, and carried on still loving. It had not left us yet.

ACKNOWLEDGMENTS

I am deeply grateful to all the *Friends* alumni and fans who shared their stories with me for this book. Listening to them helped me to understand people's passionate devotion to this show. Todd Stevens and Adam Chase were especially generous with their time, and their insights were crucial for my understanding of the *Friends* phenomenon.

Thanks as well to the many *Friends* writers, directors, crew members, and actors, and NBC employees, who cooperated with this book, including Jeff Astrof, Preston Beckman, Robby Benson, Sherry Bilsing, Michael Borkow, James Burrows, Wil Calhoun, Roger Christiansen, Ted Cohen, Jill Condon, Marjorie Coster-Praytor, Tate Donovan, Lee Fleming, Suzie Freeman, Cosimo Fusco, Candace Gingrich, Greg Grande, Jeff Greenstein, Mike Hagerty, Larry Hankin, Jessica Hecht, Sebastian Jones, Alexa Junge, Ellie Kanner, Wendy Knoller, Ellen Kreamer, Michael Lembeck, Warren Littlefield, Amaani Lyle, Greg Malins, Debra McGuire, Mary Rodriquez, Arlene Sanford, John Shaffner, Jane Sibbett, Mike Sikowitz, Michael Skloff, Jeff Strauss, Flody Suarez, Ira Ungerleider, and Mitchell Whitfield.

I would particularly like to thank David Crane, Kevin Bright, and Marta Kauffman for giving so generously of their time to speak with me. This book would have been a far lesser enterprise without their cooperation. All remaining mistakes are, of course, mine.

My agent, Laurie Abkemeier, has been instrumental to this book from its very inception, and her perspicacity, as well as her near-photographic recall of *Friends* episodes, has been inspirational. My editor, Jill Schwartzman, radiates calm, and her guidance throughout this project has been invaluable.

The entire Dutton team, including Alice Dalrymple, Marya Pasciuto, Aja Pollock, Elina Vaysbeyn, and Maria Whelan, has been a pleasure to work with.

My students from NYU's Gallatin School of Individualized Study have been delightful weekly conversational partners, and their enthusiasm for comedy and television informed this book in numerous ways. Madeline Hopson, Sarah Smith, and Julia Leonardos did superb work as research assistants. I look forward to proudly bearing witness to all their many future accomplishments in postgraduate life.

Thanks to Jennifer Keishin Armstrong for accompanying me on my *Friends* field trips, and for her insights into television history.

Thanks as well to my friends and family for all their support during the writing of this book: Ali Austerlitz, Annie Austerlitz, Jeremy Blank, Choomy Castle, Mark Fenig, Joanne Gentile, Marina Hirsch, Jesse Kellerman, EB Kelly, Daniel Mizrahi, Helane Naiman, Josh Olken, Sarah Rose, Herbie Rosen, Eli Segal, Shana Segal, Jason Seiden, Abby Silber, Carla Silber, Dan Silber, Reuben Silberman, Dan Smokler, Erin Leib Smokler, Menachem Tannen, Olia Toporovsky, Ari Vanderwalde, Adi Weinberg, Zev Wexler, and Aaron Zamost. Hi, Zack and Josh!

I still miss Lisa Choueke Blank's presence and would have loved to hear her tell me all the ways I got it wrong here.

Shout-out to Jeff Abergel and the Brooklyn Resisters for keeping the faith in dark times.

Thank you to my parents for their unending support. I watched the first episode of *Friends* in their house when I was fifteen, so I guess this all started in front of their television.

My children, Nate and Gabriel, love *Sesame Street* more than *Friends*,

but their vivacity, enthusiasm, kindness, curiosity, and friendship give me hope for the future.

Becky Silber is my most trusted editor and adviser, in addition to my wife and best friend. I could not have written this book without her.

SOURCE NOTES

CHAPTER 1
Interviews with Marta Kauffman, Warren Littlefield, David Crane, and Kevin Bright, conducted by the author.
Warren Littlefield, *Top of the Rock: Inside the Rise and Fall of Must See TV* (Anchor, 2013).
Elizabeth Kolbert, "Birth of a TV Show: A Drama All Its Own," *New York Times*, March 8, 1994.

CHAPTER 2
Interviews with Ellie Kanner, Marta Kauffman, David Crane, Kevin Bright, Mitchell Whitfield, Robby Benson, James Burrows, and Preston Beckman, conducted by the author.
Friends original pitch document, courtesy of the Writers Guild Foundation.
Warren Littlefield, *Top of the Rock: Inside the Rise and Fall of Must See TV* (Anchor, 2013).
"Lisa Kudrow's Cable Comeback," *Studio 360*, December 4, 2014.
Kate Aurthur, "Courteney Cox: 'Cougar Town's' really normal Hollywood star," *Los Angeles Times*, September 6, 2009.
Mark Binelli, "Jennifer Aniston," *Rolling Stone*, September 27, 2001.
Rich Cohen, "Jennifer Aniston: The Girl Friend," *Rolling Stone*, March 7, 1996.
Nancy Collins, "Jennifer Aniston: Cherry Poppin' Mama," *Rolling Stone*, March 4, 1999.
Nancy Collins, "Jennifer Aniston's New Life," *Harper's Bazaar*, June 2006.
Julia Dahl, "The Best Friend," *Redbook*, August 2001.
Mitchell Fink, "Jennifer in Love," *Redbook*, August 1999.
Margaret Lyons, "*Friends* Countdown: Lisa Kudrow Was Almost Roz on *Frasier*," *Vulture*, December 12, 2014.
Dan Snierson, "The Untold Story of Matt LeBlanc," *Entertainment Weekly*, July 16, 2012.
Bret Watson, "Winner & Losers," *Entertainment Weekly*, December 15, 1995.

CHAPTER 3

Interviews with Marta Kauffman, David Crane, Jeff Greenstein, Jeff Strauss, Kevin Bright, and James Burrows, conducted by the author.

Original pilot script, courtesy of the Writers Guild Foundation.

CHAPTER 4

Interviews with Preston Beckman, Kevin Bright, Marta Kauffman, Flody Suarez, David Crane, Michael Skloff, Adam Chase, Ira Ungerleider, Andrew Reich, Mike Sikowitz, Alexa Junge, James Burrows, Marta Kauffman, and Jane Sibbett, conducted by the author.

CHAPTER 5

Interviews with Kevin Bright, Jeff Greenstein, Mike Sikowitz, Marta Kauffman, Jeff Strauss, Adam Chase, Alexa Junge, Greg Grande, John Shaffner, Marjorie Coster-Praytor, David Crane, and Ira Ungerleider, conducted by the author.

Warren Littlefield, *Top of the Rock: Inside the Rise and Fall of Must See TV* (Anchor, 2013).

James Endrst, "Emergency! 2 Hospital Dramas! 2 Sets of Parents Killed in Car Crashes! Lots of Bad Shows!," *Hartford Courant*, September 4, 1994.

Lisa Kudrow as told to Jeff Jensen, "My Favorite Year," *Entertainment Weekly*, June 27, 2008.

John J. O'Connor, "Yes, More Friends Sitting Around," *New York Times*, September 29, 1994.

Ken Parish Perkins, "A Singular Formula," *Chicago Tribune*, September 21, 1994.

Howard Rosenberg, "NBC's Strongest Evening of the Week Has Its Weak Spot," *Los Angeles Times*, September 22, 1994.

Tom Shales, "Fall TV Preview," *Washington Post*, September 22, 1994.

Ken Tucker, "Winning 'Friends,'" *Entertainment Weekly*, October 21, 1994.

Richard Zoglin, "Friends and Layabouts," *Time*, March 19, 1995.

David Zurawik, "Good 'Friends' fits snugly into NBC's lineup," *Baltimore Sun*, September 22, 1994.

CHAPTER 6

Interviews with David Crane, Marta Kauffman, Jeff Astrof, Adam Chase, Kevin Bright, James Burrows, Todd Stevens, Michael Lembeck, Candace Gingrich, Jessica Hecht, and Jane Sibbett, conducted by the author.

Greg Braxton, "Black and White TV," *Los Angeles Times*, January 27, 1997.

Rob Brunner, "Theme Mates," *Entertainment Weekly*, September 15, 2001.

Jess Cagle and Dan Snierson, "The Cast of Friends," *Entertainment Weekly*, December 29, 1995–January 5, 1996.

Mike Duffy, "Sitcoms' Lack of Diversity Obvious as Black and White," *Chicago Tribune*, March 6, 1996.

Jaimie Etkin, Emily Orley, and Krystie Lee Yandoli, "The Amazing Story Behind 'I'll Be There for You,' According to the Rembrandts," BuzzFeed, September 21, 2014.

Matthew Gilbert, "Friends Diversity: Too Little, Too Late?," *Boston Globe*, April 23, 2003.

Tom Shales, "Network Knockoffs: A Friends' Frenzy," *Washington Post*, August 31, 1995.

Jonathan Storm, "Segregated Situation on Television Comedies," *Philadelphia Inquirer*, April 14, 1996.

CHAPTER 7

Interviews with James Burrows, Todd Stevens, and Marta Kauffman, conducted by the author.

CHAPTER 8

Interviews with John Shaffner, Kevin Bright, James Burrows, Greg Grande, Richard Marin, Debra McGuire, and Marta Kauffman, conducted by the author.

Warren Littlefield, *Top of the Rock: Inside the Rise and Fall of Must See TV* (Anchor, 2013).

Daniel Bates, "I Was High on Drugs When I Created the Rachel," *Daily Mail*, May 13, 2013.

Libby Calaway, "Setting Trends in TV Land," *New York Post*, January 27, 2000.

Rebecca Eckler, "He Solved Rachel's Hair Problem," *National Post*, April 4, 2002.

Elana Fishman, "'Friends' Costume Designer Looks Back on 10 Seasons of Weddings," *Racked*, June 7, 2017.

Bella Gladman, "The One Where Tom Ford Loved the Clothes," *Telegraph*, February 21, 2016.

Denise Hamilton, "Rachel Really Gets Around," *Los Angeles Times*, August 31, 1995.

Julie Logan, "Hair Like Theirs," *Los Angeles Times*, July 24, 1997.

Stephanie Mansfield, "Closet Queen," *Vogue*, May 1996.

Teresa Mendez, "Off the Small Screen and into the Closet," *Christian Science Monitor*, March 26, 2003.

Carol Vogel, "Clothes That Make the Star, the Cast and the Show They're On," *New York Times*, December 29, 1996.

CHAPTER 9

Interviews with David Crane, Todd Stevens, Greg Malins, Mike Sikowitz, and Marta Kauffman, conducted by the author.

CHAPTER 10

Interviews with Marta Kauffman, David Crane, Kevin Bright, and Ellen Plummer, conducted by the author.

Warren Littlefield, *Top of the Rock: Inside the Rise and Fall of Must See TV* (Anchor, 2013).

Jess Cagle, "'Friends' Go on Strike for a Raise," *Entertainment Weekly*, July 26, 1996.

Jess Cagle, "Friendly Ire," *Entertainment Weekly*, July 26, 1996.

Bruce Fretts and Dan Snierson, "Geek Love," *Entertainment Weekly*, April 26, 1996.

Brian Lowry, "'Friends' Cast Returning Amid Contract Dispute," *Los Angeles Times*, August 12, 1996.

Jethro Nededog, "How the 'Friends' Cast Nabbed Their Insane Salaries of $1 Million per Episode," *Business Insider*, October 6, 2016.

Dan Snierson, "Never Say Nebbish Again," *Entertainment Weekly*, November 4, 1994.

"Matthew Perry: Nobody's Fool," *Entertainment Weekly*, January 24, 1997.

CHAPTER 11

Interviews with Marta Kauffman, David Crane, Adam Chase, Jeff Astrof, Mike Sikowitz, David Lagana, Alexa Junge, Ellen Kreamer, Greg Malins, Andrew Reich, Jeff Greenstein, Jeff Strauss, Ted Cohen, Wil Calhoun, Sebastian Jones, and Michael Borkow, conducted by the author.

CHAPTER 12

Interviews with Jill Condon, Amy Toomin Straus, David Crane, Marta Kauffman, Andrew Reich, Wil Calhoun, and Ira Ungerleider, conducted by the author.

CHAPTER 13

Interviews with Tate Donovan, Todd Stevens, Marta Kauffman, David Crane, Marjorie Coster-Praytor, Michael Curtis, Debra McGuire, Adam Chase, Andrew Reich, Jeff Strauss, Kevin Bright, Michael Lembeck, and Kristin Dattilo, conducted by the author.

CHAPTER 14

Interviews with Greg Malins and David Crane, conducted by the author.

CHAPTER 15

Interviews with Kevin Bright, Jill Condon, Greg Grande, Todd Stevens, David Crane, Adam Chase, and Wil Calhoun, conducted by the author.

David Hochman and Dave Karger, "Fool's Paradise," *Entertainment Weekly*, January 24, 1997.

CHAPTER 17

Interview with Amaani Lyle, conducted by the author.

"California Supreme Court Rejects 'Friends' Lawsuit, Defends Sanctity of Writers' Room," *Gawker*, April 20, 2006.

Ronan Farrow, "Les Moonves and CBS Face Allegations of Sexual Misconduct," *New Yorker*, August 6 and 13, 2018.

Maureen Ryan, "'NCIS: New Orleans' Producer Investigated Again, Even as CBS Renews Overall Deal," *Hollywood Reporter*, June 15, 2018.

Writers Guild of America West message, May 22, 2018.

CHAPTER 18

Interview with David Crane, conducted by the author.

CHAPTER 19

Interviews with David Crane, Marta Kauffman, and Kevin Bright, conducted by
the author.

"Portraits of Grief: William F. Burke Jr.," *New York Times*, November 11, 2001.

CHAPTER 21

Interviews with Todd Stevens, David Crane, and Kevin Bright, conducted by the
author.

Warren Littlefield, *Top of the Rock: Inside the Rise and Fall of Must See TV* (Anchor,
2013).

Lynette Rice, "The 'Friends' Stars' Contracts Run Out This Season," *Entertainment
Weekly*, February 28, 2000.

Lynette Rice, "Funny Money," *Entertainment Weekly*, May 26, 2000.

Lynette Rice and Dan Snierson, "Friends or Foes," *Entertainment Weekly*, February
9, 2001.

Lynette Rice and Thom Geier, "'Friends' Forever?," *Entertainment Weekly*, Febru-
ary 15, 2002.

CHAPTER 22

Interviews with David Crane, Marjorie Coster-Praytor, Adam Chase, Ted Cohen,
Sherry Bilsing, Marta Kauffman, Jeff Greenstein, Mike Hagerty, Andrew
Reich, and Kevin Bright, conducted by the author.

Tom Shales, "A Big Hug Goodbye to 'Friends' and Maybe to the Sitcom," *Washing-
ton Post*, May 7, 2004.

Alessandra Stanley, "Twilight of the Sitcom Gods (Cue the Strings)," *New York
Times*, May 6, 2004.

Chris Suellentrop, "*Friends:* A Great Soap Opera Masquerading as a Great Sit-
com," *Slate*, May 5, 2004.

CHAPTER 23

Interview with David Crane, conducted by the author.

CHAPTER 24

Interviews with Kevin Bright, David Crane, Debra McGuire, Roger Christiansen,
and Jessica Hecht, conducted by the author.

Warren Littlefield, *Top of the Rock: Inside the Rise and Fall of Must See TV* (Anchor,
2013).

Hasani Gittens, "Jennifer in Legal Chest War," *New York Post*, February 22, 2007.

Louisa Lim, "'Friends' Will Be There for You at Beijing's Central Perk," NPR, Jan-
uary 23, 2013.

Jackie Strause, "'Friends' Takes 'Sex and the City' Avenue," *New York Post*, July 2,
2008.

James Wagner, "'Friends,' the Sitcom That's Still a Hit in Major League Baseball,"
New York Times, September 18, 2017.

"Had to Be Dad Brad or Out," Yahoo! Travel, January 9, 2005.

"Jen's Big Secret: Pregnant," *Us Weekly*, September 30, 2013.

CHAPTER 25

Interviews with Kaily Smith and Wil Calhoun, conducted by the author.

@clairewillett Twitter feed.

Kat George, "703 Outfits Rachel Wore on 'Friends,' Ranked from Worst to Best (Yes, That's Every Single Outfit)," *Bustle*, May 19, 2015.

Ruth Graham, "Chandler Bing Is the Worst Thing About Watching *Friends* in 2015," *Slate*, January 22, 2015.

Ilana Kaplan, "*Friends*: 10 Times the Classic Sitcom Was Problematic," *Independent*, January 22, 2018.

Christopher Rosa, "Sorry to Ruin Your Fond Memories, but *Friends* Was Homophobic AF," VH1.com, September 16, 2015.

Adam Sternbergh, "Is 'Friends' Still the Most Popular Show on TV?," *New York*, March 20, 2016.

Marie Telling, "I Tried Rachel's Meat Trifle from *Friends* and It Was Pretty Awful," BuzzFeed, November 22, 2016.

"12 *Friends* Plot Holes Still Keeping People Up at Night," *Cosmopolitan UK*, January 17, 2018.

INDEX

Note: *Friends* characters can be found alphabetized under their first names, including *Chandler, Joey, Monica, Phoebe, Rachel, Ross,* and others.